THE POLITICS OF

Identity

THE POLITICS OF

Identity

CLASS,

CULTURE,

SOCIAL

MOVEMENTS

STANLEY ARONOWITZ

ROUTLEDGE • NEW YORK • LONDON

Published in 1992 by

Routledge
An imprint of Routledge, Chapman and Hall, Inc.
29 West 35 Street
New York, NY 10001

Published in Great Britain by

Routledge
11 New Fetter Lane
London EC4P 4EE

Library of Congress Cataloging in Publication Data

Aronowitz, Stanley.
 The politics of identity : class, culture, social movements /
Stanley Aronowitz.
 p. cm.
 Includes index.
 ISBN 0-415-90436-6 (hard).—ISBN 0-415-90437-4 (pbk.)
 1. Social classes—United States. 2. Group identity—United
States. 3. Middle classes—United States. 4. Working class—United
States. I. Title.
HN90.S6A76 1991
305.5'0973—dc20 91-40561
 CIP

British Library Cataloguing in publication data also available

Contents

Acknowledgments vii

Preface ix

Introduction 1

1 The Decline and Rise of Working-Class Identity 10

2 Marx, Braverman, and the Logic of Capital 76

3 On Intellectuals 125

4 Theory and Socialist Strategy 175

5 Working-Class Culture in the Electronic Age 193

6 The White Working-Class and the
 Transformation of American Politics 210

7 Why Work? 225

8 Postmodernism and Politics 253

Index 273

Acknowledgments

Many people have read, edited and otherwise improved these essays. Chapter 1 has benefitted from the ideas of Robert Viscusi, Ellen Willis and Juan Flores; chapter 3 owes a debt to Bruce Robbins, who provoked me to write it; chapters 6 and 7 were developed with Bill Difazio, my friend and collaborator.

I dedicate this book, with love, to Ellen Willis, my sharpest critic.

Preface

Class, at least as the defining and structuring category in both ideology and social life, has retreated over the past two decades into the background of contemporary American politics. But its agency, I remain persuaded, has not—even if it has been displaced in other identities. Of course, by the term "displacement" I do not mean, for example, that gender and race are simply derived from class or occupy its space, in which case one clings to the centrality of class. Instead, I want to argue that we share multiple social identities, but these are not always "in evidence" in specific political contexts. What has occurred in the last quarter century is that, on the assumption that the working class shares in the general level of material culture, class has been removed ideologically and politically from the politics of subalternity, at least in late capitalist societies, and has been replaced by new identities or by conceptions according to which the "new" middle classes—hardly oppressed social categories—have emerged as political agents, but in their own behalf.

In Chapter 1, "The Decline and Rise of Working-Class Identity," I offer some grounds for holding that this assumption no longer obtains for a substantial fraction of workers. The transformation is often expressed as the change from regulated to "disorganized" capitalism, terms that are linked to the distinction between the Fordist and post-Fordist eras.

Chapter 2, "Marx, Braverman, and the Logic of Capital," first published in *Insurgent Sociologist* (Fall 1978), is a critique of some tendencies in the Marxist theory of labor and directly discusses the question of workers' agency in the labor process. Concretely, I reject the proposition, ascribed to Marx and Harry Braverman, that working-class resistance is overwhelmed by the "logic" of capital. Alternatively, I

argue for a conception of relatively autonomous concrete labor that is not (entirely) subsumed under capital.

Chapter 3, "On Intellectuals," first appeared in a different form as an essay in *Intellectuals*, edited by Bruce Robbins (University of Minnesota Press, 1990). It attempts to assess the agency of the "new" middle classes, considered in a historical perspective. This essay considers the work of Antonio Gramsci, Alvin Gouldner, and Georg Konrad and Ivan Szelenyi, all of whom, in various ways, have argued for the pertinence of intellectuals in both revolutionary and stabilized historical conditions.

Chapter 4, "Theory and Socialist Strategy," is a consideration of Ernesto Laclau and Chantal Mouffe's *Hegemony and Socialist Strategy* from the standpoint of the theory of the subject. It first appeared in *Social Text #16*.

Chapter 5, "Working-Class Culture in the Electronic Age," concerns the relationship between working-class identity and its representation in various media, particularly recent film and television. It first appeared in *Cultural Politics in Contemporary America*, edited by Ian Angus and Sut Jhally (Routledge, 1989). I take my thesis of displacement to describe how workers' culture has been treated in the media.

Chapter 6, "The White Working Class and the Transformation of American Politics," discusses the significance of the recent decline of working-class economic and political power for American politics. It appeared in Fall 1991 in a collection published in French by the journal *Autrement*. I discuss the crucial roles race and gender, linked to social movements, have played in the rightward tendencies of white working-class males.

Chapter 7, "Why Work?", first appeared in *Social Text #12* (1986). It revives a traditional issue in the labor movement, namely, whether, in the light of the historical transformations in the technical basis of labor, work can remain a defining human activity.

Chapter 8, "Postmodernism and Politics," addresses the political significance of the large-scale estrangement of underlying populations in Western countries from traditional politics. It appeared first in *Social Text #18*.

Introduction

The Politics of Identity

Ever since 1981, when the Air Traffic Controllers suffered their historic, but humiliating defeat at the hands of the Reagan Administration, the conventional wisdom has asserted that as an instrument of labor's economic strategy, the strike weapon is all but dead. Yet, after the demise of Eastern Airlines after a long strike by an unprecedented coalition of unions, and the victory of the Allied Printing Trades in the *New York Daily News* strike less than a decade after the long slide began in the fortunes of U.S. unions, reports of the death of the strike and, with it, the labor movement are, to say the least, premature. In both of these prolonged struggles organized labor had learned well the fairly simple lesson: without solidarity among workers within a single company or industry and with the general labor movement, victories against large, well-financed corporations are nearly impossible.

The second lesson is that it is no longer enough, as in earlier strikes, for workers to withhold their labor; "replacement workers," the dressed-up name for scabs, can and often will be legally employed and easily recruited by management. What management cannot do is insure that other working people, newsstand owners, and travel agents will buy their products. And, these strikes show that corporations cannot expect, automatically, to control public opinion, even when the press and television networks are entirely subservient to them. As usual, the media echoed management's claim that union successes are due, exclusively, to the use of violence. In order to get the message across, workers and their unions are obliged to use many approaches, including reaching retail and wholesale outlets, billboards, giving talks to union and civic organizations as well as the major commercial media. In short, both the *News* and Eastern Airline strikers saw themselves as an embattled "movement" rather than one

of the self-interested contestants in traditional conflicts. Moreover, the strikers understood their strike as part of labor's fight for survival.

The *News* unions made some errors. Most notably, they did not begin their boycott early enough but relied, almost exclusively at the beginning of negotiations, on collective bargaining even when it was apparent to everyone that the paper's owners, the Tribune Co., were not really interested in a settlement unless the unions completely caved in to the demand that management be granted the right to make all decisions at the workplace. Yet, when they finally decided to pull out their most potent weapons—reaching out for labor and public support and limiting, through direct action, management's ability to distribute the newspaper—the unions grabbed victory from probable defeat. Unlike the unions during the Controllers strike, they were not detained by threats of legal reprisals and decided to conduct their struggle by any means necessary to win. Within weeks after the strikers effectively reduced the *News'* circulation, the largest of the paper's advertisers pulled out, even the notorious anti-union department store Alexander's. By the end of the strike only 27 of 600 advertisers remained loyal to the paper's management. Just as the unions prepared for the next stage, a direct attack on the parent company by means of what has become known as a *corporate campaign* where stockholders are contacted to pressure management and lenders are urged to withhold their capital, the Tribune Co. declared that, unless a buyer was found for the paper which, by the end of 1990 had lost more than half of its 1 million daily circulation and millions of dollars, it was shutting down by March 15. At the last minute, a buyer, British publisher Robert Maxwell, came forward—but not before he obtained substantial concessions from the unions, most importantly, the right to reduce the labor force by one-third. Under these conditions the paper was saved, at least temporarily. The strike's major issue—the right of workers to have a voice in control of the workplace—was resolved in the workers' favor, even though 800 workers were slated, by agreement, to lose their jobs.

The outcome of the Eastern strike was more ambiguous. On the one hand, in contrast to their traditional refusal, in other strike situations, to unite with fellow employees, the pilots joined manual and clerical workers on the picket lines in the early weeks of the strike. And even after they returned to work, a determined boycott campaign led by the Machinists union proved successful enough to drive the company into bankruptcy, a setback that was followed, after almost a year, by Eastern management's decision to go out of business. While the outcome of the strike was less than the workers would have wished (after all they lost their fairly well-paid jobs at a time when jobs are

hard to find) the event demonstrated that unions remain able to inflict serious harm on employers—if they bring their case to other union members and to the public.

Yet, despite these exceptional struggles, U.S. workers and their unions *have* experienced nearly unrelieved pain since the late 1970s. The heart of the industrial heartland—from western Pennsylvania to Chicago, Detroit to Cincinnati, where workers had built powerful unions that helped deliver, not too long ago, the world's highest living standards—has suffered massive capital flight and rapid deterioration in their standard of living. Like Britain's industrial midlands a decade earlier, huge factories stand ghostly tall and produce nothing but bitter memories. These days, their legacy is confined to piles of toxic waste that may destroy the water, the soil, people's health. The costs of de-industrialization have been tremendous for U.S. workers, but no payment has been greater than their loss of dignity. Many have become internal migrants. Those who remain in the ghost towns that were once bustling communities are obliged to accept lower-paying jobs in retail or non-union construction trades.

Capital flight translates into plant closings in the older industrial towns and cities. Typically, economists have ascribed this development to the emergence of the global economy, where lower-wage foreign labor produces goods that have successfully undersold American-made products. Today, there is virtually no major industrial or consumer product that cannot be made more cheaply elsewhere. Consequently, in contrast to the earlier industrial migration from the Northeast to the southeastern United States that began shortly before the First World War with the textile and shoe industries, capital has also pulled up its historic stake in basic industries of the Northeast and the Midwest—steel, rubber, autos, and oil refining. For example, in the wake of technological change that vastly increased labor productivity and a relatively stagnant market for oil in the past twenty years, the largest corporations consolidated their production in fewer plants, closing many refineries in the 1980s. This was a second wave, the first of which occurred in the 1950s when the industry's employment was nearly cut in half by the introduction of continuous flow production processes to about 100,000 workers. In the latest cuts, brought on by further computerization, fewer than 50,000 refinery workers remain.

Similarly, employment in the steel industry was reduced since 1970 from about 500,000 to just over 200,000 in 1990, even as steel output increased when such technological innovations as the computerized Basic Oxygen Process replaced the older open hearth furnace technologies; reductions in auto employment were substantial, but not quite

as dramatic. The industry work force declined by ⅓ due to robotization, numerical controls, and laser technologies. But the rubber industry's hub, Akron, where 50,000 workers were once employed by the "big four" companies, stands today as a ghost town. Like steel, rubber has been hurt by international competition, but jobs were also lost through computerization.

The once powerful industrial unions within these industries have, concomitantly, suffered steep membership losses. The Steelworkers once boasted more than one million members at the beginning of the de-industrialization process. In 1990, its membership was about 550,000. In addition to mill closings, there have been shutdowns and technologically induced labor displacement in the can, aluminum, non-ferrous metals, steel fabricating, and chemical industries which, taken together, comprise half the union's membership. The Autoworkers membership fell from 1.2 million to about 800,000; the Ladies Garment Workers lost ⅔ of its members, mostly due to import competition; and the Clothing and Textile Workers are somewhat more than half of the combined memberships of about 400,000 in 1970. The Machinists have declined from about 800,000 members to fewer than half a million. In this period, private sector unions which, in 1970, represented about ¼ of the non-farm labor force represented, in 1990, about 12 percent. Only the dramatic expansion of public sector unionism in the late 1960s and early 1970s has helped maintain a respectable total. Of the 18 million union members, including 2 million in the independent National Education Association, union membership in the public and non-profit sectors is about 5 million.

As the proportion of union members to total employment in these industries has fallen (particularly in textile, the needle trades, coal mining, electrical and electronic manufacturing, and metal trades, including steel), workers have lost considerable bargaining power. Employers invariably threaten plant shutdowns when workers refuse to give back their past gains; the idea of labor's forward march, particularly winning contractual guarantees of job security, improved health benefits, and, especially, the possibility of reducing working hours with no reductions of pay, seem, in the current environment, entirely out of the question.

However, numbers tell only part of the story of labor's decline. Perhaps the most devastating change has been the realignment of *social space* that results from the massive dispersion of production. For example, whereas Pittsburgh's Mon Valley once harbored 100,000 steelworkers as late as 1960, there were, in 1990, fewer than 5000. In the 1980s, the industry's employers built "mini" mills in Kentucky, West Virginia, southern Missouri, and other semi-rural areas: only

200 workers were typically employed, and the plants were situated in small towns, duplicating the anti-union strategy of the textile employers earlier in the century. And Detroit has lost the bulk of its auto plants, many of which moved south or to rural areas of the border region of the United States and Mexico.

Deterritorialization has deprived labor of one of the crucial preconditions of its power—industrial concentration. When large numbers of workers share the same, or similar conditions of work and neighborhood life the means of communications are better. Although workers often huddled in small geographic areas in close proximity to factories, these conditions increased the chance of solidarity and immeasurably strengthened their political and social weight both with respect to the employer(s) and in the larger community.

For example, New York's needle trades were once powerful enough to spearhead the formation of labor's own political party, just as Minnesota and Wisconsin spawned independent parties of farmers and workers. Although in Michigan, the Autoworkers chose to enter the Democratic Party, they dominated its program and candidates for thirty years. To be sure, unions often used their power in fairly safe ways. In the main, labor's political power was wielded in behalf of the Cold War, liberal wing of the Democratic party signified by figures such as Hubert Humphrey, John F. Kennedy, and, of course, Lyndon Johnson. Mass industrial unionism was unsuccessful in its quest for a powerful welfare state to cushion the shocks of frequent layoffs, sickness, and aging. Yet, in some respects, the upsurges of the 1930s did establish a framework for the provision of welfare that could have been expanded after the war. Labor's failure may not be attributed to its weakness at the workplace, but its proclivity toward respectability, its aversion to ideological politics, and most crucially, the racial and subcultural splits that have always hobbled its solidarity. Yet, by the end of the Second World War 30% of the U.S. labor force had joined unions, and they were willing to strike for social justice.

It may be argued that capital dispersion was an inevitable consequence of globalization, that, even if the working class had achieved a greater degree of political independence and ideological coherence as a class, the centrifugal forces would have, in the end, undermined its solidarity. This explanation carries only if the degree of dispersion was similar between the United States and Western Europe after 1970. For by then, Europe had been entirely rebuilt from its wartime devastation and began, again, to experience the symptoms of a crisis of overproduction characteristic of advanced industrial societies since the mid-19th century. Yet, particularly in Germany and the Scandinavian countries, the new international environment did not suggest to

their respective ruling classes that the time had come to launch an assault on the working class and the labor movement. Or, that capital was free to migrate, at will, to other regions of the world. Instead, Northern European capital has, since the late 1950s, forged what might be termed a neo-corporatist compromise with workers, the key provision of which is to share the pain of global crisis. This agreement entails maintaining a fairly strong commitment to the social wage, and close consultation on virtually all matters having to do with the management of the enterprises, including the vital question of industrial location. For example, in Germany and Sweden closing industrial plants is a bargaining issue and so are investment decisions. Capital has invested in areas other than their home country. But, unions have won guarantees that corporations will continue to produce a substantial portion of their product within the home country and that workers adversely affected by closures will be compensated and afforded opportunities for retraining, early retirement at full pension, and other reparations.

In contrast, union-bashing and unilateral management rights are precisely the meaning of Thatcherism and the successive conservative political regimes initiated by Richard Nixon's 1968 victory in the United States. Whence the difference? Clearly, the relative weakness of the U.S. labor movement is not sufficient as an explanation, especially if we take the union strength in the most important U.S. industries into account. In the light of the experience of the last fifteen years, when corporations in both countries have mounted a concerted and systematic assault on labor's half-century gains during which labor's rights were publicly acknowledged by the decisive sections of capital, this period must be viewed as an exception to the rule of arm's length industrial relations. Since the mid-seventies, unions no longer drive industrial relations which have conclusively passed over to management. There are no major industries where labor's voice enjoys anything like equality with that of management, much less dominance. At best, in industries such as autos, some branches of transportation, and maritime trades, unions have held on to the neo-corporatist deal negotiated in the 1930s. In virtually every other major case where such arrangements were in effect, unions have retreated to their historic position of subordination, including the construction industry where, for many years, they enjoyed a monopoly over the supply of labor, a strong voice in the determination of technology, and a substantial share in profits (in the form of benefits that exceeded those of other occupations). In short, the traditional management ideology according to which unions are considered a "third party" at the workplace is today resurgent. Workers are considered a disposable

"factor of production" subject to the same efficiencies that apply to any other cost.

Some analysts have attributed this transformation to what has been described as "the end of organized capitalism," a phrase that signifies the shift from a relatively prolonged period of Fordism to a new regime of international capitalist competition. Fordism is defined as the regime of state/corporate regulation of the relation between production, consumption, profits, and wages through state intervention into finance, welfare, and labor relations. Among its crucial features is the development of mass consumer credit, a floor under consumption through the provision of state pensions, unemployment benefits, and other income transfers.

Of course, the extent of regulation and the level of income transfer provisions under this arrangement vary with the relationship of political forces within the various countries of late capitalism. For example, every country of Western Europe provides a universal health care scheme; in addition, France and Sweden have an extensive system of pre-school child care; many European countries afford education and training to workers made permanently redundant by technological change; some offer a long-term dole at fairly decent income. European pensions are state benefits at a level between 60% and 80% of annual wages during the last five years of employment.

Needless to say, although the U.S. has a social security system under which pensions are provided for older and disabled workers and health care for retired workers and other older citizens, there is neither a system of universal health nor child care; the level of pension benefits is inadequate in nearly all cases and must be supplemented, in most cases, by private pensions for an individual to earn a decent retirement income. Medical care for the aged is limited at both ends. The system has a deductible provision before it will pay and a ceiling on how much it will pay.

Still, before 1980, most union members enjoyed some (but not all) of these benefits through the union contract. An unskilled or semi-skilled job in a steel, auto, or electrical plant provided a considerable measure of the economic security—health care, long-term unemployment benefits, supplementary pensions—enjoyed by European workers through the state. As late as the mid-seventies, when a barrage of criticism began spewing from giant corporations, the press, and conservative ideologues that workers were living high off the hog and their wages were destroying American competitiveness, to be a semi-skilled or skilled industrial worker was a proud position in the community. For the past fifteen years, that place has been systematically eroded to the point where working-class identity, never strong, except

in the militant decade ending with the near-general strike in mass production industries of 1946, has nearly vanished from public view. Or, more precisely, public working-class identities have shifted to the police forces or, as the recent Gulf War signifies, to patriotism; or, in every national election since 1968, to the right; or, as the events in Bensonhurst, Brooklyn, Louisiana, and elsewhere demonstrate, to overt racism.

Claus Offe has described the new system as "disorganized" capitalism. What this term means is this: the integration of capital and labor with the state is considerably loosened, a reversal that will, at a more or less rapid rate depending on the extent of capitalist determination and worker resistance, result in the partial, if not complete, dismantling of many of the most precious taken-for-granted features of the Old Deal, especially fully paid health benefits for a worker and her/his family. American management traditions are the least corporatist and the most anti-labor of any capitalist society, except the United Kingdom. The ideology of management has asserted its absolute right to direct the work forces, to unilaterally make investment decisions, including the right to disinvest in a plant or industry without legal or contractual constraints, and to control the political system.

This program has, on the whole, succeeded, especially at the state and local levels. Here the threat of flight is usually sufficient to induce a city or town government to cut business taxes, build a plant or office building or sports stadium at public expense, or provide infrastructural facilities, such as new roads, rail spurs, or improved water and electrical services. Local communities are caught in a double vise: they compete with other U.S. communities for business, as well as foreign competitors. Under these circumstances, workers and their unions who protest are regarded as unpatriotic.

Even as workers were increasingly invisible in public representations, other "subject-positions" that had only sporadically gained attention were emerging—notably women, people of color, the handicapped, gays and lesbians. Needless to say, these identities are by no means commensurable either with respect to their spatial location, although they seem to have occupied the space of class identities that previously dominated the economic, social, and political landscape. As I shall argue in Chapter 1, the spaces of representation correspond to the emergence of new social movements, each of which impinges crucially on, but is not confined to, class issues. The category I will employ to describe the intersection is *displacement*. But, these displacements are not unidirectional: class, gender, race, and sexual preference displace each other; which subject-position dominates is purely contextual.

Although the past two decades witnessed the disappearance of class from American political and cultural discourse, the signs point to new class projects. However, unlike previous eras where the problematic of class dominated intellectual and practical debates, its relationship to social and cultural problematics today is no longer (if it ever was) given in advance. The struggle for social justice is likely to share the space of opposition and alternative, rather than constituting what, following Louis Althusser's term, is a *structure in dominance.*

1

The Decline and Rise
of Working-Class Identity

"The passing of Marxism-Leninism first from China and then from the Soviet Union will mean its death as a living ideology of world historical significance." So ends Francis Fukuyama's lament for the end of history, "a very sad time."[1] In his version of the end of ideology thesis, there are no Hegelian-Marxist contradictions that can be solved only by a relentless struggle for a "communist utopia." To be sure, according to Fukuyama, the third world will remain "mired in history," but the triumph of liberalism, at least at the ideological level, means that change is bound to be incremental or, to be exact, simply characterized by perfections of a system already in place, at least consensually.

Whatever the political merits of this thesis, first enunciated, in various ways, more than thirty years ago by, among others, Daniel Bell and Seymour Martin Lipset, the implications of its key tenets—that our era is marked by conflict but not struggle, problems but not contradictions, unions but not classes, and, most important, that no concrete utopias can animate broad social movements—have barely been explored.[2] In the heady days of the 1960s, which appeared to be submerged in ideology and animated by the not-too-distant dreams of a "new morning" (later to be appropriated by Ronald Reagan), the American and European New Lefts had no doubt what agents of historical change there were. Although some abandoned the "old" working class for revolutionary youth, women, and, especially, the third world, the framework of theoretical and political dispute remained "class analysis." For example, Shulamith Firestone's path-breaking *Dialectic of Sex* and Nancy Hartsock's attempt to assert a "feminist" historical materialism, no less than the Mao-inspired works of Samir Amin privileging the agency of the third world, adopted the class standpoint, only changing the actors.[3] In addition, the numerous "new" communist parties in the early seventies were persuaded that

their versions of Marxism-Leninism would ultimately prevail over the pack of rival revisionists.

By the early 1980s, Marxism-Leninism appeared to have definitively passed into history, even before its standard-bearers, the State Socialist societies of Eastern Europe, Asia, and Cuba, entered their period of crisis. In retrospect, the last great working-class upheavals might have been those of the French May 1968 and the Italian "Hot Autumn" of the following year.[4] For the 1970s were, in consequence of these unprecedented events, in part marked by a long economic crisis and consequent world capitalist restructuring, the effect of which has been to shift the scenes of industrial production to the global South and East, leaving in its wake high levels of permanent unemployment, drastically reduced trade union strength and, perhaps most telling, except in Sweden and Southern Europe, the relegation of labor and socialist parties to perennial and embattled minorities.

The question has been boldly, if narrowly, raised by Fukuyama: if the industrial working class of the West no longer carries the social weight of world historical transformation is the concept of agency, itself, dead? For without agency, there can be no history except an automatic kind. Or are agents destined to play within the rules of the liberal-democratic game within a capitalist framework? If this is the case, what is the status of class in contemporary western societies, in the Third World, in Eastern Europe? And, are there new social and political agents—women, people of color, gays and lesbians, the radicalized ecological and consumer-minded middle classes? Finally, what is the relation between social movements and class? Do social movements replace or displace class as a new "motor force" of history. Surely, the proponents of the new social movements reject the old dialectical theoretical framework but, insofar as they still work within historical discourse, that is, remain in the problematic of the "new," they cannot fully escape historical materialism.

In what follows, my focus will be, in the main, on the United States, but I will address these issues in comparative perspective. While, at least on the surface, the U.S. case may be considered "exceptional" to the European pattern of capitalist development the differences, I think, are not fundamental but are, instead, variations on the same economic, political and cultural themes. For European socialism abandoned revolutionary perspectives during the interwar period and adopted, instead, a long term reform strategy that has entailed collaboration with its own rulers, much as the American labor movement and popular left which, in retrospect, were in the vanguard of this drift. The differences between the U.S. and Europe relate to the differences of their history, respective political systems, and effectiveness.

But welfare state progressivism based upon the struggle for economic justice, although not invented in the U.S., was developed most fully in the U.S. of the 1930s, which was the crucial example of "regulated" capitalism.[5] The 1980s did not merely sound the death knell to the remains of revolutionary doctrine, but it has witnessed the NADIR of the strategy of class-based reform. Austerity has become a permanent slogan of the capitalist state in proportion as capital accumulation has slowed and taken different forms, making enlarging the social wage a zero-sum game. The working class and its main political vehicles have been forced to retreat on a broad front of increasing privatization, of production and social benefits in the U.S. and in Europe. Although the U.S. stands at one extreme of the end of capitalist regulation and Sweden at the other, various labor and socialist movements have arranged themselves along a spectrum of progressively deregulated national economies and weakened welfare state programs. The degree of resistance and solidarity determines the pace but not the direction of the retreat. Today, European labor and socialist movements rest on a higher level of the social wage, but have, with the exception of the German metalworkers' strike for a shorter work week, made no new dramatic gains.

I.

In the face of the apparent passing of the era of workers' power, albeit in the reformist mode, the past decade is marked by the appearance of a new politics of "identity," the terms of which are defined by the ruins of the old universal values of modernity. These values—industrialism within a market capitalist system, a liberal state that guarantees parliamentary democracy and individual rights—and identities that are defined, at least for political purposes, by economic position and interest, live an uncomfortable existence in late capitalist societies of Western Europe and North America. As a political program, modernity enjoyed an initial ascendancy against the authoritarian state socialist regimes of Eastern Europe in the 1980s and became hegemonic, briefly, with the fall of Eastern European communism. However, when the Berlin Wall toppled, and it became evident that the revolution was reasonably secure from a possible counterattack by the old leaderships, nearly every brand of long-suppressed identities surfaced: nationalism, Catholicism, monarchism, agrarianism, all of which owed their animus to premodern culture. And, especially in the West, there has developed a new politics based on race and gender identities.

The politics of identity takes no universal form. In Eastern Europe

and what is, mistakenly, termed the "Middle East," nationalism is conditioned by historical subordination of former client states to the Soviet Union or, in the case of the Arab and Muslim world, to Great Britain, France, and the United States. Lifting the Soviet yoke revealed the plain truth that under the rock of suppression seethed yearnings that cloaked strong authoritarian currents, despite the liberal-democratic program by which the anti-communist movement rode to power.

Of course, Arab nationalism requires no democratic veneer. The modernist tendencies, identified as specifically Western values, were soundly defeated by the Iranian revolution and subsequently submerged, if not eradicated, in normally secular Iraq and Egypt. As the Shah was ousted so were equal rights for women, closely linked in the Iranian context to anti-clericalism and, as it turned out, so were the possibilities for trade unionism and other forms of open class politics. Anti-imperialism, directed especially against the United States and Britain, has combined with a resurgent Islamic fundamentalism to produce a powerful pan-Arab movement that has subsumed class movements. Recently weakened by the Vietnam trauma, recession, and waves of new, apparently unmeltable immigrants from Asia, Latin America, and the Caribbean whose faith in the "American Dream" is tempered by virulent nativism, American nationalism is on the rise again in the wake of the Gulf War. This nationalism was preceded by a resurgent ethnicity in the 1970s, when large sections of the white working class—especially those with Eastern and Southern European roots—began to reevaluate the merits of assimilation and discovered one aspect of their oppression. In the Reagan era, the United States recovered its rampant militarism, which has been a crucial component of that peculiarly American idea of progress. For U.S. reliance on force to achieve state objectives is a feature both of a foreign policy that has bathed its expansionist aims in the blood of others and of the various internal wars that have been the moral equivalent of the welfare state: the "wars" on crime, sex, drugs, terrorism, dissent, the labor movement, radicals.

Certainly, American nationality has lost its utopic dimension. Militarism is no longer mediated by vital democratic and libertarian traditions, no longer masked by America's image as the "golden door" to economic opportunity and social and political freedom, no longer opposed by progressivism that tried to link U.S. imperial aims with the provision of domestic social justice. Like the British at the turn of the 20th century, but also in the late 1940s, and the French just after the War, when their efforts to preserve empire in Southeast Asia and Algeria ended in bitter defeat and national humiliation, American

nationalism rises in inverse proportion to declining U.S. global hegemony. While it is premature to announce the invasions of Grenada, Panama, and the Persian Gulf as a "last gasp" of the U.S. imperium which, for most of the past half century, was the leading economic and military power in the world, the government's almost ritual reversion to the use of force to reestablish its dominance is surely a sign of weakness.

At the same time, as the coalition that pursued the Gulf War shows, the global metastate is alive and well. In this context, descriptions of U.S. imperialism are simply inadequate. Rather, U.S.-based transnational corporations, together with an international political directorate closely linked to them, pursue their own version of imperial intervention with, of course, the nation-state performing an important, if subordinate function.

Recall that American troops have been deployed for the past century as instruments of U.S. foreign policy in five major wars and an equal number of "delightful" skirmishes on foreign soil. Between 1898 and the Gulf War, U.S. military has been involved in the following interventions to protect American interests:

1898—Spanish-American War: U.S. occupies Puerto Rico, Philippines, Cuba

1911—Nicaragua

1917–18—First World War

1920—U.S. joins 21 foreign armies, invades Soviet Union

1934—Nicaragua against the guerrilla forces of Sandino

1941–45—Second World War

1950–54—Korea

1962—Cuba

1961–74—Southeast Asia

1964—Dominican Republic

1984—Grenada

1989—Panama

1990—Gulf War

Needless to say, the list here of small wars is incomplete but it is sufficient to belie the well-publicized isolationist impulse of the American people. Nor was the century devoid of discontinuous but powerful patriotic fervor linked, in the main, to the reality of U.S. and transnational interests. I would venture the hypothesis that these interests were and are an extension of that intrinsic internal will to expansionism that has marked the entire compass of U.S. history, the signals of which are the French and Indian War of 1763, the Lewis and Clark expedition (1804), the wholesale theft of African tribes to enlarge the slave labor force, the Civil War, and the Indian wars of

the latter half of the 19th century. The recent and very naive idea, that one may join the armed forces for purely educational and training reasons or for the vague aim of "defense," may be ascribed to the post-Vietnam syndrome, the illusion of the end of the Cold War, or anything else you like. What is abundantly clear is this: if young Americans believed that they would be spared the toils, but not the spoils, of war they were deeply mistaken. After the Gulf War, the symbol of American identity remains the centaur, electronically mediated, of course. The American as policeman is supplemented by what has become a national scandal: the emergence of a permanent covert intelligence force that not only plays a vital role in foreign policy—keeping tabs on other governments, toppling or undermining them when they show signs of independence, and so forth—but also in domestic. The CIA is only the most visible of a complex network whose internal surveillance of U.S. citizens, labor unions, and social movements has never relaxed since the 1920s. The other side to identity politics is no less disruptive of the older assumptions that social divisions were defined by national boundaries and class affiliations. Although national identity retains its mesmerizing power among large sections of the underlying population, the last two decades have been marked, in nearly all major countries of the late capitalist West, by a discernable decline in politics in which class, rather than race, gender, or ethnicity, was a crucial element. Of course, this is especially true of the United States, where class-defined movements have been weak throughout its history, but also Britain, France, Germany, and Italy, where socialist and labor movements constituted the heart of the social and political opposition for most of the 20th century. With the exception of the United States, socialist and labor parties still occupy the space of the alternative to capitalist hegemonies, but no longer represent what might be termed the *determinate negation of the prevailing order*. Rather, they have settled for the position of "loyal opposition." Socialist parties and the former Italian Communist Party (now the Democratic Party of the Left) are national parties of order. Similarly, the class struggle is relentlessly waged, but, with few exceptions, the initiative has passed, perhaps decisively to capital and its political retainers. With few exceptions, the labor movements, still the mass organizations of workers, have become almost reflexively shy of militant strike action; their most fervent wish is that the status quo will remain in force.

II.

Inevitably, the concept of class entails abstraction and a severe reduction. The multiplicities of concrete relations and, in contempo-

rary parlance, of identities of individuals and collectivities are understood in one reading of historical materialism that, until recently, was dominant within Marxism, as mediations of what is conveniently described as a *fundamental* structuring relation of capital to exploited labor. Or, in the structuralist mode of analysis, the polarity of Marx's two-class model is, within this, ascribed the highest level of abstraction, termed "mode of production." Below this, the "social formation," the so-called intermediate classes, may play a larger or smaller political role depending on the specificity of a country's history.[6] However, in all versions of Marxism, class retains its dominance as a *structuring* relation. Within the paradigm, identities that may motivate political mobilization, such as gender, race and ethnicity, and even nationality, are named *displacements* of class relations and are ascribed to the unevenness of capitalist development or the specific conjuncture of the social formation which, typically, produces caste and stratification within those classes that structure the system.

Marx defined capital as a social relation the hidden term of which was that it is constituted by *labor*.[7] Capital appears in the forms not only of money, but also machinery, buildings, and raw materials, which are merely materializations of quantities of living labor. In Hegel's master-slave dialectic, the slave is the object of domination by the master but, in turn, is the vehicle through which humans dominate nature.[8] Living labor, as the embodiment of the multiplicity of nature's endowments is, for Marx, the condition for the reproduction of the entire social order, most particularly the relations of production and the social relations, the multiplicity of which is what we mean by the term "society." For Marx, the mode of appropriation of the surplus—in capitalist production relations the extraction of surplus value—is, at the end of the day, the fundamental structuring relation that determines all other social forms, including the state and politics.

Although Marx never denies the importance of considering that multiplicity of relations and, especially in his historical writings, insists on their pertinence for explaining concrete events at the political and social levels, he is chiefly concerned to reveal the underlying logic that governs the long wave of historical transformation. The subject term in the celebrated phrase "All history is the history of class struggles"[9] is "history" which, for Marx, connotes, in the first instance, the act in which "the production of the means to satisfy . . . needs, the production of material life itself."[10] Since this production depends on the means that nature provides, the degree to which production becomes a historical act seems to be inversely linked to the natural endowments any group of people confronts. The more

nature provides, the less history is made. (This, of course, is an over-coded inference but would explain many wars and other acts of conquest.)

Conversely, human communities that are obliged to use relatively scarce natural resources to produce their means of subsistence tend to become the first sites of history—making in proportion as labor develops its various skills and cultivates its talents. Among these societies obliged by deficits in natural endowments to engage in the appropriation of nature for human ends, science (even in its mythic form) and technology, the names we give to the codification and further development of crafts, on the one hand, and magic, on the other, come to occupy a privileged place within the capitalist epoch. For science, like commodity exchange, entails processes of abstraction, such as quantification, from particular differences to achieve homogeneity among apparently diverse objects.

Thus, the concept of the common denominator, a basic mathematical procedure, is crucial for understanding the meaning of class. The Marxist notion of class can only be fully grasped as a concept that conforms to the requirement of any scientific object that it be stripped of its overdeterminations, that is, the effects of conjunction and contingency and the multiplicity of relations on its constitution. In turn, the problem for a scientific theory of class is to specify those characteristics that link one type of social object with another, even at the risk of ignoring those characteristics that differentiate them.

For historical materialism, the significance of religion in earlier modes of production is that its agents—shamans, medicine men, priests—are not only the first intellectuals but also the nascent ruling class. And priests, philosophers, the early scientists, medicine men, and rainmakers are the first repositors, in the form of ritual, of intellectual knowledge as a distinct social category. In the division of labor, the bearers of intellectual knowledge gradually become the first ruling class, while the bearers of "know-how"—possessors of practical knowledge—women who are the first farmers, and men, the hunters, gatherers, and craftpersons, constitute the subaltern classes, but not, of course, on an equal footing. Although women are assigned, within the division of labor, to cultivation of animals and the land which, accordingly, is perhaps the first "history-making" occupation, their agency is erased by male force. For hunters and gatherers possess lethal weapons with which to assure domestic tranquility on the basis of their own dominance.

Ironically, women's identity remains—despite the anthropological dispute about the existence of matrilineal, even the possibility of matriarchal, societies at the dawn of civilization—that of domestic

servants to men, the history-makers. Although it would not be difficult to show that women engage in production as well as reproduction of the species, not only physically but socially, and women's work is the absolutely necessary precondition of social production—especially in agrarian societies where a significant portion of the means of existence is produced in the household by women and children—women's identity remains intractably gendered.[11] The class reduction does not seem to work here, except economically. With the advent of ancient society—Greece, Rome, and Mesopotamia among other states, women remain doubly subordinate—to the lord or the capitalist, and to their husbands—in various social formations within what might be termed "modern" history, that is, the epoch beginning with the transition from feudalism to capitalism.

From what is euphemistically described as "pre-history" to the present times, bearers of intellectual and technical knowledge have themselves entered into ruling groups as professional servants, but also as members of the "council of elders" that sometimes governs and, as often, constitutes a sort of secret or at least discrete government, deposes governments from kings to democratically elected officials.

I shall discuss other irreducible identities, such as ethnicity and race, in this essay. For now, I simply want to signal some of the problems entailed by the claim for class as the central problematic of history. It is simply not the case that women have, except in "pre"-civilized societies, been able to enter history when they engage in social production. Nor does class formation overcome racial and ethnic formations, except under very particular circumstances. When Marx claims in the *18th Brumaire* "Men make their own history" we should misread this statement to refer to gendered actors.

As is well known, historical materialism claims that modes of production are constituted by class divisions that, until the rise of capitalism, were most relevant, in political terms, among various sections of ruling classes. The subordinate classes of slave and feudal societies were simply incapable of presenting themselves to themselves much less to their masters as alternative forces of social rule. There were, of course, examples of slave and peasant revolts—some of which, notably the English peasant uprising in 1381, were virtual harbingers of things to come.[12] More to the point, subaltern resistances, expressed in slowdowns and sabotage, when not in direct strike action, have always constrained the economic and political power of ruling groups. Yet it is the antagonism between the producers and masters that remains, in every epoch, the fundamental one, while intra-class conflicts among sections of the ruling class depend, in the last analysis, on the surplus generated by labor.

In Marxist terms, the working class in the capitalist epoch is the first exploited class in human history capable of both making a revolution and of universalizing its own interests. Marx's logic, that "the specific form in which unpaid surplus labor is pumped out of the direct producers determines the relationship between those who dominate and those who are in subjection," is cited in a multiplicity of forms to assert that domination "grows directly out of production itself and reacts upon it as a determining element in its turn."[13] The centrality of class to social conflict derives from this theoretical argument; and the historical evidence that the working class in the most technologically and industrially developed societies has made a series of long-term compromises with capital and the political directorate has not, in the main, dissuaded Marxist intellectuals and revolutionary socialist activists. All efforts to amend socialist theory in the light of historical analysis and political experience are rudely condemned as "revisionism"; and the consequence of this virtual epithet has been that debates within Marxism and other elements of revolutionary socialism are circumscribed by the simple truths uttered by Marx more than a century ago, that "It is always the direct relationship of the owners of the conditions of production to the immediate producers—a relation *always* [emphasis mine] naturally corresponding to a definite stage in the development of the nature and method of labour and consequently of its social productivity—which reveals the innermost secret, the hidden foundation of the entire social structure and therefore of the political form of the relations of sovereignty dependency, in short the corresponding specific form of the state."[14]

G. E. M. Croix has, I think correctly, singled this passage out as one of the crucial statements of what might be described as "classical" historical materialism. For Marx, the literal sense of the relations of production is the "hidden foundation of the entire social structure," a formulation that would refute attempts by revisionists, especially cultural Marxists to claim Marx for their own by citing different passages from the early manuscripts, and especially the *Grundrisse*, where this archetonic prose is surely modified and otherwise qualified. When combined with some similarly decisive passages from *Capital*, Croix is able to claim that history is, indeed, the history of class struggles. In this interpretation, the fundamental class question is the mode by which surplus is extracted at the point of production; the "direct relationship" between owners of the conditions of production and the producers can be periodized and the forms will vary, but the structure remains constant. History becomes an account of the different forms of domination determined by the mode of surplus extraction. When confronted by this elegant formulation of class and

class struggle the New Left had little or no use for the social-democratic alternative (or, in the United States, progressive liberalism) because these forces and their reformist doctrines were considered hopelessly compromised by the welfare capitalism and, equally important, stand condemned of theoretical and ideological emptiness, a charge that was, to say the least, harsh. The new revolutionary left arose as a rejection of progressivist premises, if not entirely their program.

The way the story of class compromises is told by some strands of neo-Marxist historiography and sociological analysis, workers have been frequently betrayed by trusted leaders—party and trade union bureaucrats or rank-and-file heroes who, even when not for personal gain, have misdirected the class struggle into reformist blind alleys.[15] This version of the past assumes that the workers have the will but not the capacity for self-organization, owing to their educational deficits; their ideological backwardness generated by such elements of false consciousness as racism, nationalism, and sexism; or their de-skilled position. Within this explanatory paradigm, the possibility that workers, themselves, made what they considered to be rational choices is inadmissible. At the same time, considering the power of the trade union and party bureaucracies in northwestern Europe after the First World War and throughout Europe after the 1940s, the considerable conservative influence of organization acted as a constraint upon the workers' movement. Recall the French, Italian, and U.S. wildcat strikes of the early 1970s which were fiercely opposed by the leadership before, in some cases, being coopted.[16] Yet, their existence attests to the growing ability of more highly qualified industrial workers to form their own leadership because the "objective" conditions of highly concentrated capitalist production, combined with the freeing of laborer from feudal dependency, generated social movements capable of articulating their own demands on the political as well as the economic level. In contrast, those who suffered domination and were rendered powerless by social marginalization—peasants, women, sub-proletarians, that is, workers not linked to the decisive sectors in the social division of labor within mature capitalism—were certainly worse off, at least in many respects, than most industrial workers. Yet, their ability to enter history, that is, to become agents of social transformation, remained limited by their chronic incapacity for self-organization, especially at the political level.

In contrast to 19th-century England and turn-of-the-century Europe, when the class problematic dominated economic and political struggles, the tendency of contemporary politics has been to privilege the struggle against domination over exploitation. This has occurred,

in part, as a consequence of the decline of working-class social and political hegemony over the systemic opposition, but also the rise of new problems: the significance of consumption as a social and political problematic, especially for the growing legions of intellectual labor within late capitalism; the re-emergence of what might be called caste struggles; and, most especially, the declining significance of work. Surplus value is still extracted from workers, especially, in recent times, from tens of millions of workers in the southern portion of the globe—which has stimulated the rise of workers' movements in countries such as constitute themselves as an independent, extra-parliamentary, and extra-trade union force. In turn, the partial breakdown of this historic postwar compromise between organized labor and capital played a crucial role in stimulating the world capitalist restructuring that, among other things, was directed against the workers' power to resist.

We must distinguish exploitation from domination, although this distinction is ambiguous in Marx's writings. Recall, Marx never claimed the working class was the most *oppressed* or *dominated* class in the capitalist mode of production, only the most exploited. His concept of exploitation, linked to the labor process, the crucial site of the intersection of humans and nature, endowed labor with its history-making power. As we have already seen, for Marx, the mode of surplus extraction is the structuring relation of the entire mode of production, including the forms of the state.

Marx argued that the character of the specifically capitalist mode of production enabled labor to become a class in the historical sense, because capital freed labor, however brutally, from the "idyllic relations" of feudal dependency. While this evaluation proved somewhat optimistic in the wake of working-class history since the mid-1850s, its crucial point—that serfs and other peasants were freed from bondage to become wage laborers—possessed considerable force. Like all previous laboring classes, the proletariat remained exploited, but was no longer dominated by capital, if by that term we signify relations of dependency. Workers possessed the capacity for self-organization, in Brazil, South Africa, and Korea, to name the most prominent. In these regions the class problematic is alive and well even if, in both South Africa and Brazil, mediated by racial domination. Yet, the long-term movement, especially in the "West" and in Eastern Europe, is away from an exclusive or even predominant focus on traditional class identities and towards their (partial) replacement by considerations of gender and color which raise caste questions.

The two-class model that Marx proposed to grasp the structure of mature capitalism, its probable political struggles and historic

outcomes—where intermediate classes, such as independent, commercial proprietors, professions, and peasants, are proletarianized (if this term is confined to loss of property)—has been largely fulfilled. On the one hand, we have witnessed the appearance of new categories of salaried scientific/technical intellectuals whose class position, at once powerful and ambiguous, has become the object of considerable debate. On the other hand, the end of regulated capitalism in the late 1960s has been accompanied by vast shifts in the sites of production from north to south; the domination of intellectual over manual labor; and the shift in the psychological and political scene of conflicts from the realm of production to the sphere of consumption owing, among other things, to a growing popular perception of ecological crisis. Clearly, the emergence of what has become known as "consumer society" does not signify that Marx's argument—that consumption is the flip side of production—is thereby refuted.[17] But, struggles over the conditions of work, which occupied such a prominent place in the late 1960s and early 1970s, became somewhat muted in the face of what must be described as a historically significant defeat for the working class, which suffered extensive decomposition and recomposition during the following decade.

The potential power of the industrial working class emanated from its social location—chiefly from the concentration of production in large cities; from the relatively homogeneous experience of migration from the country to the city shared by millions of people within, but not across national boundaries; and from its juridical independence from the employer, if not from the state. In contrast to the widely scattered small peasants, for example, the new industrial workers possessed means of communication facilitated by the proximity of work-sites and home-sites. Their capacity for self-organization was overdetermined by these features which, however, were each a part of a structured totality. While neither Marx nor his more discerning followers claimed that revolution inevitably flows from features such as large-scale enterprises situated in large cities, there remained a high probability that, under certain conditions, they would conjoin to produce the revolutionary conditions. Here is Marx on communications:

> A relatively thinly populated country, with well developed means of communication, has a denser population than the more numerously populated country, with badly developed means of communication; and in this sense the Northern States of the American Union, for instance, are more thickly populated than India.[18]

Thus, one can derive a theory of class struggle and class consciousness from the crucial part played by communication for insuring the conditions for solidarity. When Marx argues that the French peasants could not form a class because of the isolated conditions of their existence, the presence of social communications would, presumably, facilitate class formation among a group having a common position with respect to production relations. "Communication" is the condition for the constitution of a common cultural community without which political self-representation is not possible. What is explicitly lacking here, but implied by the category of communication, is a concrete theory that links these "objective" preconditions to the process of self-consciousness of a group as a group. How do groups take themselves as their own objects, placing their particular situation in a historical rather than local context? In this respect, the great American Hegelian pragmatist George Herbert Mead may provide a clue in his explicit invocation of communication in which self and other are fused.[19] For Mead, the "I" becomes the "me" when, through communication, the ego moves from action based on personal needs to group action, a development that presupposes its recognition as a social self. What remains indeterminate in this narrative is the nature of the group that becomes the basis of the social self. As we shall see, communication may not lead to class consciousness but may, instead, produce a social self in other terms, especially race, nationality, and gender. The revolution might not inevitably succeed, but the *possibility* that the proletariat could make society in its image was produced by the conditions for capitalism's expansion, and concomitant development, of means of communication that provide the necessary population *density* without which class consciousness cannot congeal. This indeterminacy is the space of the relative autonomy of politics and organization that became the core of Leninist doctrine.

For mature capitalist states of the 19th century and the first half of the 20th century, social and cultural identities were forged by the categories of class and strata: everyday life, aesthetic expressions, and cognitive mappings articulated with production relations. People who lived in cities and towns settled in subcommunities or neighborhoods composed mainly of factory and white-collar workers or, on the other side of town, professionals and entrepreneurs. Until suburbanization in the late 20th century tended to blur these lines, friendships, extended families, and consumption patterns rarely violated class boundaries—even in the United States. The major exception, and one which has had a powerful impact on American ideology, was the relative fluidity of the boundary between working class and small

business—exemplified by those industries such as farming, needle trades, small machine shops, and stores such as grocery shops or bars, where a small, but significant, fraction of skilled workers went in and out of business throughout their working lives.

III.

Before embarking on a more detailed exploration of the fate of class discourse in the United States, I am compelled to enter a small digression. Deleuze has called attention to Bergson's discussion on the importance of the correct posing of problems.[20] Within this context Bergson has identified three wrong moves.

The assumption of questioners is that disorder precedes order, that non-being precedes being, and that one must ask questions about the "real" rather than the "possible." With respect to class, the problem has been posed in the following form: Do classes "exist" in the United States? specifically, is there a "working class" in U.S. society? The assumption is that we can know whether classes actually exist by invoking a determinate series of scientific criteria for class formation to which the supposed reality would conform. For example, some have defined classes by economic identification that is, posit, axiomatically, that a working class exists when those engaged in production neither own nor control the decisive means of production.[21] Or, in a somewhat more sophisticated argument, do wage workers in a particular national context act collectively and independently to further their interests at the workplace, in the political arenas, and constitute independent cultural communities?

Obviously, we have here versions of the correspondence theory of truth where scientific statements are made about a reality that is said to preexist outside of them. But, if we pose the problem differently, asking, historically, what has been the fate of the *possibility* of workers forming a class or, more broadly, of class discourse to structure political and cultural life?, then the solution is far more tentative. One cannot answer the existential question by scientific statements, but must trace the fairly complex disrupted history of class through *discursive* analysis within any given social formation. In this inquiry, class is taken as a prospect whose "being" is never permanent or fixed in national life. Like nationalism, it is a contingent identity whose power is not fixed, but must be evaluated within a determined set of circumstances.

The official ideology insists that, unlike industrial Europe, there are no classes in the United States, if by this term we connote that political and cultural identities are typically forged by a definite relationship

of individuals and groups to the ownership and control of the means of production, but more specifically to communities in which labor shares similar conditions of life, a common culture, and means of communication. These characteristics facilitate cohesive organization and, penultimately, political self-representation. Stated more broadly, the American popular, as well as sociological, imagination remains solidly infused with the idea that America is set off from all other societies, virtually, by the opportunities it affords for *vertical* mobility. In its more sophisticated "progressive" variants, the "rags to riches" doctrine is easily dismissed, especially after the Great Depression. But, liberal/progressive thought celebrates the chance, principally through universal access to higher education, for the son or daughter of a laborer to advance to professional and technical occupations. Thus, professionalization has largely replaced entrepreneurship as the basis for the widespread view, even among the popular left, that America is a middle-class society. Within this context discrimination—against people of color, women, and sexual minorities—is deplored as a historical anomaly within a generally democratic culture. Surely, full civil rights requires, according to this view, a resolute struggle against ingrained prejudices, as well as short-term interests of employers who might benefit from the lowered wages that result from racial or gender exclusions. But, progressivism stands on the optimistic judgment that economic expansion successfully combined with democratic vision and strong trade unions can overcome the remaining inequalities.

As Abercrombie and Urry have pointed out,[22] American sociology virtually equates class and status: skilled versus unskilled, intellectual versus manual labor, professionals opposed to "lay" people, seem the more urgent basis of distinction than relations of ownership. In turn, especially after the 1920s, when a new "Fordist" credit system was introduced,[23] status is achieved not exclusively through occupational or production relations but, as well, through *consumption*. The new status symbols are home ownership; possessing other consumer durable goods, such as late model automobiles and appliances; higher education that now can be purchased, just like houses and cars, on the installment plan; and the increasingly important status signifier—travel opportunities. The replacement of class by a new status order antidates the Second World War, but it was more closely articulated, at first, with traditional class boundaries. Professions such as law, medicine, and the clergy were typically part of the old middle class of small entrepreneurs who, in towns and small cities, constituted a significant part of the civic leadership.

However, the vast expansion of consumer credit after the War

meant that wages and salaries no longer expressed rigid boundary conditions to consumption; they differentiated the *quality* of houses and cars, not *whether* workers could buy them. With the growing importance of scientifically based technologies in the production sectors, the expansion of financial services, and the emergence of the scientific management of society as a crucial element of the American social imagination, not only in factories but also in the welfare sector and the military, post-secondary education became increasingly important. Perhaps the most significant new development in what Marx termed the *forces* of production was the growing centrality of knowledge and the dramatic expansion of universities as its crucial site. The shift from an emphasis on manual to intellectual labor in production has had far-reaching effects. It has altered the terms of politics in all late capitalist societies, and more globally has transformed the culture. One change in the 20th century was the formation of the *salaried employee* as a prototype of the new worker. This shift applied not only to engineering and other technically based professions which were created in the era of the large corporation, but also the traditional occupations of law and medicine. By the 1970s most medical and law school graduates could expect to work for health or legal organizations: lawyers may never become partners, physicians never open their own practice.

In sum, the advent of postwar mass higher education and the perfection of consumer society through the development of new communications arenas, such as television, combined with dramatic U.S. economic expansion to vitiate the social weight of the classes linked to the older industrial order. That order has been described as "regulated" or "organized" capitalism, the heart of which was the close articulation of production and consumption, of work and leisure, and of the state with the production system.[24] Workers in the mass production industries which, after the 1930s, tended to be unionized, and technical and other stable white-collar occupations (which were not typically in unions), enjoyed a level of material well-being that was, until the 1960s when Europe largely recovered from war-devastation, unprecedented in world history.

These achievements eliminated neither distinction nor conflict. People were differentiated on new bases that bore, at most, an indirect relation to class. And, consumerism introduced new types of social conflict. Yet, what counts here is that, notwithstanding the increasing *objective* proletarianization of more than 80% of the U.S. population,[25] identities based on relations of production were significantly loosened.

In the postwar era, we have witnessed the emergence of social

movements organized around a new conception of rights that marks the shifts of identity. From the burning passions of the first decades of this century to secure social justice, the new social movements have focused on the quality of life—values that articulate with the emergence of the scientific and technical intelligentsia as significant social and cultural actors. These movements have focused attention in some of the leading late capitalist countries on the nutritional and chemical content of food, the purity of air and water, the need to protect forests and other "wilderness" areas from industrial exploitation, but also the right to pleasure, to be free of social domination. In contrast to what might be termed the politics of environmental purity that were propelled, at the turn of the 20th century, by a fairly narrow layer of the intelligentsia, these movements have grown to such proportions that qualitative issues have replaced the old struggles for social justice at the cutting edge of political and social practices. This shift has occurred even as, ironically, living standards for most Americans, evaluated in quantitative measures, have steadily declined.

For example, from a relatively insignificant band of what were called "conservationists"—zealot bird watchers and hikers who objected to the exploitation by industrial corporations and land developers of "wilderness" preserves for oil exploration, lumber, and suburban housing—the ecology movement has grown into a worldview as much as a series of institutions and popular protests which have challenged, intellectually, many of the sacred assumptions about progress through industrial expansion and, equally importantly, have forced reluctant national and local governments, of which, whatever their ideological hue in the old terms, are relentless modernizers, to reform both practices and laws affecting the environment. Ecological thought questions whether *growth* is acceptable in the light of the greenhouse effect and other long-term threats to human survival.[26] Some argue that centralized, mass production regimes are deleterious to the environment, and that most human needs should be provided on a regional, even local basis;[27] and, social ecology powerfully challenges the premise that consumerism is a viable life-style in the face of ecological crisis, even in the face of evidence that its ideological influence may be attributed to the growth of consumerism as a social concern.[28]

In the past twenty years, the environmental movement has constituted a powerful force for eliminating chemicals in food processing, purifying water, controlling industrial and auto pollution, as well as fought the nuclear industry to a virtual standstill in the late 1970s and early 1980s.[29] In a major struggle of 1989–90, environmentalists

have, for example, stopped the lumber industry in Oregon from felling old trees. Earlier, spurred by intellectuals grouped around what became known as Public Interest groups, the New York Public Interest group halted New York's Westway project that would have replaced Manhattan's decayed highway system with a larger superfreeway. Environmentalists have come close to making oil spills, such as Exxon's Valdez spill off Alaska's coast, a crime punishable by imprisonment for corporate officials. In the 1990s, the scourge of overflowing garbage in major metropolitan areas, the alarming rise of big city pollution attributed to automobile fuel emissions, and similar issues that strike to the core of what constitutes decent urban life are good candidates to dominate local politics rather than struggles to house the growing number of homeless in large cities, the massive increase in permanent joblessness, or deteriorating school and health facilities and services.[30]

But, as opposed to the solid achievements of specific environmental struggles, ecology has scored its most important success by entering the social imaginary. Ecology proposes not only repairing environmental damage through greater state regulation, but a new mode of life in which nature is taken not as an antagonist to culture, but as a partner. There are, of course, conservative versions of this imaginary, particularly the movement known as *Earth First* or deep ecology, in which human priorities are subordinate to those of the supposed natural order. Moreover, nature-loving is inherent in some versions of fascist ideology. And, it has been shown that a powerful ecological strain emanates from Malthusian assumptions, especially the relationship between earth's natural endowments and human appetites.[31] But, these conservative theories only serve to emphasize that ecology is a social movement, if by that term we designate movements that propose new ways of ordering our lives, in this case, new possibilities of social being. As social movements mature, their unity is often sundered by their growing popular character. People are attracted to them from different sides of the ideological spectrum. In the most powerful cases—laborism, socialism and anarchism, race and sex-gender, for example—we can observe ideological realignment. What counted as "left" and "right" changes according to whether individuals or groups support the worldview (rather than the concrete demands) of the movement. In this respect, ecology is no exception. For example, the old wisdom, according to which achieving social justice crucially depends on the effectiveness of policies of economic growth in the global South as well as the North, is in crisis because of the claims of ecological theory. Moreover, consumerism as a way of life is in serious

trouble, not only because of the world economic restructuring, but also because of the permeation of the ecological challenge into the collective belief systems of significant elements of the population.

Similarly, feminism has made an enormous impact. Its demands—from the fairly consensual call for gender equality in employment, income, and education, to the more controversial abortion rights struggle, to the radical argument for sharing child-rearing—have shaken the foundations of patriarchal culture. For when child-rearing is no longer, in the last instance, the mother's responsibility, working hours and, more profoundly, production expectations would be transformed. For example, the common practice of compulsory overtime for both industrial workers and managers would be, in the main, abolished in a regime of equal responsibility between males and females for child-rearing. Even if this proposal has not reached the stage of social practice or even of concrete political demands, it is a logical consequence of a thoroughgoing regime of social and economic equality.[32]

Moreover, some strands of feminism have developed a sweeping critique of contemporary culture as ineluctably gendered—production relations, social and personal relations, and knowledge, especially science—that, taken together, approaches the status of a social and political theory that may be considered an alternative to both liberalism and Marxism. Some writers, such as Ursula Le Guin and Joanna Russ, have constructed concrete utopias the effect of which would be to abolish reproductive difference, which, in their conceptions, grounds gender domination.[33] Others, such as Donna Haraway, Evelyn Fox Keller, and Sandra Harding[34] have shown that the universalist claims of science can be successfully challenged on the grounds that science is gendered. (For Haraway, for instance, science is constitutive and is constituted by the imperium, the will to expansion, the male imaginary of power.) And cultural radicals have, despite the counterattack by cultural conservatives of the left as well as the right, maintained their insistence on a woman's right to pleasure and, most recently, have joined with civil libertarians in opposing the efforts of some feminists to ban pornography on the argument that it is a form of violence against women.

Like other social movements, feminists divide ideologically the more the social imaginary becomes a burning issue. Yet, these differences can hardly obscure the fact that the debate concerns the conditions of possibility of alternative ways of life and that the persistent struggles for concrete reforms are not merely ameliorative of contemporary conditions, but are comprehended by a substantial fraction of

the movement as part of a larger strategy of blurring the line between being-subordinate and the non-being of liberation whose boundaries are continually shifting.

These last two decades have witnessed contradictory developments for black Americans. On the one hand, the general decline of the labor movement that has resulted in the political marginalization of the discourse of social justice constitutes nothing less than a catastrophe for blacks. By every economic indicator—employment and income, housing, health care and mortality, education—material conditions of life have drastically deteriorated for blacks. The black poor are growing much faster than any other section of the population, and black communities suffered extreme hardship during the 1980s, when many other groups were prospering. On the other hand, these have been years of unprecedented expansion of the black middle class. Large corporations, federal, state, and local governments, universities, and leading social welfare institutions have actively promoted hiring programs for black managers and professionals.

Among the consequences of these developments is a distinctly new ideology that seeks to shift the black freedom movement from its focus on racial discrimination and exclusion to constituting black identity within an ethnic context. The term "African-American" is now widely employed in universities. This strategy attempts to reproduce the hyphen between earlier immigrants' country of origin and their adaptation to American nationality. The designation "African" becomes an equivalent of, say, "Polish" or "Irish," and is designed to obliterate the significance of racial designation which has been both a class and a caste displacement throughout U.S. history. Although racial identification has been the bane of their social and political existence and has been condemned by liberal social science as a crass instance of social Darwinism,[35] its ironic adoption by the most militant sections of the black freedom movement since the 19th century was a strategic maneuver designed to forge greater solidarity among people of color. The declaration "I'm a race man" signified that the speaker recognized black people in the United States as a *class* sharing a common economic, political, and cultural fate that was not only different from that of whites, even the most disadvantaged ethnic minorities such as Latinos or Italian-Americans, but was ultimately antagonistic.

"African-American" stands on the boundary of ethnicity and nationality. It proclaims difference and the right to cultural autonomy, but identifies with the dominant nation. In effect, the term can be read as a reconciliation with the dominant economic and political arrangements after the age of the civil rights upsurge in which blacks won partial citizenship. But it is also profoundly shaped by the ebbing of

hope among the black working class in the wake of the triumph of economic liberalism over regulated capitalism, especially to doctrines that the market, rather than the state should regulate economic gains. As the race/class matrix becomes increasingly sharp, sections of the black intelligentsia have come down for ethnicity. The implication of the shift toward a more subcultural identification is that legal remedies—if not legislation then juridical decisions—can partially erase the profound exclusions that have remained, historically, relatively intractable for the majority of blacks.

Of course, there can be no doubt that, since the mid-1960s, federal courts have been an extremely effective force for making room for a significant layer of black professionals and managers within corporations, universities, and state and local governments, even as conditions for the black working class have badly deteriorated—especially in the 1980s, when federal policy reversed the two decades during which, through national welfare policy, some sub-proletarian strata of the black working class made economic advances. However, deindustrialization, combined with the Reagan administration's program to slowly strangle the welfare state, has resulted in impoverishment for millions of blacks and other people of color.[36]

Class identities, which received their underpinning from ideology as well as culture, are severely undercut by these competing identities, especially because ecology and feminism have articulated new global ideologies that transgress the compromise that workers have conventionally made with the prevailing order and are linked to movements that are publicly visible. Just as the black freedom movement of the 1950s and 1960s challenged the conventional class identity of many African-Americans with a racial or ethnic alternative that held out the possibility of a separate politics, economics, and culture that revived the memory of social movements cannot be divorced from the relative weakness of the old interest-based class in the political and cultural debates. Later, I shall explore some of the reasons for this state of affairs. In contrast, Europeans are far more resistant to global displacements, preferring to "make space" for racial, ecological, and feminist issues within the framework of the (hegemonic) socialist movement whose fealty to class ideology, even if eroded (especially in France and Britain), is still powerful. There are parallel developments in the U.S. Democratic party and, to a lesser degree, in the U.S. labor movement as well. The difference is this: European socialisms, including the Communists, may have abandoned their revolutionary doctrines, but remain ideologically wedded to the class compromise under which the welfare state was established after the Second World War, a series of reforms that recognized the working class as a crucial

component of national solidarity, and the provision of universal social welfare as a human right.

Nevertheless, as the fifteen-year history of the German and Belgian Green Parties demonstrates, the integrative capacities of social democracy remain strained by the introduction of the new social paradigms of ecology, feminism, and racial justice—strained because these are precisely the issues that were historically sacrificed by the compromise with capital. Thus, although social democratic parties and communists have belatedly "gone along" with the issues deriving from the new paradigm, the gap between their traditional philosophy and program and the new philosophical premises of the Greens remains wide. The question for traditional socialism is whether it will be able to *theorize* its relationships to the new social movements or whether it will continue to "adapt" to their democratic demands. Since social democracy has renounced theory as political discourse, this is not a likely eventuality. For both social democracy and U.S. progressivism are wedded to the "pragmatic" dictum according to which the movement is committed to being the "left wing of the possible," a field that continually shifts rightward.

American progressive liberalism has all but renounced its New Deal redistributive ideology, but has not replaced it with an alternative universal vision. Consequently, feminists, environmentalists, and the black and Latino civil rights advocates constitute, by default, the soul, if not the power of the Democratic party, and have occupied the center of a new liberal/progressive vision that, despite considerable economistic tendencies, is struggling to find a meeting ground between the new paradigm and the older social justice ideology. In turn, the leadership of the increasingly weakened labor movement is, perhaps, the remaining relatively powerful guardian of the social justice worldview, but has witnessed the disappearance of large chunks of its active constituency and, therefore, despite its still considerable membership, appears increasingly less relevant to American political life towards the dawn of the 21st century.

The decline of the labor movement has put in jeopardy even the medium term vitality of such programs as the long-awaited national health care program, educational reform, and urban revitalization, much less the more mainstream issues of employment, training, and income equity. As for health care, the AFL-CIO executive council, which consists of the top officers of the leading unions, has been split for a decade between those favoring universal government-sponsored insurance similar to Canada's program that would provide strong controls over doctors, hospitals, and insurance companies, and a "moderate" group that favors a compromise with the insurance carri-

ers to give them the most important role in administering the program.

Since the Depression, workers in mass production industries, at least in the Northeast and the Midwest, typically organized into relatively powerful unions that, from time to time, conducted militant and, frequently, prolonged strikes. Moreover, in addition to their Fordist role in providing substantial income from which expanded private consumption was made possible, the union contract became, in the wake of the political weakness of the progressives, the repository of social welfare for union members and their families.[37] And when they voted in national elections, until 1968, workers mainly supported the Cold War welfare liberalism of the Democratic Party which, in the era of union and industrial expansion, accounted for the fact that Democrats occupied the presidency and controlled Congress for all but eight of the thirty-five years after Roosevelt's inauguration in March 1933. These conditions obtained as long as large industrial plants, each employing thousands of workers, were concentrated in urban metropoles and dominated an ever-expanding national economy whose world position was effectively unchallenged. The troubles began to mount when capitalism was obliged to restructure its global relations.

IV.

From the turn of the 20th century, industrial workers were the most cohesive and the largest category of the urban populations, and most Americans lived in cities or working-class suburbs surrounding them. The genius of the Democratic (and sometimes Republican) urban political machine was to incorporate many (but not all) of the basic demands of the new immigrant and migrant groups that constituted the majority of the working class in major industries. In turn, the discourse of social justice was integrated into what became known as "progressive" ideology, which reformulated social justice in statist terms but carefully marginalized demands for power-sharing with the working class. As in the famous passage from Marx's *18th Brumaire*, gains, within the progressives' plan, must appear as good things rained from above—a gift from on high. In this reprise, Franklin D. Roosevelt took on the aspect of a savior; in many union households his picture was placed next to that of Jesus Christ until the 1960s, when Christ remained but the Kennedys replaced that almost forgotten charmer.

The power of these machines was among the crucial "external" influences upon would-be politicized trade unions. Internally, inde-

pendent working-class political action was contested early in the century by an insurgent anarchist tendency on the "left" and African pasts, whether they participated in the civil rights struggle or not, so the discourses of gender and ecology have, at least for a generation, overshadowed that of social class for large segments of their constituents.

Some commentators have argued that, in contrast to the old social movements whose links to classes were a cardinal feature, the "new" social movements are drawn from various strands of the population, and that class considerations play little or no part in their composition. Although there is no doubt that activists in the new social movements are attracted not by traditional conceptions of interest but by the power of the new paradigm, it is also the case that their leaderships are typically drawn from the ranks of various strata of technical, scientific, and cultural intellectuals. These are often people who have been reared in what Alvin Gouldner has termed a "culture of critical discourse."[38] Even if many of the movements are situated, not at the workplace, but in the sphere of social and cultural life, of which consumption occupies considerable space, the emergence of these movements can hardly be separated from their social composition. The wide diffusion of their values may signify the appearance of intellectuals as a class of a new type—one situated not only in a unique relationship to the process of production, but in a specific way to the dominant ideology. For if knowledge has become a crucial site of power, then it cannot be located at any one particular place in the social structure, but encompasses the entire range of relations.

Of course, the success of emergent discourses of these new "pure and simple" trade unionists on the "right" who feared that (class) politics, like religion, could sunder the solidarity of workers on the job. Both sides were anti-state, although the AFL, once the bastion of anti-political thought within the labor movement, gradually shifted at the turn of the century to a kind of corporatist perspective under the aegis of the business-dominated National Civil Federation and, later, President Woodrow Wilson.[39]

In retrospect, Wilson's concerted effort to bring labor into full partnership with the Democratic party and, later, into the war effort, was a turning point. Recall, the first decade of the 20th century were years of dramatic growth for the workers' movements, both unions and the socialists. And, left gains were made among non-immigrant as well as immigrant groups—as the significant growth of the party and the IWW in the West attests. But, adroitly, the big city Democratic bosses and the party's progressive wing had already forged an alliance with a large populist fraction exemplified by the three-time presidential

candidacy of William Jennings Bryan. When in 1912 the Socialist presidential candidate Eugene V. Debs garnered nearly a million votes in his highly engaging campaign, the die was cast. Wilson understood that he owed victory to the split between progressives and conservative Republicans, but needed to mend fences with an insurgent working class that was beginning to engage seriously in a politics of class.[40]

Roosevelt transformed the Democratic party into a vehicle for a liberal/progressive version of social justice that entailed enlarging the scope of state intervention to include the provision of social welfare. More important than the New Deal's relatively modest program, at least compared to Europe, especially after the War, was the explicit alliance it forged with even greater force than had Wilson with the new labor movement. The task of the socialists who, throughout the first half of the century, were the main proponents of labor's political independence, became nearly impossible, especially when, in 1936, most trade unions socialists—left and right—were incorporated in various ways within the New Deal coalition as they had not been during the First World War.[41] The transformation of the labor movement into an arm of the coalition was always contested by the AFL, whose antagonism to Roosevelt was based on its traditional opposition, revived by Gompers's successor, William Green, to state intervention into labor relations, as much as the conservative Republican affiliations of a considerable segment of its leadership.

Pure and simple unionism, which retained substantial ideological force among important sections of the labor movement, was not really possible as the state increasingly intervened in industrial and labor relations—a measure that was much more important, in terms of the new capitalist regulation, than the few elements of social security enacted by the New Deal. While Wilson, as a wartime emergency, had established a board to mediate industrial disputes, the New Deal made permanent a variety of apparatuses, designed to regulate labor and industrial relations, and thereby make wage levels a known factor in production costs, that retain considerable force to this day.

Until the First World War, the leading forces for the development of a class-identified workers' movement were the Industrial Workers of the World, whose key figures adopted a version of anarchist ideology, and, especially, the Socialist party (SP). The SP engaged tirelessly in both political education, urging workers to break from the two major capitalist parties, and ran its own candidates at all levels of elective office. Its efforts, although minoritarian, were, nevertheless, crowned with some success. The party sent two members to Congress, characteristically from districts in which large numbers of immigrants, concentrated in a few large urban-based industries, lived. At

the same time, it made considerable inroads into some key rural districts, notably in Oklahoma and the Dakotas.[42] I want to reserve further discussion of the factors that contributed to the decline of the mass influence of the socialist movement after the War for the final section of this essay. For now, it is important to note that the periodic upsurge of union activity among workers, especially in the 1930s and the 1960s, when millions streamed into industrial and then public employees' organizations, did not advance the political and social practices that comprise the congealing of a specifically class identification. As I shall argue, until the 1960s, when feminism and consumerism, and their various manifestations, became popular movements, race and ethnic identities were carefully cultivated by urban political machines to the detriment of class—even though "objective" indicators point to economic class as a powerful barrier to vertical mobility, particularly for Southern and Eastern European immigrants and even their children, and were a boundary condition for social and cultural life. However, Roosevelt amplified the weight of these municipal political machines, not only by channelling considerable patronage to them, but also by permitting them to identify with the apparently pro-labor program of the second New Deal, the ideologically redistributive face of the Roosevelt coalition after 1935.

Any undergraduate sociology student can easily demonstrate that certain occupations—mostly factory and low-level clerical labor—structure workers' children's "life chances," and may even be a rough predictor of political behavior and social and cultural relationships such as marriage, friendships, and organizational affiliation. While intermarriage of partners belonging to different white subcultural groups is fairly common in this century, class intermarriage is far less frequent. And educational research shows that, despite a veritable explosion of post-secondary education after the Second World War, in which as many as 50% of high school graduates, by the 1970s, entered college, those which Marxism would classify as workers either never graduate from secondary schools, are school leavers after high school graduation, or drop out from colleges and universities within two years of admission.

But, the power of ideology consists not principally in its capacity to reproduce "false" consciousness in the face of the stubborn facts, but in the degree to which, in Althusser's terms, it becomes (as opposed to *corresponds to*) lived experience.[43] For there is more than a grain of truth to the thesis of American "classnessness." There is no doubt that, under ordinary circumstances, subjectivities are structured by identities other than class, especially among workers. When working

people are asked about their class affiliation they often respond "middle class" and rarely as members of a working class or even "lower" class. But, the web of group affiliations outside the workplace provides a more enduring set of identities on the basis of ethnicity (better described in this context as *subcultures*), in some cases as among Italians and Puerto Ricans, for example, regionally mediated within the same national origin.

I want to argue that America has never produced the conditions that would foster class identification as a category with effects on everyday existence. Social clubs, civic associations, and political organizations were frequently organized along subcultural rather than overtly class lines, even if their composition was delineated by class membership. For example, in the Eastern Europe neighborhoods of many large industrial cities—Pittsburgh, Chicago, Detroit—and Pennsylvania mining towns, such as Scranton and Pottsville, the unions—even when beloved—did not provide the main social and cultural center for Poles, Hungarians, Ukrainians, and other East European workers. The local branch of the Polish, Ukrainian, or Russian-based national "home," equipped with a bar, dance hall, and meeting rooms, provided the gathering place within which politics as well as friendships were forged. In the 20th century, both political parties cultivated the leadership of these institutions, which was composed of workers, but also small businesspeople, such as funeral directors, lawyers, and merchants. Consequently, organizers cultivated subcultural ties, and local unions sought to meet in ethnic social halls and churches, the second crucial site of class displacement, rather than their offices which, increasingly, became administrative rather than social and cultural centers.

In contrast, the European workers' movement, particularly in Germany and Scandinavian countries, embraced a kind of trinitarian formula: trade unions, which by the late 19th century were imbued with class ideologies; geographically situated political parties dominated by professional politicians and intellectuals, although some local organizations had worker-members as well; and social and cultural institutions directed specifically to workers such as socialist singing societies, sports organizations, schools that were alternative indoctrination sites to Church-sponsored Sunday schools, and summer camps for children and adults. As Carl Schorske has demonstrated, the socialist movement created a "state within a state" which provided for a wide range of interests and needs of its constituents, even as it inured workers from entering the mainstream of their society.[44] In the United Kingdom, perhaps the crucial social site has been

the working-class pub. But even here, the pub was never a distinctly class institution; it is more appropriately designated a national institution differentiated by class patronage.

Working-class identities were reproduced by more than ideology and program. They were forged in the sinews of everyday life—at play as well as at work. At the turn of the century in Germany and, later, in Sweden and Norway, it was possible to live one's entire life in the socialist and labor movements. Thus, the workers' movement was not merely a "worldview" combined with organizations that "represented" the immediate and long-term interests of the working class, but a "lifeworld" defining the horizons of existence.[45] In the advanced capitalist social formations of North America and Western Europe, this lifeworld often encouraged intense class loyalties and consciousness. But its unintended consequence was, in given periods, to isolate workers from other strata and social categories, a situation that frequently contributed to political defeat.

Such may have been the case with the 1984–85 Miners strike in Britain. Recall the miners, faced with wholesale mine closings by the Thatcher government, staged the most militant strike in Britain's postwar history. The Labor Party quickly split over the degree to which it should support the Miners' action. The more left-wing national executive pressed for wholehearted backing. But the Parliamentary party was reluctant: "The leadership and the PLP right wingers, however, believed the dispute, or more specifically its conduct, would damage support for Labour among the social democratic middle ground" (read new middle classes). "Opposition leader Neil Kinnock struggled to maintain unity while distancing the LP from the miners' strike."[46]

One can easily cite parallel examples in the relationship between militant union struggles against concessions during the 1980s and the Democratic party and U.S. trade union leadership. In the first example of sustained resistance, members of local P–9 of the Food and Commercial Workers at the Hormel plant in Austin, Minnesota struck in summer 1985 to restore wage levels that had been previously reduced by a concessions agreement. The International union at first supported the strike, but withdrew when the workers refused to heed the leadership's order to return to work without an agreement. The state Democratic party not only distanced itself from the struggle, but many condemned the "irresponsibility" of the local leadership. Moreover, union labor was split both locally and nationally. For the most part, the strikers successfully mobilized a segment of the unions in their support, but remained fairly isolated from both the major seg-

ments of the union movement and potential supporters among middle classes.[47]

Indeed, the socialist movement in the United States adopted the German model, in part because a large segment of it was comprised of descendants of the generation of 1848, German political refugees of the failed revolution, and partly because of the incredible success of the turn-of-the-century German Social-Democrats. The tripartite principle of organization was carried to the letter after 1900 by the newly formed Socialist Party which, with strategic acumen, competed with some success for the hearts and minds of newly arrived Eastern European immigrants. "Nationality federations," among some of the most important Eastern European immigrants, emerged as dual organizations to the more mainstream National Homes. In most cases, particularly among those immigrants whose Christian and agrarian roots were still deep—Poles, Italians, Hungarians, Ukrainians, and Russians—the Socialists had limited success. But they were more influential among immigrants from urban environments or countries such as Finland, where early immigrants had been "landless peasant laborers"[48] rather than peasants, such as Italians or Russians, who were subordinated within semi-feudal systems of land tenure.

Jewish immigration until the 1880s was largely of businesspeople and professionals from Germany and Austria. But the Eastern European Jewish immigration was largely a working-class phenomenon, and, in this respect, bore strong resemblances to the second wave of Finns who arrived after 1898. They were urban workers and intellectuals whose decision to emigrate was motivated as much by political as by economic considerations. These were, frequently, refugees from various anti-radical repressions that paralleled the earlier German experience. In both cases, these immigrants carried their socialist and labor culture with them to U.S. shores and managed to build powerful institutions that endured through the first half of the 20th century.

Unlike the Germans, who had been skilled workers in the industrializing cities of the 1850s, 1860s, and 1870s, the Finns were mainly unskilled, from the perspective of industrial society. Germans organized the skilled trades—cigar makers, brewery workers, bakers, metalworkers. Finnish miners and skilled Jewish needle trades workers, particularly the women condemned for the most part to semi-skilled "section work," were, however, at the forefront of the industrial union movements at the turn of the century. There were similar tendencies within both migrations of people who had been influenced by socialist and trade union ideas and, equally importantly, they brought a strong

store of organizational experience in the labor and socialist movements of their countries.

Among the Finns of Wisconsin and Minnesota and among New York and Chicago Jews, working class and socialist discourse was highly visible and enjoyed a considerable measure of popular support during the first half of the 20th century. After the Bolshevik Revolution, two Yiddish language daily newspapers—one ostensibly social-democratic and the other communist—were widely read among garment workers, fur and leather workers, and the older generation of intellectuals. Like the Jews, many Finns affiliated with the Socialist Party or, as in the case of Minnesota, were the organizational heart of the Farmer-Labor party that ruled that state for forty years. The socialist and communist movements in the United States were, in addition to their specific political interventions, constituted by a series of subcultures organized along nationality lines that were united by the thread of a common ideology. Concentrated in large industrial cities, the left-wing ethnic subcultures resembled, in microcosm, their European forebears. Their members were largely, if not exclusively, working class. They sustained a wide array of institutions that, until the immediate post-Second World War period provided health and burial benefits, as well as cultural and political activities. Given the weakness of the state system of social welfare, even after the New Deal, trade unions and the socialist movement with which they were loosely affiliated assumed many of these functions: unemployment benefits, a system of health clinics, paid holidays, pensions, and vacations paid in lieu of wages by employers and secured by collective bargaining agreements. Their welfare institutions were fatally weakened when, in the 1930s and in the 1940s, many unions negotiated these benefits through the collective bargaining agreement, and the Roosevelt administration enacted a series of measures, especially pensions, relief payments and unemployment insurance.

But, labor and the left did not generate this infrastructure for reasons of economic necessity alone. Neither the socialist vision nor the redistributive vision implicit in collective bargaining could sustain the movement without the ties that only culture can provide. Where the left formed successful and enduring mass parties, especially in New York, Minnesota, and Wisconsin, the political club was more than an electoral vehicle and a counseling service for people having trouble with landlords or government. The socialist or labor party political club was mainly a male social center, providing library facilities, rehearsal rooms for music and drama groups, Sunday schools, and, especially, space for card games and games of chess. Saturday nights were times for youth or adult dances, concerts, sings, and other

social activities involving the whole family. Electoral activity arose "organically" from these social and cultural activities.

When the Communists expanded their membership in the 1930s, so did their youth movement and cultural sections. Much of the socialist-communist split after 1919 occurred on the battleground of the national minority social and cultural organizations. The Communists emerged from these battles with strong sections among Hungarians, Finns, and Yugoslavs, as well as weaker, but still substantial sections among Italians, Germans, Poles, and Jews who, in the majority, remained close to the social-democrats. However, pro-Soviet sentiment among Jews and CP influence in the needle trades insured the Party and same unions that had a large Jewish membership of a significant minority. The Fur and Leather Workers, an exception in the otherwise socialist-dominated needle trades (although until the Second World War there were strong CP caucuses in the ILGWU), New York department store workers, wholesale and retail workers, public employees, teachers, social workers, and other "sub"-professionals were close to the Communist party.

The CP organized its work among these "national minorities" along classic social-democratic lines, not only in style but, given the reform perspectives of the popular front, ideologically as well. The International Workers Order, the communist alternative to the socialist Workmen's Circle, a much larger organization, provided life insurance, medical and dental services, and burial benefits. The party's cultural sections sponsored Sunday schools, summer camps, women's organizations, and so forth. The CP-affiliated youth movement was strongest in working-class neighborhoods where, like the lower East Side of New York, the Fairfax district of Los Angeles, or Chicago's near North Side, strong subcultural fraternal organizations had been established.

The Communist affiliation with the New Deal was motivated, in part, by the popular front strategy of alliances between the various tendencies among the working class and the "progressive," that is, anti-fascist wing of capital. Inevitably, the terms of this alliance entailed substantial ideological concessions by the left, not the least of which was the doctrine according to which workers and capitalists had diametrically opposed interests. Despite tactical left turns in 1939–40 and 1945–48, the popular front period from 1935 to the early 1950s, the span of an entire generation, was marked by noticeable softening of class struggle discourse, even in the midst of militant industrial struggles for unionization that were frequently organized and led by Communists and Socialists.

The most important intervention of the CP and its organizations

among the native born was in several large urban black communities (although the party made significant efforts in rural districts as well). The party was an influential force in Harlem, Chicago's South Side, Detroit, and in black areas of Philadelphia and Baltimore, among others. The basis of this influence was first, its ability to stretch its hand towards the nationalist and religious culture of American black people; second, its determined and often militant struggles around the immediate issues affecting these communities, particularly housing and employment, and against police brutality; and third, its willingness to elevate many of its black cadre to district and national leadership. Thus, despite the many shifts in the party line regarding black Americans and its declining influence within the labor movement and other sectors where it was once influential, the communists retained considerable respect within black activist circles well into the 1960s.[49]

One can plausibly claim that the relative absence of class politics in the industrial workers' upsurge of this period was abetted by circumstances, namely, the threat of fascism. Yet, when put in context of the largely, if not exclusively, subcultural base of radical movements from the turn of the century, which also formed the context for unionization in mining, steel, and many other industries, the reason for the relatively weak class identity in the labor movement in the period of its most dramatic growth becomes clearer. Even the class-oriented left felt obliged to work through other identities—including race identities—because they believed these were, for various reasons, primary among those they sought to reach. This was true, not only of those who spoke foreign tongues, but also of English speakers. I want to consider two cases, the Irish-Americans who played an enormously important role throughout this century in the leadership of mass industrial unions and the "native-born" whites in the Southwest who, emerging from the populist explosion of the 1880s and 1890s, briefly affiliated with the Socialist Party.

Irish socialism and laborism were, like many colonial movements, closely tied to nationalism. James Connolly, the leading figure of Irish socialism until his death in the Easter rising of 1916 for Irish independence, posed the problem of socialism in terms that were strikingly similar to Lenin's conception of national liberation. Connolly argued that the working class had a double task: to lead the movement for national independence and to struggle for socialism. In the context of the heated debates within the socialist international, this was by no means a majority position.[50]

But, Connolly symbolized the problem of generations of Irish radicals who felt obliged to work within the nationalist movement or risk

isolation. Consequently, nationalism became for the not inconsiderable radical wing of Irish immigration of the early 20th century, an important dimension of their ideological arsenal. This was the imperative faced by Connolly's collaborator, James Larkin, who migrated to the United States and helped organize the largely Irish-American Transport Workers Union, as well as the Transport and General Workers Union of Ireland.[51] Larkin's legatee and long-time communist leader of the Transport Workers Union, Michael Quill, who was also an elected New York City Council member, was identified as closely by his Irish heritage and cultural ties as he was by his trade union and radical credentials. Like many other radicals, it was simply not possible, despite his considerable support in the Jewish working-class community of the Bronx, to build a political base outside the framework of close subcultural identification.

In the case of the "grassroots" agrarian socialism that, briefly, inherited the populist movements following among poor southern and western U.S. farmers (who Lawrence Goodwyn has called agricultural laborers because they really didn't own the land), the category of the "people," even "poor people," always dominated class identity.[52] (This, despite Goodwyn's and James Green's convincing argument that the populist and the socialist movements of the South and Southwest were largely working-class and not middle-class movements.) The two parties successively organized around anti-capitalist issues, specifically against the big banks, the railroads, and the food-processing corporations that had reduced them to little more than workers, even though they ostensibly held title to the land.

But, what remains unanswered by these class analyses is why the aspirations of the farmers were for land ownership, why the images of cooperative ownership of the land did not accompany proposals for cooperative graineries and processing plants. As Craig Calhoun has shown in his detailed critique of E. P. Thompson's *Making of the English Working Class*, "class" struggle is often fought in the name of the "people," itself an ambiguous category that signifies a broader stratum within society.[53] When we speak of "class" the practices to which this signifier refers may be termed a "bloc" that is comprised of a multitude of social groups. Our designation of class refers as much to the negative object of struggle, the fractions of capital that are arrayed against the people, as it is to a group of concrete actors, the composition of which frequently belies class identity.

In these two examples, the Irish-dominated Transport Workers Union of the 1920s and 1930s and the turn-of-the-century agrarian radicals, we see that class is, at most, an empirical description made from the outside with the assistance of Marxist categories. Class is

often part of the political vocabulary of actors who, nevertheless, are impelled to use a different language—either nationalism, cultural or otherwise, or populism—to achieve their organizational goals. Of course, this is not merely another example of American exceptionalism. For, not only did Connolly face the problem of reconciling socialism with Irish independence, but socialist movements everywhere in Europe have been forced to mediate class ideologies with the heterogeneity of their constituents and the complex traditions they find already in place. A good example of this are the strong laborist traditions of Scotland and Wales which, nevertheless, are laced with heavy doses of nationalism. Similarly, the older U.S. socialist movement entered its long-term decline much earlier but still retained remnants of the old cultural organizations, particularly the largely Jewish Workmen's Circle (renamed the Workers Circle in the 1970s, in deference to feminism), that, together with the Jewish Bund, upheld *Yiddishkeit* against the twin threats of assimilation and Zionism (which favored Hebrew as the language of Jewish ethnic identity and dissolved class politics into nationalism). Even in the labor-Zionist movement that eventually became the first government after Israeli independence, the relation of labor to nation was characteristically resolved in favor of the latter.

In the wake of the restructuration of world capitalism, in which the most technologically advanced societies exhibit features of postindustrialism, as much as postmodern culture; and the splintering of Soviet power—especially the precipitous decline of its persistent ideological influence over significant fractions of workers' movements and intellectuals during the past seventy years—working-class identity has increasingly become local, when not entirely incoherent. For even when workers and intellectuals linked to workers' and socialist movements did not adhere to the proposition that really existing socialism was a kind of global vanguard in every country the left, old and new, responded to the Soviet example. Nor could left anti-communism escape from the entanglement.

The Russian Revolution was understood in terms that extended beyond its real or imagined economic and political achievements. More to the point was the fact that the Soviets systematically disseminated revolutionary Marxist culture and proved, through sometimes orchestrated example, that capitalism's invincibility was a mirage. Even when its own version of socialism or Marxism was held in contempt, the survival of the Soviet Union provided a target for debate—and hope for socialist prospects in a single lifetime. Dissenters from the Soviet model could claim that if only a different strategy had been pursued by Lenin—or Stalin—, if only they. . .were more

democratic;[54] let the NEP (New Economic Policy) work for a prolonged period of market relations;[55] had not beaten the peasantry into submission;[56] established workers' control over production;[57] supported a vital civil society and a public sphere within which important issues and ideas could freely be debated; and so on. If one or more of these goals had been pursued by the revolution's leaders and legatees, today the world would look different. Prospects for revolution were, according to this position, indefinitely postponed, if not smashed, by the repugnant Soviet experience.

During the past seventy years, when the parties of social-democracy, and the labor parties, especially the Germans and the British, seemed to yield both revolutionary and working-class ground to welfarism, colonialism, and nationalism, the communist world, notwithstanding its strategic and tactical twists and turns, maintained rhetorical fealty to the revolutionary doctrines of Marx and Lenin, to internationalism and anti-imperialism. Even most Trotskyists, long implacable opponents of Stalinism, readily acknowledged that the socialist project, itself ineluctably tied to the fate of the workers' movements, depended, among other things, on the solution to the "deformation" of the Bolshevik revolution and its international consequences.

But, the issue goes beyond various assessments of Soviet leadership offered by leaders and intellectuals connected to workers' and socialist movements, or of the character of Soviet society as a workers' state, or its brand of Marxism. As important as these are for comprehending the world-historical significance of the collapse, the whole question of the historical agency of the working class became wrapped up after 1917 with the fate of the Russian Revolution and its global influence, tentacles which reached into nearly all countries. The greatest international victory of the Russian Revolution was to impose upon at least two generations of radicals a new class imaginary in advanced capitalist societies, countries of the so-called semi-periphery and, especially, the colonial and postcolonial world where the Leninist linkage of anti-imperialism with global class struggle took on the status of a political religion. It hardly matters that the idea of the Soviet Union as a workers' state could be easily refuted by various measures, including the determination of whether workers were genuine participants in running the factories, the neighborhood, or the state. More important was that disputes among people who should have known better turned on whether it was a *degenerate* or healthy workers' state.

With the exception of one (tiny) faction of Trotskyists, and an even tinier enclave of anti-Leninist libertarian communists—Marxist as

well as anarchists—there was a consensus during the interwar years among revolutionaries that the Soviet Union was the living embodiment of workers' power. Further, the question of the international class struggle gradually evolved toward the idea of the absolute necessity to defend the Soviet Union against capitalist economic and military aggression, a position that widened with the postwar establishment of the Eastern European "people's democracies," China, and Cuba.

Of course, it is important to remember that working-class identity and its most ubiquitous political expressions, socialism and anarchism, predated the advent of the Bolsheviks and their Stalinist legatees. But, the example of the Bolsheviks captured the hearts and minds of the overwhelming majority of the world's radicals. Neither anarchist purity nor social-democratic realism were able to halt the flood of new adherents among most left-wing intellectuals and militants, especially in the popular front period of the 1930s and, again, after the War. Even where social-democracy retained its firm electoral and trade union base it was unable or unwilling to go beyond the politics of the "real" and, perhaps more damaging, remained incapable of attracting the bearers of avant-garde political and cultural thought or the activist youth.

Which meant that social democracy became moribund in the period of the rise of the generational movement called The New Left, the 1960s. Although this was the period during which the German social democrats gained government power for the first time since the immediate years after the First World War, and British Labor was able to grasp the reins of government after more than a decade of conservative rule, these were not parties of *movement* and ideology, but parties of order. For this reason, the main dialogue of the young, independent left was with the various tendencies of communists: in France and Italy with the Communist parties and their intellectuals, in Britain and Germany with Marxist theory and the question of Soviet power. This was a measure of the degree to which, notwithstanding its reformist *practice*, the theoretical and ideological communist commitment to revolutionary doctrine enabled the various parties of revolutionary socialism to retain their appeal to the new radical generation of 1968.[58] Surely, the idea of the working class as liberator of all humanity because of its status as the most exploited of all oppressed groups—the term signifying a definite relation to the capitalist labor process rather than poverty or discrimination—has died hard, despite the mounting evidence of working-class fragmentation and defeat by restructured global capital.

There can be no doubt that the past two decades have been marked,

in most countries of the West and the most industrially developed postcolonial and Eastern European states, by the decline of working-class economic and political power. In Western Europe and the United States, conservative political ascendancy is accompanied by world economic restructuration. As is well known, one of the key elements of the new world economic order has been the massive shutdowns of plants in heavy industrial sectors, such as steel, engineering, and mining. In the course of this development, centers of working-class power—such as the English midlands, northern England and Wales, the French steelmaking Lorraine region, and the U.S. "heartland," from Pittsburgh's Mon Valley to Chicago—were decimated. For much of the 1980s, these areas experienced depression-level unemployment rates; trade unions were reduced to a fraction of their former strength; significant portions of the population migrated in search of work. Equally significant, these regions lost their traditional left-workerist character. Communists and left socialist electoral strength in France was reduced, the Labor Party lost considerable strength in Britain, and the social justice wing of the Democrats became almost marginal within the party. From signs of "advanced industrial societies" these once proud areas became economic backwaters of what became known as "post-industrial" capitalism.[59]

In Eastern Europe and the Soviet Union, sites of the celebrated sudden collapse of what may be called oligarchic collectivist regimes, one of the distinguishing features of the dramatic transformations already underway was the attempt by the more "liberal," reform-minded sections of the oligarchy to break much of the social compact with the workers that had prevailed for nearly forty years. Beginning with the Solidarity Labor Union and its nationwide strike against the government's attempt to rescind the substantial food subsidies that had sustained working-class support for decades, the 1980s were marked by increasing tension between these governments and the workers.

Although the victory of Solidarity in Poland was not typical of the pattern in the rest of the region which, in the main, turned to intellectuals to lead the new regimes, working-class ascent was a necessary condition for the victory of the liberal-democratic forces. However, the workers were not necessarily motivated by the same republican impulses as intellectuals. For them, the birth of a new civil society where free public debate about public issues could be carried on, a multiparty parliamentary political system, and a market system for determining the rules for production and distribution were necessary, but not sufficient, conditions for change. In the last analysis, the almost forgotten promises of egalitarian socialism remain powerful

forces among industrial workers, particularly the chance to gain genuine power in the workplace—whether in concert with markets or not. Moreover, many workers—in the mining and metallurgical industries of Russia and Poland—are hostile to the creation of any economic system that would widen the privileges of the emerging economic elites. For many, there is no special virtue in replacing the party bureaucrats, with their special stores, country homes, and state-financed cars, with entrepreneurs who would enjoy even greater wealth.

Those who came to political power in Eastern Europe (including the leader of the Solidarity Labor Union, Lech Walesa) have been little inclined to reestablish the old social contract with the workers, one which guaranteed a measure of job and income security, an extensive welfare program, and fairly good working conditions. Instead, they demonstrated the truism that only revolutionaries are able to impose austerity. The first post-communist Polish government took decisions that made the gestures towards economic rationality of the last Communist government of General Jaruszelski appear extremely modest, even inadequate. For when the World Bank and other Western lenders finally called a halt to lending to East Europe and the postcolonial world in the mid-1980s, the Communists were literally forced against their will to take draconian measures, such as reducing subsidies for food and housing, thereby driving prices up, but were unwilling to share the decision-making so that the victims of austerity could consent in their own pain. For a time, the new democratic regimes have benefited from their legitimacy gained at the expense of the discredited oligarchs. They took even more harsh decisions to cut subsidies, shut archaic factories, and introduced the market as the arbiter of many, but not yet most, economic decisions. Needless to say, after a year of popular jubilation in the face of liberalization, despite the economic hardships, Eastern Europe is already hearing cries for justice from working classes which have suffered not only disastrous wage cuts, but also serious erosion of one of the basic tenets of socialist religion—the welfare state. And, of course, in Yugoslavia, the Soviet Union, and Czechoslovakia, nationalism, sometimes under the patronage of former Communist parties and leaders, has reared its sometimes ugly head to displace, but also exacerbate resentments. East European nationalism has expressed in its political choices its preference for the long suppressed nationalities struggle to assert its autonomy from central power to the forced march toward modernity prescribed by communist rule—even if the price of independence might be a long slide into the "third world." In addition to economic motives, the appeal of a reunited Germany proved too powerful for

the skeptics and doubters to prevail, even if unification will prove extremely painful for the former East Germans, at least in the near term. Eventually, they may dramatically raise their levels of private consumption, but they have already lost important public goods, such as abortion on demand and unlimited health care. And, in the long run, one should not be surprised if the draconian measures of the conservative Christian Democratic regime ignites memories of socialism among the East Germans.

We are also witnessing the resurgence of pan-Africanism, modulated by the demand for racial equality and radical democracy that replaced the revolutionary communist turn of the late 1960s, which, although not extinct, no longer enjoys ideological hegemony in postcolonial politics after the breakup of the communist world. Today, at least in Africa and the Caribbean, the term and even the content of "national liberation" has been replaced, at best, by the ideas of freedom, equality, and democracy—a kind of black social democracy, as interpreted by concrete movements, whose meanings vary with specific circumstances. At worst, many countries of Africa and the Caribbean have turned to more authoritarian forms of rule.

The two visible, and, indeed, most important instances of growing workers' organization and political influence are in Brazil—where the newly formed Workers Party (PT) has emerged as the likely alternative to the center-right coalition that governs the country—and South Africa—where a black trade union federation closely aligned with the African National Congress has recruited more than a million adherents over the past five years. Some highly publicized successful strikes conducted by the trade union federation during the 1980s became a significant factor in the emergence of the ANC and its apparently successful efforts to crack the color bar, if not the political white monopoly. While these movements are, in many ways, incommensurable, either with traditional workers' movements in the history of Western capitalism or with each other, they are, nonetheless, signs that reports of the death of the working class are, to say the least, premature.

The common link between Solidarity, the upsurge of Korean workers and those of Brazil and South Africa is that they have emerged in the context of industrializing societies, as opposed to the societies of late capitalism suffering, to various degrees, from the prevailing deindustrialization of Western Europe and, especially, the U.S. and the U.K. In the majority of instances where workers' movements are on the rise, their fate is ineluctably tied to investment decisions by international capital and, therefore, directly to the losses suffered by workers in the so-called "first world." In a situation of worldwide

stagnation in industrial production, the industrialization of postcolonial and otherwise dependent regions of the world constitutes losses for the older developed areas. This situation has exacerbated what is already present in late capitalist societies that have experienced new waves of immigration, a phenomenon that is perceived by many workers, correctly, as a depressing influence on wages. For beyond nativism, nationalism is exhibited within the United States in the form of protectionism. The sentiment to prohibit or otherwise restrict imports from Japan, Korea, and Western Europe has accompanied a marked decline in domestic production of automobiles, steel, machine tools, and other basic commodities, and the virtual demise of the once buoyant domestic electronic industry.

European and U.S. workers are aware of this relationship. Now, foreign investment is labeled "capital flight," in contrast to the immediate postwar era when overseas investment represented "expansion." This pattern is well illustrated by the growth of the petrochemical industry on Puerto Rico's southern coast in the 1960s and the establishment of a parallel pharmaceutical sector. As a recent suit by the U.S.-based Oil, Chemical, and Atomic Workers union alleges, the recent transfer of production by American Home Products Corporation to Puerto Rico was at direct expense of its Indiana plant, where hundreds of workers are scheduled to lose their jobs. In some cases, notably Germany and France, postwar labor shortages were addressed by opening up their respective borders to Middle Eastern and North African migrants, just as the United States admitted, legally and illegally, millions of Caribbean and Latin American immigrants to work in industrialized agriculture, as well as in low-wage factories which produced light consumer goods.

For this reason, protectionist ideology among American workers and their unions was not uncommon in the 1950s and 1960s. But as consumer goods imports from Japan and Korea rose in the 1970s, the first signs of U.S. plants closings within the same industries were immediately linked up to growing trade imbalances. Of course, the United States has, since the 19th century, exported a third of its agricultural production, a proportion that rose to 40% during the 1970s, when imports of finished manufactured products dramatically increased. Lacking prospects for industrial revitalization, these facts could hardly be expected to ease the demands for restrictive import quotas by workers in these sectors of production industries that were shrinking in the 1980s. That protectionist demands were combined with expressions of xenophobia and outright racism should come as no surprise in a situation in which no strong left ideological constraints were present. Unfortunately, the situation has been no better

in Labor Britain in the wake of new waves of Indian, Caribbean and African immigrations. To its credit, the French Socialists *have* made some efforts to combat racism, sponsoring in 1987–88 a fairly vigorous antiracist campaign in connection with the presidential and legislative elections.

The world economic crisis of the 1970s and 1980s was experienced differently in various countries of advanced industrial capitalism. Hidden from most Americans by the paucity of news, was the extremely high jobless rates of the United Kingdom and most Western European countries. Beginning in the early 1970s, unemployment attained a level of about 10% in France, and Germany, and slightly higher in Italy. During these years, the U.K. was hit hardest; its official rate was nearly 15% in the late 1970s and early 1980s, close to the rates of the Great Depression.

The official U.S. rate was never that high until the "Reagan" recession of 1981–83, when the U.S. joined its European counterparts in double digit joblessness, although it never dipped below 6% throughout the 1970s. When added to the large number of discouraged workers (about 1%) who stopped looking for jobs, and part-time workers unable to find full-time jobs (another 2%), the U.S. rate was close to Europe's. But in 1982, the official rate had climbed to 11%, the worst since the Depression.

However, statistics tell only part of the story. For by the end of the recession, the face of industrial America had profoundly changed. America had been transformed from the leading industrial power into what many economists and journalists called a "service" economy which is, to say the least, an overstatement. There are still 25 million industrial workers in the United States, but their number has stagnated for most of the past twenty years and, in the past five years, has embarked on a steady decline. The key factor is both the declining proportion of Americans producing, transporting, and handling capital and consumer goods and, perhaps more importantly, the dispersal of production sites from cities and large towns dominated by factories to small communities and rural areas where industrial workers are isolated. By the middle of the 1980s, the major U.S. service products were financial services, computer software, wholesale and retail trades, including the highly visible fast food industry that absorbed more than half the U.S. beef output and employed millions of (mostly young) workers, many on a part-time basis.

However, popular images tend to obliterate the fact that the manufacturing sector which, although considerably reduced by labor-saving technologies and the recessions of 1981–83 and late 1980s and early 1990s, remains strong in autos and especially trucks, machine

tools, agricultural equipment (which is an export industry), oil refining and chemicals, massive military production, and even the declining but substantial textile and garment industries. Yet, with the shift of *perception*[60] from industrial to post-industrial society and the incredible denaturing of the cities—even Detroit, Pittsburgh, and Chicago—the heart of the industrial heartland—we have witnessed a fracturing of traditional working-class identities which depended crucially on the proliferate local cultures that sustained them. For, it is clearly not enough to infer from either labor statistics or even political participation data that a working class "exists" as a sociological object. The one element of class identity that had been powerful until the 1960s, a strong sense of union solidarity, especially among workers in the so-called "basic" industries, has been considerably weakened in the past twenty years. What must be shown is that the several instances of the persistence of a labor ethic—notably in the late 1980s and early 1990s Eastern Airline and *Daily News* strikes—are more than evidences of rearguard actions.

V.

In the United States and the United Kingdom, where there are large populations of people of African, Asian, and Caribbean descent that have been enlarged by recent and massive waves of immigration, assertions of race or national identities are punctuated by demands for inclusion into the dominant society and culture. People of color from postcolonial societies simply cannot afford to turn their backs on the opportunities afforded by economic and political inclusion, despite the increasingly insistent attacks by intellectuals on Eurocentrism. This postmodern paradox is entirely understandable once we give up the expectation that strategic intervention can obey the rule of linear consistency. What is involved here is a series of contradictions: between the permeation by U.S. culture—commercial and popular—of postcolonial societies, such that the blunt statement that contemporary popular culture *is* American seems as obvious as it is horrific to those who would preserve the older identities, not only embodied in "folk" art and cultures but also in national musical and other artistic forms; between the relative openness of U.S. society compared to those of western Europe, where immigration is strictly regulated and the growing degree of draconian police surveillance of "guest" workers by the Immigration and Naturalization service. Moreover, we are witnessing a powerful counterattack against efforts, especially in school curricula, to recognize the integrity of immigrant cultures. There is a new campaign by many erstwhile liberals, as well

as conservatives, to assert the cultural imperiousness of the discourse of assimilation with respect to those who wish to preserve their own language and culture. We note the deepening conflict between the fact of growing immigration among subaltern peoples, despite restrictive laws and blatant nativist sentiments that are designed to limit their entrance.

We have not yet experienced the full scope of the consequences of the new immigrant millions who have arrived in the United States in the past fifteen years. In California, Spanish-surnamed people will constitute a majority of the state's population before the end of the century. This tendency has already changed the political climate of the state's most populous area—Los Angeles. In New York, New Jersey, and Connecticut, Latino and Caribbean populations soared in the 1990 census, and the average increase of Asians in these states was 33 percent. Even in the Midwest, where Asian, Latino, and Caribbean populations are smaller than on both coasts, there are significant gains.

In this regard, the difference between race and ethnic identities comes to the surface. The searing reality of race discrimination in the U.S., the effect of which has been to sharpen the exclusion of African-Americans from many sectors of economic, political, and cultural life—despite the concerted effort by the black freedom movement and its (periodic) white allies over the past half century—has strengthened race consciousness among blacks who experience the multiple pains of exclusion from the dominant society and culture. At the same time, ethnicity signifies assimilation, and many people of color continue to act *as if* this objective has been achieved, and the remaining task for subalterns is to acquire the credentials of inclusion, principally through education, training, and legal protection against discrimination.

The cacaphonic themes of race and ethnicity reveal the discursive power of American ideology. For while race invariably signifies exclusion, ethnicity signifies subculture. Ethnicity is a term that contains within it the presumption of structured class inequality, but not a problematic nationality. The prevailing perception of Southern and Eastern European communities within the United States is that of *deficit* born of the exigencies of origin. For example, Italian-American youth may suffer the third-highest dropout rates in New York City, just above Latinos and blacks, and their inability to rise into business, professional, and managerial strata has been amply documented.[61] But there is little imputation of institutionalized discrimination to this situation. Educators may recognize that Italian-American students have formidable obstacles to overcome, but these are considered

to be primarily cultural in nature. Since the overwhelming majority of Italian-Americans migrated from Sicily and other regions of southern Italy marked by a low level of industrial and urban development, their lack of school success is correlated to the absence of cosmopolitan, i.e., intellectual culture in these areas. Peasant areas are traditionally preliterate.

Like all Southern and Eastern European immigrant groups, Italians brought significant aspects of their peasant culture with them to the United States. Among them, placing high priority on maintaining close-knit families whose solidarity at work and at play was and remains valued above any other form of social adherence is only the most visible. Another legacy of their agricultural background was their relative lack of industrial skills, a deficit that obliged Italians to seek to establish labor monopolies over unskilled and semi-skilled occupations within industries available to them. Consequently, according to this account, the relatively low level of Italian-American class mobility is intimately linked to the close-knit communities that Italians have established in the United States which are, in turn, linked to their claim to ownership over manual occupations in specific industries, notably transportation—particularly the waterfront—, mining, steelmaking, and, above all, the trowel trades in the construction industry (such as bricklaying; street, road, and building labor; and roofing, none of which is highly technical in nature and requires little education or formal training).

But, acknowledging that Italians fought for job property rights in these sectors and that the partial monopolies they enjoyed in some of them exist(ed)—the past tense signifying erosion and even losses due to massive technological and urban shifts in the past two decades— what remains to be explained is their relative disadvantage compared to Northern European migrations. What led them to seek perquisites in trades that, until the postwar era, were at or near the bottom of the job hierarchy? A close examination of the economic position of Italian-Americans, together with the representations of Italians in the popular imagination, abetted by media depictions, might reveal the degree to which they became the object of racial stereotypes, such as are perpetuated, for example, by the seemingly endless series of films, television series, and novels about underworld life or the more recent *Rocky* series.

Italians were recruited for some of the heaviest and most dangerous occupations in the U.S. industrial structure. For example, they were, together with Slavs, the heart of the coal mining and steelmaking industries, but were also heavily represented in the construction, textile, garment, and shoe production when these were among the

most important, but lower-paid, industries of the Northeast. In the pre-mechanized era, they were the dockers in Brooklyn, once the largest port on the East Coast, and constituted a significant portion of the waterfront labor force in New Jersey as well. All of these industries had skilled workers, but the Italians were not represented, to any significant degree, among them. Rather, Northern Europeans, largely migrants from the older industrial areas of Wales, England, Scotland, and Germany dominated the mechanical trades in both light and heavy industry; they brought their skills with them, skills which entailed a relatively high level of reading and writing and formal training. In many cases, it was the Northern Europeans who later became both managers and foremen and, equally importantly, dominated the unions.

It was not until late in the development of industrial unions—the 1960s—that some Italians—and Eastern Europeans—were elevated to the skilled trades in some of these industries, and were elected to important local and national union posts. Peter Bommarito became president of the United Rubber Workers; William DuChessi was secretary-treasurer of the Textile Workers; Tony Mazzocchi became a national leader of the Oil, Chemical, and Atomic Workers; and Anthony Scotto, the president of the Brooklyn dockers union was, until his indictment and conviction, a major figure in the International Longshoremen's Association (ILA). But, despite some gains in Italian-American representation, the top offices in the ILA stayed with Irish-Americans, whose representation among the rank and file dropped sharply after the 1950s. A similar experience can be recorded about Eastern Europeans, both in the labor movement and the skilled trades in U.S. industry. It is significant that these men achieved leadership during the period of declining memberships in their respective organizations.

As Robert Viscusi has demonstrated, the common thread in nearly all representations of Italian-American men, especially since the War, has been their penchant for violence (to which I would add sexist relations with women).[62] These images have become a routine feature of American popular culture and have contributed to the reproduction of their subordination. Even in relatively dignified portrayals such as *Moonstruck*, the male lead is depicted as an angry, often irrational person who frequently flies into rages, particularly against his brother but, more generally, against his fate.

Needless to say, the dominant mass-mediated image of Italian-Americans since the 1930s has been that of the Mafia and other crime syndicates. From Edward G. Robinson's fictional representation of Al Capone in *Little Caesar* (1932) to the sophisticated figure of the postmodern Godfather by Al Pacino in 1990, the underlying themes

persist: the heroic figures of the Italian immigration are those who beat up people or kill them. Martin Scorsese's three commentaries on this hegemonic narrative, *Mean Streets, Raging Bull,* and *Goodfellas,* are obliged to work within the genre while simultaneously attempting to deconstruct it. This is achieved by disrupting the relationship between private and "public" practices, between character and action. Certainly, there is no effort, in Scorsese's films, from his early work in *Mean Streets* (1973) and on, to disguise the utter futility of the choices his characters are obliged to make, whether those choices center on Jake La Motta's boxing career and his subsequent work as an entertainer, or the conflict between family loyalty and a life of crime in the *Goodfellas.* He does not romanticize or attempt to hide the violence that accompanies underworld life or the parallel world of professional boxing. What is different is that the inhabitants of these worlds for whom crime is a skilled trade, even a passion, view certain practices, such as beating opponents in the boxing ring or killing them in the course of underworld activity, as routine, often distasteful necessities.

Compared to one of the canonical works in this genre of an earlier generation, *Kiss of Death* (1947)—which became famous for Richard Widmark's ghoulish characterization of a sadistic hit man who, in one scene, pushes a crippled wheelchaired mother of an intended victim down several flights of stairs—Scorsese's people enjoy their families, friends, and lovers, which, in the context of mob life, serve to blur the distinction between private and public. They perform the distasteful tasks of murder only with some embarrassment, but really live for the intimate relationships that they struggle to maintain in the wake of the chaotic life they publicly lead.

Six decades of Hollywood stereotypes articulated with more than a century of discrimination within working-class hierarchies, especially the fairly limited Italian-American mobility compared to Northern Europeans. This record invites comparison with others who have suffered the stigma of stereotypical cultural representations that correspond to their marginal position within the economic and social hierarchies, notably African-Americans. I do not want to claim that the resemblance is exactly parallel or that Italian-Americans suffer the same degree of economic and social exclusion. Needless to say, the brutal dichotomy of white and black that constitutes one of the characteristic divisions in the U.S. has provided Italians with a (marginal) comparative advantage to that of blacks. Nevertheless, the comparison is apt. Italian-Americans are the most numerous white subcultural minority within the American population and are chronically underrepresented in the professions, among managerial strata,

in the political directorate. Their signal achievement has been to win a secure place in the industrial working class as semi-skilled and, especially in the construction and needle trades, as skilled workers.

However, as we have seen, most of these places are rapidly disappearing, and many younger Italian-Americans, lacking education or union seniority, are being driven into the ranks of the unemployed and the working poor. The public representations of their rise within the corporate world, the Giannini group that controlled Bank of America and the Pope family that developed a successful food business as well as owned the largest Italian language daily newspaper, are notable as exceptions. And, of course, the singular figure of Chrysler president Lee Iaccoca distorts the fact that he is (merely) an extremely high-paid manager whose relation to the ruling corporate class has always been controversial. Or, to be more precise, he has been excluded from the commanding heights of economic and political power, one suspects, because of his ethnicity.

True to the experience of other newly arrived turn-of-the-century immigrants, Italian-Americans found that sports and entertainment and, of course, organized crime, provided the best routes to riches and to social status. In the past century, this has scarcely changed, as the careers of singers Frank Sinatra, Perry Como, and the recent meteoric rise of actors Al Pacino and Sylvester Stallone, Cher, and Madonna attest. Earlier, Joe DiMaggio, Rocky Graziano, Rocky Marciano, and the later stardom of 49ers Quarterback Joe Montagna demonstrated the significance of Italian-Americans in sports. Needless to say, a similar account can be rendered for blacks, especially from the 1920s to the present.

Now, the idea that Italian-Americans occupy structurally subordinate subject-positions despite their categorization as Caucasian, challenges the prevailing view that they, like immigrants from Northern Europe were, more or less successfully, assimilated into mainstream American economic, political, and cultural life. Accordingly, to argue, provisionally, for Italian "racial" identity as at least one among their several collective subject-positions is also to interrogate the corollary idea that Italians themselves *chose* a series of positions, the result of which was to limit their options. If "Italian-American" has been constructed within the terms of exclusion as well as a troubled inclusion, the recent and past incidents of their acts of violence against blacks may be understood as a form in which they themselves live the contradiction between the multiple realities of racial and subcultural identities. But, it also provides an illustration of one of the central ambiguities inherent in U.S. working-class history since the Civil War.

Italian and Eastern Europeans are commonly identified with the

broad social and racial category of "white," which is the result of the conflation of race with color and other biologically derived physical characteristics. Accordingly, since nearly all Europeans are socially constructed as "white," differences among various European migrations are ideologically and culturally, rather than physically, constructed. Accordingly, given the general recognition that sons and daughters of black slave lineage are, at least historically, objects of systematic institutional racism, white is a signifier of class privilege, just as "black" signifies economic oppression, political marginality, and cultural deprivation. Since Italians have achieved some purchase on sectors of the economy, albeit in manual labor occupations and small businesses linked to working-class communities, and Eastern Europeans, although often blond and fair-skinned have traveled a strikingly parallel course, to suggest that they occupy, in part, "racial" subject-positions seems incongruous with our common understanding.

With the de-industrialization, these major national minorities have suffered profound deterioration in their living standards and in their social position. But as the two largest "white" minorities in the United States, Eastern Europeans and Italians have suffered at the level of political representation as well. To state that blacks are politically excluded is hardly disputed; to claim the same for Southern and Eastern Europeans raises a series of doubts about the claims for the democratic character of the liberal American state.

When Spiro Agnew, a Greek-American, was nominated and elected Vice-President of the United States in 1968, it was the first time in the history of the republic that anyone of Southern European background had achieved national elective office. The feat was almost duplicated by the Democrats twenty years later, when Massachusetts governor Michael Dukakis was nominated to be their presidential candidate. It is arguable that he lost to Vice-President George Bush, in part, because of the racial issue which focused on his pardon of a rapist, a black man named Willie Horton, who repeated his offense after release from prison. But, like Agnew who was tarred with the brush of corruption, Dukakis, who had spent his entire political career cultivating the image of technocratic efficiency, was finally nailed by his Northern European opponent for incompetence—the politician's deadliest sin in our technoculture. Dukakis left office in 1990, disgraced for having failed to stem a rather small state deficit that paled in comparison to the gargantuan debt piled up by the national administration of which his opponent was a player. America can ignore or otherwise forgive its Northern European leaders, but send those of Jewish or Southern European backgrounds to jail or political oblivion.

Which, I believe, goes far to explain the fiscal conservatism of New York's governor Mario Cuomo and New York City's black mayor David Dinkins. The unwritten code to which they must conform—especially as racially and ethnically targeted politicians—is hard-nosed administration that means, in times of recession and de-industrialization, layoffs of public employees and draconian public economies that further erode working-class living standards. The name of the political game, one that Governor Jim Florio of New Jersey entirely underestimated in his first year of office, is that Italian-American, black, and Latino elected officials may not make their jurisdictions the vehicles for a determined effort to achieve social, i.e., class justice, lest they be accused of reverse discrimination against the rich and upper middle class. Of course, neither Cuomo nor Dinkins has been seduced by the redistributive class rhetoric of their own campaign platforms, or the needs of their working-class constituents; but Florio attempted exactly such a legislative and political program and was instantly attacked by both conservatives and a substantial segment of his own working-class constituency and was forced to beat a rapid retreat to save his political future.

Thus, the absence of class discourse in American politics does not relieve white or black national minorities from the exigencies of class struggle. When Florio attempted to realign the state's tax system to benefit workers and poor blacks and other urban people of color by redistributing state education funds to the most disadvantaged districts, he was confronted by a carefully orchestrated outcry—masked as a citizens' lobby against taxes—from all segments of business. During his first year in office, he was forced to retreat until, by early 1991, his program was nearly dead. Of course, Florio was defeated as much by the weakness of the movements that he had to mobilize as by those that would be expected to oppose him. Since the discourse of justice is intimately tied to class, ethnicity, race, and gender, the absence of one of its most salient components—class—foredoomed his efforts.

It could be plausibly argued that Florio was equally victimized by the recession and the conservative ideological climate that accompanied his rise to power. But how to explain the caution of Mario Cuomo who, despite the fact that he presided over the most prosperous period in his state's economic history, fashioned an economic agenda that could have been pursued by any liberal Republican? On the one hand, the ideological climate of the eighties was distinctly unfavorable to programs that recalled the modest New Deal efforts to redistribute income through equitable taxation or, indeed, a substantial expansion of the critically enfeebled welfare state. This climate was produced,

in part, by the doctrine of "trickle down" according to which what is good for business is good for the country—hence deregulation to encourage competition, wage restraint to discourage capital migration, and union-free work environments. It was made possible by the decline of the leading forces of redistributive justice, the labor movement and the black freedom movements, both of which retained, despite many disclaimers, a keen sense of class interest.

The fractured identities that have disrupted the feminist movement in recent years serve as a useful reminder that external portrayals tend to simplify and reduce what are always complex multilayered realities. The discovery of *difference* among women—between lesbian and straight, married and unmarried, radical and liberal, cultural separatist and cultural radical and, what has become increasingly controversial, white and black—often overshadows the fragile unities that can be mustered around issues of rights, especially abortion and employment. What developed within the feminist movement is, to some extent, genuinely tragic. There is a tendency—admittedly underground—to *counterpose* social and cultural issues to those of economic justice. For example, even though there are liberal and leftist reformulations of abortion rights, the former emphasizing a woman's right to "choose" whether to have an abortion and the latter shifting the discourse to "reproductive rights," the statement that women have an unconditional right to control their own destinies, especially their bodies, has always been a controversial formulation among those who would soften the impact of abortion on religious sensibilities. For what is implied by self-control over one's body is sexual freedom, more specifically, the right to pleasure without suffering dire moral consequences. This formulation has been criticized from a number of different directions. Of course, the most powerful has been the traditional position of the Catholic Church's hierarchy, that a woman's sexual activity be limited to the aim of reproduction. Indeed, other objections offer what might be described as a secular version of the same argument. Among them, Christopher Lasch's indictment of cultural radicalism, whose cornerstone is the right to pleasure, has grafted the clinical concept of narcissism as an emotional disease to the social phenomenon of pleasure-seeking. As the argument goes, the demand for sexual freedom masks a deeply narcissistic social personality that tends to be irresponsible to family and community (read men). Although the call for the return of women's subordination is rarely blatant, the attack on abortion rights as selfish and sexual freedom as irresponsible is really an attack on women as moral agents, on their capacity to take responsibility for their own choices, for the determination of how they will permit their bodies to be deployed.

The film *Kramer vs. Kramer* (1979) was, in retrospect, the harbinger of a decade during which the concept of woman as moral agent was under severe attack. A woman leaves her up-and-coming advertising executive husband and their five-year-old-male child. Having stopped paid labor after marriage, she wants to find something of her own to do; she wants a career outside the home. Eighteen months after her departure, she sues for custody of their child. She *has* found a vocation that pays a salary that approximates that of her former husband who, meanwhile, has struggled with the vicissitudes of single parenting. For him, the result has been a closer relationship to their son and a downwardly mobile professional career. He is fired from his job because of lateness in meeting deadlines and other negligences, all of which are caused by the fact that he places his child's needs above the firm's. In the end, the wife wins the suit, but finds that she cannot bring herself to reclaim their son because she has come to realize that the boy is "at home" with the father. She has gained a job and sexual freedom but has foresaken the joys of family life, especially the responsibilities of motherhood, and has thereby threatened a major part of her identity. This film is properly interpreted in the context of the attack on feminism that began to gain momentum in the late 1970s, but it also accurately connotes the decisive and perhaps irreversible move of women out of the home.

The prevailing imagery shifted as millions of women entered the labor force in the 1980s under the conflicting influences of feminism and the decline and fall of the family wage (which obliged virtually half of America's households to seek two incomes to maintain living standards). At the same time, the family reeled. By the middle of the decade, half of all marriages could expect to end in divorce for reasons that were inexorably linked to women's growing independence. For men, whose intellectual voice was articulated well by Lasch, American culture was in crisis in proportion that their position in private life deteriorated.

What needs to be noticed here is that women have gradually become one of the mainstays of the labor movement, whose popular representation has been obliquely celebrated in the film *9 to 5* (1980), obliquely because there is no question of a union in the film, only the collective revolt by women against sexual harassment and other office horrors. In some ways, Sally Field's portrayal of a reluctant shop union leader in a textile mill, in the 1979 *Norma Rae*, is more to the point.

Although the majority of union members are still men, almost all of the organizing gains of the past fifteen years have been among women workers in clerical, service, and professional occupations, particularly teaching and nursing. At the same time, many of these

women have become increasingly ambivalent about feminism, not only because of the religiously influenced moral conflicts generated by the controversies over abortion rights, but because of the weakness of the U.S. welfare system that has failed to provide adequate medical care, child care, and a decent income for women heads of households. The loss of the nuclear family may or may not be mourned by working-class women in the wake of increasing male violence against women and their own perception of the limitations of married life. But the material and social costs of the breakdown of the family to themselves and their children have been substantial. The steep rise in single mothering has been accompanied by the feminization of poverty, because women's wages are still only ⅔ those of men. Moreover, many women experience a loss of status in the wake of the absence of a significant alternative community that can provide spiritual support for the decision to go it alone despite social disapproval.

Yet, rarely, if ever, are the questions of economic justice and cultural freedom articulated within feminist discourse. Part of the reason has to do with the genuine cultural differences between women intellectuals and working-class women. Class really becomes an operative difference in relation to culture because the economic and ideological environment of working-class life tends to frame cultural discourse. Working-class women are often *privately* bitter about their marriages, but are constrained to maintain public silence. One of the constraints is, plainly, the homophobia of ethnic working-class communities, where even the most indirect hint that women and, to a lesser extent, men are prepared to exercise sexual preferences that do not conform to the heterosexual norm becomes an occasion for verbal and physical abuse and, frequently, exile from the community.

A recent representation of this situation appears in the 1989 European-made film of the Hubert Selby Jr. novel, *Last Exit to Brooklyn*. Here we can see the binaries of 1950s ethnic working-class life: women are constructed as desexualized unpaid domestic servants or sluts; the strict homophobic code of male culture completely closes off the opportunity of a shop steward to exercise gay desire freely. Blocked by the repressive code of his own community, the shop steward ends his life—but not before engaging in a lurid attempt to seduce a young boy that earns him the scorn and ultimate exclusion from his comrades. (This theme of homophobia within male working-class environments is repeated, with considerable variation, in Melvin Dixon's *Vanishing Rooms* (1991). The novel, set in the 1970s, devolves around a gang rape and murder of a gay white man by a group of young Italian-Americans. One of the group, Lonnie Russo, is the son of a small painting contractor who, in a series of episodically arranged first-

person narratives, reveals his own latent homosexuality during and after his encounter with the victim and his attempts to distance himself from the violence in which he played a reluctant role. Lonnie's widowed mother's refrain "Christ Jesus, he never had a chance" is a constant comment on his own double oppression: as an Italian-American and as a teen-age boy seeking to come to terms with his own sexuality. The strict homophobic male working-class culture becomes the thisness of his own otherness. In contrast, the gay victim's black lover, Jesse, struggles over his own sexuality, but not his gay identity. The third main character, Rusella, an aspiring black woman dancer, comforts Lonnie after his loss and tries to find a way to reconcile her attraction for Jesse with his own search for the soul of his dead friend.)

At the same time as feminism and economic necessity have tugged women of different classes in sometimes different directions, or in the same direction for sometimes different reasons, so sexual practices have had their own class differences as well—at least until recently. Premarital sexual intercourse among young women of high school age is common within working-class communities, white and black, but is exceptional, if not rare, within the middle classes. It is here that the question of abortion takes on its most exquisite class dimension. Since the white working class is typically either Catholic or fundamentalist Protestant, especially in the South and Southwest, social sanctions against women as moral agents are the greatest amongst the working classes. For these young women moral strictures are radically dissociated from everyday life, but retain their coercive authority to produce profound emotional turmoil.

These examples illustrate some of the ways in which class culture remains powerful in everyday life. Even today, in cities such as Chicago, Hamtramck, Michigan, a Detroit industrial suburb, New York's Italian-American neighborhoods, such as Bensonhurst, Howard Beach, south Greenwich Village, and northern New Jersey and the Long Island suburbs, some blue collar communities survive. And they are places of political mobilization, but not necessarily on behalf of the progressive agenda of the traditional labor movement or, indeed, the old Democratic political machine. To the extent that they are politicized, they have become hotbeds of patriotism, racism, and anti-feminist control over the right of "their" women (and their young men) to make sexual choices, especially for men who are identified as people of color.

During the recent Gulf War, as with the earlier U.S. invasions of Panama and Grenada, the deep-going patriotic fervor of working-class and lower middle-class Americans was amply demonstrated in the

proliferation of American flags, yellow ribbons, and signs announcing "We Support our Troops in Operation Desert Storm" in windows, cars, and neighborhood shops. Absent a political left-wing counter-weight that could address the economic and social insecurity of many people within these communities, anger and frustration—especially in the light of the growing youth joblessness and the fact that the army has become, for many, the employer of last resort—is directed against those whose destiny seems most reminiscent of their own condition. Working-class nationalism is an outgrowth of power-lessness, of the absence of viable alternatives, of a sense that war and violence against people of color is a way to ward off defeat.

Militarism cannot be understood exclusively as the product of a conspiracy of governing elites seeking solutions to their own economic and political weakness in a changing world. As Wilhelm Reich argued,[64] working-class authoritarianism arises because of the multiple dimensions of powerlessness, of which sexual deprivations are among the most crucial. Recall that Reich insisted that in the struggle against fascism, the left should take up the problem of the crisis of the family, and most especially the "sexual misery" of the masses. For him, the moral conservatism of the left was complicit in the ability of the right to build a base among the workers. Of course, Reich's analysis ran counter to the official communist position, that Nazism could be understood as the "open dictatorship of the most reactionary sections of finance capital"[65] whose mass base was virtually confined to the proletarianized petty bourgeoisie. Reich adduced statistical evidence to support his claim that a significant portion of workers voted for the National Socialists after 1930.

There is another problem not anticipated by Reich's cultural cri-tique. The concept of citizenship is ingrained in the formation of the 19th-century nation-state, and there is no *practical*, as opposed to theoretical, notion of citizenship that corresponds to internation-alism—except the fairly ambiguous idea of class, race, or gender solidarity. Of course, solidarity expresses itself even among trade unionists who, in other respects, are profoundly nationalistic on occa-sions such as major strikes. In Winter 1991, I saw a window of a south Brooklyn two-family home that had an American flag and a yellow ribbons, the symbols of support for U.S. troops in the Gulf War, next to a sign that read "Teamsters support *Daily News* Strikers." These were codes of solidarity that might appear incongruous to the radical intellectual. But, for this working-class, white household they made perfect sense.

And there is a small, but definite anti-war movement based on the ideological precepts of anti-capitalism (only the rich benefit from

most wars) and anti-imperialism that spans the traditional left and progressive traditions. But, it must be admitted, these are exceptions to the rule that the rights of citizenship imply the contractual obligation to military and other types of service and to support that service when at war.

In the recent Gulf War, polls reported that while 80% of all Americans approved of U.S. aims, 50% of blacks were opposed to military intervention. This sentiment must be comprehended within the framework of the perception shared by many within the black community that they are excluded from the substantive, if not the procedural aspects of citizenship. They may freely exercise their right to vote, at least in the North and West, but this ritual act does not necessarily obviate their profound feeling of powerlessness in economic, political, or social terms. The structural exclusion of blacks has produced a strong strain of radicalism in ghetto communities, one that expresses itself as separatism, revolutionary nationalism, strong anti-war positions and, to a lesser extent, internationalism of the Marxist or racial variants. In contrast, white Americans, especially first- and second-generation Eastern and Southern European immigrants, accepted, with varying degrees of enthusiasm, the ideology of assimilation, but only unevenly its cultural practices. Assimilation means surrendering their language and their culture as the price they paid for being granted citizenship rights and the extremely hazy idea of "equality of opportunity" to achieve mobility. While, as I have argued, the historical record is complex and not entirely convincing regarding the extent to which they made it in America, elements of the American Dream were achieved without, however, being attended by genuine power. As we have seen, Eastern and Southern European immigrants often felt obliged to form economically powerful subcultures that sometimes took the form of labor unions, to protect their gains against the incursion by employers and competitive subcultural groups. These labor monopolies and the persistence of relatively closed family and neighborhood relationships—even in today's postmodern culture—are signs that the Deal has not yet been entirely consummated. Nevertheless, during the Gulf crisis, white subcultural working-class communities, responding, in part, to the fact that their kids constitute a large part of the military forces, rallied powerfully to the administration, even as they had united behind policies of racial exclusion in the construction and other key industries in which they had gained some degree of power.

Since the breakup of the old socialist and communist organizations, and the decline of the New Left, the American left has been confined, in the main, to cheerleading progressive ideology and programs and

organizing for issues of economic justice and against U.S. military intervention abroad. The brief decade of the New Left was characterized, in part, by a significant turn by many activists and intellectuals towards what became known as "social issues"—sexuality, child-rearing, the problem of the youth generation, their popular culture, the family, and other sites of everyday life. Several strains of the New Left comprehended that these issues are inextricably linked to problems faced by working people, particularly youth.

However, since the middle 1970s, leftist intervention in working-class issues are confined, almost exclusively, to the predominantly defensive struggles of embattled trade unions against the employer offensive of the Reagan era. In effect, the left, conceived in its broadest connotation to include the still formidable popular forces for economic and social justice, including significant elements of the feminist and civil rights movements, has reverted to vulgar economism and the politics of the lowest common denominator—features that also characterized the 1930's popular front against fascism, when social, cultural, and educational radicalism was viewed as an impediment to the aim of achieving maximum unity in the struggle.

Despite the recent upsurge of cultural and political authoritarianism at the commanding heights of economic and political power and among working people, an upsurge which has successfully masked the deepening of social inequality at every level, we are not in a pre-fascist era. Yet, bereft of intellectual seriousness, the American non-university left finds itself without either analytic resources or the political will to address the profound cultural crisis manifested in the decay and disorder that marks urban life, the surface tendencies towards violence against women and people of color, or even the massive attack from corporations and the political directorate against the remaining provisions of the welfare state.

VI.

Class has always been powerful in the United States, but not mainly in the way classical Marxism or even socialist ideology assumes. To be sure, America has had its share of militant labor struggles and dramatic surges of union organizing that invoked the most repressive responses of police and the army and, for a time, changed the landscape of national politics. In every decade of the 20th century, visible signs of class combat have been present; from the Miners strike of 1902 and the uprising of the 20,000 needle trades women in 1909 to the recent Eastern Airlines and *Daily News* strikes, U.S. workers, embattled by employers' offensives against their living conditions

and elementary trade union rights, have engaged in monumental resistance. But, as Werner Sombart argued in 1907, the socialist movement has been weak and, one might add, the broader ideological left has been only a sporadic presence in American life. In the final accounting, the inability of the left to place the egalitarian ideas in the forefront of public debate, much less political solutions, accounts, in the main, for the absence of a clearly articulated discourse about class.

Needless to say, subcultures, new social movements concerned the quality of life, and the civil rights and feminist struggles are not *merely* class displacements. I have argued in this essay that the historically exclusive focus of class-based movements on a narrow definition of the issues of economic justice has frequently excluded gender, race, and qualitative issues, questions of workers' control over production, and similar problems. The almost exclusive emphasis on narrow quantitative issues has narrowed the political base of labor and socialist movements and made all but inevitable the emergence of social movements which, as often as not, perceived class politics as inimical to their aims.

Nevertheless, class shapes the collective fate of most Americans, not only economically, but ideologically and spiritually as well. For example, the social issues, such as racial justice and sexual freedom, are mediated within working-class communities by class considerations. As we have seen, working-class women and girls are subject to considerably more stringent controls than women in middle-class neighborhoods. And while young people interacting more extensively with popular music and other social influences may view questions of race and sexuality differently from their elders, they are also constrained by both the psychological and social limits of class affiliation in their ability to act on sentiments other than those approved by the subculture. Class fatally shapes the relation of children to schooling which, in turn, has a great deal to do, not only with the economic dimensions of their lives, but their relation to politics and what is taken as legitimate knowledge and art.

Absent a vital discourse of class, many Americans have displaced their resentments resulting from what Sennett and Cobb called the "hidden injuries" of class to patriotism and other varieties of nationalism.[66] Moreover, working-class racism and sexism mask the considerable insecurity suffered by many white male workers in the face of capital migration, depression and recession, and the deterioration of their living standards, particularly their ability to earn a "family wage"—a situation that has forced many women into the wage labor force and has had devastating consequences for the working-class

family. These economic strains have combined with social and cultural strains, especially the influence on women of an otherwise maligned cultural radicalism, to produce the largest divorce rate in the history of the West. The further proletarianization of large chunks of the contemporary working class is particularly acute among young workers, whose best hope for job training and job security has become the armed forces.

Further, the more desperate situation confronting many white workers has strengthened what was once, in the halcyon era of assimilation, considered moribund: ethnically based subcultures. As economic independence becomes a distant shore for many white working-class youth, they are obliged to remain at home, and this compulsory extension of their childhood has thereby reinforced their subcultural identity, despite contrary pressures from the media and education systems. With the increasing identification of class fate with subculture, working-class life appears increasingly distinct, but "class consciousness," encased in largely segregated and culturally homogeneous neighborhoods, tends to become ideologically conservative and politically authoritarian. This is not the result of "inherent" tendencies in the constitution of the working class, but may be considered as part of a specific conjuncture of the strengthening of corporate capitalist hegemony and the profound weakness of the labor movement.

Despite job discrimination, segregation, and social exclusion, blacks have been, since the industrial union campaigns of the 1930s, when, for a brief period, they were invited, albeit ambivalently, into the House of Labor, among the most loyal and militant trade unionists. Similarly, women have streamed into the new public employees and service unions in large numbers since the 1960s and have become a counterweight to the relative decline of unionism engendered, in part, by recent disaffections among white men. From this follows the conclusion that class no longer has an autonomous ideological existence among U.S. workers, but lives as a hybrid with the discourse of social movements, particularly of gender and race, not only in this country. For while class is no longer dominant over these emergent discourses, neither has it disappeared; it remains true that, at a concrete level, many workers still rely on the collective power of labor organizations to sustain, much less improve, their standard of living even when unions are no longer perceived as resolute champions of workers' interests on the shop floor.

The changing composition of the U.S. labor movement corresponds to its increasing marginality within American life. Unions are strongest among public employees in the cities whose populations have in the past three decades become increasingly black and Latino. In turn,

from its proudest monuments, the cities have become the backwater of what may be described as American civilization. In a nation without viable centers, the working class, whose power has always been crucially tied to these centers, becomes invisible or, alternatively, appears only when it disrupts the ordinary rhythms of public life. At such times, the "public," a term that is always a euphemism for the white middle class, looks on not only with puzzlement, but with ire, because it has become convinced that the "once mighty unions" are no longer a threat to their tranquility and resent the temerity of these people of color to believe they have the right to disrupt essential services in the interest of their salaries.

Of course, in the case of strikes by physicians, journalists, pilots, teachers, and social workers that have dotted the landscape in recent years, a fraction of the public itself becomes the object of public scorn and discovers the ambiguity of its own class affiliations. These events have become more frequent the more that employers, having successfully "taken out" many industrial unions, now concentrate on the organized part of the service sector. In these cases, the "public" seems more confused because it can easily identify with the respectable people walking the picket lines. Even television and press reports seem softer, less bellicosely anti-union. Perhaps, as confrontations between professionals, who have become the core of the public sphere, and large institutions and corporations become more frequent, the situation of class will take on a new and different coloration.

The working poor remain invisible in debates about class. Situated in casual, part-time, and extremely insecure labor in small, competitive workplaces, they typically earn incomes at, or below, the minimum wage. Many of these workers are employed in the service sector or light manufacturing by employers whose positions in their respective industries is shaky. Thus, they are frequently laid off, and are constantly seeking work. Since, U.S. and state labor laws favor the largest, most stable employers, the working poor find themselves deprived of jobless benefits, decent health and child care, and chances for education and training.

Part-time work has become the fastest growing category of employment. There are nearly four ½ million officially part-time workers, or about 3¾% of the labor force and tens of thousands in the underground economy. In the legal sector these are the most vulnerable of all workers. Contrary to earlier periods when many women with children sought part-time work during school hours because of the absence of affordable all-day or after-school child care facilities, part-time work, some of it done in the home, has become the arrangement of choice for many employers who, beleaguered by increasing competition, are

anxious to reduce labor costs, such as health benefits, paid holidays and vacations, and others that might accrue to unionized workers. Part-time arrangements put many workers in a precarious position with respect to job security, especially where the work is casual.

The major unions have spent little effort trying to organize among the millions who find themselves in these situations—most of whom are people of color, women, often single mothers and youth. In the instances where organizing has been relatively successful—hospital workers, agricultural workers, needle trades workers—the unions have almost invariably been part of what might be described as "social," as opposed to "business," unions—the distinction is one of ideology, if not always trade union practices. Yet, the fact that more than a half a million hospital workers have joined unions in the past thirty years, especially in the large cities, and the farm workers conducted heroic and often successful strikes throughout the 1960s and 1970s attests to the possibility that the most oppressed of the working class are, indeed, likely candidates for membership, if the unions fuse struggles for social justice with those of racial and gender dignity.

The considerable fraction of workers in the underground economy who are not engaged in drug dealing, sexwork (commonly referred to as prostitution), or other ostensibly illegal activities, has mostly escaped scholarly, much less trade union, attention. Today, there are considerable sections of the garment, toy, and novelty, plastics, and other light manufacturing industries that operate outside various labor and health laws. The work force is composed, typically, of recent immigrants who are part of the wave of Latin, Caribbean, and Central American migrations, and Asians. Where unions, such as the Ladies Garment Workers, have made a concentrated drive to unionize these workers, they have met with some success and, even in failure, have elicited a gratifying response among undocumented workers who face deportation if their employer reports them to the INS.

Of course, the plight of immigrant workers, when discussed, is depicted in terms of issues of immigration because of the informal enforced silence about class discourse. The struggle of these workers entails, indeed, constant efforts to overcome the effects of the restrictive immigration laws and policies of the U.S. government which are directed, not at immigration itself (indeed, tens of thousands continue to enter the U.S. each month), but at the capacity of workers for self-organization, for class or other identity. Immigrant workers live an underground existence and are often terrorized by the knowledge that any overt resistance on their part is an invitation for deportation. However, as the second economy occupies a more important position, these restrictions appear increasingly irrational and have produced

several misguided efforts at immigration reform which, despite the fact that they benefit some, have merely tightened the repressive controls of the federal government, making economic and political organization increasingly difficult.

The excruciating consequence of these compulsions is to further close off the most important resource to those who need it most: time. For the condition of achieving collective self-consciousness is the ability of individuals and groups to take the self as an object, to distance ourselves from our situation in order to recognize it and, potentially, to overcome it. This is not done primarily through intro-spection, although this is a necessary concomitant of self-evaluation. The formation of groups that study relationships—sexual and other-wise—that become able to understand broad economic and social developments and connect these to their own situation, is an abso-lutely crucial method for developing and sustaining the critical self.

However, large numbers of people are working at two or three jobs or are caught in the vise of consumption and overtime, as in the case of autoworkers. They are unable to read anything beyond the daily newspaper or receive news apart from that offered by the car radio or the television channels. For women, the "double shift" is devasta-ting to their capacity to transcend conditions of their own oppression. Even when they walk out on their husbands or lovers, the pressures of earning a living and child care keep them chained to the home. Under these circumstances, it is all the more remarkable that so many women and men have succeeded in adopting one or another critical position with respect to everyday life, politics, and culture.

The American evasion of class is not universal. We have no trouble speaking of ourselves as a "middle class" society or, indeed, endowing the economically and politically powerful with the rights and privi-leges of rule. American ideology identifies the middle class with power and, in its global reach, has attempted to incorporate manual workers into this family. The anomaly of the large and growing working poor, some of whom are hungry, others homeless and, indeed, the increasing insecurity suffered not only by industrial workers but also by profes-sionals and clerical employees in the service sector, make some uneasy but have, until recently, failed to faze the ongoing celebration. Or, to be more accurate, class issues are given other names: crime, especially drugs; teenage pregnancy and suicide; homelessness and hunger; chronic "regional" unemployment that is grasped as an exception to an otherwise healthy national economy.

These will remain "disturbances" in a calm sea of progress so long as opposition is confined to resistance and alternatives remain murky. Needless to say, this essay has not been directed toward a revival of

some antiquated idea of class. Instead, what I have tried to show is that class never appears in its pure form. It is always alloyed, short of what might be called the rare instances of "epochal" transformations, with other identities, discourses, movements. In the United States, where socialism, anarchism, and laborism have suffered marginal existences for most of this century, we are afflicted with a serious case of social amnesia, the only treatment for which is the emergence of a new radicalism at once sophisticated and militant.

Notes

1. Francis Fukuyama, "The End of History?," *The National Interest*, 16 (Summer 1989).

2. Daniel Bell, *The End of Ideology* (Glencoe: Free Press, 1960); Daniel Bell, *The Coming of Post-Industrial Society* (New York: Basic Books, 1973); S. M. Lipset, *Political Man* (New York: Doubleday, 1960).

3. Nancy Hartsock, *Money, Sex and Power* (London: Longmans, 1984).

4. For a contemporary account see Henri Lefebvre, *The Explosion* (New York; Monthly Review Press, 1969); Also Daniel Singer, *Prelude to Revolution: The French May 1968;* A more recent treatment is Laurent Joffrin, *Mai 1968: Histoire et événments* (Paris: Editions du Seuil, 1988). For the Italian situation, the best account in English is Joanne Barkan, *Visions of Emancipation* (New York: Praeger Publishers, 1985).

5. The most comprehensive and theoretically elaborated treatment of capitalist regulation in the U.S. context is Michel Aglietta, *A Theory of Capitalist Regulation: The US Experience* (London: New Left Books, 1979).

6. Louis Althusser and Etienne Balibar, *Reading Capital* (London: New Left Books, 1970).

7. Karl Marx, *Capital*, vol. 1 (New York: Vintage Books, 1976).

8. G. W. F. Hegel, *Phenomenology of Spirit*, translated by A. V. Miller (London and New York: Oxford University Press, 1976).

9. Karl Marx, *Communist Manifesto*, in Marx, *Selected Writings*, vol. 1 (New York: International Publishers, n.d.).

10. Karl Marx, *German Ideology* (Moscow: Foreign Languages Publishing House), p. 39.

11. Even Engels acknowledges this. See Frederick Engels, *The Origins of the Family, Private Property and the State* (New York: International Publishers, 1935).

12. R. H. Hilton and H. Fagan, *The English Rising of 1381;* R. H. Hilton, *Bond Men Made Free* (New York: Viking Press, 1973), especially part 2.

13. Marx, *Capital*, vol. 111, quoted in G. E. M. Croix, *The Class Struggle in the Ancient World* (London: Duckworth, 1981), p. 51–52.

14. Croix, *Class Struggle*.

15. For a representative example, see Art Preis, *Labor's Giant Step* (New York, Pioneer Press, 1964).

16. Stanley Aronowitz, *Working Class Hero: A New Strategy for Labor* (New York, Pilgrim Press, 1983).

17. See Karl Marx, "Introduction," *Grundrisse*, translated by Martin Nicholaus (London: Penguin Books, 1973).

18. Marx, *Capital*, vol. 1 (Moscow: Foreign Languages Publishing House, 1964), p. 352.

19. George Herbert Mead, *Mind, Self and Society* (Chicago: University of Chicago Press, 1934).

20. Gilles Deleuze *Bergsonism* (NY Zone Books, 1989).

21. Eric Olin Wright, *Classes* (London: Verso Books, 1985).

22. Nicholas Abercrombie and John Urry, *Capital, Labour and the Middle Classes* (London: Allen and Unwin, 1983).

23. Michel Algietta, *A Theory of Capitalist Regulation*.

24. Scott Lash and John Urry, *The End of Organized Capitalism* (Madison: University of Wisconsin Press, 1987), chapters 1 and 2.

25. By "objective" I mean the striking increase in the number of wage and salaried workers in proportion to the absolute decline of the family farm and the relative decline of small business with respect, particularly, to its share of total production of goods and services.

26. For the best theoretical statement of the position of social ecology, see Murray Bookchin, *The Ecology of Freedom* (Palo Alto: Cheshire Books, 1982). Also Bookchin's earlier book, *Our Synthetic Environment* (New York: Alfred A. Knopf, 1962). This book appeared in the same year as Rachel Carson's immensely influential *Silent Spring*, but was more far-reaching and, therefore, less easily accepted. See also Barry Commoner, *Closing Circle* (New York: Alfred A. Knopf, 1972) and Stephen H. Schneider, *Global Warming* (New York: Vintage Books, 1989).

27. Kirkpatrick Sale, *Human Scale* (New York: 1985).

28. Bookchin, *Ecology of Freedom*.

29. However, the danger now presented by the sluggish economy, especially rising unemployment and reduced consumer spending, is that employers can effectively threaten plant shutdowns if state-imposed sanctions become more stringent. A case in point is the argument made by the U.S. automobile industry that safety measures, such as air bags, more efficient pollution control devices, and legislation that would restrict the use of internal combustion engines, would drive up costs and reduce their ability to compete with Japanese, Korean, and European imports.

30. Of course, the advancing decay of our major cities is more than just one more "social problem." Our cities have been sites of cultural avant-gardes, social movements, and political left-liberalism. While rapid suburbanization has spawned new ecologically linked consumer movements, the widespread support enjoyed by movements for social justice has been eroded by the acceleration of *de facto* racial segregation since the 1960s.

31. Anne Bramwell, *Ecology in the 20th Century: A History* (New Haven: Yale University Press, 1989).

32. Ellen Willis, "Is Motherhood Moonlighting?," *Newsday*, March 12, 1991.

33. Ursula Le Guin, *The Left Hand of Darkness*; Joanne Russ, *The Female Man*.

34. Donna Haraway, *Primate Visions* (New York: Routledge, 1990); Evelyn Fox Keller, *Reflections on Gender and Science* (New Haven: Yale University Press, 1985); San-

dra Harding, *The Science Question in Feminism* (Ithaca: Cornell University Press, 1986).

35. Ashley Montagu, *Man's Most Dangerous Myth: The Fallacy of Race.*

36. William Julius Wilson, *The Truly Disadvantaged* (Chicago: 1985).

37. Alvin Gouldner, *The Future of Intellectuals and the Rise of the New Class* (New York: Continuum Books, 1979).

38. For a discussion of these issues, see Stanley Aronowitz, *False Promises: The Shaping of American Working Class Consciousness* (2nd edition) (Durham: Duke University Press, 1992).

39. James Weinstein, *The Corporate Ideal and the Liberal State* (Boston: Beacon Press, 1966).

40. Weinstein, *Corporate Ideal.*

41. William Leuchtenburg, *Franklin Delano Roosevelt and the New Deal* (New York: Harper and Row, 1963), pp. 188–89; also Stanley Aronowitz, *Working Class Hero*, p. 75ff.

42. James Green, *Grass Roots Socialism* (Baton Rouge: Louisiana University Press, 1978).

43. Louis Althusser, "Ideology and Ideological State Apparatuses," in *Lenin and Philosophy and Other Essays* (New York: Monthly Review Press, 1971).

44. Carl Schorske, *German Social Democracy 1905–1917* (Cambridge: Harvard University Press, 1955).

45. Alfred Schutz and Thomas Luckmann, *Structures of the Life World*, translated by Richard Zaner and Tristram Engelhardt Jr. (Evanston: Northwestern University Press, 1973), p. 3: "The everyday life-world is the region of reality in which man can engage himself and which he can change while he operates in it by means of his animate organism. At the same time, the objectivities and events which are already found in this realm (including the acts and the results of the actions of other men) limit his possibility of action . . . Furthermore only within this realm can one be understood by his fellow men and only in it can he work together with them. Only in the world of everyday life can a common communicative surrounding world be constituted." Shutz relies here on Husserl. See particularly, Edmund Husserl, *Ideas: General Introduction to Pure Phenomenology*, translated by W. R. Boyce Gibson (New York: Humanities Press, 1931); and Edmund Husserl, *Crisis in European Sciences and Transcendental Phenomenology*, translated by David Carr (Evanston, Northwestern University Press, 1970).

46. John and Ruth Winterton, *Coal, Crisis and Conflict: The 1984 Miners Strike in Yorkshire* (Manchester: Manchester University Press, 1989), pp. 109–10.

47. Hardy Green, *On Strike at Hormel* (Philadelphia: Temple University Press, 1990).

48. Carl Ross, *The Finn Factor in American Labor, Culture and Society* (New York: Mills MN Parta Press, 1977), p. 12.

49. This can be seen in the fact that Angela Davis's stature far outlasted that of the Communist Party of which she is a leader, so too the enduring popularity of W. E. B. DuBois and Paul Robeson, both of whom had long associations with the communist movement.

50. James Connolly, *Nationalism and Socialism.*

51. Emmett Larkin, *James Larkin.*

52. Lawrence Goodwyn, *Democratic Promise.*

53. Craig Calhoun, *The Question of Class Struggle* (Chicago: University of Chicago Press, 1981).

54. Samuel Farber, *Before Stalin* (London: Verso Books, 1990).

55. Steven Cohen, *Bukharin and the Bolshevik Revolution* (New York: Alfred A. Knopf, 1974).

56. Moshe Lewin, *Russian Peasant and Soviet Power.*

57. Carmen Siriani, *Workers Control and Workers Democracy* (London: Verso Books, 1982).

58. Daniel Singer, *Prelude to Revolution: The French May 1968*; Alain Touraine, *The May Movement* (New York: Random House, 1970).

59. Daniel Bell, *Coming of Post-Industrial Society;* Alain Touraine, *Post-Industrial Society.*

60. The idea of the material significance of economic and social perception still unfortunately requires argument. Here are two examples: despite the enormous decline of U.S. working-class living standards during the past twenty years, many workers perceive themselves and are perceived by others as members of the "middle class." By all statistical measures, blacks have suffered an even greater economic disaster in the same period. Still, many whites perceive that blacks are privileged by the welfare system; that they do not work because they don't choose to. Liberals may deplore such widespread misperceptions of the contemporary black economic conditions, but they have serious political consequences.

61. Joseph Cescelca and Vincenzo Milione, "Statistical Profile of Educational Attendance of Italian Americans," John D. Callandra Institute.

62. Robert Viscusi.

63. Christopher Lasch, *Haven in a Heartless World*

64. Wilhelm Reich, *Mass Psychology of Fascism*, translated by Theodore Wolfe (Orgone Press, 1946).

65. George Dimitroff, *United Front Against Fascism and War* (New York: International Publishers, 1935).

66. Richard Sennett and Jonathan Cobb, *The Hidden Injuries of Class* (New York: Random House, 1972).

2

Marx, Braverman, and the Logic of Capital

Introduction

The power and scope of large-scale industry among advanced capitalist societies has made it increasingly difficult for us to imagine a different mode of material production. We are all convinced that artisanship in our epoch is merely a form of bourgeois ideology, whose effect, if not intention, is to foster illusions of mobility among workers, and to create an artificial hierarchy within the labor process. The few instances of handicraft which remain in our social world are considered to be so marginal that we have learned to take for granted the mechanization of the labor process and its consequences for the transformation of the content of labor.

Perhaps the most serious consequence of the obliteration of history by the totalizing force of industrialization has been the tendency of the population to regard the texture of the social world, especially the work world, as self-evident. Indeed, Marxism, after Marx, ratified that perception of the permanence of mechanical reproduction by accepting the development of the so-called "forces of production" as a part of the legacy of socialism. For the leaders of both the Second and Third Internationals, the development of science and technology were progressive and autonomous features of the capitalist mode of production.[1] The task of socialists, in their algebra of revolution, was to help transform the relations of production so that they would conform to the new forces of production generated by capitalism. The exploitation of labor by capital, personified by the subordination of workers under capitalists, would be ended by the workers' assumption of power over the means of production. In the process the whole of social life would be changed, since the relations of production, at least in the last instance, determined the character of everyday life and the

relations of domination within social institutions (such as education, the family, and the political structures of societies).

In the new society, collective ownership of the means of production and workers' control over the state would result in the full development of science and technology, which were relatively fettered by capital. In consequence, labor would be freed from its subordination and from back-breaking routinized labor. In the conception of socialism of the orthodox Marxist traditions, the new society would undertake production cooperatively, for the use of its members rather than for the profit of the few. Individual enterprises would be merged into socialized units and the concentration of industrial means would be even greater than in the present. For both Kautsky and Lenin, the advent of monopoly capitalism crushed the small producers' handicrafts and small capitalists, but was a matter of complete indifference to the proletariat. At best, the concentration and centralization of capital made easier the transition to socialism since capital itself performed the task of socializing the forces of production in its own interest.[2]

The received truth of the socialist movement is that socialist revolution is made inevitable by three features of capitalist development. (1) The concentration of capital into ever larger units brings millions of proletarians into communication with each other and facilitates their class organization and consciousness. (2) The contradiction between the forces of production (which develop up to a certain point independently of the social structure) and the capitalist relations of production which fetter them, is the most general cause of the capitalist crisis. (3) The particular cause of the crisis, the contradiction between the social character of production and its private appropriation, manifested in the crisis of overproduction and unemployment, generates the objective conditions for social transformation, of which the mass organization and social consciousness of the workers are the subjective condition. Along with these features, Lenin, Stalin, and Trotsky stressed the absolute centrality of the party as the vanguard of the working class, its function as the general staff of revolution and as the guiding force in the transition from capitalism to socialism after the revolution.

We are in the midst of a major re-evaluation of all of these propositions, largely as a result of the failure of socialist revolution to succeed in any capitalist country, except as nascent tendencies in western Europe, which however remain curiously underdeveloped (or overripe, as Trotsky put it) and the breakdown of state socialist regimes throughout the world. By now, most socialists are aware of the historical explanations for the retardation of social transformation in the

West. These vary from the theory of the emergence of the labor aristocracy, both within the working class and the socialist movement, to the theory of imperialism which speaks to the displacement of the capitalist crisis by the exploitation of the Third World (that is, by the formation of capitalist world system), to cultural theories which, while acknowledging the centrality of political and economic integration, insist that the specificity of ideological and cultural domination must also be stressed. The mainstream of historical explanations insists that the corpus of Marx's work remains valid, that what they are doing is to "update" the theory to account for historical changes within the capitalist mode of production.

Others have argued that the problems with the Marxian theory of revolution lies in omissions and reductions within the basic theory of social development. Jürgen Habermas, Alvin Gouldner, Marshall Sahlins, Jean Baudrillard, and Pierre Bourdieu[3] have, each in his own way, argued a similar point: the dialectic of labor, according to which the relations of humans with nature form the character of social relations, is seriously flawed. In their view, Marx reduced the complexity of social relations and therefore of historical change to a single dimension, the labor process. Humans, according to this theory are not formed just by their labor, but are formed by their interaction as well, by noninstrumental relations of exchange among themselves. Marx errs, in their view, when he ascribes the self-formation of human societies in every epoch exclusively to the character of their relations of social production.

According to Baudrillard and Sahlins, relations of symbolic exchange are more significant in human history then commodity exchange or the production process, except under capitalism, when the commodity form becomes universal. For Baudrillard, Marx becomes a 19th-century thinker, perhaps that century's most important theorist. Beyond acknowledging his contribution to the theory of the origins and development of capitalism, then, Baudrillard and the other writers try to historicize Marx. They claim that his theory is valid for capitalism in its emergent phase, but is adequate neither for the advanced stage of capitalism nor for precapitalist modes of production. Baudrillard has gone so far as to repudiate the concept of mode of production, as itself determined by bourgeois ideology, according to which production is the center of the social universe.

This chapter will attempt to assess some of the problems raised in recent Marxist theory in the light of fundamental tendencies of Marx's own work which may have led both to the misconceptions characteristic of the orthodox Marxist view and to the inadequacies of the historical response, which tends to disregard the problems in Marx's theoret-

ical formulations. On the other hand, I do not propose to treat in any detail the specific objections of post-Marxian theorists, whose conclusions in my view rest largely on the reductionism of orthodox readings of Marx.

However, I must locate the sources of some of the confusions prevalent in recent interpretations of Marx. It is my contention that much of the problem at the theoretical level resides in Marx's description of the underlying logic of capital, particularly its inherent tendency to "subsume" labor, science, and technology under its domination. By subsumption, Marx means the reduction of the autonomy of these forms of mental and manual labor to "moments" of capital. In turn the "form of appearance" of capital, given the universality of commodity, is autonomy. Thus, the relations of labor to capital in the process of material production are reversed. In material production, capital appears to labor as a passive object, since it has been materialized into raw materials, machinery, and buildings which are acted upon by the workers as preconditions for the production of commodities. Within the material production process, living labor is sovereign as a form of activity, an active subject, while capital, as the past, dead form of labor, already appropriated by the capitalist as surplus value, is merely the object upon which living labor operates.

The machines, raw materials, and buildings, however, do not *appear* to be a function of labor. Labor is increasingly subsumed as a factor of production whose guiding force is capital; labor appears to be a function of capital. Science and technology, which result from the work both of craftspersons and of independent scientists outside the production process, are also increasingly integrated by capital under its laws of accumulation. The social relation between capital and labor appears separate from the material relation. In the social relations of production, according to Marx, capital takes on the appearance of dominance even though in the materialization of these relations, living, purposive labor dominates capital since labor confronts capital as mere raw materials.

The "logic" of capital's self-expansion is its increasing subsumption of labor under its laws. This subsumption does not signify the destruction of labor as the crucial force animating the entire production process, but rather the appearance of the reduction of labor to just another "factor" of production, alongside the science and technology congealed in the machines. Capital also subsumes scientific investigation as one of its aspects, these appear as aspects external to the worker, as the property of capital, and appear to have been created by capital.

Capitalism is marked by the dominance of the social relation over

the material relation and the appearance of the social relation as a material force.

The inner logic of capital consists precisely in its capacity to determine the character of labor, the object, method, and form of results of scientific investigation, and the subordination of all science to a technology for capital's expansion. In turn, science and technology are related to labor in so far as they are directed by capital towards labor's degradation. Of course, the use of science to segment, routinize, and otherwise de-skill the labor force appears as a "natural" benefit owing to the claim that machine production relieves labor of onerous and arduous tasks and provides material plenty. Technologies of degradation appears as "progressive"—not only to capitalists and workers who have been subjected to their "inevitability," but also to those socialists who have come to regard the forces of production as independent of capital's rule, at least in part.

As Marx drew the consequences of the subsumption of labor, science, and technology under capital, the outward appearance of his writing is that this process so reduces culture, ideology, and politics to a function of capital that socialism appears to come to the working class "from the outside." Its ally, the forces of production—which are nothing but human knowledge materialize in machinery, the social organization of labor, and scientific invention, as well as human skills—also appears external to the existing relations of production.

It may be argued that the prevalence, in the first half of this century, of breakdown theories of capitalism's downfall, and the doctrine that the Third World has become, in toto, the modern proletariat (owing to the absolute power of capital among advanced industrial societies), are ascribable to the implicit reification of Marx's theory of subsumption.[4]

It may also be shown that the darkest analysis of the theorists of everyday life and cultural production, particularly the representatives of the Frankfurt school, were also animated by their belief in the absolute power of capital over all social relations. For Theodore Adorno and Herbert Marcuse, the advent of mass culture could only be understood as a function of the accumulation and expansion of capital into the farthest reaches of ordinary existence, of the invasion of the private sphere by the marketplace. In the felicitous phrase of Hans Magnus Enzensberger, the tendency of late capitalism is to "industrialize the mind," just as capitalism industrialized the production of goods during its rise. Human thinking becomes mechanized and the mind corresponds to the machine—a technicized, segmented, and degraded instrument that has lost its capacity for critical thought, especially its ability to imagine another way of life.[5]

The culture industry, for Henri Lefebvre, is responsible for more than the production of cultural commodities. It has colonized everyday life, transforming it into a "bureaucratic society of controlled consumption." The development of habitual consumption is no less pernicious than the habituation of the worker to routinized, degraded labor. If the Marxist theories of capital's logic have pointed to the narrowing of the universe (at the point of production) to the laws dictated by capital, "neo-Marxism" argues for a similarly relentless closing of the universe of critical discourse, one in which consciousness is bound by the requirements of technological domination. For those Marxists applying to everyday relations the logical principles of capital accumulation and the universalization of the commodity form, the culture of degradation may be regarded as the sufficient condition, and degraded labor the necessary condition, for the hegemony of capital.

Finally, we must mention recent developments in the Marxist theory of the state. Capital not only achieves hegemony over the labor process and the cultural domains, but its domination over political structures has become an essential component of its self-reproduction.

The two leading Marxist theories of the state[6] agree that one of the main characteristics of late capitalism is the transformation of the state from "watchman" of capital's interests and protector of property, into an aggressive "intervenor" in the accumulation process itself. From the point of view of capital's logic, the mobilization of the state as its adjunct capitalist is simply an extension of the categories of hegemony. Another crucial aspect of hegemonic relations between labor and capital is the formalization of a series of ideological apparatuses of the state. That is, bourgeois ideology no longer remains merely a series of values and beliefs about the eternal life of the capitalist system, but now produces a series of materializations, institutions that embody bourgeois ideology. Bourgeois ideology becomes a form of "lived experience." For Louis Althusser the state apparatuses are perhaps the main forms in which experience is lived.

This contribution to the Marxist theory of the state is complementary to Lefebvre's thesis about the bureaucratization of everyday life. For the soul of the state is the bureaucracy; and the ideological state apparatuses of schools, mass media, family, trade unions, and health institutions (to mention some key institutions) make it all but impossible for the individual to escape living the experience of bureaucratic domination, since all spaces of the everyday have been filled.

As capital incorporates and subordinates the state to its needs, it may be argued that the idea of the historical subject—of the relatively autonomous class of workers who are forced to labor under capital's

domination in order to live but who do not share the rewards of bourgeois society—has now been occluded from social experience. A socialism that arises from the internal contradictions of capital itself becomes increasingly problematic. Instead, recent Marxist theory of nearly all stripes has explained the fortunes of the revolutionary project in terms of Marx's description of capital's inexorable logic.

The inescapable conclusion from the drawing together of the three strands of contemporary Marxism—the degradation thesis, the notion of one-dimensionality, and the new functions of the state in capitalist society—is that we have come to the end of the inner dialectic of capitalism's development and decline. For the inference that may be drawn from these positions, when taken as part of a single theoretical system, is that capitalism is able to repress its contradictions, not because of this or that policy, but because its logic of integration and subsumption makes the concept of a "class in radical chains" absurd within the prevailing order.

I will now probe the heart of capital-logic, the doctrine of the subsumption of labor, science, and technology under capital. The first part of the paper will suggest some theses arising from Marx's analysis of the development of capitalism, particularly the transition from the artisanal to the industrialization stages of the labor process. Second, I will relate the historical dimension of the logic of capital to the structural dimension; that is, I will relate (a) the changes brought about by industrialization to (b) the emergence of the relative form of production of surplus value to centrality within the production process. The third part will deal with technology and science as forms of bourgeois ideology, corresponding to their subsumption by capital in the transition from manufacture (artisanship) to industry. Here, the attempt will be made to distinguish my reading of the approach Marx takes to the question of the social relations of science from orthodox Marxist views which adopt the traditional concept of the neutrality of these structures in order to argue for the revolutionary impact of the so-called forces of production.

Fourth, I shall suggest some empirical and theoretical contradictions in the logic of capital that may point to a view that the logic of subsumption is no more than a *tendency*. Just as the law of the tendency of the rate of profit to fall has its counteracting causes, the theses of degradation of labor, industrialization of culture, and state integration must be seen as theoretical and historical generalizations that are fought day to day by workers, popular movements, and individuals. My thesis here is that the configuration of capital—including the social organization of labor, the application of machine technologies to the production process, the production of ideology and culture

(and therefore consciousness)—cannot be deduced from social "scientific" formulae according to which the entire social world appears to be a function of capital accumulation.

Instead, *I argue for the relative autonomy of labor, culture, and consciousness within the broad framework of Marxist theory of capitalist development.* That is, I take the aphorism "all history is the history of class struggle" seriously. If this is the case, then the doctrine of subsumption must not be taken as an empirical description; rather it is a powerful tendency that becomes an aspect of the mode of production, but is counteracted both by the historical cultures of the working class (which have their roots in precapitalist social formations as much as the culture that arises from the labor process itself), and by the formal and informal organization of the working class, which restrains the subsumption process and causes its retardation and deformation. That is, the general rule that capitalism "sweeps away all the idyllic relations" of past societies is empirically accurate as an impulse of capital accumulation—but it may not be taken to mean that class fragments of prior modes of production do not exert significant social influence, and even power, within advanced capitalism, any more than it may be taken as a description of the end of proletarian discourse never emerged within capitalism (nor could it emerge except incipiently), it does not follow that the concept of a working-class culture is completely overtaken by the laws of capitalist development.

I wish to caution the reader that in some of the first sections of this paper I will render an account of the central themes of the subsumption thesis from the point of view of an advocate. The reason for this strategy is that I believe it impossible to understand the full significance of a theory unless one renders it from the inside. This method is sometimes referred to as immanent critique; the critique consists in drawing out the implications of the thesis under examination in relentless manner in order to show its inner tendency.

In the case of the capital-logic or subsumption thesis, and its relation to Marx's corpus, let me say at the outset that I believe that Marx developed this side of his theory most fully; the oppositional side remained underdeveloped theoretically, both during his lifetime and among his epigones. With the notable exceptions of Lenin and Gramsci, who in different ways tried to suggest theoretical supplements that retained the possibility of a socialist revolution from inside capitalist social relations, all other Marxist theories of revolution after Marx relied on versions of the breakdown thesis. Thus this chapter should be seen as a contribution to the critique of Marx as well as Marxism *from the inside.*

I

Among the most significant developments in Marxist thought over the past decade was the rediscovery of the centrality of Capital's domination over the labor process for an understanding of the persistence of bourgeois hegemony in the 20th century, especially in advanced capitalist countries. The work of Harry Braverman, Steven Marglin, Kathy Stone, Andre Gorz, and others[7] has explored the dimensions of this domination, particularly in the historical emergence of what has been variously called "Taylorism" and (by Gramsci) "Fordism."[8] The specific discovery was already present in Marx, but was ignored since his death in many sectors of the socialist movement.

The key concept is this: the rise of modern industry, with the introduction of large-scale machine production and the concomitant employment of science and technology as key productive forces, was no neutral process. The modern factory is a capitalist factory; the consequence of the rationalization of the labor process, signified by the introduction of assembly-line methods of production, has been to degrade and dequalify labor. The fundamental mechanisms of this degradation are implied by the "technical" division of labor: the separation of mental from manual labor, or, as Braverman put it, the division of concept from execution, such that the worker is reduced to a detail operative under the supervision and direction of management, which (alongside science) has now been simultaneously to destroy the last vestiges of the old artisanal mode of production, subordinating skilled workers to the rule of capital, and to accelerate the emergence of collective labor; the working class is largely de-skilled, at the mercy of capital, and reduced in its functions to an aspect of capital. Contrary to both popular belief and the ideologies of contemporary capitalism, most work has become routinized, boring, and repetitive.

The reduction of human faculties to a single dimension, that of performing the same detailed operation over and over, is of course not confined to the factory. The same rationalization of tasks divested of their creative and autonomous function has permeated the office, many professions, and the service industries. The checker behind a supermarket counter performs no more conceptually challenging or socially "meaningful" labor than the automobile assembly line worker. Witness cash registers at Taco Time: the keys no longer have numerical faces, but rather each stands for one product—taco, burrito, chips, etc. The medical specialist (say, a resident in a large hospital) may enjoy higher income than the detail worker in a factory or office, but the *tendency* of her/his labor is toward narrower spheres of activity.

The full contours of the descriptive content of this discovery are too well known to be repeated here. What I attempt to explore here are the consequences of the issue of the degradation and subordination of labor to capital in modern capitalism for a Marxist theory of technology, science, and social consciousness.

My contention is that the theoretical underpinnings of the historical· researchers of Braverman and others include five theses, as follows. (1) That science and technology perform specific functions within the framework of capitalist production such that their characteristics cannot be separated from the structure of bourgeois hegemony. Thus the distinction between forces and relations of production made by Marx in the famous *Preface* to the *Contribution to the Critique of Political Economy*[9] is not, even for Marx in *Capital*[10] a defensible position, except for analytic purposes. Not only do relations of production constrain the development of the forces of production, but they shape them in accordance with the subsumption of labor under capital.

(2) That technology is not a socially neutral "thing" that can be extracted from its uses within the framework of capitalist production. Technology is rooted in the social and technical divisions of labor specific to the capitalist mode of production. Therefore it can be characterized as bourgeois technology or monopoly capitalist technology depending on the epoch under examination.

(3) That capital not only subsumes labor under its rule but subsumes science as well. The implication, which Marx only hints at, is that the view that science is absolutely separate from ideology—upheld in some versions of Marxist theory, notably Althusser and some older versions of Marxism—is itself a type of bourgeois ideology.

The relations of humans with nature, including their labor as well as their scientific practice, is mediated by the force of the subsumption of all human activity under capital. Therefore, science is bourgeois science within the capitalist mode of production. This does not limit the "truth value" of science's discoveries. Just as the concepts of democracy, the individual, self-management and control, and freedom were developed by the rising bourgeois class (as an expression of its bid for moral and intellectual leadership in the transition from feudalism to capitalism) and are taken over and transformed by the working class and the socialist movement in our day, so the basic theoretical framework of modern science is an aspect of bourgeois hegemony, particularly its claims to find the "objective" laws of nature, the mechanical world picture that obeys the rules of bourgeois rationality, and to be able to know the world exclusively through the senses.

To the extent that praxis within the capitalist mode of production

is the self-reflexivity of science, as well as of a technology that no longer functions (if it ever did) apart from the imperatives of capital's logic, the notion of the autonomy of science expresses nothing else but the desire of scientific labor for independence in the wake of its almost total permeation by capital's requirements.

(4) That, therefore, the transfer of technology and science from one country to another, in the period of the transition from capitalism to socialism, is politically and ideologically significant. It may not be argued that technological transfer necessarily signifies the convergence of one society with another as many have claimed—since culture and social structure mediate the effect of these technologies—but the reverse is true.[11] That is, technology that is developed within the framework of bourgeois relations of production is nothing but the objectification of those relations, and would tend therefore to subvert the socialist intentions of a society that refused to recognize this formulation.

(5) That the theory upon which the concept of labor degradation is based contains the danger of an undialectical view of historical process, because its *tendency*, Marx's intentions notwithstanding, is to generate a closed system from which the only possible escape is its breakdown. That is, the basic direction of Marx's theory of the *"Results of the Immediate Process of Production,"*[12] in which Marx outlines his fundamental perspective on the emergence of developed capitalist society, is to close the spaces within which the working class may struggle for its emancipation, except under limited conditions that arise from the breakdown but are essentially outside the control of workers. The consequence of "capital logic theory", which has been given historical and contemporary specification in Braverman's work, is to raise the whole question to whether socialist revolution is theoretically possible.

II

The *"Results of the Immediate Process of Production"* was originally intended by Marx to be Part 7 of *Capital*. According to Ernest Mandel's introduction to the English translation of this section, which was included in a recent edition of *Capital*, Vol. I, as an appendix, the "Results" may have been conceived as a transition between Vol. 1 and Vol. 2.

Whatever the reason that Marx failed to include the "Results" in the first volume, it may safely be said that this section constitutes much more than a summary of *Capital*. It constitutes nothing less than the foundation upon which Marx develops an argument that (1)

the subsumption and subordination of labor under capital is the heart of the logic of the capitalist system, and (2) modern capitalism tends toward the absolute, self-directed hegemony of capital as a social relation, rather than as a system where exploitation and domination are contingent features determined by the actions of capital's personifications, the employer class and the state. In a little less than 150 pages, Marx shows with relentless coherence the stages by which capital both sweeps away the old modes of production (which, during its rise, linger as fragments in the labor process), and establishes itself as a "mode of production sui generis" in all branches of industry and, by extension, in all forms of labor.[13] Let us examine the concept of subsumption in the two forms that Marx describes.

The core of Marx's argument is that the production of surplus value not only is a process that reveals the secret of capitalist profit, but also contains an inexorable logic of domination as well. It will be recalled that the earliest form of surplus value production is what he calls "absolute" surplus value; that is, surplus value consists in the prolongation of the working day so that the proportion of labor time required for the reproduction of the laborer and her family is reduced in relation to the amount of time spent working for the capitalist's surplus.

In early manufacture, the capitalist employs skilled labor inherited from the artisan mode of production. The assumption made is that capitalist domination is limited to the transformation of the independent artisan into a wage worker; the worker is separated from the "natural" conditions under which both labor and labor power remain the property of the producer. In this early stage, the capitalist merely succeeds in divesting labor of its ownership of the means of production, but leaves the labor process intact. In the manufacturing stage, the old artisanal mode of production remains, which implies that workers may still control the process of production, even if they have been divested by ownership of their means. Surplus value is extracted by an increment of the amount of socially necessary labor time required for the production of the commodity over that portion of labor time required for the reproduction of surplus value by the only possible means available, given the transitional stage at which the system functions in this historical period—that is, by increasing the working day.

Marx calls this the *formal* subsumption of labor under capital, because the only change (in comparison to the artisanal mode of production) is the appearance of wage labor, under which workers must sell their labor power rather than the commodities that they have produced. In effect, the formal subsumption of labor under capital signals the formation of a working class from those feudal and transi-

tional classes that historically possessed the instruments of production as social private property. It also marks the first stage in the domination of capital over labor.

The purchase and sale of labor power is, for Marx, the hallmark of capitalist production as a whole, even though wage labor existed prior to the rise of capitalism as a system. Marx defines capital as nothing but "objectified" labor. Its existence as an autonomous "thing" appears self-evident because, as Marx points out, it is congealed in objects: the money, machinery, raw materials, and commodities that are consumed for subsistence.

It may be said that "things" are the form of appearance of social relations, which constitute the essence of capitalist society. Capital becomes the key social relation in the capitalist mode of production but appears as an autonomous force. Its existence is owed to the labor that produces it. Its power increases as it is able to reduce the time required for the reproduction of the laborer in comparison with the labor time appropriated by the capitalist.

But under the formal subsumption of labor under capital, only an extension of the working day can increase the size and power of capital. The workers constantly try both to reduce the length of the working day and to raise wages, and thus to increase the amount of labor time spent in their own reproduction in comparison to the surplus value extracted. It can be shown that the transformation of absolute surplus value into relative surplus value, as the central mode of exploitation under capital, is in part the outcome of the class struggle over the length of the working day as well as the falling rate of profit. In the United States, the eight-hour day movement in the late 19th century, just like the earlier ten-hour-day struggles in Britain, was conducted by the skilled workers, who by virtue of their power in the production process, are able to limit their subsumption under capital. In addition, competition among capitals on a world scale generated the conditions for measures to increase relative surplus values.

For Marx, even the relatively limited *formal* subsumption of labor under capital introduces changes in the labor process. The capitalist directs the labor process more and more, as he attempts to get workers to intensify their labor by producing more in less time, to extend their working day, and to reduce the amount of "soldiering" on the job. (Marx calls this reduction "making the work more continuous and orderly."[14]) But "in themselves these changes do not affect the character of the actual labor process, the actual mode of working." What he calls a "specifically *capitalist mode of production* (large scale industry

etc.)"[15] is characterized by the transformation of the labor process by capital.

In the period of the formal subsumption of labor within capitalist production, the extent of capitalist domination is mediated by the *relative* autonomy of the skilled workers. Even where they are not able to control the process of production completely, their power at the workplace is expressed by their possession both of tools, and of the knowledge (at the conceptual as well as the detail levels) of the labor process. Their ability to organize collectively against the power of capital to extract surplus value is enhanced by the fact that capital still *appears* as an external force, that is, as a force confined to supplying raw materials on one side of the production process, and disposing of the finished commodity on the other side, in the exchange relationship. The mercantile character of capital is expressed in that its function appears to be a matter of buying and selling.

At this moment in the historical process, capital is still personified by the capitalist; personal relations between employer and worker have not yet been abstracted. Although the employer may or may not appear at the workplace as a director, the function of supervision is determined by the boundaries established by handicraft. Typically, the journeyman produces the whole product or an entire section of the product. The craft is established by tradition as "multivalenced"; that is, the worker's *power* to labor contains, within its definition, qualifications that span several different skills. Work is performed by hand; more exactly, the hand is extended in its productive powers by tools whose efficacy has historically been measured, not so much by the ratio of labor time to surplus value (which demands that the commodity be of *average* quality, so that it may qualify as a use value), as by customs and rules that have their own laws not fully subordinate to exchange value. Because off this, tradition modifies and competes with capital's inner compulsion for absolute domination.

In the early stages of manufacturing the old guild system retains its influence over the production process. But commodities of a definite quality, produced by methods which, as Marx remarks, are controlled "not by tradition but by the Guild,"[16] are inimical to capital accumulation. Since there are physical limits to the ability of the worker to endure the expansion of the working day, as well as customary limits to intensification of labor beyond the bounds of craft, the formal subsumption of labor under capital reaches its internal limits from the point of view of capital accumulation and capital's domination.

Now Marx introduces the concept of "real" subsumption of labor under capital, corresponding to the centrality of relative as opposed

to absolute surplus value, to signify the initiative and intervention of the capitalist in the labor process. This intervention—marked by the introduction of machinery simultaneously to replace labor and to reduce the worker from multivalenced artisan to detail worker—results in the intensification of labor by reducing the amount of socially necessary time required for the production and reproduction of the worker, but without increasing the working day. Wages remain the same, but the volume of surplus is increased by means of (a) replacement of living labor with machinery, and (b) intensification of labor, in the form of speedups, stretchouts, or increased work loads.

The order and flow of the work is guaranteed by the domination of the machine over the worker. The machine appears to employ the worker, not the other way around. Marx calls this the confrontation of "objectified" dead labor with living labor. That is, past labor congealed in raw materials and machinery confronts the worker as an alien power that stands over him and appears as pure alterity (otherness). This otherness the form of appearance of capital which Marx reveals to be nothing else than a definite quantity of labor time congealed in things.

By this process, skills are destroyed, and labor is made infinitely versatile, that is, able to move from job to job, industry to industry, and country to country without the barriers of tradition, craft, or even language (since the tendency of this specific capitalist mode of production is to produce labor as a universal and virtually mute function of the machine).

The contribution of Braverman, Marglin, and Stone consists in their rich historical descriptions of the forms of intervention of capitalist management in the 20th century. They have characterized the entire function of management in terms of the task of reducing labor to an aspect of the organization of production according to the new logic of capital. This logic compels the capitalist constantly to reduce the part played by living labor in the production process.

This reduction takes two principal forms. On the one hand, the worker becomes a single-valenced detail in a highly rationalized specialization of tasks, in which it is no longer possible for labor to conceptualize the labor process; rather, these conceptual functions are systematically transferred to the managers. The function of the bosses, as Braverman and Marglin show, is to degrade labor beyond its reduction to a commodity. Capitalist rationalization is a means to remove the boundaries, set historically by working-class self-organization, culture, and skill traditions, upon the capacity of capital to become the tendency toward production for its own sake—that is, production as an end in itself (which under the formal subsumption

of labor under capital is merely incipient)—now becomes realized and dispensible to capitalist production, becomes in other words a compulsion.

On the other hand, the introduction of machinery "freeing" the laborer from the production process is viewed as an aspect of the fierce competition that ensues with the industrialization process. Machinery, however, does not simply replace living labor that performed the tasks of production. It simultaneously replaces labor and transforms the labor process in accordance with the rationalization and segmentation of labor. The new machines are forms of the social organization of labor introduced by management. That is, from the multivalenced character of the all-purpose lathe, for example, where the drill, the cutting tool, and the facing tool were combined in a single machine, production machine shops separate these tools into three machines. Further, the functions of design, of the setting up of the machine in accordance with a blueprint representing the design, and of the single operation performed by a single-valenced machine tool (say, the hole boring operation of the drill press), are segmented into three jobs, personified by three different workers.

Whereas in the old tool-makers' trade, designing the tools and parts, setting up the machine, and producing the parts were invested in a single craft, now the organization of machine-tool and metal-parts production has created an army of semi-skilled workers. Some of them are called craftspersons, such as designers, toolmakers and machinists, set-up men, and maintenance mechanics. But even these crafts have experienced considerable degradation in comparison to the period of manufacture, when a single "artisan" performed all of these functions, combining design and execution.

For Marx, the increasing scale of production made possible by machinery, and by capital's intervention in the labor process by its devalorizing labor, becomes identical with the mode of production. The production of relative surplus value—that is, the increase in the proportion of unpaid labor to living labor embodied in the commodity—is the sole purpose of production. The subsumption and subordination of science, technology, and human labor are merely facets of this compulsion toward extracting profits.

> It is not just the objective conditions of the process of production that appear at its [the real subsumption] result. The same thing is true also of its specific social character. The social relations and therefore the social position of the agents of production in relation to each other, i.e. the relations of production, are themselves produced: they are also constantly renewed as a result of this process.[17]

Thus the production of relative surplus value tends toward the absolute subordination of all consciousness purposive activity within its parameters. The worker has become a collective worker since the particularity of her labor has been dissolved by its transfer to the machine. As Marx notices in the *Grundrisse*,

> The specific mode of working here appears directly as becoming transferred from the worker to capital in the form of the machine, and his own labor capacity devalued thereby . . .[18]

Under the capitalist mode of production, the transformation of science consists in its subordination to the division of labor appropriate to the devalorization of labor and the domination of capital. Chemistry, mechanical engineering, and computer technology do not appear derivative of the division of labor. On the contrary. Scientific knowledge, which is nothing other than the formalization and commodification of the transfer of artisan skill, appears to determine the process of production. Actually, Marx shows the relations of science to industry to be mutually determining. Large-scale production is the condition for the transformation of "invention (into) business."[19] In turn, science and technology as forms of objectified labor now confront the living laborer as a form of capital's compulsion that appears inexorable and even beneficial.

III

Before considering the problems that arise from the theory of capital logic for the prospects for socialist transformation, I want to draw out the implications of this theory for understanding the production of ideology. Students of Marx have noted the distinction he made between (a) the essence of capitalist production that resides in the alienation of labor and its exploitation by capital, and (b) the *forms of appearance* that this exploitation takes. Marx's distinction forms the basis of his late theory of ideology.[20] The character of labor as objectified labor congealed in machinery strands opposed to living labor such that both capital and labor appear to possess a thing like appearance rather than a social relation. The function of management, even its scientificity, is not perceived as an aspect of the function of capital's logic, but seems to possess a natural existence, insofar as the totalizing power of the real subsumption of labor mystifies the centrality of the labor process for human existence. Science and technology appear to be autonomous forces rather than the outcome of the struggle between capital (itself a form of congealed labor under

specific historical conditions) and living labor. Living labor's own devalorization and degradation *appear* to be functions of the inadequacy of the worker himself, rather than an aspect of the inherent logic of capitalist production.

For Marx then, ideology does not consist principally of ruling ideas that are imposed upon the workers from above—e.g., a system of ethics and morality that are "reflections" of capitalist interests. This view of ideology, all too common among Marxists, tends to impute ideological domination to conscious intention. The Marxist theory of ideology begins with an understanding of the process by which the forms of appearance of a commodity, such as labor power, are materialized as practices having an existence independent of human activity. Ideology is rooted in (1) the invisibility of labor within the "thinghood" of the commodity, and (2) the real subsumption of labor under capital such that labor can no longer conceive of its mental side and can only see itself as a detail of large-scale industrial production. Thus, production's degraded division of labor appears "technical" rather than a function of domination, "rational" from the point of view of capital, but "irrational" from the perspective of specific humanity of labor.

The capitalist as the personification of Capital is no more able to comprehend the essence of the social process within which he functions than is the worker. For Marx, the labor of supervision, or management, produces its ideologies of rationality, of what Braverman calls the "habituation of the worker"—e.g., industrial psychology and education, mass advertising and other forms of mass culture, and technologies of industrial production—not as conscious means to subordinate the worker to its concrete interests, but as compulsion over which the manager has no control.[21] The manager believes his function to be "necessary" from the point of view of the labor process as well as of the general interests of society. His activity of intervention to reduce labor to a detail appears as technical as that of the quality control engineer who insures that the commodity conforms to the requirement for average quality in order to qualify as a use value.

Thus ideologies that legitimate the rule of capital arise from the process of capitalist production, and are aspects of the production of relative surplus value, the dominant mode by which the real subsumption of labor under capital occurs. The forms of appearance are "real" insofar as capital overturns historical memory, not just as a process of consciousness repression (Henry Ford: "History is bunk."), but because social relations are always materialized in the forms of machines, raw materials, money, and consumer goods.

Among the most significant ideological productions of the logic

of capital is the notion of the autonomy of science and technology. Braverman superbly demolishes the concept of technology's neutrality by showing that degradation of labor (a function of management within the detailed division of labor) is the presupposition of the so-called scientific revolution of the 20th century.[22] "Scientific management" as the crucial technology of monopoly capital cannot be separated from the rule of capital over labor, and can no more be ascribed to the technical division of labor than can the division of mental from manual labor be ascribed to differences among the innate capacities of persons. Historically, labor is devalorized both qualitatively and quantitatively by what Proudhon, referring to property, once called "theft".[23] Just as property is the theft of the labor of the immediate producer in the transition from feudalism to capitalism, so technology is the theft of the artisan's craft in the transition from the formal to the real subsumption of labor under capital.

Of course, the question of science as ideology is far more complex. The conception of science as a neutral form of knowledge is so deeply imbedded in bourgeois culture that the assertion of its ideological character appears absurd. Since the so-called "Copernican Revolution" of the 16th and 17th centuries, during which what Dijksterhuis calls the "mechanization of the world picture" occurs,[24] the basic concepts of modern science appear self-evident. Even Marxists such as Louis Althusser take these concepts for granted, while at the same time acknowledging that ideology is a type of "lived experience" of bourgeois society rooted in material institutions such as the state, schools, trade unions, and art.

According to Althusser, Marxism is a science of society and history analogous to physics and chemistry. It is not the idea that scientific propositions are ultimately empirically verifiable that is at issue here, if by empirical we mean the correspondence of our ideas to a reality independent of our volition. For Althusser science is a body of knowledge, or, to be more precise, a theoretical practice, that is radically separated from ideology by virtue of its explicit or implicit self-detachment from ideology. This detachment is achieved by revealing its past to be ideological. Presumably modern physical sciences are genuine, scientific *sui generis*, because of their epistomological break from prior theories that were pseudo-scientific because they were permeated by idealism. This definition of science includes just two elements: first, the critical side, namely, the continuous critique of ideology which is, in every case, a material practice located inside the system of social relations; second, a system of concepts held together in contradictory unity according to the principles of the materialist dialectic. Naturally, Marxism for Althusser is not just a theory of

society that possesses a scientific character—as opposed to those theories that are ideological because they are the lived experience of social relations, despite their appearance as science. Rather, Marxism is also a theory of theory, revealing the general laws of all scientific discourse.[25]

Althusser's claim stands in continuous relation with the claims of the history of science, except that he does not accept its positivist methodological premises. What is common to both his theory and bourgeois scientific philosophy is the assertion that science may avoid a mediated relationship with nature, that is, that the specific characteristic of scientific propositions may be related to the configuration of social relations within a given mode of production, not only with respect to their uses and transformation into bourgeois technology, but also with respect to the content of the propositions themselves.

But if Marx is correct concerning the subsumption of science as well as labor under Capital, then it should be possible to trace the ways in which scientific discovery is subsumed by capitalist social relations, not only with respect to the object of scientific investigation (and how much it is determined by the compulsions of capital to direct scientific practice toward modes of domination of nature that result in domination of labor), but also with respect to scientific methodologies and theoretical concepts. Dijksterhuis has shown, for instance, that the development of physical science is attributable in great measure to the "far reaching effect (of) the emergence of the conception of the world usually called mechanical or mechanistic."[26] The burden of his argument is that the mechanical world picture determined, as well as was determined by, the development of science. Of course no history of science, including Dijksterhuis's, has pointed to the degree to which the picture of the world as a giant machine (whose laws, subject to quantification by mathematical means, are verifiable (or falsifiable) by empirical observation and experiment) corresponded to the processes of capitalist rationalization of industry. But even if we admit that mechanization as a philosophical tenet need not correspond, as a precise reflection, to underlying economic relations, there can be no doubt that the bourgeois world outlook which preceded the development of modern industry presupposes capital's compulsion to subsume society and nature under its rule. The mechanization of the world picture is the ideological form of social domination insofar as capital claims that its epistemology is an immutable law of nature.

Even the claims of bourgeois science to empirical proof of the truth of its propositions rests on assumptions about ways of knowing the world that are already permeated with its ideology. The experimental method of knowledge enunciated so eloquently by Francis Bacon "for-

gets" that the scientist acts on the world, mediated by social class and ideology, in order to know it. All knowledge of the external world is conditioned, if not determined, by the fundamental premise of all labor, i.e., by the determination of all activity within the bourgeois mode of production by its instrumental character. Even if the scientist believes that knowledge is acquired for its own sake, capital imposes its forms, if not a specific content, on investigation. These forms are the general parameters of scientific discourse, according to which (a) the world is orderly and lawful; (b) all knowledge is subject in principle to mathematical reduction, such that quantity dominates over quality and, in the development of bourgeois philosophy, quality is regarded as belonging entirely to the subjective realm; (c) science is, if properly cleansed of its ideological remnants, capable of value-free inquiry; and (d) the world corresponds to the principles of classical mechanics.

Dijksterhuis disputes the theses of Franz Borkenau and George Simmel that the development of science in the 15th and 16th centuries owed a great deal to the early innovation within handicraft production of mechanical tools.[27] His argument rests on the apparent temporal discrepancy and geographical dispersal of scientific discovery in this period, a spread that does not appear to be influenced by technology. It seems to me that Marx's theory of the development of capitalism and the formation of capital transcends arguments whose veracity depends upon causal explanation. *For the thrust of Marx's argument is that the capitalist mode of production produces ideologies that seek to preserve a system of social relations, quite apart from the relation of any particular part of that complex to another. The question of determination between science and technology may be unanswerable at the level of causal discourse. What is at stake in Marx's theory is the concept of the hegemony of the specific system of social relations called capitalism over forms of thought as well as over the fate of social classes within it.*[28]

We may speak of the relative autonomy of science insofar as scientific discovery constitutes a moment of determination within a complex totality. One does not need a theory of correspondence to assert the dependence of science on capital if the propositions concerning the subsumption of science under capital are accepted as a historical phenomenon. The historical specificity of the universality of the commodity form, based upon the separation of labor from its natural conditions within the feudal mode of production, and the formation of a class of wage workers, creates the conditions for the domination of capital, if not of the capitalist class, over all forms of social life. The primacy of social relations over the forces of production is not to be construed as an invariant law of historical materialism. What it im-

plies is the reversibility of the concept of a science that can stand apart from the system of social production, that is, as an autonomous sphere. For this reason, the merging of science and ideology under the rule of capital emancipates thought from the scientific ideology which declares its independence from social relations, and makes the project of scientific autonomy an aspect of socialist struggle.

The problem with recent treatments of the labor process within late capitalism is that the "scientific/technical revolution" is treated as conjunctural with the capitalist division of labor and the subsumption of technology under capital. The inner laws of science—its ideological presuppositions rooted in the relations of domination between predatory capital and nature, whose configuration expresses the relations of domination among humans—are left untouched.

Braverman repeats the error: "The old epoch of industry gave way to the new during the last decades of the 19th century primarily as a result of advance in four fields: electricity, steel, coal-petroleum and the internal combustion engine."[29] He goes on to describe how these innovations were recognized by the capitalist class as important "as means for furthering the accumulation of capital" but deals with the phenomenon of the incorporation of science into industry as the meeting of two relatively autonomous structures. One could argue that the chemical, electronic, and information revolutions were themselves subordinate features of the logic of domination. They did not merely conjoin with the emergence of large-scale industries that arose from the concentration and centralization of capital; rather, they appeared as the result of the separation of mental from manual labor and the "theft" of the conceptual functions that had been merged with execution within the artisanal mode of production. More specifically, they are expressions of the tendency of the "specifically capitalist mode of production" for continuity and order in the labor process.

The chemical, electrical, and information technologies arose out of scientific labor resting on the foundations of mathematical reduction of the materiality of the world to number. Whereas the older industrial revolution was based on pulleys, gears, and other machines that rested on the mechanical world picture and still entailed the confrontation between objectified labor and living labor at the level of sensuous experience (that is, it was a visible confrontation, even if mystified by the reification of social relations in their thing-hood), the new scientific discoveries and technical processes were invisible. They abstracted labor as a use value to a much higher level, such that mental labor, not so much management as science, emerges as the primary productive force.

Thus the historical process whereby labor is degraded and the ma-

chine appears to possess skill as an inherent property is advanced to a new stage: capital now subsumes the mental laborer and presses the laboratory into its service. But this incorporation rests on the traditional insistence of bourgeois science that the world can be expressed in terms of numbers that stand in objective relations to each other according to definite logical processes.

When number becomes the language of science, its transformation into technique ensures the continuity of production, even if the worker refuses to be subordinate to the machine. Under the mechanical means of production, this refusal could be materialized as the refusal to work, as a disruption of production expressed as sabotage, slowdowns, and strikes. The new technologies are based upon scientific principles that are anti-mechanical. Whereas auto workers may still shut down the assembly line, revealing to them that the line is after all objectified labor and merely an extension of their own productive powers, the cracking plant or power generator, indeed the computer that can regulate machine production, appears to be autonomous with regard to human labor. Of course, as Marx pointed out in the *Grundrisse*, this form of appearance is essentially no different from the mechanical processes of production.[30] Now, however, mental labor, personified not by engineers and technicians but also by electronic controls, may operate the machines even if the manual workers refuse to perform the labor of watching and recording.

Automated production is not based upon the application of time and motion studies to human labor, as in the mechanical phase of production, since the tendency of these technologies is to make production continuous without the intervention of labor since all operations are regulated by electronic controls that simulate human activities numerically. Of course, the machine is still partially built by labor, including the labor of calculating the various frequency of numerical control devices corresponding to operations that were performed by manual labor. But the process of devalorization of living labor approaches, but never reaches, zero.

This tendency toward the absolute devalorization of labor time required for the production of commodities is still undeveloped in most sectors of American industry, but exists in almost all basic industries in theory. Marx spoke of abstract labor as the result of the separation of exchange value from use value, and of the quantification of labor as a function of time; now capital has found a way—via the development of scientific principles inherent in the paradigm of modern scientific principles inherent in the paradigm of modern science itself—to create the abstract worker within the labor process. Under these circumstances, plants become smaller, employing fewer

workers, whose productivity is virtually incommensurable with the mechanical phase of capitalist industry. At the same time, the centralization of capital, assisted by the new technology, results in a tendency toward the decentralization of industrial production. The need to be close to waterways, once the *sine qua non* of industrial location, has disappeared because neither power nor transportation depend on water. Under these circumstances, the new logic of subsumption makes possible the dissolution of the natural bonds of working-class solidarity which Marx found to be an unintended consequence of the centralization of capital in ever larger industrial units during the period mechanization.

IV: Social Movements and Revolution (Self-Activity)

The emergence of science as a primary productive force under capital results in the further fragmentation of labor; that is, the relation between its objectified form and its living form appears even more alien. Even the function of management appears superfluous, since the logic of industrial production appears to reside within the self-correcting continuous flow operation of electronic or chemical processes that now conceal more than they reveal.

The trade union is already a dependent variable to the old industrial order, since it has been reduced to fighting to prevent the price of labor power from sinking below its value, and to maintain the position of a shrinking industrial labor force, while at the same time serving as a central instrument to discipline that force and make it a cooperative factor of production; now it is placed in an even more ambiguous position by the logic of capital. Now the union struggles to valorize capital, by acting as a counter-tendency against the compulsion of capital to deprive labor of "its direct form"; the subsumption of living labor under "self-activating objectified labor" generates a crisis of valorization of capital for the system as a whole, since unpaid labor is the only source of surplus value. One of the functions of trade unions becomes to safeguard capital against its own tendency to render the worker superfluous to itself within the labor process, since, at the level of exchange value, labor remains absolutely essential.

This contradiction in the character of workers' organization is not a product of the "class collaboration" of the union leaders, their misleadership, or even their bureaucratic character. Rather these characteristics of the unions are produced by the logic of subsumption. The unions' subordination to capital does not consist in their selling out, even though this is the appearance. The necessity for labor time to be

present, as a regulator of exchange value preventing the surplus value within commodities from actually reaching zero, is expressed in trade union demands for minimum crews on various industrial operations, even on those that (because of high levels of technological development) reduce the worker to a watcher and tender of a machine that appears to produce commodities independent of the direct intervention of the worker.

Marx calls unions "insurance societies formed by the workers themselves for the protection of the value of their labor power."[31] In the earlier transitional artisan mode of production, in which the labor process was still under the control of the workers but the product had already been alienated by capital, workers' combinations prevented the extension of the working day beyond the bounds of human endurance, and thus produced the transformation between the formal subsumption of labor under capital and the real subsumption (in which objectified labor confronts living labor in an antagonistic relation and reduces the latter to a function of the machine). But the role of unions, in the period when "the workers' activity [is] reduced to a mere abstraction of activity [and] determined and regulated on all sides by the movement of machinery"[32] (i.e., modern industry), is reduced to protecting the value of a fragment of the value of the commodity. The workers can no longer through combined activity do more than accelerate or retard the transformation of the labor process into one wherein objectified labor rather than living labor dominates.

The results of the immediate process of production tend toward the elimination of living labor as a force of production and its replacement by the dead hand of objectified labor. The past dominates the present, and, insofar as Marx has charted a logical process that no longer admits of human intervention except in the period of the breakdown of capital's self-reproduction, capitalism becomes a system where the future is an extension of the present.

The idea of a scientific-technological "revolution" is a form of reification in Marx's schema of subsumption. Although mental and physical labor remain the basis of the entire productive system,

> [the] science which compels the inanimate limbs of the machinery, by their construction, to act purposefully, as an automation, does not exist in the worker's consciousness, but rather acts upon him through the machine as an alien power, as the power of the machine itself. . . . The production process has ceased to be a labour process in the sense of a process dominated by labour as its governing unity. Labour appears, rather, merely as a conscious organ, scattered among the individual living workers as numerous points of the mechanical system; subsumed under the total process of machinery itself, as itself

only a link in the system, whose living unity exists not in the living
workers, but rather in the living [active] machinery, which confronts
his individual insignificant doings as a mighty organism.[33]

If Marx is correct that the character of the labor process structurally
prevents the workers from recognizing themselves as the motive force
of the entire system, and that all institutions of society are subsumed
by capital, including labor, then even the forms of workers' resistance
are imprisoned within the boundaries set by capital itself. At least,
the tendency toward the replacement of living labor by its objectified,
mechanical form shrinks the power of the working class within the
system; this does not happen as a function of its false consciousness;
the "false consciousness" is itself produced by capital as an aspect of
its inner logic. Nor is the material base of the loss of workers' power
the perfidy of trade union or socialist leaders; rather it is the "scatter-
ing" of the workers among the giant machines of modern capitalism.
Anyone who has ever witnessed the operations of an oil refinery, a
modern heavy chemical processing plant, a food processing plant, or
a modern electronics facility cannot fail to understand the concrete
specification of Marx's synthetic and prophetic vision of the inherent
tendencies of the labor process. Here the worker is actually reduced
to a watcher and tender, while scientific and technical employees,
whose labor appears abstract to the workers since it is embodied
(invisibly as it were) within the machine's parts, become the key
productive force. But the form of appearance of this productive force
has no personification, only an embodiment in the inanimate object
which Marx says appears as the "active force". Since scientific and
technological labor is analogously degraded to that of manual labor,
its centrality to the labor process is no less hidden to itself than is the
labor of manual workers subsumed in the autonomy of the machine.
The ominous consequence of this historical process—one in which
even its historical character has no immediate existence to those
who have become its objects, the workers and technical intelligentsia
within the labor process—is nothing less than the tendency of capital-
ism to abolish the subject as an historical actor. For subjectivity or
consciousness depends, not on the "scientific" understanding of the
few intellectuals whose social formation and distance from the over-
whelming power of capital's domination within the labor process
allows for the possibility of critical analysis, but rather upon the
contradictions of the social system that produce the necessary condi-
tions for self-activity. This self-activity, within the framework of Marx-
ist theory, may not be regarded as a phenomenon that arises from the
depths of human volition; Marx had patience neither with doctrines

that relied on innate characteristics of human nature to explain the possibility of revolutionary action, nor with those that relied on moral outrage. His theoretical premise is that subjectivity must have a material basis within the process of production, in the alienation of human labor from itself, which of course remains in existence between the two principal stages in the development of the labor process under capital's domination.

But the problem with the second stage of this process is that his theory only permits of two sources for the emergence of the proletariat's self-consciousness. The first (a conclusion to which Lenin and Lukacs were irresistibly drawn by their analysis of capitalist production arising out of their reading of *Capital*) was that the working class, by its own efforts, could not achieve revolutionary consciousness; the recognition of its historical task must be brought to it from the outside, because of the occlusion of capitalism's essential processes by the appearance of its social relations in the form of thing-like relations.

It must be emphasized that the Leninist theory of the party is not a variety of "elitism," as many have argued; rather it is the inexorable result of the rigorous application of Marx's theory of capitalist development, particularly his analysis of the labor process, to problems of political organization. It will not do to ascribe the notion of the structural limitation of worker's consciousness, as some have charged, to the petty bourgeois character of socialist leadership. According to this critique, Leninism is the self-justification of a jacobinite tendency in the socialist movement. Whether or not the theory of reification that permeates Marx's *Grundrisse* and "*Results*," as well as the first chapter of *Capital*, is defensible in the last analysis, it is a powerful description of the logic of capital, one that has withstood a century of world history. Even in a cursory reading, Lukacs' *History and Class Consciousness* argues persuasively for the theory of the Leninist party, on the basis of the repression of subjectivity by late capitalist society.

When Braverman warns that *Labor and Monopoly Capital* will make "no attempt . . . to deal with the modern working class on the level of its consciousness, organization or activities," even as he acknowledges the importance of this line of inquiry, he may not have chosen this limitation, as he says he has, because of the priority of the task of describing the working class "in itself" before trying to find the basis of the formation of the class "for itself." Rather, the "shape given to the working population by the capital accumulation process,"[34] the subject of the book, may itself exclude the question of consciousness, if Marx's theory is rigorously followed, as Braverman attempts to do. For the result of the process is the exclusion of contradictory processes of capitalist accumulation of a kind that may reveal to the workers

themselves the truth about the labor process and the capitalist system as a whole.

The theory of the Leninist party becomes a perfectly reasonable deduction from the capital-logic argument, although even here a relentless application of capital logic would preclude the appearance of those radical intellectuals who, at the turn of the century, were still formed by the humanist tradition which capital was in the midst of extirpating from public discourse. As Andre Gorz has shown,[35] following Marx's doctrine of subsumption of all science under capital, the intellectual educated in the philosophical and cultural traditions of classical Greek thought, Renaissance ideas, and the French revolution has all but disappeared in the modern world. The scientist no longer engages in "pure" research, but "research directly or indirectly connected with the production process." The traditional intellectual has given way to a "technical tentelligentsia"; these strata "supervise, organize, control and command groups of production workers,"[36] or, within universities and mass communication media, generate and disseminate technocratic ideologies which function both to legitimate capitalist domination and to reproduce a labor force that regards its own subordination as a natural fact. The fundamental distinction between the traditional intellectual, and the technical intellectual devoted to the reproduction of appearances since he is tied to the logic of capital, makes the project of a revolutionary party problematic. For where can we expect the critical intellectuals to emerge from, if the proletariat has become merely a "conscious organ of the machine"? Clearly, the program of Lenin and Lukacs relied on the transitional nature of eastern European societies, where traditional intellectuals still existed who could go over to the proletariat.

However, the technocratic character of the French and Italian Communist parties may attest to the difficulties in the Leninist conception in advanced countries. These mass parties adhered to revolutionary ideologies albeit in a degraded form, but seem unable to develop an autocritique of their own practice—the only possibility of retarding, if not totally precluding, their integration within capital's political as well as economic hegemony. At the same time, the working class, which in the main supports socialist and communist parties in these countries, frequently shows its capacity for revolt, but seems unable to transcend the objective conditions of its fragmentation. At best the workers pursued the dual strategy of disrupting both the factory and the trade union bureaucracies that appear as their antagonists, and supporting their left parties at the polls, as the best chance to achieve amelioration of social grievances within the system.

Of course, these parties, which for the most part are identical with

the trade unions (if not in function at least in personnel), reveal the contradictions within working-class practice. To draw an homology to the relation of the worker to the machine, the trade unions and left political parties are themselves personifications of capital, even as they represent the workers' immediate interests. The unions and the parties, as forms of objectified labor, confront their constituency in the form of bureaucracy, itself an alienated moment of capital. For it cannot be denied that workers form these organizations as their "insurance societies" against the reduction of their living standards, that is, support the left as organized labor's defensive instrument. But the parties have ceased to express the revolutionary intellectual's self transformation into a catalyst of working-class activity. They have become the political sign of capital logic. This is the phenomenon often referred to as the "integration of the working class into late capitalism," when monopoly capital incorporates its own opposition as a feature of the system such that the workers are no longer in "radical chains." They are now, according to this view, both *in* and *of* capitalist society; and Marx's theory of the production of relative surplus value and its consequences becomes both the necessary and sufficient explanations for this historical development.

Recognizing the problem of late capitalist integration, one important political tendency in advanced capitalist countries, often defined as the extreme left, has attempted to find a way out by the relentless pursuit of the capitalist crisis. The underlying hope of those who look to the crisis as the sufficient condition for revolutionary action is the tendency of the capitalist system periodically to experience economic breakdown. According to Marx's theory of capitalist development, breakdown is only one of the possibilities arising from the higher organic composition of capital, that is, from the rising proportion of capital to living labor. Since living labor is the only source of surplus value, this historical replacement of humans by machinery within the labor process is only the qualitative expression of the drive of capital to subsume labor under itself, in order to facilitate the accumulation of capital on a continuous basis. Marx argues that this subsumption constitutes an internal contradiction in capital's logic of accumulation since it reduces the amount of socially necessary labor required for production of commodities and thus reduces the portion of surplus to congealed capital. But Marx was quick to point out "counteracting causes" of the tendency of the rate of profit to fall and of industrial production to be disrupted by this lower rate.[37]

Among these counteracting trends is (1) raising the intensity of labor by supplementing the production of relative surplus value with absolute surplus value extraction. The working day is lengthened in

our epoch by both compulsory and voluntary overtime, which in such industries as auto are not the exception but during peak season have become the rule; and by the old-fashioned methods of speedup in "medium" technology industries, that is, in industries not yet characterized by continuous or automatic production, like auto assembly or steel, which have a relatively high level of mechanization but not yet a system of developed numerical control systems based on information processes. Among other counteracting trends are the following:

(2) One can cheapen the elements of constant capital; this is a relative category expressing the difference in the rate of growth of value of constant capital to the volume of total capital. As the volume of total capital is larger because of the productivity of labor, the decline of the rate of profit of each unit of production does not result in a significant halt or slowdown in industrial production or mass of profit.

(3) Marx says that "relative overpopulation" is inseparably linked with "the development of the productivity of labor expressed as the falling rate of profit."[38] The large number of unemployed tend to depress wages in some branches of industry, retarding the subordination of labor to capital by reducing the pace of the introduction of labor saving technologies that reduce the rate of profit. Lenin adapted this counteracting cause to his theory of uneven development, according to which the masses in the least developed sectors of the capitalist world system would show the way to revolutionary change.[39] If Marx's theory is followed in its implication, one might infer that the possibility of revolution is either reduced or increased partially on the basis of the pace of subordination of labor under capital. At the same time, this phenomenon is internally contradictory to the doctrine of the inevitability of capitalist crisis, since unevenness is among the retardants of the crisis (seen in some versions of Marxist analysis to be the *sine qua non* of either revolution, radicalization of the working class, or both).

(4) It may be argued that Marx's designation of "foreign trade" as a major deterrent to crisis was adapted in the 20th century to the theory of imperialism, notably by Lenin, Hilferding, Luxemburg, and Bukharin. Capitalism may avoid breakdown by expanding its foreign trade so that, by competing with countries producing commodities under less developed conditions of production, it permits an enlargement of its own scale of production, thus cheapening the elements of production (such as raw materials and machinery) even as the mass of commodities produced is increased and the number of employed laborer is increased in absolute terms. Thus the rate of surplus value is raised, vitiating the tendency of the profit rate to fall.

(5) But the most significant of the counteracting causes of capitalist crisis is contained in the tendency of capital to subsume the state, its own opposition (labor), and science. This is the fundamental basis of the historical appearance of state capitalist planning in the 20th century with its capacity to counteract the inherent crisis tendencies of the system. It is not that crisis has been permanently pre-empted by state intervention in the economy, the reduction of the working class to a function of capital, or the advent of modern imperialism as a counteracting tendency to crisis. Rather, the crisis is displaced by the enlargement of the state's function as employer of labor, by the arms economy, by the export of capital to other countries (who, owing to the law of uneven development are now burdened by capital's internal disruptions), by the phenomenon of "internal colonialism" expressed as the systematic exploitation of the countryside by the town within advanced capitalist countries, and by racist and sexist divisions of labor that constitute a "counteracting cause" insofar as they allow capital to contain the falling rate of profit by increasing the rate of exploitation among sectors of the "surplus population."

Thus the logic of subsumption, in which capital presses all social institutions into its service either as ideological or economic apparatuses, forms the core of what may be termed "managed" capitalism, which extends from the labor process to society as a whole. Management is a technological expression of the logic of domination, a means of creating a closed universe such that contradictions, far from disappearing take the form of the appearance of "social problems" subject to manipulation of social policy. In the wake of this displacement, a virtual army of social workers, educators, and other strata of the technical intelligentsia arise as the personification of the state—as personifications of the ideology adequate to an epoch of capitalism in which, in conformity with the degradation of labor, the social world is broken up into a series of "problems." Capital successfully transforms "alienation" into a social neurosis that becomes the property of an individual who is now called "deviant" from the social norm of integration and subordination.

Since the Second World War, "overpopulation" (i.e., unemployment and underemployment) has been disguised by the internationalization of the division of labor, which between 1880 and 1920 had functioned as an effective counteracting cause to the agrarian crisis by displacing redundant labor to the United States. Now, unemployment is absorbed by the most advanced countries, a result of the ability of capitalism to subject its own contradictions to its underlying logic of technical rationality so that they appear as phenomena subject to rational calculation and solution. When Marxists assert with confi-

dence that these are not subject to such manipulations, but merely taken on a different appearance within the world system, the problem remains of the ideological form that effectively makes possible the reproduction of the system. Here the concept of ideology as a set of material practices is particularly relevant to understanding why the working classes view themselves as a function of capital. For it is capital which appears to send good things from above, to paraphrase Marx's description of the conditions for the formation of a "class."[40]

I will set aside, for the purposes of this argument, the questions of whether workers' organization constitutes the necessary condition for a revolutionary situation and whether, given this circumstance, the crisis becomes its sufficient condition. What I have attempted to show casts doubt upon the certainty *either* of the emergence of a revolutionary party within advanced capitalism, *or* of the economic crisis that may transform the workers from a function of capital of a world historical revolutionary force.

It has been remarked that *Capital*, despite its bulk and complexity, was an unfinished work and, as the very last pages of the third volume indicate, was meant to constitute a description only of the objective side of the capitalist order. The manuscript stops at the moment when Marx was preparing to derive a theory of class from the motion of capital. Presumably the theory of consciousness would have followed, or at least a more complete theory of revolution than is offered in the *Communist Manifesto*.

The problem is, however, not what Marx intended, but what his legacy is. The result of his analysis of the labor process, and of the accumulation of capital of which it is a part, has been to abolish the possibility for a theory of subjectivity. Braverman, Marglin, and others who have studied the degradation of labor following Marx's suggestions cannot find a solution for the problem of consciousness, not because they are "bad" Marxists, but because they have been faithful to the framework that he set out in his magisterial fragment. The results of degradation as Marx outlined it are not to destroy the empirical consciousness of particular groups of workers, to destroy their will to struggle against the results of the domination of capital. The problem is to locate the theoretical basis of the revolt such that its character transcends particularity without the decisive substitution of the party for the class since, as I have tried to show, the party is, as much as any institution within capital's hegemony, subject to its domination and becomes a function of it.

Lenin found the solution not so much in the theory of the party as in his law of uneven development. The counteracting cause of crisis became, for him, the space within which revolutionary politics was

possible. That is even if the subordination of labor under capital is taken as an empirical truth within a limited historical frame, the progressive freeing of labor by capital, and its ruthless pursuit of markets by penetrating colonial and semicolonial countries, constitute the "Achilles heel" of the system. From this perspective, Braverman's modest hope that his work could "supplement" the work of Paul Baran and Paul Sweezy is more than that. It is the internal argument for why the working classes in the developed capitalist societies can not be expected to attain revolutionary consciousness, and for why only the masses of those underdeveloped countries in which capital attempts to attenuate its own contradictions can provide the scene of social transformation. For the specification of degradation in the metropolitan countries of western Europe and the U.S. can be understood only within the context of uneven development, which generates opposition to the system from the unexpected sources of peasant societies or the backward sectors of advanced countries. Braverman, then, lends his updating of Marx's analysis of capital logic to the doctrine according to which the center of world revolution has shifted to the so-called Third World.

This is not the place to show the historical tendency of these revolutions to become subsumed under capital, just as labor has become subsumed within advanced countries. The point is that Marx's theory of capital accumulation leads to the conclusion that its global character makes revolution a conjunctural phenomenon. There is no counter-logic of revolutionary upheaval *within* the theory, since subjectivity itself, under the rule of capital, is afforded no autonomous space. Working-class praxis is at best disruptive of the reproduction process, which is simply restored by the rising investment in constant capital.

Of course, this dialectical relation—between (a) workers' struggle at the point of production against the formal and real subsumption of labor under capital, and (b) the tendency toward a rising organic composition of capital which, in the form of the falling rate of profit, becomes part of a "scissors" crisis of capitalism—is part of the story of the development of European neocapitalism since the end of the Second World War. In countries like France, Italy, and Great Britain, trade union struggles, combined with the political organization of the working class, have partially arrested the logic of capital (or, to be more exact, have shaped its development to a degree not anticipated by the category of subsumption). After the forward march of western European capitalism until 1955, workers' militancy successfully limited the capacity of capital to extract surplus value at the international rate, and simultaneously limited the power of capital to recoup its position by a shift to the underdeveloped world or by a new surge of

introductions of labor-saving technologies. This is not to say that technological change and the international migration of capital were not the characteristic moves of capital. The point is that mass working-class and middle-strata mobilizations at both the extra-parliamentary and parliamentary levels were major forces in restricting the success of these strategies.

The political class struggle and the cultural struggle, at the point of production and in the spheres of social consumption, do constitute "counteracting" causes to the logic of capital. This is precisely the central significance of the movements for social, cultural, and political emancipation in the 1960s, both in the United States and in several countries of western Europe. In terms of the capital-logic argument, some of the emergence of neo-socialist (new left) and workers' movements in this period is explicable by the "law" of uneven development, according to which surplus populations generated by the international subsumption of labor under capital are not yet sufficiently fragmented by the subsumption (that is, they share a mode of life in which the bonds of social and cultural solidarity have not yet been sundered).

Another possibility is contained in the so-called new working class thesis advanced by several neo-Marxist theorists, including Gorz and Mallet, in the period during which the subsumption of science was under way in France in the 1960's. The core of the theory, which has now been severely and widely criticized, even by Gorz himself, remains compelling in the context of the problem of socialist praxis: scientific and technological labor is only partially subsumed under capital. The contradiction between the demands of capital for its degradation and the cultural and ideological traditions of autonomy and social responsibility constitute a basis for an oppositional practice by these groups.

Their recognition that the ideologies of emancipation imbedded in scientific education and bourgeois culture are subverted by the technicization of all science, and by its subordination to the requirements of capital, generates political and cultural movements among some sections of the middle strata. This is not a result of some abstract oppositional moral assumptions, but rather is a result of the unevenness of relationship between the institutions of material production (in which the logic of subordination appears hegemonic) and the institutions of "social reproduction", in which capital logic is mediated by ideologies which, if not anti-capitalist in origin, become problematic from the point of view of capital's domination in its monopoly stage.

New ideologies, more consonant with the real subsumption phase

corresponding to the rise of monopoly capital, are certainly in the process of being created—but these ideologies are by no means hegemonic, even against the old bourgeois morality of the 18th century that calls forth science as a liberating force against the evils of capital accumulation (e.g., against poverty, back-breaking labor, and cultural deprivation). Many scientists and technicians in France and elsewhere joined students' and workers' revolts in the late 1960's participating in factory occupations, joining parties of the left in the 1970's and organizing ecology movements explicitly directed against the subordination of science under capital. It may even be argued that the crisis of European capital is due as much to the disaffection of sections of the middle strata, and the revolt against the logic of subsumption of labor under capital, as it is to the subordination of national European capital to international U.S.-based multi-national capital in this period.

V

The above illustrations are offered as an introduction to the conclusion that the theses adopted by Braverman and others who have applied Marx's capital-logic argument, may only be taken as *tendencies* within a broader social and historical context. On the other side are the counteracting causes, among them the law of uneven development, the profound influence of ideological and cultural questions within capitalist societies, and of course the contradictions of the internationalization of capital.

The most serious error of much of modern Marxism was to fall into a kind of historical amnesia in the 1970's and 1980's. The rise of capital-logic theory is an important addition to Marxist theory if it is understood as an abstraction of one side of concrete historical processes which cannot be subsumed under its laws. For even though there is a tendency toward the technicization of all intelligence (a phenomenon well described by Herbert Marcuse in his seminal work, *One Dimensional Man*[41]), and a powerful tendency toward the limiting of all workers' struggles within the terms dictated by the real subsumption of labor under capital, there are also counteracting tendencies.

I wish to offer several theses about what it would be necessary to amplify in order to construct a theory of the capitalist totality adequate to the requirement explicit in Marx himself that the role of human praxis is central to any possible theory of social transformation.[42]

(1) Capital logic must not be taken as an *empirical* description of the process of capitalist development. Instead, it should be regarded

as an *approximation* of one side of that process, the side suggested by the doctrine of the fetishism of commodities, in which capital *appears* to be an autonomous, internally-generating subject of history. Marx argues that the essence of capital is living labor and that the core of the labor process is the relationship of humans to nature and the social relations of production. The actualization of labor—which becomes the object of socialist revolution—is the emancipation of labor from its subsumption by capital. This objective can only be achieved by the assertion of workers' autonomy over production, freed from the domination of capital which (as Biaverman and Marglin have shown) is mediated within modern capitalism by the function of "scientific management".

(2) Since the possibility of the subsumption of labor under capital is implied by the detail laborer, whose central category is mental and manual division, a theory of social transformation must show that much of that division functions on the ideological level rather than as an empirical given, i.e. as a fact. Even the most degraded labor involves considerable mental operations. Execution is a type of conception and conception a kind of execution. The object of the assertion of an antinomy between mental and manual labor is to secure the habituation of the worker in order to reproduce herself in as degraded a form as the objectivity of degradation produces. Yet part of the everyday life of the factory or office is the constant effort of workers to create a work culture that becomes the focus of resistance against the absolute domination of capital over the labor process.[43]

This culture of resistance must be first *theorized* as one of the results of the immediate process of production in order to be investigated. It is the moment, or aspect of the labor process that represents the workers' praxis. Among its manifestations are informal rules established by workers to govern the quantity of production; the frequent acts of sabotage that reduce productivity even in highly mechanized plants; the refusal to work, manifested as absenteeism and lateness, a big issue of the 1960's and early 1970's that was temporarily "solved" by the two recessions of 1974–5 and 1978–79; the refusal of workers to tolerate the results of the chemical and electronics revolution that tend to endanger life and limb (not only the coal strike of 1978 signifies this refusal, but so do the recent struggles of occupational health and safety regulations in various important industries including oil, asbestos, textiles, and chemicals); and rank-and-file struggles against bureaucratic and corrupt union officials in the name of democracy.

This slogan of democracy both reveals and conceals the depth of discontent at the workplace: it reveals that workers do not accept simply the "insurance society" functions of the union, but which the

union to be the political representative of their *community* as well; it conceals the profound cultural base that already exists in the work-place. For if such a community in formation did not exist, how would the Sadlowski campaign be possible, or the wildcat strikes in coal, or the feminist movement among clerical workers? As Henri Lefebvre has remarked, referring to the May 1968 events in Paris, "events belie forecasts."[44] That is, the model of capitalist accumulation of the tendency toward subsumption and subordination has only limited predictive value. Time and again, confident forecasts of working-class embourgeoisement and capitalist integration have suffered in the wake of history. Unless one holds to a dialectical view of the labor process which accounts for resistance as more than spontaneity, Marxism becomes a sterile, deterministic doctrine which prefigures its own demise in the loom of historical change.

But the concept that work culture is intrinsic to the labor process, particularly to its collective character, cannot depend on scattered evidence that workers desire workplace democracy or resist degradation. The view that degraded labor is only one tendency of the specific capitalist labor process, even if it appears as the dominant historical tendency, depends on two separate arguments.

(a) The first argument consists of the dialectical theory of development, according to which the new stage of the labor process generated by the dominance of relative surplus value has contradictory aspects: on the one hand, degradation and de-skilling of labor; on the other hand, the reconstitution of the working class such that new skills are created within the general movement of degradation. That is, degradation presupposes the artisan as the standard of skilled labor because, in this form of work, mental and manual labor are united in a single craft. What the "degradation thesis" forgets, however, is that the loss of craft may not signal the end of skill. The reconstitution process entails the development of a "new" working class. The socialization of labor, its mutual dependence in the production process, makes united action easier. Putatively the formation of class consciousness is no longer a function of the struggle to maintain craft in the wake of capitalist rationalization; it now becomes the function of the collective character of labor.

The new "natural" conditions of labor are collective in so far as each worker may recognize herself as a link in the chain of production without which the process cannot be reproduced. The collective powers of labor are not just a Marxist slogan. They are manifested every day in the forms of interaction among workers that reproduce work culture (for example, in the emergence of a world of social discourse that tries to maintain its autonomy from the eyes and ears of foremen

and supervisors). As I have shown elsewhere,[45] this is manifested in work-sharing arrangements, or in saving finished pieces that are lent to others so that rates may be met by fellow workers having a hard day (because of machine breakdown, because they do not feel good, etc.).

The cooperation of workers in rolling mills and basic steel operations is by now legendary, especially in management circles. The work is performed by crews whose coordination is the essential condition of production and it is not managed by capital, except by the process of trying progressively to replace and segment labor by new processes that transfer skills to the machine. The U.S. steel industry has failed to "modernize" not only because of the stupidity and greed of the owners, although this narrow-sightedness is certainly germane to the last 20 years of steel production. Rather, steelworkers were militant in protecting the older processes, which were grounded in their solidarity. Here the erosion of older skills was *not* replaced by mere degradation in the 20th century.

As Charles Walker and Steve Packard[46] have shown in their respective studies (written more than 25 years apart) of the modern U.S. steel corporation, the degree of worker autonomy even within mechanized operations is considerable. Workers have a culture sufficiently developed to make their role in the configuration of production significant. Listen to Packard:

> One day a white crane man was assigned to a good crane that should have gone to a black. . . . Black cranemen decided to sabotage production until this bullshit was straightened out. They had mild support from most white cranemen, who also thought the foreman was wrong.

> Nothing can operate without the cranes bringing and taking steel, so blacks quietly stopped the whole mill. They kept the cranes in lowest gear and worked in super slow motion. Foremen soon began hatching out of their offices, looking around, rubbing their eyes in disbelief. It was like the whole building popped LSD or the air had turned into some kind of thick jelly: everything but the foremen moved at one-tenth of normal speed.[47]

Packard goes on to describe how "union sharpies swooped down" urging the men to "submit a grievance." He reports that after a couple of hours "the company backed down."

In Packard and Walker's descriptions of steel labor, the degree of "management" that is on the surface of the auto industry, or even a garment factory, is severely limited by the power of workers' coopera-

tion. To be sure, "men don't usually talk about this stuff," according to Packard. "Communication is carried out through undercurrents and understandings" that are part of the workers' own unspoken cultural life within the mill. Occasionally, he reports, the right to "sluff off" by working less is a subject of wash-house graffiti.

Packard notes, "there is something revolutionary about the workers' controlling the pace of work in this way." At the same time he notes the "circles of soot-black hulking shapes sitting joyless, motionless around the salamanders."[48] Steel labor cannot be glorified beyond what it is—hard, dirty labor where autonomy is sought as a subversive activity. The culture that lurks beneath the surface is generated by the reconstitution of the labor as degraded.

But the workers have learned new skills; there is a "high rate of human interaction between all members of the crew either by word of mouth or by other means."[49] This report of Charles Walker, written in 1950 about a hot rolling mill, corresponds to Packard's description of life in a Gary, Indiana mill more than 25 years later. Even though considerable technological transformation has occurred in the steel industry in this period, it has not diminished the degree to which degradation is counteracted by the workers' own relationships. "This condition may be contrasted with certain jobs on the assembly line and with other types of work where layout and mechanical conditions often preclude such interaction during the working day."[50] In three major studies of steelworkers in America spanning a 75-year period, the characteristic of a work culture remains throughout changing technical conditions.[51]

Crane operators are not de-skilled; many operations in modern steelmills require collective rather than individual skills to manipulate machinery. While some rolling processes have been automated, a longtime struggle among steelworkers dating from the Homestead strike of 1892 has prevented capital from subsuming labor entirely by mechanization. The past 20 years have witnessed two major industrywide strikes in steel and several stages of rank-and-file effort to make the United Steelworkers union responsive to the defense of a work culture that does control the pace of work under the older technologies. Unless the thesis of degradation is mediated dialectically by an understanding of work culture, it becomes a new orthodoxy, dogmatic and ideological, and prevents an understanding of how mass struggles are possible among workers.

Nor is the case of steel an exception to the general rule, of which the automobile assembly line may be considered paradigmatic. Close human interaction based on the persistence of "layout and mechanical conditions" have not succeeded in fragmenting and atomizing workers

in mining, steel fabricating, and most labor-intensive industries such as textiles and clothing. The model of the assembly line is really an ideal for subsumption, not mainly because it de-skills, but because it separates labor during the working day and restricts its ability to act collectively to control the pace of work. What I wish to argue is that de-skilling is a historically relative category. Contemporary labor has, indeed, lost most of the old craft skills, but these have been replaced by new skills: workers today are obliged to be more inventive in their resistance. They can communicate by writing as much as by speech, thanks to the requirement that most workers be literate (and this requirement is more important in industries having continuous flow technologies than in mechanical trades).

Degradation has forced many workers to take their culture underground. Of course, this maneuver makes sociological and economic investigation harder, because it is not subject to the usual quantitative methods, such as survey research, interviews, or participant observation, except in unusual cases. For this reason, the nature of social investigation becomes significantly more complex to unearth these phenomena. The observer must, as Walker and Packard did, theorize the existence of culture in order to find it.

But just as the Ancient Order of Hibernians (the Molly Maguires) lit up the coalfields in the 1870's before formal union organization was well developed, the steel and longshore experiences[52] demonstrate the existence of two types of organization at the workplace (at least in the monopoly sectors where unionism is strong). The first is the formal organization of labor by management and by unions who are integrated into existing normative relations determined by capital's logic. Here I do not mean to reduce the trade unions entirely to functions of management, but rather to point out that the social organization of labor by capital defines the limits of trade union functions on a day-to-day level. The second is the self-organization of the workers into informal work groups (a term I learned from the excellent work of Stan Weir), which, although determined by layout and mechanical conditions as outer boundaries, have their elements of autonomy. That is, there are new "natural" conditions that countervail the imposition from above of conditions of labor. These conditions may be called "interactions," both spoken and gestural, personified and anonymous, written as graffiti and whispered as conspiracy.

Most sociologists and economists cannot grasp the significance of the play element in work culture, much less the existence of the culture itself. Since bourgeois training in sociology privileges the "scientific" mode of inquiry (read here, "positivist"), qualitative investigations are trivialized as so many forms of "poetry" or journalism. But is not

the dialectic itself the "play" of oppositions, their mutual determination, rather than such rigid binaries as skill and de-skill? As workers lose many of their old skills to management, they acquire the new skills related to interaction.

(b) The second argument is the historical argument concerning the question of the uneven development of capital, both on a world scale and within the advanced capitalist countries themselves. The labor process varies within the same plant or industry as well, so that workers both acquire skills within the framework of technological change. The new skill of crane operation could be duplicated within the steel plant; workers now may bid for jobs as inspectors and other semi-clerical operations the character of which is not commensurable to the older processes, but not necessarily degraded, except by craft criteria. Older skills of heater and helpers on furnaces—while different from those performed in the iron foundries of the 1840's, or even in the Bessemer and early Open Hearth operation in the late 19th and early 20th centuries, because of the introduction of new oxygen furnaces—are not comparable to automobile assembly work or assembly of television sets (although even here, the self-images of performing "donkey-work" ought not to obscure the significant degree to which mental and manual labor is combined in many operations, or the degree to which workers try to vary the labor by sub-rosa rotation schemes).

Moreover, many workers, perhaps a majority of those in manufacturing, are in labor-intensive industries in which older skills are still a significant component of the labor process. The tendency toward degradation is somewhat attenuated by the low capital-output ratio, the nature of the market for certain commodities, and the persistence of traditions among the workers. For every instance such as printing, where the old typesetting skills have become virtually extinct, mechanical processes in garment cutting have not succeeded in reducing the skill to a mere abstraction of capital.

Similarly, while the technology exists for replacing the meticulous machinist trade with numerically controlled lathes and milling machines, in which the programmer rather than the operator controls the process, it is also important to note that numerical controls have not yet dominated the machine tool industry, nor does their introduction signal absolute degradation except in comparison to a standard suggested by the old trade. Further, the introduction of numerical controls into machine tool plants has not meant that their *use* is by any means insured. Machine tool manufacturing plants have installed numerical controls devices that remain unemployed for various reasons: many toolmakers and machinists have claimed that their effi-

ciency is debatable, and have either refused to work with them or have demonstrated their technological difficulties. The struggle over the use of numerical controls has not been won by management, and recent evidence points to a long-drawn-out fight. Similarly, recent technological changes in the steel industry are not of a qualitative nature; that is, many of them do not represent revolutionary new methods of production. Instead, many "improvements" are investments of mere replacement of worn out equipment.

In sum, what lies behind much of the thesis of degradation is an anterior standard of craft, combined with a tendency toward overgeneralization that prevents investigators from making a concrete, historical study of the differences among industries, of the definition of skills and of the mediation of culture.

(3) Braverman's model of all capitalist production is the assembly line, exemplified by the ideology of Taylorism. But there is a substantial difference between the model of the reduction of work to a detail of capital accumulation, and its actual unfolding. Concrete investigations of types of work in advanced, medium, and low technology industries would reveal that the work process is far more complex than the Taylorists would have liked.

Braverman, of course, understood the difference between the logic of degradation and its empirical reality. We must avoid the danger of taking the critique of Taylorism too literally. In the first place, the pace and direction of technological innovation is uneven for the economy as a whole, as well as for particular sectors. While upgrading is not the tendency of this innovation, its boundaries are determined by the struggle at the point of production as well as in the public sphere. For example, it took a compliant trade union to enable the steel industry to "modernize" its production, after 25 years of technological backwardness facilitated by the privileged position of U.S. capital in the world market. Even though the Steelworkers union has agreed to a six-year contract without a strike, it is by no means inevitable that numerical controls will be widely introduced, that older plants will be shut down without resistance, and that strike activity will not disrupt production.

In this case, the logic of degradation is undeniable from the point of view of capital. But unless Marxists make *no a priori* theoretical assumptions about the results of the struggle, a concrete understanding of the situation is impossible. To be more general: any theoretical model must be mediated by the *real* relations of class struggle. In the final analysis, human praxis is not determined by its preconditions; only the boundaries of possibility are given in advance. But no situation points in a single direction: workers have choices, even within

the framework of degraded labor, relative fragmentation, and the iron grip of bureaucratic unionism. These choices constitute the possibility for genuine contradictions, within the system, that may transcend it.

(4) The moment of praxis is relatively autonomous. That is, a theory of determination is only part of the "algebra of revolution." It is not a question of what workers or degraded members of the middle strata think, but of what they do. Could capital logic have predicted that Paris technicians and broadcasters would have seized communications media in behalf of the revolt during May–June 1968? Could the LIP strike against the shutdown of a watch factory have been predicted, or that workers would have resumed watch production on their own, rather than setting up a picket line as in bourgeois unionist practice? Of course, each of these circumstances may be considered "exceptional" because they have specific features, such as a large body of relatively skilled workers in each setting. Or American coal miners struggles in the recent past could be explained as an exception, since they still have a living historical culture. Or Italian Fiat workers' struggles since the mid-1960's, or the Clyde shipyard workers' seizure of their workplace. What these events of the past decade show is that a Marxism shorn of a theory of culture, of everyday life, becomes a recipe rather than a living theory.

(5) The final point concerns the theory of ideology, to which I have already referred. Althusser's theory of ideology constitutes a valuable addition to the concept of ideology as the perception of the form of appearance of social relations. His notion of ideology as a set of material practices through which people live their experience of capitalist social relations enables us to understand the concept of mediation as a material force and to remove it from its ideal form. Mediations are inscribed in institutions which are the scenes of the social reproduction of capital, that is, in the ways in which labor is reproduced in the family, school, religion, and bourgeois trade unions. These are not just groups to which persons adhere in the same way that they wear clothes or own a television set. What we mean by experience is materialized within these institutions, and they are contradictory in their internal relations just as the point of production is formed out of the contradiction between labor and capital. These institutions are determined only in the last instance by the conditions of capitalist domination, but function relatively autonomously within the social process.

The class struggle, then, is conducted at the ideological level, as well as at the point of production (even within the realm of theory as a practice and not merely as a "battle of ideas"). Since the process by which domination is legitimated and internalized depends upon the

degree to which institutional life, or what I will call everyday life, is experienced as rational, to that degree labor can be subsumed under capital. Thus, the point of production is only one side of the social totality, even if it is a central aspect of it. The displacement of the contradictions of the accumulation process to the sphere of social consumption—by which I mean the totality of relations inscribed ideologically within institutions but also experienced as language, interaction, and artistic culture—constitutes both an integrating and oppositional feature of contemporary capitalism.

The descriptions by Baran and Sweezy, as well as Braverman in his chapter "The Universal Marketplace,"[53] reveal and pitfalls of capital-logic analysis because these phenomena are not grasped dialectically, but are understood as mere functions of capital, subject to the same laws of subsumption. An alternative understanding would entail an examination of the cultural contradictions of capitalism in order to locate the crisis features of the system which are not typically mani-fested as a problem of accumulation. Marxists have been mystified by the forms of appearance insofar as they have reduced all capitalist contradictions to their economic dimension.

Another feature of ideology is Gramsci's concept of bourgcois he-gemony, which is defined as the process by which capital secures the "spontaneous consent" of the masses to its "general direction of social life."[54] Gramsci argues that this consent must be won through the mediation of intellectuals who struggle for moral and intellectual leadership of society. Their self-understanding, of course, is far from that of conscious agents of the bourgeoisie. Rather, capital wins their consent by persuading them that intellectual life is free of the rule of society, much less capital. An example of this form of appearance of autonomy is the slogan "art for art's sake," or the notion of "pure science" that has no apparent functional relation with production.

Gramsci theorizes the possibility that bourgeois hegemony may fail, because consent of either the intellectuals or the masses cannot be won under certain circumstances. Capital tries to confine intellectual functions to "the social necessities of production"[55] but the character of bourgeois democratic society expands intellectual functions beyond this sphere. The sphere of social consumption, the production of ideol-ogies, the unemployment of intellectuals, all subvert capital logic, which functions at best as a broad framework for cultural and intellec-tual discourse. Within this framework, oppositional ideologies con-tend for hegemony against the dominant ideology. For example, within the bourgeois university, Marxism may be said to be opposi-tional within the framework of bourgeois hegemony, so long as its theories and research is confined to the work of intellectuals. When

the working class and middle strata call into existence their own intellectuals, or, to use Gramsci's terms, when they establish their hegemony over a group of intellectuals, Marxism and other revolutionary doctrines become "counter-hegemonic" in character. That is, as Marx remarked, theory becomes a material force "when it has gripped the masses." Gramsci's clarification is important here because of this reversal of the meaning of the process: theory becomes a revolutionary force when the masses have gripped the theoreticians against bourgeois hegemony. The signal contribution of Gramsci was to remind us that the level of struggle for "moral and intellectual" leadership is a sphere of class struggle, wherein this struggle, if conducted with determination, reduces the chance of the "spontaneous consent" capital seeks for its domination over labor.

Notes

1. For an interesting convergence on the question of the autonomy of the forces of production compare Karl Kautsky *Class Struggle* especially part IV (New York, 1971) with Joseph Stalin *Dialectical and Historical Materialism* first published as a section of his History of the CPSU (B) and subsequently reprinted in pamphlet form. In both treatments of the theory of social revolution, the concept of the irreconcilability of the forces of production and the capitalist relations of production is seen as the driving force for socialist transformation. However, the forces of production are viewed by both as subversive to capitalist relations because they have been socialized and represent the accumulation of human labor including its form as knowledge. In this perspective, capitalism fetters the productive forces which seek room to develop under a system of socialized property (Stalin referred to this process as the cunning of history, an adaptation of Hegel's concept of the cunning of reason that, however repressed, becomes the unifying force of historical development).

2. See V.I. Lenin *Imperialism: the highest state of capitalism.*

3. Jurgen Habermas, *Knowledge and Human Interests* (Boston: Beacon Press, 1971); Alvin Gouldner, *Dialectic of Technology and Ideology* (New York: Seabury Press, 1976); Marshall Sahlins, *Culture and Practical Reason* (Chicago: University of Chicago Press, 1976); Pierre Bourdieu, *Outline of a Theory of Practice* (Cambridge: Cambridge University Press, 1977); Jean Baudrillard, *Mirror of Production* (St. Louis: Telos Press, 1975).

4. It should be pointed out that Marx himself was not a subsumption theorist. Rather he regarded subsumption as a moment in the social process. To those who may object that the evidence for this thesis which has been called "capital-logic" by some European Marxist writers remains fragmentary, I would retort that all of Marx's writings after 1850 have a fragmentary character since his magnum opus *Capital* was never finished during his lifetime. Further, the theory of relative surplus value to which I will refer below contains the seed of the subsumption thesis in so far as the formula entails the assertion that enlarging the volume of surplus value becomes a function of reducing the laborer in comparison to the value of the commodity. In the period of machine production and especially the so-called third industrial revolution of recent times, the domination of capital is

immeasurably enlarged by virtue of its capacity to subsume all the factors of production.

5. See Max Horkheimer and Theodore Adorno, *Dialectic of the Enlightenment* (New York: Seabury Press, 1972); and Herbert Marcuse, *One Dimensional Man* (Boston: Beacon Press, 1964); Hans Magnus Enzensberger, *The Consciousness Industry* (New York: Seabury Press, 1974), Chap. 1; Henri Lefebvre, *Everyday Life in the Modern World* (New York: Harper and Row, 1971).

6. Among the most recent work in this area see especially Nicos Poulantzas, *Political Power and Social Classes* (London: New Left Books, 1974); and Ralph Miliband *State in Capitalist Society* (New York: Pantheon Books). The Miliband-Poulantzas debate on certain points of the theory of the state does not obviate their essential agreement on its integrative functions. Following Louis Althusser, Poulantzas expands the concept of the state to include the family and trade unions. These "ideological apparatuses" of the state function to preserve the rule of capital by penetrating the spheres of working class activity that were once autonomous. We cannot explore the theoretical underpinnings of this view here, but it suffices to point out that the Althusserians advance a mechanism of subsumption which is at once novel and depressing when they insist that ideology is a material practice. Since bourgeois ideas are hegemonic in capitalist society, their materialization within the public and private spheres of working class life extends the rule of capital beyond the workplace or the institutions of repression such as the police and courts. Miliband adopts the thesis of capitalist integration exemplified in the ability of the modern state to accommodate working-class demands for reform, even at the structural level, including the possibility that labor and socialist parties may manage the capitalist state.

7. Harry Braverman, *Labor and Monopoly Capital*, (New York, Monthly Review Press, 1974); Steve Marglin, "What do Bosses Do?" in Andre Gorz, editor, *The Division of Labor*, (London: Harvester Press, 1976); Kathy Stone, "Origin of Job Structures in the Steel Industry" in RRPE, Summer, 1974; and Andre Gorz, "Technology, Technicians and the Class Struggle" in Gorz, ed., *op. cit.*

8. Antonio Gramsci's "Americanism and Fordism" in *Selections from Prison Notebooks*, edited by Quintin Hoare and Geoffrey Nowell Smith, (New York: International Publishers, 1971).

9. Karl Marx, *Contribution to the Critique of Political Economy*, translated by N. Stone, (Chicago: Charles Kerr Co., 1904).

10. All references are from the Penguin edition of *Capital*, (London: 1976).

11. See Frederick Fleron, editor, *Technology and Communist Culture*, (New York: Praeger, 1977); particularly Andrew Feenberg's "Transition or Convergence: Communism and the Paradox of Development" where he argues that technology transfer does not automatically imply the convergence of capitalism and socialism because socialism has its cultural autonomy that mediates the ideological impact of technology.

12. In Karl Marx, *Capital*, included as an appendix to the 1976 Penguin edition.

13. The basis of Marx's hostility to the political programs of anarchism and of the utopian socialists of his day, which in the Soviet produced Foreign Languages Publishing House edition of *Selected Correspondence*, are termed "petty bourgeois," was his scorn for their belief in the concept of self-directed workers' cooperatives or councils within the framework of the industrial stage of capitalist production. In the 1840's Marx was particularly concerned to reduce the influence of Pierre

Joseph Proudhon because he held that the demand to restore the artisanal mode of production when elements of producer control still existed was nothing but the pipe dream of a stratum of society that could only look backward rather than discover how socialism could arise from the conditions of capitalist development. The popularity of ideas of producer control over production, of cooperatives, and of anti-industrialism within the socialist movement was to plague Marx and Engles throughout their activity in the First International and after its demise in 1864. The problem was that Marx's critique of capitalism was grounded in the British case, which for most of the 19th century was an exception to the general pattern of economic and social development. The fundamental strength of Proudhonism was in the Mediterranean countries and Latin America, where artisanship was very much alive and the predatory impact of imperialism that was destroying this mode of production was among the best recruiting grounds for revolutionary socialism, if not its Marxian variety. Of course, Marx did not oppose self-management as a socialist goal, but he believed that the struggle against capital had to be based upon the "mass" worker, i.e., on that growing portion of the working class for whom the artisanal mode was not even a living memory.

14. Marx, *op. cit.*

15. *Ibid.*, p. 986.

16. *Ibid.*, pp. 1029–1030.

17. *Ibid.*, p. 1065.

18. *Ibid.*

19. Karl Marx, *Grundrisse*, (London: Penguin Books, 1973).

20. Marx, *Capital*, Volume I, Section 4, and also "Results of the Immediate Process of Production," pp. 1005–1006.

21. Braverman, *op. cit.*, Chapters 6 and 13.

22. *Ibid.*, Chapter 4. But in his section on science and technology "as such" this insight is partially nullified by his failure to come to grips with science and technology as ideology. See Chapters 7 and 8 especially for this point.

23. Unfortunately most Marxists read about Proudhon through Marx, especially his *Poverty of Philosophy*, a merciless attack against Proudhon's *Philosophy of Poverty* in which the concept of property as theft is enunciated. In fact, although Marx and Engels regarded some of Proudhon's doctrines as wrong-headed and even dangerous to the socialist movement, they adapted many of his ideas to their own, particularly the idea that communism was the free association of producers and that worker's self-management of production was a necessary condition of human emancipation. See the Writings of Pierre Joseph Proudhon.

24. E.J. Dijksterhuis, *The Mechanization of the World Picture*, (New York: Oxford University Press, 1961).

25. Louis Althusser, *For Marx*, translated by Ben Brewster, (New York: Vintage Books, 1970).

26. Dijksterhuis, *op. cit.*, p. 3.

27. Georg Simmel, *Philosophie Des Geides* (Leipsig: 1900); Franz Borkenau, *Studies in the History of the Period of Manufacture* (in German), (Paris: 1934). Simmel's book, which has never been translated into English except fragments in several anthologies of his writings, must be rated as among the masterpieces of the theory of reification which has influenced Lukacs' *History and Class Consciousness*, and

was itself an important addition to the critique of bourgeois culture, albeit from a non-Marxist neo-Kantian perspective. I have not read Borkenau's book.

28. Marx, *Capital*, Volume I, Chapter 1, especially section 4, "The Fetishism of Commodities." Also Georg Lukacs' *History and Class Consciousness*, (Boston: MIT Press, 1971); "Reification and the Consciousness of the Proletariat." The theory of appearances extends to the idea that science and technology may be forms of thought that enjoy a relation with nature unmediated by ideological forms is a result of the rise of the scientific world view during the renaissance according to which empirical verification of propositions about the world can be derived from experiment and the evidence of the senses, in the last instance. The power of Marx and Lukacs is their insistence on a historical framework for all knowledge which, under the capitalist mode of production takes the form of ideological production as a mediation of and concomitant of science for reasons explained below.

29. Braverman, *op. cit.*, p. 159. My objection to this formulation is that it tries to establish a causal relation between these advances and the new epoch of industry without comprehending not only the social conditions within which the advances were made, but also the ideological struggles that helped form scientific thought. However, Braverman understands the relation of scientific development to the development of technique following the work of David Landes in the *Unbound Prometheus* and thus breaks with the conventional view of the determination of social relations by the "forces of production", which in the Marxism of Kautsky, Piekhanov, and Stalin are the driving forces of history.

30. Marx, *Grundrisse*, p. 693.

31. Marx, *Capital*, pp. 1066–1071 (The Sale of Labour Power and Trade Unions).

32. Marx, *Grundrisse*, p. 693.

33. *Ibid.*

34. Braverman, *op. cit.*, pp. 26–27.

35. Gorz, *op. cit.*

36. *Ibid.*, pp. 162–163.

37. Marx, *Capital*, Volume III, Chapter 14.

38. *Ibid.*, p. 277.

39. V.I. Lenin, *Imperialism: The Highest Stage of Capitalism*, in Selected Works, Volume 5. Also in the same volume a more explicit application of the theory to the concept of the right of Nations to Self-Determination which is included in part 4 as a series of theses called "The Socialist Revolution and the Right of Nations to Self-Determination." The content of the strategic argument between Lenin and the Bolsheviks and the German social democrats whose chief spokesperson on this question was Rosa Luxemburg is too well known to be repeated here. Suffice it to say that for Lenin, the results of the export of capital, i.e., foreign trade in capital as well as commodities, were both to temporarily resolve the tendency within the advanced capitalist countries towards crisis and to provoke a political, economic and cultural crisis within the colonial and semi-colonial countries owing to the constraints of capitalist domination on the native bourgeoisie and the brutal exploitation of wage labor within extractive industries of these countries.

40. Karl Marx, *The Eighteenth Brumaire of Louis Bonaparte*, in Karl Marx, *Surveys From Exile*, Political Writings, Volume II, edited by David Fernbach, (New York: Vintage Books, 1974). See especially part 7, p. 239, where Marx offers the only 'definition' of class under capitalism in his work.

41. Herbert Marcuse, *One Dimensional Man,* (Boston: Beacon Press, 1964). While Marcuse seems often too impressed by the degree to which technology has become a social force *sui generis,* his descriptions of the transformation of critical reason into instrumental technical thought in which among other things language as discourse is pressed into the service of domination, is an important concretization of the thesis of real subsumption.

42. For the Marx of *Economic and Philosophical Manuscripts* and *German Ideology,* praxis is the self-conscious political and social activity of humans directed towards purposive goals. Here determination by past praxis became the "conditions" of this activity in the present. But just as living labor cannot be entirely determined by its past, congealed form, so the social conditions in which classes in society confront their own future cannot circumscribe either the content or the form in which emancipatory practice occurs. There is a moment of indeterminancy in the collective action, that is, the transformation of what Sartre calls "seriality" into fusion, the process by which people take control of their own activity calls into existence new forms of social life, i.e., self-management.

43. For the most comprehensive treatment of the question of work culture, I have consulted the unpublished manuscript of Stan Weir on the work culture of Longshore industry of the U.S. west coast. Scheduled for publication by Free Press.

44. Henri Lefebvre, *The Explosion,* (New York: Monthly Review Press, 1969), p. 7.

45. See Stanley Aronowitz, *False Promises,* (New York: McGraw Hill, 1973), Chapter 1.

46. Charles Walker, *Steeltown,* (New Haven: Yale University Press, 1950); Steve Packard, *Steelmill Blues,* (San Pedro: Singlejack Books, 1978).

47. Packard, *op. cit.,* pp. 12–13.

48. *Ibid.,* pp. 14–16.

49. Walker, *op. cit.,* pp. 81–82.

50. *Ibid.,* p. 83. Yet, the auto industry has produced more militancy in the past 45 years than any other manufacturing sector. Even the "layout and mechanical conditions" of "pure" execution has not prevented the collective laborer from struggling against speedup. Not that the pace of the auto assembly line remains about where it was in 1955 except in Lordstown and a few other small-car plants.

51. They are David Brody, *Steelworkers in America,* (Cambridge: Harvard University Press, 1960); John Fitch, *Steelworkers,* (Reprinted, New York: Arno Press, 1969); and William T. Hogan, *Economic History of the Iron and Steel Industry in the United States* (Five volumes), (Lexington: D.D. Heath Co.. 1971).

52. Weir, *op. cit.*

53. Braverman, *op. cit.,* Chapter 14. This is perhaps the weakest chapter of his book because of its failure to probe the specificity of cultural questions and its methodological functionalism.

54. Gramsci, *op. cit.,* pp. 12–13.

55. *Ibid.*

3

On Intellectuals

Introduction

Since the 1970s, a new debate has emerged concerning the social and political significance of intellectuals. For the most part, the discussion has centered around questions raised at various times since the turn of the 20th century concerning the emergence of intellectuals as historical agents in both "advanced" and developing societies.[1] The context for the revival of interest in the economic and political positions of intellectuals is rooted, in part, in the apparently definitive passing of the era of proletarian ascendancy, even of its relatively staid social-democratic variety. More profoundly, we may no longer speak of the present epoch in terms of "late" capitalism, for the optimism that attended this amendment can no longer be comfortably sustained at a time when state socialism scrambles toward "market" economy and other features of *echt* modernity, which often resemble key elements of capitalist democracies. While world capitalism continues to wallow in one of the longer global economic crises of its 400 year history, it has never been ideologically more powerful or, to put it more precisely, its key tenets—market, entrepreneurship, private ownership and control of the means of production, and possessive individualism (which is no longer merely an Anglo-American belief)—have gripped a significant portion of the "masses" in the East as well as the West. The emergence of these ideas conjoins with the increasingly powerful argument that freedom presupposes a relatively free market, especially for consumer goods.

The debate about intellectuals cannot be separated from these contexts. Its contemporary history is clearly intertwined with the void produced by the diminishing political strength of a working class that grew under largely surpassed historical conditions, except in countries of the semi-periphery, such as Brazil, Poland, and South

Africa, where working-class struggles in a new form appear as democratic as well as class movements.[2] And, the compromises by third world revolutions with capitalist economic hegemonies have produced not only second thoughts among Marxists and other socialists, but have also spawned a certain anti-third worldism among liberal proponents of modernity which is, on the one hand a healthy counterpoint to the almost slavish subordination of one part of the left to this doctrine and the movements it "represents," and, on the other is a symptom of the reborn conservative revival in our midst.

The central terms of the new debate are those of *agency:* more specifically, the debate is motored by the question, are intellectuals under capitalism becoming a new class—the central contention of Barbara and John Ehrenreich and Alvin Gouldner—among others?[3] Or, as Konrad and Szelenyi argue, is this class emergence confined to state socialist societies in which the private ownership of the decisive means of production has been abolished?[4] Second, what are the elements of class formation under transformed conditions, namely, the emergence of knowledge as the crucial productive force in nearly all societies? The core question is whether the undeveloped Marxist theory of class, in which relations of ownership and control is the defining category or, whether, owing to the new conditions of production and reproduction, new relations constitute the sufficient basis of class formation.

I want to sketch the assumptions of class in Marxist theory, and review the state of the theory of intellectuals prior to the publication of what has become the seminar work of the new debate, Alvin Gouldner's *The Future of Intellectuals and the Rise of the New Class.* Then, I will summarize and critique Gouldner's approach and take up some recent developments in the Soviet Union, Western and Southern Europe, and the United States that bear on the questions.

I.

Needless to say, the burning question since Marx bearing on class theory is not, as is often assumed, the spatial relation of social categories to the mode of production of material existence. The economic identification of social classes—whether they own, control, or are the objects of the production and reproduction of material existence, whether they occupy an intermediate position between the owners and the propertyless—are interesting sociological questions but do not exhaust the politico-historico dimension of class issues. While the elegant simplicity of the *Communist Manifesto* infers historical agency from such structural considerations, elsewhere Marx and Engels are

equally clear that actual historical situations warrant no direct rela-
tion between structure and agency. Indeed, as Marx's pamphlet *The
18th Brumaire of Louis Bonaparte* argues with respect to the question
of whether French peasants form a class, their common relation to
the ownership of means of production is necessary but not sufficient
for class formation. Marx argues that their dispersal into small hold-
ings militates against forming a community, a common culture, and,
therefore, self-representation at the political level. "They must be
represented by others"[5] says Marx. In these passages two further quali-
fications beyond economic identification emerge: what we might call
a discursive community and political self-organization are the suffi-
cient elements of class formation. In this mode, classes are the out-
come of a social process the congealing of which is indeterminate
from the structural perspective. In the same pamphlet, Marx argues
that historical context is the boundary condition of agency: "Men
make their own history but not as they please." They are constrained
by circumstances, which, having been produced by the interaction of
prior structures and agents, present themselves in a naturalized form
to actors and appear to resist change. We might add that, at any
moment, the outcome of acts, speech or otherwise, is undetermined
from the perspective of either structure or agency by results from the
specificities of the interaction between them.

Note here that rereading this famous passage of Marx—by slightly
altering the language—also alters the significance of his formulations
concerning class. Classes come into being when groups of people (a)
occupy a common structural space within the mode of production,
(b) have a common discursive (cultural) position in the specific social
formation in question which, however, is not presupposed by struc-
tural unity, and (c) are, therefore, capable of forming political organi-
zations exemplified by parties, trade unions, and other class-based
associations which also function discursively. This last condition need
not imply a correspondence between the representatives and constit-
uents on every point, but it does infer the democratic model of partici-
pation, that is, that the party be *of* as well as *for* the agents. Here we
can see the development of the problem of divergence since the turn of
the century, especially between the party leadership and the working
class.

Since Robert Michels made us aware that socialist bureaus, by
controlling the apparatus of social action, especially communications,
may evolve into elites in a conventional way, political studies of
socialist and workers' parties have identified a plurality of organiza-
tional models.[6] These studies have, correctly, thrown into question the
theory of representation according to which socialist parties reflect,

in broad outlines, working-class interests and elections provide the corrective to the entrenchment of an unresponsive elite. One counter-actual example is the British Labor Party, within which the Trades Unions have enjoyed a dominant position, especially at the discursive level, since its founding. Notwithstanding this dominance, the party is actually a coalition of different social categories with intellectuals and professionals playing important and sometimes divergent roles both in the apparatus and, historically at least, in the constituencies both from the unions and the middle class constituents. The French Socialists did not enjoy substantial support among union members until the late 1970's when the Communist ideological and political hegemony began to rapidly erode, after which working-class votes went socialist without an appreciable growth of working-class influence over party policy. This pattern of a Socialist party which is chiefly a national rather than a class party holds for all Southern European countries, even Italy where the socialists were, until recently, linked to working-class movements. Yet, in the past decade, under the leadership of Bennito Craxi, the PSI has fashioned itself in the mold of the French and, especially the Spanish Socialists. In the North, especially Sweden and Germany, the relation of party to the working masses remains close and has only been loosened in the eighties.

I invoke these differences in the composition and orientation of Social Democratic parties in order to illustrate heterogeneity in the configuration of representation, as well as the relative autonomy of politics from its structural determinants. I want to argue that each level of articulation is underdetermined by the others. This poses the problem of adopting a general rule with a wide application. Although theory must articulate the categories of analysis prior to a concrete historically specific investigation, the relations among these categories are not, *a priori*, determined. In this discussion of intellectuals we are obliged to observe the same rule: whether intellectuals form a class or a social category is always an empirical question once the elements of class formation are stated. As we review the more influential works on intellectuals in the neo-Marxist literature, we will discover changing emphases in different historical periods.

Recent "post-Marxist" literature addressing agency has tried to shift the scene of analysis from the class/power problematic to one of knowledge/power. Agents are constituted discursively, or in the language of Foucault, Laclau, and Mouffe, the discursive position situates agents. Here we can see that the social is reformulated in the categories of discourse: power is ineluctably linked to knowledge rather

than to capital which, in turn, becomes simply another (albeit more privileged) discursive position. So, it is no longer a question of deciding whether intellectuals are a class under the new historically determined circumstances of the "information" society, the emergence of knowledge as a productive force and so on.[7] The question is whether the discursive position of intellectuals articulates power in a different and more potent way.

According to Foucault, the knowledge/power system is transhistorical and becomes a way to realign history as well as politics. That is, he reads this system back into history rather than imputing its emergence to changed productive forces or, indeed, any possible series of circumstances. In this mode of reading the past we may specify changed circumstances, but the productive relations have never defined power relations. Accordingly, the forms of discourse have always been interchangeable with power and have determined the fate of human groups. There are, of course, different discursive formations, of which intellectuals as the category engaged in the production and dissemination of ideas are crucial for not only the political but the moral economy of a given "society."

Foucault's reformulation of the power system can be taken in at least two ways: as a displacement of class as the master discourse of history; or as a necessary supplement to class/power theory, which has typically failed to understand the materiality of language and knowledge. In this essay, I treat the knowledge/power system as a partial displacement of class/power relation without, however, abolishing this latter dimension. However, the new work on discourse and agency emanating from Foucault's arguments about knowledge provides a necessary framework for understanding the current conjuncture and is clearly superior to older versions of "class" analysis in which discourse is identified with ideology and, thereby, located in the superstructure of society. The central innovation is to refuse the proposition according to which knowledge is dependent upon the character of economic class relations. Or, in what is nothing more than mirror image of this assertion, science holds a privileged place outside the class structure, in which case it is "mobilized" by capital to enter the sphere of production as an instrument. When Marx argues, in the *Grundrisse* that (scientific and technological) knowledge has become itself a "productive force," one can already see the tendential collapse of the base-superstructure model.[8]

II.

In 1968, students and other intellectuals presented themselves as new agents—not only in Paris, Berlin, and other Western capitals, but

also in Mexico City, Buenos Aires, and Prague. In the struggle to comprehend the nature of their emergence Antonio Gramsci, until the sixties a shadowy figure outside his own country, Italy, quickly surfaced as a crucial guide. His *Selections from the Prison Notebooks*, published in English translation in 1971, provided an argument, if not an elaborated theory, that placed intellectuals at the cusp of social transformation in societies where rule by consent replaces rule by force as the primary mode. By the late 20th century this describes almost all countries, even those burdened by military and other types of authoritarian rule. For in a historical epoch when democratic ideology, at least as negative freedom (defined here as the absence of rigid constraints on speech, assembly by individuals and groups, and so on), is crucially linked to what used to be called rising economic expectations by the widest strata of all societies, coercion alone can only be expected to insure social order for brief periods, after which democratic awakening, or at least rule by ideological means, appears virtually assured. This formula is based not upon an abstract conception of modernity but on the palpable internationalization of culture, particularly consumer society, since the end of the War. The export of Western culture to formerly inchoate areas is linked with the imperative of market expansion beyond the usual colonial search for raw materials and strategic bases with which to defend capital investments.

Now the third world has become a consumer market in proportion as its role as a provider of oil, metals, and food is supplemented by industrial production, itself the outcome of international competition and working-class strength in the developed countries. Under these conditions, a new, urban working class comes into being and, within a relatively short period of time, begins to form not only a new object for mass consumption but also trade unions and political parties which, taken together, constitute new class discourses to which the ruling order must respond. We can see this process at work in the emergence of a qualitatively different type of opposition in what has been described as countries of the "semi"-periphery, such as Brazil, Korea, and among black workers in South Africa. Where once the opposition was constituted, in the main, by intellectuals, peasant movements, and a fraction of the native salaried, bureaucratic middle class now an industrial working class, armed with a democratic as well as socialist program, shares power with elements of the older opposition when it has not yet dominated it.

Consequently, argues Gramsci, classes wishing to overturn the dominant form of rule are obliged to contend for "intellectual and moral leadership" of society, and wage wars of position long before a "war

of maneuver" or insurrection can be successfully staged.[9] This struggle for hegemony entails, among other things, imposing a new common sense to replace the one which prevails. In effect, intellectuals acting in behalf of a rising class become, in Gramsci's argument, a central object as well as a subject of political and cultural discourse: "The central point of the question remains the distinction between intellectuals as an organic category of every fundamental social group and intellectuals as a traditional category." According to Gramsci, "The political party for some social groups is nothing other than their specific way of elaborating their own category of organic intellectuals directly in the political and philosophical field and not just in the field of productive technique."[10]

Among the tools of displacement in advanced industrial societies none stands higher than the use of the categories of ideology-critique and the identification of the new common sense with science. Science is a term we affix to ideology that wishes to become hegemonic; in turn "ideology" is the name given to the discourse of the putatively vanquished. My reading, freely borrowed from Louis Althusser's Gramscian ruminations, emphasizes the intimate link of knowledge and power. It suggests a political theory of intellectuals by showing that science, far from its claim to social neutrality, becomes a master discourse and confers legitimate power upon its agents, and others who subscribe to science as the embodiment of what we mean by truth. Further, in these societies in which the scientific worldview is the measure of all knowledge claims it becomes the new common sense. In democratic countries hegemonic ideas do not thereby ban others; those ideas which cannot pass muster as scientific are merely consigned to the margins of public discussion. They may be valued in other terms (as poetry, myth, or opinion) but they are not taken seriously as knowledge which contributes to the collective goal of progress or to state policy. Therefore, it is virtually incumbent upon the intellectuals who have identified themselves either with the prevailing power or with its opposition to claim the mantle of science for their ideas and to condemn competing conceptions as "ideology."

In Gramsci's own conception there is no question of intellectuals becoming, themselves, historical agents; their social weight consists in their ability to link themselves with "real" agents, namely those classes which for Gramsci and all Marxists until recently which constitute the only forces capable of making history in their own name. This is precisely the contention I want to explore in what follows. There are two questions here: first, can intellectuals as a social category act on their own (in Gramsci's words "are intellectuals an autonomous and independent social group,"[11] that is, do they constitute distinct

discursive and political communities which generate unique subject-positions (not so much by virtue of their critical mass or their growing significance to the social order—as by their capacity for autonomous organization—these points are fairly well established by now)? In terms of "class" formation the issue is whether they can represent themselves politically and sustain the claim, thereby, to represent, by the elaboration of a philosophical worldview, all of humanity in a similar manner to the great social classes of the bourgeois epoch. Or, are they destined merely to affiliate with classes arising from new production relations already in existence (in which case their role is as Gramsci specified: to articulate the worldviews of hegemonic or counterhegemonic classes)? This formulation brackets the issues of intellectuals as a "class" for reasons which will become evident below. Of course, the presupposition of this question is the Marxist conception according to which only classes occupy the historical stage while social movements and social categories may influence, even decisively, the actions of classes but may not be truly *historical* actors.

The second question concerns the precise circumstances under which intellectuals perform specifically political functions. For, however important their work is for various state institutions prior to the contemporary epoch, intellectuals begin to occupy a unique political position when the question of the "masses" enters political discourse. On the whole, the masses appear in the context of the bourgeois revolutions as a necessary but not central participant and are first articulated in the form of the "social" question, at the moment they acquire their own voice whose first expression coincides with the proclamation of universal rights by their new patrons—the bourgeoisie.

The transformation of the crowd into a genuine working class that possesses the capacity for self-representation only occurs under determinate historical conditions, that is, cannot be derived from structural considerations. While the development of industrial capitalism is certainly the necessary presupposition of this process, it has proven to be insufficient. As the cases of France, Germany, and Great Britain demonstrate (as opposed to the United States), class formation in the cultural and political sense—as well as in the sense of economic identification—entails, among other things, the determined struggle of nascent working-class fractions for sufferage. In turn, this struggle is made necessary by the remnants of feudal social relations in which property requirements are solidly supported by an ascendant bourgeoisie (which in Britain and the United States became oligarchic as early as the 18th century), as well as by the still powerful European aristocracy which forged an alliance with a leading fraction of capital.

Of course, the struggle for universal "manhood" suffrage is only one of the elements in a conjuncture. More to the point, as recent historical research amply demonstrates, the crowd is not merely an undifferentiated mass, but has a political identity within the emerging bourgeois order whose demands coincide, but are by no means identical, with those of the artisans and property-owners.[12] At first, the propertyless are buried in the "third" estate; they are the foot-soldiers of the American and French Revolutions, derisively labeled as a "mob" by even the more democratic popular tribunes of both revolutions.

It is abundantly clear that in the late 18th century most intellectuals are organically tied to the "better sorts" of the pre- and post-revolutionary society. However, it may be argued that they take power and become identical with what is called the "state" in the middle and late stages of the French Revolution. In the case of the American Revolution, the middling strata and the upper crust were deeply divided between those merchants loyal to the Crown and those for whom independence was an urgent demand. They were united, however, when the "crowd" of artisans and laborers intervened to seek redress of specific grievances against the privileges of property within both the colonial and postcolonial administrations. One of these privileges, ineluctably, was the invocation, inherited from the English political system, of property qualifications for voting. In contrast to the mythology of the "democratic" New England town meetings of the revolutionary period, Dirk Hoerder conclusively demonstrates that questions concerning participation in decisions ranging from town policy to relations with the Massachusetts colonial administration and state government were hotly contested along class lines.[13] Those who were to become some of the leading Whig intellectuals of the Revolution—the writers, politicians, speakers, and military leaders—were united with Tories on the need to restrict the franchise to those possessing minimum property qualifications. (Of course, differences arose with the Whig camp regarding the amount of property in terms of currency value.) Before the Revolution, where the social and political weight of the crowd was too powerful to permit its exclusion from both high office and voting, the emerging oligarchy's organic intellectuals wrote and spoke to it in order to win its support; collected proxies on specific issues; and otherwise tried to coopt the crowd's potential power. Delegates and representatives to late colonial legislatures, as well as to the committees of correspondence during the Revolution and the Continental Congress, rarely included individuals recruited from the lower rungs. In effect, the public sphere of political discourse was marked as much by its exclusions as by its inclusions. Most laborers were excluded from the right to vote at New

England town meetings, and many farmers and artisans who qualified were either ignored or their votes solicited by politicians linked to merchants and large landowners.

Only recently have historians of the American Revolution paid close attention to the typical expressions of crowd action. While other social categories tended to express their interests through organized bodies, such as the manipulation and political perfidy by Whig and Tory leaders in various official capacities, "riot" or "rebellion" became the preferred mode of crowd action. Riots were spontaneously undertaken to redress specific but limited grievances which had been frustrated or ignored by private commercial interests or political bodies. They were not unfocused expressions of rage. These actions were largely non-violent and extremely specific, but did not exclude violence. Moreover, in the wake of the overwhelming evidence of condescension, contempt, and manipulation of the crowd by politicians and public officials and the palpable control of many of the larger towns by groups representing the upper reaches of the emerging social structure, riots were undertaken as a rational response to an increasingly oligarchic political situation before the Revolution.

Local governments during the Revolution became radicalized as the crowd, impressed in the revolutionary army in a manner similar to that of the Crown, asserted its newly acquired political power within, as well as outside, official institutions. Artisans were more frequently elected to legislative, if not executive, bodies and New England town meetings more often heard the voice of the crowd, particularly on the question of whether courts should be permitted to convene. In many cases, at least in Massachusetts, the crowd succeeded, by force, in preventing courts from convening because they were widely perceived as allies of the economic interests of the upper reaches of local society. The part played by intellectuals in the revolution was largely, if not entirely, subsumed under the task of political mobilization. In order to pursue the War of Independence—as long as the energy of all rebels was directed against the external adversary—the crowd, as much as the elites, heard their own voices in epistles, pamphlets, and journals exhorting them to riot, if necessary, in the service of the united objective of displacing the Crown and establishing a constitutional order in which social justice could, at least tendentially, be promulgated.[14] The crowd's demands for a truly democratic polity enjoyed little, if any, literary expression. The New England crowd's program implied no separation of powers between the judiciary and the legislative branches in which the former would occupy a space of privilege and include crucial economic grievances: against high prices for bread and flour; against unjust taxes on small property

levied not only by the British Crown, but also by local administrations; struggles over land titles in which large landholders claimed lands belonging to smallholders. The crowd of propertyless and smallholders were gradually won over to the cause of independence with promises that their demands would be considered, if not entirely met, by the new revolutionary regime. After 1775, direct crowd action succeeded in Massachusetts in closing courts because participants perceived the courts as favoring the rich landowners and merchants (although they did accept military authority under wartime conditions as a necessary measure). According to Hoerder "After the break-down of British rule the committees [of correspondence, the leading revolutionary civil authority] called conventions and functioned as courts. Town meeting votes regulated the take-over of judicial powers. Criminal matters and the affairs of imprisoned persons were acted upon. ... In a New Hampshire town the people decided that the government was dissolved, set up a code of laws for local use, and managed their town affairs without difficulties."[15]

Of course, these were much smaller societies than exist today. I invoke this history to indicate the proclivities of intellectuals during the American Revolution in relation to the crowd. Revolutionary bourgeois intellectuals were responsible for the enunciation of the doctrine—expressed especially by James Madison and John Jay in the *Federalist Papers*—of separation of powers, according to which courts were a necessary institution for the adjudication of civil and criminal disputes and acted on the basis of an elaborated legal system enacted by legislatures. In turn, legislative power displaced the imperfect forms of popular power, the town meetings, and thereby constituted a second-order remove from the diverse sources of popular power. As we have noted, the town meeting contained its own exclusions— although by no means as extensive as the legislature whose electors typically represented only the propertied interests and whose members were overwhelmingly recruited from only the largest and most powerful property holders and their retainers.

In contrast to these arguments for indirect rule through representative government, Thomas Paine and countless pamphleteers were forthrightly egalitarian in writings directed against the Crown. In a manner similar to Franklin Roosevelt's wartime doctrine of the Four Freedoms and Henry Wallace's more populist Age of the Common Man as national goals, Paine's *Age of Reason* and other works were agitational documents directed at the crowd; Paine's rhetoric was deliberately abusive to the "summer soldiers and sunshine patriots," euphemisms for the feint-hearted Tories who in the early days of the rebellion felt obliged to ally themselves with the rebel cause but,

foreseeing a long and indeterminate outcome to the war, either with-
drew from the movement or went over to the enemy. Paine's writings
were words of mobilization aimed at gaining crowd acceptance of the
military draft, even as large numbers of men of the upper crust were
dodging military service. Just as in the Second World War, the Ameri-
can Revolutionary war had to be perceived as a people's struggle or it
was destined to suffer defeat. Yet, contrary to his popularly conceived
legacy, Paine was neither of nor truly for the crowd. He functioned as
an organic intellectual of the wing of the revolutionary coalition
whose major aim was to separate from the Crown, but who also
understood the necessity of a broad mobilization of artisans, property-
less workers, and small farmers—categories largely excluded from
the state legislatures, the military leadership, and the public sphere.

However, this strategic discourse did not signify the merging of
popular and elite power. For as the struggle for the Bill of Rights
attests, the strongly centralist conservatives had no intention of shar-
ing power or being diverted from their intention to replace the com-
mittees of correspondence and the town meetings with courts, repre-
sentative bodies, and executive government. The Declaration of
Independence, plainly a wartime manifesto aimed at national unity
was displaced by the Articles of Confederation and the Constitution—
whose initial discourse signified a defeat for the radical democratic
wing of the Revolution. As with the French Revolution, the utility of
radical intellectuals ceased with the victorious conclusion of the war.
But, the rhetoric of the crowd persisted alongside reactionary nation-
alism as a mobilizing ideology in America. During the Civil and Sec-
ond World Wars the historic legatees of the crowd were called upon
again and again to fight in much the same terms. Apart from national-
ism, the cadences of mobilization still remained those of broad popu-
lar democratic participation and social, i.e., economic justice.

The 18th- and 19th-century intellectuals were largely "traditional,"
that is, were students of religion, philosophy, and literature; their role
in the revolutionary process was precisely as Gramsci sketched. They
became the organic intellectuals of a revolutionary nationalist bour-
geoisie that elaborated the crucial 18th-century doctrine of liberal
democracy as a "natural" right; more broadly, they were direct parti-
cipants, even leaders, in the various revolutionary movements of that
century. (Quite like Michael Faraday, Charles Lyell, Charles Darwin,
and Louis Pasteur became pioneers in the theoretical development
and practical application, especially to industry, of the new physics,
geology, biology, and chemistry.) In addition, the 19th century wit-
nessed the maturing of a distinctly 18th-century development, that of
the figure of the political intellectual, a person for whom politics

itself becomes a vocation. These are, in the first place, the publicists, theoreticians, and leaders of the first truly mass parties of liberalism in France, Italy, and Germany in the 1830s and 1840s, the American expression of which were the Democratic and Workingmen's parties. In parliaments and legislatures, delegation gradually ceased to be a part-time job of artisans, merchants, and other members of civil society, but was increasingly reserved to professionals, some of whom were recruited from among lawyers or physicians as well as the literati.

III.

The 20th century adds an entirely new dimension to the role of intellectuals; now the category of scientific and technical intelligentsia is created by the systematic application of science to the labor process and the elevation of administration to a social principle, rather than a technology for the achievement of predefined ends. For André Gorz, intellectuals, neither part of the working class nor full partners in the power system, are as a social category divorced from history, or more exactly, are understood as a subordinate part of the prevailing capitalist and state socialist systems.[16] Scientists and engineers are servants; they lack genuine autonomy in the performance of their labor; they may take decisions only on a narrow range of technical issues. In the labor process they are clearly subordinate to managers, even though they can join these ranks. Thus, they enjoy no independent political expression, nor are they capable of it. Even when they organize unions they are not part of the labor movement, but form separate organizations of cadres which usually are given to pronouncements which place them outside the political and economic ideologies of the working class. It is important to note that in Gorz's theory of intellectuals, the distinction of managers and technicians is retained because he still holds to the separation of means and ends. Clearly, if these are conflated, the scientist and technical cadres are continuous with administration, actually an arm of it which accounts for the interchangeability of these categories.

Contrast this state of affairs to the stature of intellectuals during the extended period of the bourgeois revolutions of the 18th and 19th centuries and, again, in the 20th-century national liberation movements in Central Europe and later in the third world. Or, indeed, their position in the socialist revolutions immediately following the two world wars. In these situations, intellectuals link themselves with class and national movements and are relied upon to articulate the movement's goals, devise strategies and programs, and organize pro-

paganda networks through the party and state apparatuses which they increasingly control. This means that, absent a real bourgeoisie or even autonomous peasants' and workers' movements with their own ideology, programs, and apparatuses, intellectuals are, for all practical purposes, the leadership.[17]

Left-wing intellectuals become crucial for revolutionary movements precisely because their talents, traditionally cultivated in the service of the established order, are indispensible for any project to transform state power. They direct economic development under conditions where the market is dominated by petty commodity production and exchange. They impose a new common sense on the underlying population without which the struggle for political and economic transformation is impossible. This new common sense often entails the imposition of national over regional and sectoral goals and consequently demands the integration of whatever independent movements have affiliated with the national revolution—for, more often than not, these movements tend to cling to their "parochial" class or ethnic, subcultural interests, which, from the perspective of the revolutionary center often constitutes a barrier to fulfilling national objectives, the content of which is modernization, industrialization, representative government but, especially in the 20th century, not necessarily individual liberties. Where the movements do not voluntarily surrender autonomy they are frequently repressed by bourgeois, socialist, or nationalist intelligentsias in the name of progressive social change.

In this reprise, intellectuals are more than functionaries of power held by others; they are, in all circumstances, the core of the movement. They propose a new conception of citizenship tied, not to universal conceptions of the human community, but to the nation-state. Their utopias form the political imaginary of social transformation, their organizational and literary skills provide the sinews of administration without which revolutionary wars and states founder or die. What makes the bourgeois intellect so valuable is "his" training as a universal intellectual, a trait which is part of the scientific and cosmopolitan ideology according to which intellectual knowledge is equivalent to reason.

Lenin's *What is to be Done?* may be understood as the most significant recent theoretical statement of intellectuals as historical agents, although he retains the view that they are no more than a social category whose political effectivity depends, in the final instance, on the development of a mass working-class movement. But, the final instance never came. For the history of the Russian Revolution may be told, in part, as the struggle for the integration of that working-

class movement into the national movement led by intellectuals orga-
nized as the Communist party. In this sense, the Soviet intellectuals
performed tasks that were entirely consistent with 19th-century na-
tionalist movements, but adopted the flags of proletarian internation-
alism rather than the older bourgeois ideologies. The integration oc-
curred both ideologically and coercively, but the outcome of the
struggle was painful, albeit classic, in its dimensions: the independent
popular movements of workers and peasants were destroyed by force
as much as persuasion, as well as the movements of opposition intel-
lectuals.[18]

That political intellectuals have come to power in nearly all revolu-
tions in the 20th century testifies to the historicity of the Gramscian
notion of the organic intellectual—a notion whose relevance depends
upon the formation of intellectuals within the hegemonic or counter-
hegemonic classes, as well as the fusion of traditional intellectuals
with sovereign political formations of and by, as well as for, the
class in question. This model is drawn from the early stages of the
revolutions of the late 18th and 19th centuries under conditions of a
fairly well-developed bourgeois class which, as often as not, recruited
intellectuals from its own ranks as much as it attracted the traditional
literati. However, notwithstanding the immense educational appara-
tus the Bolsheviks organized in the wake of the revolution, the Soviet
Union did not give birth to a new category or worker-intellectuals—
except at the level of technical expertise, an event which reached
fruition only after the Second World War. The proletarian dictator-
ship was *for* the workers, at least rhetorically, but was never *by* them.
Eastern European and Asian regimes which have come to power in
the name of communism are fundamental instances of rule by intellec-
tuals who monopolize both the means of legitimate violence and the
means of ideological production.[19] Moreover, they constitute a state
oligarchy which determines what counts as science, and, more
broadly, legitimate knowledge.

In state socialist societies political, but not scientific and technical,
intellectuals have come to power. Gramsci anticipates this develop-
ment by situating their work within civil society, a term that connotes,
in his conception, the sphere of activity at the base of social and
cultural discussion and debate. The intellectuals are functionaries of
political *movements* whose crucial role is to articulate a definite vision
of life, as well as to provide the organizational sinews of their activity.

However, the revolutionary role of political intellectuals ends with
the consolidation of their power. In the aftermath of the revolutions—
in Russia, Eastern Europe, and China—the political intellectual typi-
cally becomes a bureaucrat, at lower levels, and an oligarch at the

top. The concentration of power in the hands of the party hierarchies which are composed, almost entirely, of political intellectuals, whatever technical or professional training they may have had, creates new problems for regimes plagued by serious economic difficulties abetted, in part, by the disaffection of the bearers of their most precious productive force—scientific and technical knowledge. These regimes have experienced mass disaffection from a considerable fraction of the scientific and technical intelligentsia.

In Eastern Europe and China it is no longer enough to provide a relatively sumptuous living standard for scientific and managerial categories or, as in the case of natural sciences, to lift constraints on the production of knowledge which is not (yet) officially sanctioned. The blatant imbalance of social power between the party and the scientific and technical cadres upon which the viability of the system increasingly depends, creates tensions between them which mushroomed in the eighties into full-blown contradictions. To put the matter more graphically, a widening gap has been opened between the possessors of human capital and their relatively impoverished symbolic or cultural capital which the regime does not reward by offering shares of concomitant political power.[20] In the 1990s, scientific intellectuals in the Soviet Union and Eastern Europe have joined with dissident political intellectuals to form new political parties that are typically anti-socialist as much as anti-communist, since the two are ineluctably tied in public discourse. (Indeed, many erstwhile Communist parties have changed their name to Socialist parties without discernible difference in the leadership or in their style of functioning. The major programmatic distinction is a new, ritualistic adherence to democracy and to the "market.")

To be sure, many Soviet scientists and engineers remained party members, but they rarely attained high or influential positions—a measure of which would be to examine the social composition of the political bureaus and the leading ministries. Of course, one finds a fair representation of individuals of working-class origin, but this does not signify that the party is a working-class party. It is significant only in that the hierarchy feels compelled, given the official political ideology, to represent those of working class origin on its leading committees, even if these individuals have operated for many years as functionaries and have lost, for the most part, their concrete links with the workers.

On the other hand, neither the Soviet Communist party's adoption of the slogans of the "scientific-technological revolution," first enunciated by a group of Czech Communist reformers in 1967 during the ill-fated Dubček government, as quasi-official ideology nor its proclama-

tions in the Gorbachev era for free discussion and political restructuration have yet resulted in a major reconciliation between the party and its cultural and scientific intellectuals. Even though Konrad and Szelenyi may have been mistaken in announcing the rise of these intellectuals to class power in the mid-1970s, the error proved to be of timing rather than in concept. For it is still not clear whether in state socialist societies scientific and cultural intellectuals can be integrated without the rulers sharing power with them. This crisis becomes increasingly apparent the more economic and cultural life is organized around technical rather than ideological discourse, the latter being the traditional province of the political intelligentsia.

In the recent moves toward reform in the Soviet Union and China refers to three areas: (1) to assure the scientific and technical cadres of their secure place in the future of the society. Recently, this promise has included recognizing the candidacy for the Supreme Soviet of a dissident figure such as Andrei Sakharov on the 1989 official slate of the Academy of Sciences. The official reformers hope to enlist dissident intellectuals in the struggle for modernization of production and cultural life; (2) the post-Brezhnev party and state leadership is desperate to raise worker productivity, a reform which entails more than persuading workers to produce more in the same time as previously. For what is involved is nothing less than the proposal to abrogate the long-time social contract in which many, if not most, workers observe only loosely the rigors of industrial discipline—in short, do not work hard by Western or Japanese standards. The most reliable method of addressing worker resistance to higher work norms is, of course, to eliminate manual labor. This well-known capitalist strategy entails, invariably, intensifying the application of scientific knowledge in the workplace in all economic sectors. Intellectuals seem enthusiastic to support the regime's effort to decentralize economic decisions by introducing some market criteria for determining what is produced, by what means, and how much—an innovation which implies offering incentives to managers to accelerate worker performance, which would not exclude technologically induced redundancy as well as dismissing those who refuse to meet production norms. For the present, a large section of the cultural intellectuals are pleased with the reforms and take issue only with the relatively slow pace by which they occur. On the other side, a substantial section of the party and perhaps an even greater portion of the industrial working class remains suspicious and, in some cases, openly hostile to the reforms; (3) it is clear that the degree to which scientific and technical intelligence is recuperated by the new regime will depend on its capacity to share genuine power over decision-making at all levels,

including the party. The call for more democracy, which has not (yet) extended to the party, responds to widespread disaffection from the regime by many in the politically active population.

However, one cannot assume that, in the emerging order, Soviet intellectuals intend to speak for more than themselves. Indeed, all indications are that their definition of cultural and scientific freedom does not necessarily extend to workers and peasants or to those whose opposition is globally directed at the regime itself rather than its specific weaknesses. In an interview, Andrei Sakharov made clear he had no contact with other disaffected social forces within the Soviet Union, least of all workers. Upon assuming power in 1985, Gorbachev spoke of openness in the context of the party's program for restructuring economic, cultural, and political life, but was not prepared to overhaul political life to abolish the one-party state or the official ideology—despite the electoral reforms which permit individuals to run for elective office against the party's candidates, but limit their number to a minority of delegates..

The scientific intellectuals want more power in areas that go beyond their work. They want to share control over the results of their work, such as a voice in determining nuclear weapons and energy policy, ecological issues, and the migration of Jews (who have frequently been refused exit visas). They want educational reform reflecting the cultural and intellectual changes of the past decades. I would not want to deprecate the significance of either the electoral reforms or the emergence of scientific and independent political intellectuals such as Sakharov and Yeltsin in contesting and gaining public office against the party's candidates. These are highly visible and significant democratic victories which are symptomatic of the depth of discontent in the country and symbolic of the relative boldness of the process initiated by Gorbachev that became, much to his chagrin, his nemesis.

Nevertheless, the term "democracy" lacks a universal application, even if its invocation has become a universal signifier. Soviet intellectuals, in the current conjuncture, want to share power with the ruling elite, want a voice within and not against the prevailing party and state order. With the exception of the organic intellectuals of the growing nationalist movements against what Lenin called "Great Russian chauvinism," who have articulated a panoply of demands ranging from greater autonomy to independence from the Soviet Union, most cosmopolitan intellectuals have not demanded a pluralist political system in the Western sense (a term which implies a multiple party system and the legalization of non-official newspapers and other publications, both of which entail a participatory democratic model). Rather, they have contented themselves with negative democratic

demands, that is, freedom *from* the state, with respect to individual rights, including speech, and greater participation for their social category in state policy.

The limits of intellectuals' dissent (except for a small faction of participatory democrats) reflect two general features of Soviet dissent: much of it remains a demand for inner party democracy or a greater openness at the level of elites, and the perception by intellectuals of the severe boundaries of tolerated opposition. In short, many intellectuals are loyal party members despite their dissent from its policies, and others remain skeptical about the extent to which opposition may safely be expressed—a wariness borne out by the drift, after a promising beginning in the 1980s, away from the democratic promise of the earlier declarations in the wake of a ferocious nationalist onslaught from the Republics and growing anti-democratic sentiments within the party, emanating from the low and middle ranks of the bureaucracy and, especially, the military.

The nationalist intelligentsia has intensified its campaigns directed at the inequalities between Russia and other Republics, in both the more "advanced" Western border—especially the annexed nations of Estonia, Latvia, and Lithuania—and in the semi-rural east and south. These movements, concentrated among various intellectual strata, especially a rising political intelligentsia, propose to separate from the Soviet system in favor of either an independent democratic state (presumably with a welfare-mixed market economy) or an ideologically unspecified (except with respect to its nationalism) economic and political system which is, nevertheless, independent of the Soviet Union, as in the cases of Georgia and Armenia. In these struggles are revealed the limits of *perestroika:* it does not extend to the traditional Leninist dictum of the right of nations to self-determination.[21]

IV.

Gorz's post-1968 contention, that in the West scientific and technical intelligentsia has not thus far chosen to constitute itself as a new class, remains a fair judgment of the current situation. The cultural intellectuals who, until the mid-1970s, were asserting their independence of the state, especially with respect to policies affecting the environment, the size and content of defense spending, and the conduct of foreign affairs have, during the past fifteen years, steadily retreated from positions of political independence. In Germany and other European states, Green parties, that harbored in the late 1970s and early 1980s a substantial fraction of political and cultural intellectuals seeking independent political identity, have temporarily been

stalled—not only because of internal factional strife over their fundamental direction, but because strategically flexible social-democratic parties have effectively reached agreements with their own left-wings to form coalitions with these new parties. In the process, the social-democrats have accommodated their own program to the new ecological program but have also succeeded, at least for the time being, in slowing, if not halting, the forward march of the Greens.

This is not to say that debate on these and other questions has entirely ended or that some U.S. scientists (e.g., the recent dissent of a substantial fraction of the American physics establishment over the Reagan/Bush proposal to build a defense shield popularly known as Star Wars), artists, and other intellectuals do not speak out on specific issues. More recently, Exxon's neglect, which resulted in the massive Alaska oil spill and the fierce debate concerning whether stricter environmental controls are economically feasible in the wake of the thinning of the ozone layer and the so-called Greenhouse effect, are among the events which have rekindled the embers of what was once, however briefly, a hearty fire. Yet, whatever these developments may portend, until now the drift of U.S. scientific intellectuals is, with some reservations, away from social responsibility and toward a position of subordination to capital and the state.

At MIT, a leading group of biologists and engineers have agreed to surrender ownership of patents for bioengineering discoveries in return for substantial corporate funding for their research. Although the scientists did not initiate the collaboration, they have approved such arrangements by large majorities wherever these questions have been put on the academic agenda. On the one side, this indicates the still powerful pull of capital's subordination of knowledge; on the other, the steady decline of federal support for basic research has shifted the scene of research to applied, commercially oriented areas. Yet, the passing of science as independent, intellectually disinterested inquiry (even if "disinterest" remains a vital aspect of scientific ideology) is rooted in the partial merger of science and industry as early as the middle of the 19th century, a relationship which Marx had already noted in his *Grundrisse* (1857). The career of Michael Faraday illustrates this historical movement:

> Michael Faraday was born in 1791 in a London slum and died in 1867 as a pensioner of the Queen. Most pensioners there were high civil servants and military personnel. Perhaps he was the only scientist who ever lived there as a pensioner of the Crown. Men of science of earlier times were, at least supposedly, gentlemen of independent means, or at least people whose employment offered them sufficient

leisure and money . . . Faraday was employed by the Royal Institution
which hardly supported him.[22]

Unlike his predecessors Newton, Hooke, and Lavoisier, who per-
sonified the ideal of the gentleman-scientist, Faraday's humble origins
obliged him to seek sponsorship for his research. The Royal Institution
was poorly funded, but provided the necessary living quarters and
laboratory and a small income without which the man, who Joseph
Agassi describes as the "grand old man of British science," would have
been unable to pursue his work. Faraday was not only the first of a
long line of scientists employed by the state and the corporations, he
was one of the earliest scientist-inventors whose theoretical discover-
ies he, himself, translated into practical applications. His isolation of
benzene became one of the crucial elements of the organic chemistry
industry and his discovery of electromagnetic induction generated
numerous patents. Although Faraday's work became the basis for the
theoretical advances made by William Maxwell which were part of
the process which led to the second modern revolution in physics, his
status as a civil servant marked the beginning of the subsumption of
science under the state and capital.

As Bruno Latour has shown in his study of Louis Pasteur's discovery
of a vaccine for anthrax,[23] the close partnership with the state and
capital became a crucial element in the emergence of science in the
late 19th century. While science was made increasingly dependent
upon the provision of large funds, since the laboratory was now consti-
tuted as an organization with a concomitant hierarchical division of
labor and required progressively sophisticated technologies in order
to perform experimental work, the integration of science and technol-
ogy also made the scientist a new man of power. To be sure, with
major exceptions, the full maturity of science as power did not emerge
decisively until the last decades of the 20th century. Nevertheless, two
crucial changes—science as a profession most of whose members are
salaried employees and the development of science as a collective
enterprise—really began with Faraday. The merger of science and
industry received a tremendous impetus by the employment of chem-
ists in the U.S. and German steel industries in the 1880s, but only
took definite shape with the industrial applications of chemistry and
electromagnetic physics to the new oil, chemical, and electrical indus-
tries at the turn of the century. From this time, the large companies
in these new industries employed a veritable army of scientists, engi-
neers, and designers, one which rapidly became the decisive produc-
tive force. Of course, this tendency was accelerated by automation
and computerization which rapidly overcame the mechanical mode

of production by the 1960s. After three decades, during which time the technical intelligentsia has played a dominant role in the crucial sectors of world capitalist production, American scientists and technical intellectuals remain, albeit with increasing tension, professional/managerial servants of the corporate capitalist order—despite indications that this situation has begun to change both at the corporate level, particularly in computer-mediated industries, and the state.

It would be a serious mistake to judge various theoretical formulations which posit the relative autonomy of knowledge from capital and, thus, the possibility of intellectuals occupying the subject-positions of social agents without organic links to other classes by the inconclusive historical evidence at the political level outside Eastern Europe. For just as a weak bourgeois class slowly expanded its ideological and political horizons even as its economic position had already overshadowed feudal relations, so the role of the technical intellectual in production; the fundamental importance of basic research for technological innovation; the crucial and expanded role of the cultural intellectuals in the reproduction of discursive legitimations for the prevailing order; their struggle for influence over state policy, and so on, may prefigure new forms of political self-representation within the capitalist order. While Alvin Gouldner's theory of the Culture of Critical Discourse (CCD) as the foundation for intellectuals' autonomy is a necessary ingredient of an adequate theory, it is insufficient, possibly because, despite his criticism of orthodox versions, it remains ensconced in the Marxist framework; that is, it is crucially tied to class analysis for comprehending agency.

Of course, Marx recognizes the power of knowledge, as we can see from the statement in the *German Ideology* that the "ruling ideas of every epoch are the ideas of the ruling class." But this formulation acknowledges only the ideological function of ideas as superstructure which, however crucial to class rule, play no genuinely independent role in social processes. As industrial production becomes characteristically based upon scientific, rather than traditional craft, knowledge, Marx deepens his conception of the degree to which knowledge becomes a productive force and thereby acquires a place within the infrastructure as well as the ideological superstructure. Since, at the time of writing the notebooks for *Capital*, this development is still in its early stages, Marx does not theorize intellectuals as a social category that inserts itself as a social actor. Yet, despite his statement that the industrial stage of capitalist development is marked by the subsumption of science under capital, the crucial role of knowledge and its embodiment in a new social category is tacitly asserted. That is, Marx sets the agenda for further investigation, even if his concep-

tion of knowledge does not explicitly address its bearers as new social agents.

V.

It may be argued that a theory of intellectuals awaited the full development of industrial capitalism, the maturation of parliamentary regimes, and, especially, the rise of labor, socialist, and other parties and movements which signified the political aspirations of the working class. This political expression was not confined to participation in legislatures or executive organs of democratic states. It also manifested itself in direct action: the Italian factory council movement that replaced trade unions during 1919–20; the great U.S. 1919 Steel strike; the 1926 general strike in Britain; and, of course, the crucial significance of 1905, the year of the first Russian Revolution which, among other things, gave birth to Soviet power. Inspired, in part, by the French Revolution and the Paris Commune as much as by the ineffectiveness of the Duma, the Czarist-sponsored legislature, Russian workers conceived of popular assemblies and "delegates" whose accountability was directly to them as an alternative to traditional bodies, where parties mediate the relationship between the state and the masses. And, it was precisely this example that prompted the debate concerning intellectuals which became an important theme of socialist theory in the first decades of the 20th century.

Neo-Marxists, such as the Austrian school of Max Adler and especially Otto Bauer, as well as Luxemburg, Lenin, and Gramsci, were constrained to ponder the differences between the leaders and the led. In her review of Lenin's pamphlet "One Step Forward, Two Steps Back"—which calls for a highly centralized all-Russian social-democratic party to replace the panoply of small groups, study circles, locally based political clubs, and so on—Luxemburg argues that Lenin's Jacobin and even Blanquist model of organization (according to which a central organization literally dictates to lower bodies), not only ideologically and strategically but tactically as well, violates the specifically socialist character of the movement.[24] According to Luxemburg, social-democracy is a movement of a new type: "it is the movement of the working class" in which "self-centralism," "the rule of the majority," replaces the rule of an elite both in society and in the party organization. Therefore, centralism becomes necessary, not for the purpose of working out tactics, but for coordinating the actions of a whole class. But coordination is not the same as command. Against Lenin's ultra-centralism, in which the party directs revolutionary activity, Luxemburg insists that the role of the social-demo-

cratic leadership "is of an essentially conservative character." As the proletariat gains new terrain on the basis of spontaneous mass actions, such as the mass strike which began in Russia with a student movement in Petersburg in 1901 and culminated in a workers' strike shortly thereafter in Rostov-on-Don, a strike "that the boldest Social Democratic daredevil would not have dared to imagine only a few years before,"[25] the party's tendency is to consolidate the gains on the basis of compromise and reforms such as parliamentarism. In this way, parties often reverse the creativity of the masses. For these reasons, Luxemburg argues for tactical freedom at the base of the movement, leaving to party congresses the determination of broad policies. Lenin's error, according to Luxemburg, is to see only the anarchistic, decentralist tendencies among intellectuals which must be remedied by powerful proletarian-minded central control. He does not understand that overcentralization is also the product of an intellectual fraction within social-democracy that would stifle working-class initiative in the name of revolutionary discipline. Although persuaded, against anarchism and other libertarian ideologies, that the party is necessary to provide a "framework" for conscious activity, Luxemburg places emphasis on the struggle against bureaucratism and elitism rather than being primarily concerned with the possibility of opportunism through centralized leadership.

Thus, in political terms, the turn-of-the-century Marxist debate over intellectuals concerns relationships between the leaders and the led, the role of the party versus the role of the masses under revolutionary and pre-revolutionary conditions, and the relation between strategy and tactics. Lenin's position remains that of Karl Kautsky, for whom the working class could itself produce only trade union consciousness as opposed to revolutionary consciousness.[26] Therefore, especially under conditions of the absolutist state, a revolutionary vanguard composed primarily, if not exclusively, of uprooted intellectuals, most of whom would be "class traitors," is necessary—not only to safeguard the integrity of the organization against the police, but to insure systematic struggle against the opportunists who would settle for reforms. Lenin sees "localism" as the preferred organizational form of bourgeois intellectuals within the movement who, lacking the working class's discipline gained largely from the regimen of factory labor, sow the seeds of opportunism while resisting the power of the center.

In this debate, both sides express serious reservations about intellectuals. Despite his ultimate reliance on their education and economically wrought freedom from bourgeois obligation, Lenin is deeply suspicious of intellectuals' demands for autonomy and their resistance to party discipline. Luxemburg understands the socialist revolution

to consist precisely in the emergence of the working class as the apparatus, as well as the soul, of the movement, the first oppressed class in human history capable of self-liberation. In her discourse, intellectuals, as the possessors of the party apparatus, are inherently conservative forces retarding creativity, a characteristic reserved for the mass movement. Intellectuals are the masters of maneuver and compromise within a relatively complex parliamentary system. Referring to German Social Democracy, she praises it, ironically, for having "adapted itself wonderfully, in the smallest detail to the parliamentary system . . . At the same time, however, this specific tactical form so thoroughly covers the further horizons that, to a great degree, the inclination to eternalize, to consider the parliamentary tactic as purely and simply the tactic of Social Democracy makes itself felt."[27] Thus, it is not the localism of intellectuals that leads to reformism and opportunism in relation to the revolutionary goal; it is, implicitly, the passion for winning within the rules of the prevailing game— which are made by the political and bureaucratic intellectuals of the bourgeois regime—that constitutes this conservatism. For Luxemburg the logjam cannot be freed from above or purely by discussion in leading bodies. The "inertia" of current parliamentary tactics inhibits a debate concerning an imagined future whose contours are still vague. But the movement must keep itself responsive to innovations from below in which local organizations, addressing changed conditions, attempt to invent new tactics on the way to establishing a new terrain of struggle. In a word, the party must assist these local organizations or get out of the way. So, the concept of "spontaneous" action always refers to the initiatives of existing party or workers' collectivities, not to some idea that movements contain no preconditions in the organized experiences of prior generations of actors.

In this dialogue, we can see the distance between the two speakers. It is not enough, as some commentators are wont to do, to ascribe Lenin's theory of organization (which posits the formation of an intellectual vanguard), to absolutist conditions, especially in the light of its reliance on Kautsky's formulations concerning class consciousness. More to the point are Lenin's Jacobin assumptions: that is, the idea that the revolution whose aims are universal is conducted by a dedicated minority in behalf of the majority. Needless to say, the tradition emanating from at least one tendency in Marx's work, and from Luxemburg and the democratic and libertarian councilist movements of this century, harbors, as does Lenin, ambivalence regarding the intellectuals as a social and political category. Yet, with the exception of Marx himself, the problem of knowledge remains unexamined until Gramsci, except tacitly. To be sure, within the political discourse of

Marxism, intellectuals are taken in their traditional significance, as possessors of high culture—writers, artists, philosophers, priests. Although the incorporation of these strata into the state bureaucracy is as old as civilization itself, Marxism takes them as objects of controversy in relation to their participation in the working-class movement, an issue which perhaps refers more to the problem of the capacity of workers for self-emancipation than to the intellectuals themselves. This tradition is preserved in Gramsci's theory of hegemony which, however much light it sheds on the space intellectuals occupy in the class struggle, regards knowledge and its bearers within social formations whose principal actors are defined by the older paradigm of classical political economy.

Drawing heavily from both Weber and Marx, Norbert Elias, by positing the independence of knowledge within social formations, makes possible the development of a theory in which the history of knowledge itself, as much as its relations with other components of social power, provides us with a framework for a theory of intellectuals.[28] For even if Marxism has recognized the historical significance of science and ideology in the processes of production and reproduction, it holds that these are in the final instance subordinate functions to those of economic relations. Elias argues that the monopoly over knowledge and control of the means of violence are the two spheres that constitute the state formation in contemporary life. This argument changes the social conception of the state. It cannot be understood merely as the expression of the interest of the dominant economic class or, in later neo-Marxist theories, as a field within which classes contest. As the holder of a virtual monopoly over the exercise of violence, it establishes the boundary conditions for economic and political combat. Within this framework, one may measure democracy in terms of whether these boundaries are wide or narrow; whether the transfer of power entails not the necessity of a group exercising a transgression of boundaries but a "peaceful process." Marxism insists that such a peaceful transfer of power can occur only on condition that economic relations remain intact, that any intention to change these relations entails breaking the rule that only the state may use the means of violence.

Elias's theory of power may provide a more adequate basis for developing a theory of intellectuals. Elias proposes four spheres in which power is exercised in any society: control or monopolies over the means of economic production; control over the means and norms of violence; knowledge; and the civilizing process. Elias refuses the primacy of the economic; his major concern is to investigate the conditions for the constitution of mutual relations. He finds that it is

these four determinate sets which obtain in social formations in which the state plays the crucial organizing role.

The development of classes articulates with these spheres. Feudal and bourgeois economic relations are not presumed in Elias's theory to determine other relations, a presumption already rejected by one of his progenitors, Max Weber. On the contrary. The warriors (or in modern times, the military) actively intervene on their own terms in many societies. Similarly, priests, the conventional bearers of knowledge, and their successors, the ideological and scientific intellectuals, are among the controlling interests, regardless of whether they own productive property. Although Elias is silent on the issue, one would have to infer that the technical intelligentsia in modern social formations, which includes the scientists, would be part of the complex state in which power is routinely exercised in all spheres of social life.

Within these boundaries the rule of law, a complex of reified codes governing both public and private behavior, is supreme, at least normatively. Although laws express the changing nature of the economic, political, and ideological compromise among contending forces, they also have their own history, which, if Elias's theory of the civilizing process holds, becomes trans-situational against which the action system must be measured. In other words, while the historicity of the Constitution (whether tacit as in the U.K. or explicit as in the U.S.) must be acknowledged, it is mediated by norms which often span historical epochs. These norms are not, therefore, merely functional justifications of the existing state of affairs. They regulate, in a large measure, the given state of affairs and have their basis in legal and ethical intellectuals (lawyers, jurists, and legal scholars, priests, teachers), their knowledge, and the systems they administer. As scholars and experts, intellectuals are the repositors of the accumulated knowledge of law and, in this sense, have more than legitimating status. Legal expertise, as we have recently seen in the confirmation hearings for U.S. Supreme Court Justices, plays an important role for determining who is qualified to arbitrate contending interests in accordance with acceptable interpretations of constitutional law. Thus, the statement that members of this body read the newspapers signifies that interpretation is subject to political hegemony and counterhegemonies. But this maxim does not exhaust explanation for court rulings. Accumulated knowledge configured by the doctrine of legal precedent controls a considerable amount of juridical adjudication, and this doctrine does limit the degree to which the contemporary discursive context makes a crucial difference. While the specific form of this knowledge is overdetermined, it is surely underdetermined by both conjunctural political struggles and interests and by

the letter of the law. Knowledge itself of which legal ideologies are constitutive acts, plays a relatively autonomous role within the multiplicity of determinations whose outcome is a legal decision.

Each institutional sphere of the state has its own history which is controlled by intellectuals. Of course, the idea that science has an internal history which can be traced through the various disputes among competing paradigms is widely acknowledged. That modern science, law, and other discourses live out this history in the context of economic, political, and ideological struggles has also been amply demonstrated by both historians and sociologists (although Elias accepts the methodology of modern science as axiomatic to his work). Nevertheless, the degree to which knowledge is an independent social force is expressed in the claim of science to value neutrality, exempt from the propositions of the sociology of knowledge, the heart of which is the idea that knowledge (except science) is interested inquiry and therefore partial. Consequently, we may trace the social interest which underlies ordinary non-scientific knowledge, but not science, because it is held to be situated outside the ideological system. This claim is grounded in its self-critical methodology, the procedures of which are meant to screen out interests.

That science has a purely internal history in which discoveries are built on others without social mediation, and, like art, is subject only to the influence of the metaphysics of the age (which themselves have internal histories[29]) forms the major claims of intellectuals to stand outside the class system. Karl Mannheim's declaration that the problem of truth could be solved only by a social category which was "free floating" is based on the concept that society requires a sphere of knowledge which cannot be relativized in order to dominate nature and to manage human affairs. Thus, the utopian conception of a "science" of politics which, eventually, could enjoy the status of, say, high energy particle physics. In the terms in which Jürgen Habermas frames the question, a society's survival depends on its capacity to learn, that is, to adapt its rules for communicative action to new conditions—especially those not subject to purposively rational solutions such as are found in the sphere of production.[30] Where "problem-solving" mechanisms no longer suffice because the rules of the game do not encompass the class of actions in question, society tends to reduce the problem to manageable proportions, an action which ineluctably occludes or excludes issues that cry out for collective address. The intellectuals whose main activity can be described as producers of non-instrumental knowledge through the invention of new language games, ought to be able to intervene in the affairs of both state and civil society to represent the new questions, as well as their

solutions, even as class- or work-based knowledge remains ensconced in particular interests. Habermas has no explicit theory of intellectuals and society, but privileges the new bearers of critical communications as catalysts for change. In this "reconstruction" of historical materialism, Habermas implicitly condemns the tendency of all social formations to subordinate intellectuals to the game of technical rationality or, to be more exact, to set too restrictive boundary conditions over legitimate intellectual activity without condemning it to a marginal existence. The real criterion of a dynamic society is whether new, non-instrumental knowledge is genuinely valued, not only as art, but as the basis for social decisions. Where critical intelligence is shunted to the margins, even in democratic societies, the given social formation is destined for decline for, while there is no law of social determination that can predict that a given society will rely on its own critics (tacit or overt) to set its directions, they remain the only learning class precisely because of their distance from economic and social reproduction. Consequently, a society that narrows the space for critical discourse risks oblivion, or, at least, stagnation and decline. We may find similar positions articulated by Mannheim in the early postwar period which visualize a world in which, with the help of intellectuals, states widely adopt the norm of "democratic" planning to regulate economic and political relations; here planning is the term that stands for "rationality" in a period during which the irrational held sway over human affairs.[31]

Today, we can see the attempt to democratize and rationalize Soviet public life at work in the 30 year effort in the Soviet Union and Eastern Europe to reform archaic institutions, such as the central planning of all economic sectors and state control over knowledge and the arts and a totalitarian political system which represses virtually all dissent. A fraction of the ruling bureaucracy, perceiving stagnation and decline, has attempted to save the system by integrating scientific, cultural, and dissident political intellectuals into the state as partners rather than subordinates. On the one hand, reforms, such as introducing a limited market, especially for agricultural goods, and genuine elections for some high offices, are implemented for the practical interest of assuring cooperation among peasants and intellectuals in the face of severe economic hardship. The provision of consumer goods and the recruiting of scientists and engineers to participate in technologically driven growth are measures designed to legitimate the Soviet system among an increasingly disaffected young, educated middle class frustrated by the system's rigidities.

On the other hand, a substantial fraction of hegemonic intellectuals who occupy key party, state, and economic positions has grasped the

possibility that the "legitimation" problems of the regime do not exhaust the necessary reasons for reform. While change from above may, in the end, prove chimerical because of the inherent conservatism of party and state apparatuses, the social forces set in motion by the reform are beginning to go beyond the limits proposed by these authorities in Poland, China, and Hungary. In Poland and China, intellectuals have reached beyond their own social category toward a new discursive basis for social rule—democracy, a term which is not defined exclusively by its conventional parliamentary connotation but embraces conceptions of negative freedom, such as human rights, recognizing independent trade unions and, more broadly, a new egalitarian morality. Some of these tenets have not reached the Soviet Union, especially the idea of trade union autonomy and that of multiple political parties, which have already been recognized in Czechoslovakia, Poland and Hungary. Yet ideas of genuine social renovation are enjoying currency, if not ascendancy, in these societies which have experienced ideological monologism for two generations.

With the stunning exception of Poland, democratic ideology is an emanation of scientific and political intellectuals armed with democratic as well as economic liberal ideology, a fact which signifies their emergence as new social agents in societies marked by decades of Communist rule. Yet, it is still not clear whether, without the strength of alliances with other social categories, the intellectuals can, after their initial successes—especially in Czechoslovakia and Hungary—retain power. In Poland, the alliance of workers and intellectuals was broken by a split between the Prime Minister, an intellectual supported by Adam Michnik and other pro-Solidary intellectuals, and the leader of Solidarity, the shipyard electrician, Lech Walesa. The split, which concerned sharp differences of economic and political strategies for the country's post-Communist reconstruction, resulted in the presidential election of Lech Walesa and a political defeat for the intellectuals.

The question of the complex relations of intellectuals to the state is sharply raised by Miklos Háraszti's recent essay on the artists under state socialism, written before the stunning transformation of Hungary from a "liberal" Communist state to liberal democracy.[32] According to Háraszti, the old censorship, in which artists were strictly monitored and repressed by the state, has given way to a new system of integration. In Hungary before the democratic reform of 1990, artists may write, paint, or perform their works without fear of crackdown—provided they solicit and receive state approbation, a requirement that appears to have been the condition of Solidarity's official recognition in Poland as well. The party wishes the artist to conform,

voluntarily, only to the authority of the state or, at the minimum, to agree that artistic production be subsumed under its aegis, whatever the content of the particular work. Artistic autonomy is not allowed, if by that term we mean artists' ability to constitute themselves as agents without consultation with the authorities. *Authorization* is the key to legitimacy in the new, relatively liberal environment of state socialism. In short, artists can be anything except authors.

It is not clear whether these circumstances, designed to facilitate the freeing of intellectuals from strict ideological censorship, can do the trick of unleashing the desired scientific and cultural creativity. For if intellectuals require genuine independence to make a radical contribution to society's self-knowledge, if something like the alienation effect is necessary, integration may be "counterproductive." It may do little more than substitute a "velvet prison" for the iron bars of overt repression, a prison where artists are invited to contribute their talents but not to spurn the ultimate patronage of the regime. Of course, in most Eastern European societies and, until recently in the Soviet Union as well, cultural intellectuals were free to authorize themselves without, however, expecting the patronage of the state— an exchange which may not remain one for rejoicing. Immersed in both economic crisis and liberal assumptions, Eastern Europe has withdrawn, to a considerable degree, its routine support to non-university intellectuals and artists. This measure entails a new relationship between intellectuals and the commodity system, in which the fashion process rather than ideological constraints is destined to play a much larger role in determining who will make a living as intellectuals and who will be relegated to the rank of talented amateur.

In Western societies, scientists and artists enjoy autonomy, but those holding dissenting or avant-garde ideas are not always invited to contribute. Those who dissent from normatively approved paradigms of scientific or artistic culture may form groups, publish their work (in marginal journals), and agitate for them without overt interference from the authorities who hold the means of violence. On the other hand, the press is free for those who own one; major print and visual media may not publish or broadcast the work of those too far outside the mainstream. Still, marginal and subaltern discourses are published in small, alternative presses, although radio and television access for these views is strongly restricted by financial and ideological forms of censorship.

For scientists, the pressure to conform is more severe. Dominant paradigms exercise both intellectual and institutional power and demand that those who would perform scientific work establish the validity of their discoveries within approved frameworks. The conse-

quences for those who refuse may not entail imprisonment, as in totalitarian regimes, but they are, nonetheless, serious. Laboratory facilities, the necessary condition for virtually all experimental work in the natural sciences and psychology, may not be made available by corporate or university administrations; the leading journals may decline to publish the findings of those whose adherence to the prevailing wisdom, much less the dominant paradigm, is in doubt. In turn, federal grants, the grease of most basic science, will surely not be offered to those practicing marginal science, a restriction which places in question the possibility of breaking the barriers erected by current "normal" science, despite the appearance of anomalies.[33]

Paradigms have two aspects: most important is the method of discovery, the imperative that hypotheses be subject to repeatable tests; second is the agreement of the tested hypothesis with the dominant paradigm at any specified time. For, even if method is observed, the leading presupposition upon which experimental science is based, it must itself conform to the central metaphors of hegemonic science. As Thomas Kuhn argues,[34] even if both conditions are fulfilled (or if the paradigm is under attack from the investigator) the acceptance of new knowledge depends on persuading key members of the scientific community. In this respect, the history of science paints an extremely ambiguous picture. Canonical theories are frequently overturned, but often the scientific community holds dogmatically to already established knowledge, even in the wake of substantial evidence, by its own criteria, to the contrary. The "democratic" norms to which the scientific community is supposed to adhere are observed as much in their breach as by their exercise. Dogma in science as well as statecraft inhibits effectivity of critical discourse, even when it does not prevent it from happening by violent means. The West has its velvet prisons too.

Which raises the question of the status of scientific and cultural communities, East and West. Clearly, the term "community" signifies collective work and decision-making. While the sociology of science has found that such activity occurs, investigation reveals that these "communities" are also power systems which guard their particular knowledge and its forms jealously and frequently repel challenges with considerable ferocity.[35] This tradition owes its virulence, undoubtedly, to the powerful oppositions enlightenment science encountered from the established Church during the Renaissance and Reformation, and the equally repressive encounters with Soviet and Eastern European regimes in the Stalin era. But it cannot be said that Western science is genuinely autonomous, especially in the late 20th century when its alliance (and reliance upon) the state and large

corporations has been established and verified by a large body of literature.[36]

The close relationship of intellectuals in the sciences and arts (except for the artistic avant-garde) with the state carries a price for the entire society for its collective capacity to adapt to new conditions. Here I want to cite only two examples (although others can be mentioned): nuclear weapons proliferation and the ecological crisis. While a relatively small fraction of scientists has opposed nuclear production and a somewhat larger group has advised against proliferation, the overwhelming majority of U.S., Soviet, and French scientists are tied to the defense establishments. In the United States, when an influential group wrote a secret (and repressed) report against President Reagan's plan for a strategic defense initiative, their arguments were framed entirely in terms of technical feasibility rather than addressing the moral and strategic issues. One can infer that a technical discourse invites wider reception among policy makers, while to challenge U.S. strategy places the alliance of science and the state in jcopardy. But this is precisely the point. In Western societies, the claim of science to autonomy is ideological, only the forms of constraint differ with those of Eastern Europe.

The case is equally powerful in relation to the ecological consequences of industrial pollution for water, air, and food. In this regard the scientific community has entered the debates as technicians, but has as yet refused to raise the larger issues: should society continue to pursue policies of economic growth that entail poisoned waters and carcinogenic air, and should public policy sanction the production and use of industrial herbicides on the basis of economic necessity? Scientists and engineers often demur from addressing these questions, arguing that they are really political, not scientific, issues. Thus, the separation of science from its political consequences preserves the moral right of scientists to engage in research which may be harmful to public health even as they engage, hesitantly in criticism of prevailing practices.

Perhaps the questions raised by the introduction of bioengineering are most revealing in this respect. At issue is the use of technologies which alter genes in order to produce new varieties of grain, make organisms resistant to viruses and other infections, and, more broadly, alter the functions of nervous systems, especially the brain. Many, including some molecular biologists from whose science the technology derives, have challenged the potential harmful effects of releasing new organisms into the environment. But few if any have declared that the further production of these organisms may be inimical to human survival. Instead, one often hears the refrain, emanating

from scientists, the bioengineering is "here" and therefore cannot be subject to either a moratorium on further production pending investigation or a reversal of the practice of gene-splicing. Here, the facticity of a science and its technical applications bears heavily upon the scientific community which cannot imagine halting a particular scientific practice as a remedy to the dangers engendered by its activities.[37]

It would be too simple to claim that the reluctance of even the most active critics of the uses of biotechnologies to call for suspending the technology itself bears on their dependence, for the performance of scientific work, on the patronage of those who provide funds. This is surely an important element for explaining the limits of criticism within the scientific community, but is, in the end, insufficient. The power of science consists in its claim to both common sense and the space of truth. Molecular biology is today received in most quarters as what counts as legitimate biological knowledge. The validity of its applications, which are intimately bound with its theoretical presuppositions, is taken as self-evident, subject only to the self-regulation of the scientific community and scrutiny which, in most cases, is directed by scientists themselves under the not-too-close supervision of public bodies. On the one hand, the ideology of scientific autonomy fits nicely with the current practice of deregulation; on the other hand, molecular science's dispassion is undermined by its virtual subsumption under commercially linked technology.

The reluctance of science to submit to public control contrasts sharply with its willing subordination to state and corporate institutions who assure the resources for research. In the latter instance, collaboration between science and industry is considered legitimate because science enters the arrangement voluntarily, while oversight prescribed by law is equated with the heavy hand of Church and Crown against modern science in the 16th and 17th centuries. The traditional stance of science since the 16th century is autonomy; in the contemporary context, scientists resist arguments that show the economic and social constitution of scientific knowledge, the relation of scientific knowledge to interest is no less intimate than any other social practice.

In this brief discussion I have focused on the importance of the emergence of scientific and technical intellectuals in contemporary late capitalist societies because social theory has only begun to recognize these sites. In the main, my attention has been placed on the literary intelligentsia and those intellectuals for whom politics, as such, is a vocation, especially in the period beginning with the First World War and ending with the close of the 1950s (attention which

may be explained by the consensual judgment that the close of this era also concludes a much longer span of historical time during which intellectuals constituted a public sphere of critical discourse).

This discourse was by no means confined to criticism of industrial capitalism, but also a broad range of public issues bearing on the civilizing process in America, the nature of the artistic and scientific culture, and the character of U.S. foreign affairs at a time of this country's world ascendancy. In this endeavor, literary intellectuals of the left play an important part, out of proportion to their number. In fact, the small network of literary and political magazines from the turn of the century to about 1960 embodying the avant-garde of political and artistic dissent were the channels through which modernisms of all sorts received their most ardent defense and aesthetic and theoretical articulation.[38] It may also be argued that the literary left, described recently in a veritable cascade of books and articles, memoirs and biographies by and about key actors in these circles, and collective (mostly literary/political) studies of institutions of the intellectual left, have bequeathed more than interesting social history; they have left a legacy to which current and future intellectual generations must respond. For the overwhelming portrait is that of the past as cornucopia; if not an integrated civilization, at least a spiritual community which, in its cantankerous response to the American mainstream and in spite of its Eurocentrism, succeeded in producing new intellectual voices in a predominantly yahoo culture. In this view, the present signifies retreat as intellectuals have left public spaces for the academy, which, for Russell Jacoby, is a space of impotence.[39]

I want to offer an alternative view of the present: the university has become a knowledge factory, but also a center of cultural explosion the impact of which is as great as that of the independent intellectuals of the "golden" age. We may mourn its passing, but only those with the most myopic vision can speak seriously of the intellectuals of that bygone era as the "last." Indeed, the passing of the public intellectual of the old type does not signify the passing of the public intellectual as such. The forms and the issues are different, and it may be that we have lost the capacity for master discourses. Today, the left intellectual is a feminist, an ecologist, a critic of science and technology, a person of color. Right-wing intellectuals still occupy those universal spaces once the province of the left and liberals. And, in an era where science and technology are forms of power, its organic intellectuals are far more powerful than ever. Yet, as recent fulminations by conservative and liberal magazines and journals attest, at least indirectly, the right is worried about the rise of dissenting and alternative intellectual communities in U.S. universities. (Here I use the term "right"

not as a conventional ideological category, but in the specific context of the *form* in which the current struggle takes: modernism's reaction against postmodern discourses, e.g., the attack against the canon, the search for subcultures, the attempt to suggest the outline of new sciences, and so forth.)[40]

VI.

Gouldner contends that intellectuals are rapidly constituting themselves as a new class capable of contending for political power corresponding to their already formidable economic and cultural position.[41] For Gouldner, the fundamental contradiction in the contemporary situation of late capitalist and state socialist societies consists precisely in the disparity between the considerable autonomy intellectuals already enjoy owing to the culture of critical discourse and their political subordination. Gouldner insists that the old "moneyed" class is dying; moreover, the old base of capitalist social relations is being eclipsed, and not by a revolutionary proletariat, but by the new class of knowledge holders. Although Gouldner criticizes Marxism's dogmatic assertions of the persistence of the class struggle in the old terms, he has not advanced too far beyond some crucial features of Marxist class analysis: with Pierre Bourdieu, he offers a fairly mechanical analogy between material and cultural capital. Even though the new class is salaried and therefore does not own the material means of production either the juridical sense, its power derives from its centrality in production, its possession of knowledge, and the discourse that derives from it. Thus since the new class possesses the means of material production through its monopoly over the means of intellectual production its "blocked ascendancy" at the political level must result in social contradictions which have historical consequences.

Despite the evident economism of these propositions, Gouldner has advanced the debate beyond Gramsci's theory of hegemony in which, it will be recalled, intellectuals derive their social weight from the characteristic classes of a given mode of production. By insisting that intellectuals are self-legitimating, the real burden for his new class theory relies, in the last instance, on the idea of post-industrial society. The chief characteristics of societies in which the old capital-labor relation no longer dominates the social landscape is that cultural capital has displaced material capital as their leading dynamic, and the knowledge/power system is the structure in dominance. In these terms, cultural capital is understood not as a property of superstructure, in which the struggle over accumulation is the infrastructure,

but as a new universal signifier for the system as a whole. If knowledge has displaced manual labor as the crucial component of capital formation, a thesis which can be quantitatively, as well as theoretically, substantiated, its bearers must constitute not only a new and increasingly significant social category, but also a class challenge to the prevailing bases of power which are rooted in the old production relations.

Thus, Gouldner's provocative suggestion of intellectuals as a new class parallels Elias's theory of knowledge as independent of the productive forces or, more exactly, he argues for the autonomy, at least in the present conjunction of knowledge from its dependence on capital. The difference between the two is that Elias posits knowledge as a structural feature of the constitution of any civilization while Gouldner, retaining a historical materialist framework, situates the rise of intellectuals historically, both in terms of the transformation in conditions of accumulation and the passing of industrial society. The Marxist categorical scaffolding remains in place, but the actors, corresponding to new "higher" production relations, have changed. The "class" struggle is depicted in terms consonant with the transition from feudalism to capitalism: a rising new class, having established the domination of the production relations of which it is the bearer, confronts old political and social powers. From this premise, the old regime is "more or less rapidly" transformed into new, higher relations of production. The crucial move is to abolish the machinery of the state and replace it with new class power.

At the same time, Gouldner borrows a major theme from conventional sociology of science: those who participate in the Cultural of Critical Discourse, a norm of the scientific community, want free communication in the dissemination of knowledge, an objective frustrated by corporate and state bureaucracies which value knowledge only as a commodity and wish, therefore, to hold it as property. This notion was advanced in the late 1930s by Gouldner's mentor Robert Merton, who posited "communism" as an inherent feature of science.[42] For Merton, the conflict of science and society arises when society imposes, for any reason, restrictions on the free flow of information among scientists. Therefore, free science requires a democratic society. The subversive side of this theory of the social relations of science is its tacit critique of the notion of the private ownership of knowledge; on the other hand, Merton has constructed an ideal type whose correspondence to the actual social relations of science, both of the internal power structure of the scientific communities and their links with the larger social nexus, is not only imprecise but tends to justify the social relations of science under conditions of Western capitalism, indeed,

to justify a kind of democratic pluralist state as the only context sympathetic to the flowering of scientific knowledge. Gouldner accepts this framework as a basis of his own theory of intellectuals, and this borrowing results in a series of fundamental lacunae. He identifies capitalist and state socialist states as inimical to the underlying values of the knowledge communities which, he assumes, are "interested" in critical discourse. This assertion is made without the benefit of argument; that knowledge communities constitute a culture of critical discourse is taken as axiomatic and combined with well-known sociological insights to form a thesis of class formation. Indeed, the idea of science as critical inquiry is what precisely is in contention by the new sociology of science. Far from accepting Merton's theses regarding the normative content of scientific communities, a new generation of writers has shown, with considerable theoretical and empirical acumen, that science and particular interests have become inextricably linked, such that science is ordinary discourse: i.e., its supposed character as self-reflexive, self-correcting (ideological influences) inquiry is part of its mythology upon which its social power is based. If this view is right, then we may not uncritically include science in the cohort of critical intellectuals. Yet, by relying on the notion of knowledge as a productive force to justify his theory, Gouldner's concept of intellectuals not only includes scientific and technological workers, but is crucially dependent on them. One might argue, especially in revolutionary societies, for the idea of cultural intellectuals as a new source of class power; certainly the humanistic intellectuals in China, the Soviet Union, and Poland have played important roles in the democratic movement. But this is not what Gouldner means. Although he has not explicitly acknowledged the origin of CCD in the scientific and technological communities, the ninth thesis of his *Future of Intellectuals*, which concerns their conflict with bureaucratic and political elites, reveals that he believes that the interest of the new class is not constrained by conventional ideologies or, more to the point, refuses the authorization of established institutions of authority. Instead, the obstacles to their political ascendancy and enhanced status honor appear increasingly irrational from the perspective of the actual movement of the productive forces. The new class appears, at least to itself, as the legitimate inheritor of political authority because it holds scientific and technical knowledge, which is more than possession, but constitutes a force which finds itself at odds with the still dominant culture which demands subordination.

Gouldner ignores the mounting evidence, already available prior to 1979 when his book was published, demonstrating that the norms of

freedom which purportedly inform the scientific community are norms which the Scientific community rarely observes.[43] The fact is, established scientific knowledge is frequently defended against new knowledge by those who possess the means of its production, means of production that no longer embody the intellect as such but, rather, the machinery and the institutions for the production of knowledge. For the modern laboratory, no less than the university, is a knowledge factory controlled by those whose power to pronounce truth is held as private property against others who might challenge their hegemony. Far from conforming to the culture of critical discourse, much of modern science and technology is constituted as dogma. In short, if the scientific community is taken as a model of CCD there is reason to believe that its invocation is seriously flawed as the presupposition for the thesis of a new class. Both those engaged in "pure" science and the so-called technical intelligentsia are paradigm-bound. Those challenging the dominant paradigm are consigned to the margins of the communities or, more routinely, completed excluded. As Ludvik Fleck, Bruno Latour, and others have forcefully argued, scientific paradigms are forms of power, forms which go beyond intellectual authority in the narrow meaning of the phrase. The displacement of a given paradigm entails not only the overthrow of intellectual orientations, but also leading institutions and groups within the community, methods of production, types of capital investment, and so on. In turn, this struggle is implicated with larger social forces in other ways: the scientific community may enjoy relative autonomy, and its exercise of power confronts the old moneyed classes and state bureaucrats as both opponents and allies. To shift a paradigm entails, therefore, more than Kuhn allows: it's not only a group of leading scientists who must be persuaded, but corporate leaders and politicians as well. Moreover, the internal content of the paradigm is not independent of the ideologies and discourses of the dominant social formation. In short, the culture of science and technology is a subset of hegemonic rationalities from which knowledge communities are not free. For the thesis of a new class formation among intellectuals would have to demonstrate that knowledge is independent of its social context, with respect both to its methods of inquiry as well as its results and their form, in order to contravene the idea that its place within the prevailing division of labor does not set boundary conditions for its range of action. Gouldner's new class theory falls on his acceptance of the internal history of scientific knowledge as an adequate basis for class formation under determinate, historically constituted conditions.

Having said this, there is growing evidence that scientific and tech-

nical intellectuals are seeking an independent role in state formations, even as they are subordinate to capital and bureaucratic states. I have argued that this is particularly relevant to state socialist societies, but there is a second sign of nascent class formation in the emergence of the French Socialist Party under Mitterand after 1968. In contrast to the Communist party, which was a mass party whose cadre were recruited largely from the industrial working class, the traditional, cultural intellectuals, and a fraction of local professional politicos, the Socialists, once derisively described as a party of provincial teachers, were rebuilt mostly under the Mitterand's leadership as a party of technical and managerial intellectuals. To be sure, the French bureaucracy has always had a strong grip on the state, owing to the centralization of crucial economic and social institutions under its aegis. The technocratic class is by no means a new phenomenon associated solely with the Socialists. The top rungs of the powerful French state bureaucracy have, for more than a century, been recruited from among graduates of the *grandes écoles*, especially the Ecole Normale Supérieure, the site for training traditional intellectuals, the écoles administratifs, and the leading scientific schools that train scientists and bureaucrats. However, the originality of the new configuration consists in the fact that the party leadership is recruited almost exclusively from this social category, a development highlighted by its ostentatious and obligatory fronting of figures of proletarian or trade union origin in a sea of leaders whose careers have been made as high bureaucrats or professors. What is new here is that this social category has taken over a traditional political party of the left and transformed it into a second party of the nation, alongside the Gaullist formations.

Faced with the post-De Gaulle, post-1968 disarray of the Grand bourgeoisie and the breakup of the right Gaullist hegemony over the old political class, the Parti Socialiste (PS) became the party of government of the 1980s and early 1990s. This is a party whose relation to traditional constituencies of the old capitalist regime is extremely tenuous. The postwar PS was rife with factions and experienced several splits in the 1950s, most notably from a left-wing formation called the Unified Socialist Party (PSU) which built some ties to trade union activists, especially within the CFDT, France's second largest Labor federation. Under the leadership of Jean-Pierre Chevenment, the CRES, another left fraction, played an important role in forging the PS alliance with the Communists which endured from 1972–86; this alliance, Daniel Singer, among others, has argued, was the linchpin of the new Socialist ascendancy.[44]

But this group virtually disappeared as an independent party force in the years since Mitterand took presidential power and won a parlia-

mentary majority in 1981. With the reintegration of the majority of the PSU, the left of the party (which, at least in tendency, was oriented to building a mass, democratically based organization that had some of the characteristics of a social movement) no longer plays a real role in policy formation; nor is the traditional socialist "right" particularly strong, except in the south of France where Socialists capture important local offices in and around Marseilles, victories accomplished with the help of the staunchly anti-communist Catholic center. These forces have never enjoyed significant national influence in the reconstituted PS and remain content to support the technocratic leadership of Mitterand and former PSU leader Michel Rocard. In fact, Rocard has been a major force in transforming the party from one of opposition (and therefore faction-ridden) to one of government (and consequently unified under the leadership of technical intellectuals).

As a party of government, the PS has felt obliged to move even further to the center, replicating its traditional alliance with the moderate right in the 1950s at the local level. This opening persuaded many disaffected Communist voters to return home in the 1988 legislative elections, when the PS ran a campaign designed to win a bare parliamentary majority on the basis of a *de facto* coalition with the center-right in preference to achieving a clear left majority. After his decisive victory over Jacques Chirac, Mitterand's strategy was to hold down the legislative victory so that workers, immigrants, and intellectuals could not reasonably demand, as they did in 1981, a new wave of social reform, such as dramatic rises in wage minimums, voting rights for immigrants, and other major redistributive measures. The PS objective, to administer economic austerity with a human face, is based upon growth-oriented politics. According to the conventional technocratic wisdom of which the PS, more than the traditional political class, is the supreme expression in contemporary France, the key to growth is scientific and technological investment, especially in the new industries such as genetic engineering, computers/electronics, arms, and nuclear energy. Further, the Socialists have made political modernization one of their top priorities. This latter policy is aimed at reducing the importance of both extreme right-wing parties and those of the extreme left to the electoral vanishing point, to weaken the fighting capacity of the labor movement and the Communist party which, to a considerable degree, still dominates labor although with reduced strength, and, concomitantly, to take ideological considerations out of politics—at least those ideologies emanating indirectly from the unfinished business of the French Revolutions of 1789 and 1871. In short, the PS program amounts to the politics of vote aggregation rather than of social movements, new or old and, moreover, is

heavily electorally oriented, which implies the conflation of democracy, republicanism, and a conception of socialist responsibility identical to the welfare state. Even the PS democratic promise of decentralized, locally based authority, so boldly announced in the wake of its 1981 victory, has been quietly relegated to the backburner. Notwithstanding Lenin's fear that intellectuals favor reformist localism, decentralization is really anathema to new class technocratic intellectuals, for whom effective planning requires more concentration of power at the top.

This is a politics profoundly suspicious of organized constituencies and of social movements which are often not subject to the exigencies of representative government but generally insist on retaining their own voices. The Socialists have amassed something more than ⅓ of the vote, but their coherence is defined by the broad and increasingly ambiguous concept of the "left" alliance under the hegemony, both ideologically and organizationally, of the state bureaucracy which, even in violation of its own party, the PS, constitutes a relatively autonomous force in French state politics. Thus, in contrast to Germany and Sweden where a specific social-democratic movement has dominated the left since the turn of the century, the French Socialists constitute a significant fraction of graduates of the grand literary and administrative *écoles* and are constituted by two generations of these schools. For example, one of Mitterand's closest political advisors and his undisputed confidant, Jacques Attali, historian and critic, is representative of the academic social category which has affiliated with the new PS; Michel Rocard, a *grand école*-trained high government civil servant is typical of a second and increasingly dominant group of intellectuals, the technical and administrative stratum. Taken together with the specifically significant French scientific establishment which is largely part of the civil service, these categories constitute a new political class sharing the same or similar social backgrounds, educational formation, and occupational identities.

That these categories form the core cadre of the dominant party in contemporary French politics may be attributable to the three-way ideological split on the right, but also the deep left divisions that are unable to choose between opposition and power. The unflinching characteristic of the PS is its taste for power at nearly all costs. The burning questions of the old socialist movements, e.g., whether to take state power within a capitalist framework and, if so, the degree of socialization of ownership that may be imposed without revolutionary transformation, fail to detain mainline socialist leaders even for a second: these are men for whom power calls out its own demands. Since their social base is, at once, diverse and massified, and their ties

with the traditional party, its discipline, and its ideology have been severed, they are not constrained, except by the rituals of political campaigns. To a large extent, the PS is, like U.S. political parties, a child of the new media and the polling organizations to which they are subordinate for both style and policy. Statistics may not have completely replaced live persons, but the effects are as if this displacement defines the political terrain. Consequently, the 1988 presidential campaign was conducted in the media by the PS; its face-to-face encounters with potential voters were restricted to party rallies. But, in a country where television is beginning to come into its own as a political force, Mitterand, whose rhetorical mastery is unsurpassed in French politics, made maximum use of his fluency and image of reasonableness to defeat his more strident opponents.

Among the new political principles is that socialism signifies left-Gaullism, left insofar as Mitterand and his associates recognize that France may not pursue a national strategy apart from the European interest to become an economic and political force independent of the two superpowers (although this desire for independence was severely tested during the recent Gulf crisis when, after some half-hearted moves towards an independent stand, the Mitterand government crumbled under U.S. pressure, which caused the resignation of the erstwhile leftist defense minister, Jean-Pierre Chevenment). Gaullist in that even this European internationalism takes second place to nationalism. The socialists have supported a strong military establishment, including a substantial French nuclear capability, just as did De Gaulle. Thus, the French have led the way for other European socialist parties (particularly Italy, Spain, and Greece). As national parties, the socialists can do no more than initiate or carry over elements of the welfare state, insure trade union freedom to organize and bargain collectively, and safeguard the infrastructures of parliamentary democracy. The Southern European socialists feel constrained by the world economic crisis which has impacted heavily on their national economies. Hence, they have more steadily moved rightward; in Spain, for example, they are now perceived as a pro-business, pro-international investment government.

In all of these countries the intellectuals, far from remaining professional servants in the model of the old bureaucracy, or organically tied to traditional classes, have forged political vehicles in which they hold the reins of power, even as they are obliged to recognize, but only tactically, some of the demands of movements whose support they seek or, more pertinently, wish to divert from entering politics on an autonomous plane. For example, the Greens, who are weak everywhere in Southern Europe except Italy, have nevertheless

evoked a cynical, but superficially sympathetic response by Mitter-and. He named their former leader minister of the environment, only to defund and ultimately embarrass him. Moreover, the leading party group regards ecological concerns as inimical to growth politics. As the economic crisis wears on in Europe, the socialists as the party of state managers grow in proportion as the right, whose rise to power was propelled by postwar economic "miracles," loses legitimacy in its *echt* conservative manifestation, but not in its populist mode. The Communist left struggles, unsuccessfully, to gain a new lease on political life after de-industrialization which has, even more than Mitter-and's brilliant war of maneuver that outflanked it on its own "red-belt" turf, deprived the CP of its natural constituency.

Each of these partially discredited parties were constituted once by great social movements which intervened in making history. The socialists, on the other hand, betray the tendencies normally associated with hegemonic ideologies and parties: their "movement" roots lie far in the past and today resemble contemporary Western progressivism; that is, they are agents of modernity. They disclaim interest in structural reform, but instead present themselves in the garb of honest and efficient government, economic recovery, and technological progress. The new class seeks to make of its metier a set of new political principles, by signifying that effective administration, scientific and technological progress, and cultural dissemination includes social justice as a byproduct. Far from representing CCD, the new class dedicates itself to government as a process of puzzle-solving; just like normal science in Kuhn's reprise, its grasp of the economy is drawn from neo-liberal economics, and its understanding of the social question is purely instrumental and disinterested.

The vision of the new class is one where technologies of administration and economic growth replace ideology as the stuff of social rule. As in the United States, social justice is a signifier whose meaning has shifted to compassion. Now compassion is a term whose meaning can only be discerned in the context of an idea of *noblesse oblige*, in this case the largesse of a government and the classes which constitute its power constellation. The compassionate state is an image shared by the center-left and the center-right which have together agreed that the old democratic slogan of self-management first advanced before 1968 by the extreme left and adopted briefly as the Common PS–PC program in the seventies is infantile or worse, disruptive in the quest for the smooth society.

Yet, this technocratic shift in "really existing" socialist ideology remains unchallenged on the French and other lefts where it has become hegemonic precisely because of the decline of the working

class and the traditional intellectuals who took the action-critique of factory occupations and generalized it to a new anti-bureaucratic principle, not only as an antidote to corporate and state bureaucracies but to those of the labor movement itself. The new class emerges, but not from the culture of critical discourse. Its growth is attributable to the void produced by the demobilization of these social categories, but also the weight of technicism in modern life whose legitimating characteristic is the claim to neutrality, that is, the idea of bureaucratic administration as an instrument of, rather than barrier to, democratic process.

Which raises the problem of the avant-garde in contemporary society. For the common feature of artistic and political vanguards is their marginality or, put another way, the possibility of a margin in technocratic regimes. While the thesis of total administration advanced by the later Frankfurt School[45] is not only excessive in its empirical claim, but theoretically forecloses the emergence of new agents and fails to account for the persistence of the opposition even in darkest times, the valid core of the theory emerges with special poignancy in periods of of retrenchment—such as we have collectively experienced since 1968. The explosion of that year, today celebrated as nostalgia, as well as legacy, by left remnants everywhere, reminds us that nothing is forever, that today's upsurge is tomorrow's museum piece. But it is also important to remember Weber's hesitation before Marx's sweeping historical judgment about the permanence of class formations within the capitalist mode of production. Weber argued that classes and class struggle could only be posited in concrete contexts; in one language, they consolidate around problematics whose historicity constitutes their boundaries. Thus, the industrial working class is a crucial social actor in the epoch of machine production, the struggle for universal male suffrage, the formation of powerful trade unions based on craft and industry, and so forth. The end of this epoch, which lasted more than a century in the United States and longer in Britain, produces a profound shift in class structure even as capitalist social relations prevail. The new epoch is marked by the domination of intellectual over manual labor in proportion as scientific knowledge become the major productive force. But, beyond production cultural hegemony is the condition for reproducing the system as a whole, particularly popular consent for the prevailing order, especially when force cannot even be used as a last resort without the ruling group suffering serious consequences. In the transition from one regime to another, Laclau and Mouffe have argued that class is replaced by discourse and the concept of the social itself disappears. Such judgments cannot be examined here, except to note that those who claim

privilege of discourse over class formation in historical description
may, unintentionally, signify the dominance of knowledge categories
as a characteristic of the new regime. Gouldner's new class theory
may have misidentified the source of the power of intellectuals. Provi-
sionally, I want to argue that in these societies in which the knowledge
mode of production prevails and culture is an ineluctable feature of
social rule, intellectuals may become the only genuine political class.
Thus, the political avant-garde can no longer imitate the old profes-
sional revolutionary for whom the conquest of state power by the
class-conscious proletariat was ideological cant. Such a proletariat
no longer exists in these societies, even as it emerges in state socialist
and peripheral capitalist regimes.

The new avant-gardes must today challenge the democratic claims
of the bureaucratic state of which the new class has become the
soul. To be sure, the new class cannot be theorized as an inevitable
consequence of the passing of the powers of the old working class. It
comes into being when the old ruling class reveals its incapacity for
political rule, a crisis which is expressed not so much in terms of the
economic displacements which are currently afflicting workers in
advanced capitalist countries and, tendentially, in state socialist soci-
eties. The mechanisms of the welfare state do not, on the whole,
permit these societies to replicate the mass suffering of the last great
depression. Rather, the crisis is one of legitimation of the entire politi-
cal and cultural order, including the old left parties which were an
integral part of it. Lacking Keynesian solutions to the economic crisis
or socialist alternatives to it, the terms of political debate turn on
questions of administration. Elections are fought on the proposition
that the administration must replace the old ideological debates, on
the consensus that these are times when there are no real answers
that go beyond considerations of policy. The victory of the right over
the left in the 1980s is in the process of being superceded by a new
class hegemony speaking in the name of the "left," but resembling it
in only the threadbare remnants of Keynesianism, a framework it
adopts only opportunistically for the purposes of capturing office
without power, but in which it has no confidence. The new avant-
garde must be utopian even as it takes into account the drift of utopias
to authoritarianism, and no longer—in concerns of utopia primarily
in technological sense—followed by intellectuals since Saint-Simon
and Fourier. It can only prevail as an educational force by engaging
the signifiers of power—democracy, management, justice—in a way
which systematically delegitimates the claims of the new class to own
the images associated with these signs.

In the United States, the Jesse Jackson campaign of the eighties

succeeded in addressing justice and removing its signifying power from new class representations. But his campaign lacked a language to extend the debate beyond its Keynesian connotations to questions of management, that is, to a new conception of democracy. In this respect, he followed the myopia of the conventional "left-progressives" who lacked even a democratic rhetorical practice, except that derived from the popular front slogans of the thirties. These signs, taken together with the elusive ideas of freedom and pleasure which have always been the palpable enemies of total administration and work-oriented societies, constitute in their totality the elements of a new utopian discourse. To be sure, their constituencies are, for now, defeated and dispersed in the West, taking shelter in the underground of the dominant culture. In their intellectual manifestation they do constitute a culture of critical discourse, because they challenge the scientifically based technocratic culture which is emblematic of the new class. In germ, this is the basis of the doctrines of radical feminism and social ecology discourses which have, until recently, lacked a language of social justice and thereby often cut themselves off from crucial political interventions. Green politics is today an important component of a new, not yet emerged political culture. Its class basis shifts contextually, but comprises strong currents of disaffected new class members. Similarly, feminism, often disparaged by the conventional left for its middle-class basis, may be read as another crucial indicator of the power of the new social categories of knowledge producers; feminism may signify, together with the ecology and gay movements, a countervailing weight to the still dominant technological discourse within the professional/managerial "class" (here the quotation marks are meant to indicate the still indeterminate character of these categories.) Whatever the outcome of the struggle, there is simply no doubt that new agents have emerged, the histories of which are in the process of shifting from that of subordination to social power.

Notes

1. See especially Alvin Gouldner, *The Future of Intellectuals and the Rise of the New Class* (New York: Seabury Press, 1979); André Gorz, "Technology, technicians, and the class struggle," in André Gorz, ed., *The Division of Labour* (London: Harvester Press, 1976); Antonio Gramsci, "On Intellectuals," in Gramsci, *Selections from the Prison Notebooks*, translated and edited by Quintin Hoare and Geoffrey Nowell Smith (New York: International Publishers, 1971).

2. For a discussion of this issue see my "Marxism and Democracy," in Stanley Aronowitz, *Crisis in Historical Materialism* (2nd edition) (Minneapolis: University of Minnesota Press, 1990).

3. John and Barbara Ehrenreich, "The Professional Managerial Class," in Pat Walker, ed., *Between Labor and Capital* (Boston: South End Press, 1976); also my response in the same volume, Stanley Aronowitz, "Professional Managerial Class or Middle Strata?"

4. Georg Konrad and Ivan Szelenyi, *Intellectuals on the Road to Class Power* (New York: Harcourt Brace Jovanovich, 1979).

5. Karl Marx, *18th Brumaire of Louis Bonaparte*, in Karl Marx, *Selected Writings*, vol. 1 (New York: International Publishers, n.d.).

6. Robert Michels, *Political Parties* (Glencoe, Ill.: Free Press, 1955).

7. Ernesto Laclau and Chantal Mouffe, *Hegemony and Socialist Strategy* (London: Verso, 1985).

8. Karl Marx, *Grundrisse*, translated by Martin Nicholaus (London: Penguin Books, 1973), p. 706: "The development of fixed capital indicates to what degree general social knowledge has become a direct force of production and to what degree hence the conditions of the process of social life itself have come under the control of the general intellect and been transformed in accordance with it."

9. Gramsci, "On Intellectuals."

10. Gramsci, *Prison Notebooks*, p. 15.

11. *Ibid.*

12. See especially Dirk Hoerder, *People and Mobs: Crowd Action During the American Revolution 1765–1780* (Berlin: Free University, 1971); Bernard Bailyn, *Ideological Origins of the American Revolution* (Cambridge: Harvard University Press, 1967); Arthur M. Schlesinger, Sr., "Political Mobs in the American Revolution 1775–1776," *American Philosophical Society Proceedings* (1955), pp. 244–50.

13. Hoerder, *People and Mobs*, chapter 2.

14. Bailyn has collected these pamphlets for the Library of Congress. His *Ideological Origins* is really a close analysis of these primary texts.

15. Hoerder, *People and Mobs*, p. 144.

16. See Gorz, "Technology, technicians, and the class struggle."

17. This argument is more fully developed in David Rousset, *The Legacy of the Bolshevik Revolution, vol. 1* (London: Allison and Busby, 1982). See also Samuel Farber, *Before Stalinism: The Rise and Fall of Soviet Democracy* (London: Verso, 1990). This study is a scathing indictment of pre-Stalin Bolshevism and a startling repudiation of the commonly held belief among many radical intellectuals that the origins of authoritarian Bolshevism may be traced to the rise of Joseph Stalin to preeminence within the Soviet State. However, Farber does not stress the conflict of workers and intellectuals, but attributes this conflict, whose roots are in the party's distrust of the autonomy of working-class institutions, to the 1905 period!

18. Rousset, *Legacy of the Bolshevik Revolution*.

19. Ferenc Feher, Agnes Heller, and Georgy Markus, *Dictatorship Over Needs* (London: Basil Blackwell, 1982).

20. Pierre Bourdieu and Jean Passeron have elaborated the category of cultural capital to describe the function of educational institutions in capitalist societies. See Bourdieu and Passeron, *Reproduction in Education, Culture and Society* (London and Los Angeles: Sage Publications, 1979).

21. Indeed, Soviet President Mikhail Gorbachev has resolutely opposed separatism,

especially that of Lithuania, Latvia, and Estonia, annexed in 1940 and, of course, Russia, which is the most populous and industrially developed Republic in the Soviet Union.

22. Joseph Agassi, *Faraday as a Natural Philosopher* (Chicago: University of Chicago Press, 1971), p. 1.

23. Bruno Latour, "Give me a Laboratory . . . ," in Karen Knorr-Cetina and Michael Mulkey, eds., *Science Observed: Perspectives in the Social Study of Science* (London: Sage Publications, 1983).

24. Rosa Luxemburg, "Organizational Questions of Social Democracy," in Dick Howard, ed., *Political Writings* (New York: Monthly Review Press, 1975).

25. *Ibid.*, p. 294.

26. V.I. Lenin, *What is to be Done?* (in VI Lenin, *Selected Works.* International Publishers ND).

27. Luxemburg, "Organizational Questions," p. 299.

28. Norbert Elias, *Power and Civility* (New York: Pantheon Books, 1982).

29. Alexandre Koyre, *From the Closed World to the Infinite Universe* (Baltimore: Johns Hopkins University Press, 1957), chapter 1; Karl Mannheim, *Ideology and Utopia* (London: Routledge and Kegan Paul, 1936).

30. Jürgen Habermas, "Historical Materialism and the Development of Normative Structures," in *Communications and the Evolution of Society* (Boston: Beacon Press, 1979).

31. Karl Mannheim, *Freedom, Power and Democratic Planning* (London: Routledge and Kegan Paul, 1946).

32. Miklos Háraszti, *The Velvet Prison* (New York: Basic Books, 1987).

33. Stanley Aronowitz, *Science as Power: Discourse and Ideology in Modern Society* (Minneapolis: University of Minnesota Press, 1988).

34. Thomas Kuhn, *Structure of Scientific Revolutions* (Chicago: University of Chicago Press, 1962, 1969).

35. For a case study, see Arthur Koestler, *The Case of the Midwife Toad* (New York: Random House, 1972).

36. For a comprehensive treatment of the relation of science, corporations, and the state, see David Dickson, *The New Politics of Science* (New York: Pantheon Books, 1984).

37. For a fine study of the contemporary politics of biotechnology, see Sheldon Krimsky, *Genetic Alchemy: The Social History of the DNA Controversy* (Cambridge: MIT Press, 1982).

38. Of course, the leading left intellectual journal of the late 1930s and the 1940s was *Partisan Review*, which played an enormously influential role in intellectuals circles until the mid-1950s when it discovered, belatedly, nationalism and even patriotism. From its 1952 symposium "Our Country and Our Culture" to the present, the magazine ceased to be on the cutting edge of avant-garde cultural politics.

39. Russell Jacoby, *The Last Intellectuals* (New York: Basic Books, 1987).

40. But for a genuinely right-wing response, see Roger Kimball, *Tenured Radicals* (New York: Basic Books, 1990).

41. Gouldner, *The Future of Intellectuals.*

42. Robert Merton, *The Sociology of Science* (Chicago: University of Chicago Press, 1973).

43. For example, see Ludvik Fleck, *The Genesis and Development of a Scientific Fact* (Chicago: University of Chicago Press, 1979). This study of the "discovery" of syphilis was first published in German in 1935.

44. Daniel Singer, *Is Socialism Doomed?* (New York: Oxford University Press, 1988).

45. The thesis pervades the writing of the later Frankfurt School. Adorno is probably responsible for the formulation of the "totally administered society," but the idea appears as well in Marcuse's *One Dimensional Man* (Boston: Beacon Press, 1964). The concept comprehends the degree to which state and corporate institutions—indeed the very idea of organization—permeate the so-called "private sphere," and instrumental rationality dominates all public discussion and state policy. However, the notion of one-dimensionality advanced by Marcuse as early as 1941 in his essay "Some Social Implications of Modern Technology" is criticized, tacitly, by Adorno:

> The organic composition of man is growing. [Where "organic composition" refers to Marx's historical judgment that the proportion of past dead labor in the form of machinery and raw materials to "living" labor grows as capital relies increasingly on technological innovation to maintain the rate of profit.] That which determines subjects as means of production and not as living purposes, increases with the proportion of machinery to variable capital [wages]. The pat phrase about the "mechanization" of man is deceptive because it thinks of him as something static. . . . Only when the process that begins with the metamorphosis of labour-power into a commodity has permeated man through and through and objectified each of their impulses as formally commensurable variations of the exchange relationship, is it possible for life to reproduce itself under prevailing conditions of production. Its consummate organization demands the coordination of people that are dead. The will to live finds itself dependent on the denial of the will to live: self-preservation annuls all who live in subjectivity . . . The organic composition of man refers by no means only to the specialized technical faculties, but—and this the usual cultural criticism will not at any price admit—equally to their opposite moments of naturalness which once themselves sprung from the social dialectic and are now succumbing to it. Even what differs from technology in man is now being incorporated into it as a kind of lubrication. *Minima Moralia* (London: New Left Books, 1974), pp. 229–30 (commentary within brackets mine).

Here Adorno relies on Marx's critique of political economy, not just metaphorically, but in its letter. The logic of accumulation, in which the subordination of labor appears to be a "natural" process through both its commodification and its incorporation into the productive forces as only one among several "factors" of production is, in the final instance, the explanation for total administration.

4

Theory and Socialist Strategy

The global left is embroiled in two concurrent but separate debates. The first concerns the so-called "crisis in Marxism," the second is a much more recent controversy: what is the status of socialism, both as an alternative to capitalism considered historically, and as a social movement? The crisis in Marxism is not new; it has reappeared periodically since the turn of the 20th century and possesses a different character than the issues surrounding socialism. First of all, since Marxism considers itself a critical or positive science (depending on tendency), its links to socialist politics, which have a distinctly "ideological" character, are indirect. One may argue that the new self-examination of Marxism has been detonated by the conjuncture of economic and political developments, but the nature of the questions asked and the answers provided are connected to the specific discourses of science. Put another way, the sociological and ideological aspects of the crisis of Marxism as a science do not exhaust the issues. Later, I will try to survey the history of the crisis in Marxism problem since the turn of the 20th century. Suffice it here to point out that while it is not new, every reincarnation adds more challenges to the Marxist scientific paradigm. For example, none of the previous periods in this debate subjected socialism to such scrutiny as is currently the norm, or challenged the role of the working class as a vital component of any possible emancipatory project. Thus socialism suffers today from the first global challenge to at least three of its fundamental claims: 1) to be the *determinate* alternative to the prevailing capitalist world order; 2) that the societies that constitute the "really existing" socialisms represent an historical advance over advanced capitalist countries, and that under conditions of world economic and political crisis of the capitalist order the movements toward socialism are clearly on the political agenda; and 3) that socialism as an ideology

subsumes other oppositional social movements and can accommodate their demands within its program.

Ernesto Laclau and Chantal Mouffe have added their voices to these debates. What distinguishes *Hegemony and Socialist Strategy* from other contributions are two critical differences. First, theirs is the boldest, if not the first, attempt to marshal the entire corpus of French poststructuralist philosophy as methodological and epistemological critiques of historical materialism. They have not only provided an external critique in the light of events, but have attempted to refute Marxism from within as a form of essentialism. Further, they have proposed an alternate paradigm in which the primacy of the economic, indeed the existence of the social as an axiom of political and social theory, is denied. Second, this is the premier effort to carry the apparatus of poststructuralism, particularly the work of Derrida and Foucault, in the examination of socialism as the defining vision of a putative radical or revolutionary movement. They have affirmed the key tenets of democracy, especially its radical version, as unfinished business in those societies of which they are a part. Democracy constitutes itself as the alternative, of which socialism is a subordinate aspect in their discourse. Ideas such as pluralism, when placed in the context of Laclau and Mouffe's political theory, separate themselves from liberalism. Thus, unlike the spate of post-Marxisms of the late 1970s, this is a *left* critique of Marxism that tacitly accepts Marx's own attack against representative democracy and the "free" market as proposed by 19th-century liberals.

Laclau and Mouffe have proposed a libertarian model of democratic society that rests on the power of social movements rather than political parties to transform civil society. Given the political backgrounds of the authors, their adoption of a "social movements" perspective is undoubtedly linked to the character of the postwar reliance of the socialist movements, including the communists, on the electoral arena for representing their program. Consequently, the rise of bureaucratic leftism, so vividly portrayed by Claude Lefort and Cornelius Castoriadis, raised serious questions concerning the status of the established European left as an alternative to late capitalism. Rather, implied by the parliamentary focus of the left is a deep desire to integrate themselves as part of the forces of order, not against them.

Hegemony and Socialist Strategy is deeply influenced by the action-critique of "new" historical agents, particularly feminists and ecologists, but also the ultra-left splits from the communist and socialist parties for whom the declarations of the Italian Communists that they are a party of order represent the death of the mainstream socialist movement. More concretely, the agendas of both feminist and ecologi-

cally based movements challenge the hegemony of the traditional working class in their respective national contexts. Laclau and Mouffe's renunciation of the idea of working-class hegemony is also a critique of the practical strategy of seeking parliamentary reforms adopted by the parties of the left. For them, it is not only an historical question (the working-class movement has declined in social weight since the end of the 1950s, for example), but a matter of the formulation of the question of historical agency itself. The heart of this book is the discourse concerning agency, but as I will try to show below, it succeeds only in raising the question, not in providing a solid alternative theory.

Denying the working class's *a priori* hegemony over the social and political opposition, they argue for a pluralism of emancipatory discourses. Thus, *Hegemony and Socialist Strategy* functions on three levels: 1) it is a critique of Marxism as science, showing instead that its axioms and propositions are ideological; 2) it is an exposition of the fundamental concepts of discourse theory developed by Foucault, Derrida, and Wittgenstein; and 3) it develops the outline of a new political theory based on these ideas. I will argue that they have succeeded in making their case against some varieties of Marxism, but that their poststructuralist critique of historical materialism, although fascinating, contains large caveats that they cannot overcome without revising their framework. I will also argue that while their political theory is suggestive and sometimes exciting, it suffers from a lack of specificity—it must, therefore, be considered a series of *hypotheses* rather than a real theory.

I.

Louis Althusser may have been the preeminent Marxist philosopher of science in the 20th century. His effort to establish the scientificity of Marxism was undertaken to answer critics who claimed that Marxism was non-science (cf. *For Marx*, 1969). Althusser's strategy was to show that one tendency in the Marxist tradition, humanism, certainly corresponded to characterizations such as those of Karl Popper that Marxism was both essentialist and historicist (cf. *The Poverty of Historicism*, 1962). To preserve Marx's paradigm of the social world in the light of contemporary philosophy, it was necessary to recast the axiomatic structure: to proclaim an epistemological break between Marx and Hegel, not primarily concerning the theory of knowledge, but the crucial question of the object of scientific investigation. By substituting the mode of production for the "essentialist" man, by reconstituting the dialectic as a structured rather than expressive

totality and other moves, Marx had effected nothing less than a scientific revolution, one that was constructed by the critique of humanism, even Marx's own earlier version. Thus, science was distinguished from ideology through *criticism* and *self-criticism*.

Although Althusser does not adopt Popper's criteria for truth (the capacity of a proposition to be subject to falsifiability, refutation, and empirical test), their conceptions of science are remarkably similar. Both are concerned with the problem of demarcation between science and non-science. Both understand science as a *critical* activity if those who practice it are ruthless in constantly examining their own presuppositions. That such ideas were shared by Gaston Bachelard does not obviate the fact that the movement of scientific philosophy emanating from Wittgenstein, Bertrand Russell, and Popper had become so overpowering by the mid-20th century that Marxism was obliged to accommodate to the fundamental notions of the new philosophy of science, that revolutions in knowledge occur if the knowledge community remains unafraid to banish its old conceptions in the light of new findings (cf. especially Bachelard, *The New Scientific Spirit*, 1985).

Thomas Kuhn tells us that the breakup of any scientific paradigm takes place when its theories can no longer explain anomalies that appear in the course of doing "normal" science (cf. *The Structure of Scientific Revolutions*, 1962). The new paradigm appears to have little relation to the one it replaces; its chief virtue is that it can explain a wider range of phenomena, and its only similarity to the old view is that it must satisfy the criteria for verisimilitude established by the prevailing scientific community. Kuhn's "internal" theory of scientific revolutions has alluded to, but never explored, the ideological-historical environment that surrounds transformations of science. Indeed, the history and philosophy of science is, for the most part, lacking in such "external" explorations. The reason why it is not hard to fathom: enlightenment science sought to free itself from political and ideological censors, to make the knowledge of the external world a matter for the scientific community(ies) alone. As for knowledge of the social, it has never enjoyed even the ideology of autonomy, since its very existence is enmeshed with its economic, political, and social objects. In fact, the social sciences have conventionally suffered in the comparison. The truth value of their discoveries is always provisional, not only in the usual sense, of which Lenin spoke of the relativity of scientific truth (relative to the level of development of the productive forces and of scientific explanation), but also because propositions about the social world are suffused with "interest," condemned to relative truths because of their one-sidedness.

Marxism's claims to scientificity rests not on the argument that it

avoids the historical relativity of its various theories and propositions, but on the idea that the "interests" that permeate the paradigm from which it works are universal. The working class is not just another group with demands—its demands become, at a certain conjuncture, consonant with the project of historical transformation, while all others seek a piece of the existing pie. Marxists have always been obliged by circumstances to distinguish the empirical existence of the proletariat from its "world-historical" position.

The 20th century has been particularly unkind to Marxism, even as Marx himself enjoys scholars' fascination. While socialism remains the central ideological alternative to capitalism (although its "really existing" forms have come under increasing scrutiny and attack), the anomalies of "late" or "advanced" capitalist development have dogged the paradigm. It is not only the theory of capitalist crisis, perhaps the core of scientific Marxism, that has been subjected to endless criticism and revision, but the idea that the really existing proletariat ineluctably evolves into a revolutionary agent has been greeted with massive skepticism.

Early criticisms of the centrality of the proletariat as historical agent of systematic transformation are centered, almost exclusively, on the practical activities of the working classes in major capitalist countries—their limited trade union struggles, parliamentary struggles for reforms and, most distressing, the support of socialist and labor parties for the war policies of their own governments in both world wars (although the struggle against fascism was of a different kind than the First World War). Moreover, a large segment of the "empirical" proletariat supported German and Italian fascism in the 1930s, not because of economic policies of these regimes, which are intimately bound to their war preparations, but because, as Wilhelm Reich, George Bataille, and Ernst Bloch note, fascism becomes a mass movement precisely to the extent that it renounces accumulation of capital as the foundation of the social order, an impulse which liberalism shares with socialism. Fascism is never defeated from within but requires the combined efforts of the Soviet and U.S. military machines to crush its states because the spirit of bureaucratic and technical rationality which permeates the left and the center between the wars is simply incapable of opposing its cultural hegemony.

Later, critics begin to generalize from these instances and conclude that the proletariat has become a "working class," de-radicalized to the core in proportion as its "rational" demands are met by late capitalist states, and these demands signal a new corporativism in which the parties of the left are a vital component. The crisis in

Marxism, then, begins to resemble the crisis in the working-class movement: Marxism's will to scientificity signals its desire for legitimation within the late capitalist order, just as its scientific hegemony in the second world creates an ineluctable link between intellectuals and state power.

II.

The "crisis in Marxism" problem appears first at the turn of the century. Its early protagonists, Eduard Bernstein and Georges Sorel, laid out the principle themes that are repeated today (cf. Bernstein, *Evolutionary Socialism;* J. Stanley, ed., *From Georges Sorel;* and Sorel, *Illusion of Progress*). Bernstein challenges Marxist crisis theory by declaring capitalism's capacity for rational organization as well as positing a radical distinction between reform and revolution, arguing for the primacy of the former, or, to be more exact, the impossibility of a revolutionary rupture under conditions of bourgeois democratic planning. For Bernstein, Marx accurately predicted the emergence of the proletariat as a new historical agent, but underestimated the power of capitalist self-regulation. The conjuncture produces a new working-class strategy in which the moment of rupture never comes and socialism, far from constituting the inevitable future of capitalist societies, becomes an ethical ideal that informs labor's practice within an evolving capitalist order but in no way determines them.

Sorel's attack proceeds from his contention that Marxism emulates 18th-century scientific determinism. Most telling is his critique of Marxism as a form of idealism, a doctrine suffused with self-deception, especially in its effort to establish the law-like character of social and economic development. What Sorel calls Marxism's "dialectical illusion" consists precisely in the notion of reciprocal and determinate relations between productive forces and relations. Although accepting Marxist categories, he tries to show that the determination by the economic "in the last instance" of all social phenomena is simply not right because the economy "is subject to chance" in effect, is itself indeterminate under conditions of competition. Reductionist formulas "conceal the true nature of phenomena from the ideas of the inattentive observer and hides fundamental chance beneath the apparent social physics" (cf. Stanley, ed., *From Georges Sorel*). Thus, while admitting the usefulness of historical materialism's insistence that history must be explained strictly by material means, he accuses Marxism of resorting to metaphysical abstraction to make its case.

From a contemporary perspective, these criticisms might be dismissed as valid objections to Second International Marxism that

imagined itself the analogy to physics or chemistry, but the Sorelian critique emerges again in the late 1930s during an era when Leninist orthodoxy dominates the theoretical landscape. For Sidney Hook, without citing either Sorel or Bernstein, repeats their critique and adds another point, a blistering attack on Engels's concept of the dialectic of nature and a criticism of the Hegelian dialectic as so much mysticism (cf. Hook, *Reason, Social Myth and Democracy*, 1940). Now, at this time (1940), Hook is still a Marxist in the sense that he relies on the working class to dig capitalism's grave and holds that capitalist inequality is systemic rather than conjunctural. His admiration for Trotsky does not prevent him from criticizing Marxism from a scientific perspective, i.e., from the point of view of experimental method.

No doubt the crisis in Marxism problem is engendered by the appearance of social and political crises. Hook's fundamental break from Leninist orthodoxy was surely influenced by his embrace of American pragmatism, and acceptance of parliamentary democracy as a permanent achievement, but also by his refusal to regard the Soviet Union as aberrant in an otherwise determined progressive course of historical development. Hook's subsequent militantly conservative anti-socialism as well as anti-Marxism cannot detract from his contribution to Marxist criticism or indeed diminish the fact that he independently arrived at most of the critiques of Marxism that have reappeared in the late 1970s and 1980s.

One of Hook's most trenchant and prescient arguments is his critique of historical materialism's traditional failure to recognize the disjuncture between the economic infrastructure and the forms of political rule characteristic of various capitalist societies. Hook contends Marxism's economism cannot explain how and why different forms of the state may emerge from similar economic arrangements. In effect, in current parlance, he is arguing both for the specificity of the political as well as its relative autonomy from the economic base. That is to say, forms of state power and political struggle differ according to divergent cultural traditions, specific characteristics of the capitalist class, and the state bureaucracy. Hook recognizes the importance of the "elite" theories of the state of Mosca, Pareto, and Michels without embracing their undemocratic conclusion that history is made by elites and counter-elites with little or no intervention of the masses (cf. Mosca, *The Ruling Class;* Pareto, *Mind and Society;* and Michels, *Political Parties*). Hook's argument for the relative autonomy of the superstructure prefigures the more theoretically sophisticated efforts of Althusser, Nicos Poulantzas, and others to retain the Marxist architecture by constructing new categories to explain the indeterminacy of social relations. That the structuralists were obliged

to graft linguistic and psychoanalytic categories onto Marxism in order to preserve it from the cruel blows of historical anomaly augured badly for its future, even if this maneuver succeeded for a time in patching up the holes in the corpus.

Gramsci's theory of politics anticipated much of Hook's criticism. His theory of hegemony seemed to accord primacy to ideology in the complex of relations between state, economic infrastructure, and politics (cf. especially "The Intellectuals" in *Selections from the Prison Notebooks*). Since capital ruled by consent even more than force, its ability to impose its worldview and common sense on the masses was the key to its tenacious hold on power, even against the weight of economic breakdown and war. It could be argued that the same holds for revolution which, after all, has not implied even a fundamental transformation of social relations in most cases or even a basic change of authority. One can see the derivation of Althusser's notion of "ideological apparatuses" of the state from Gramsci's insistence that education, religion, literature, and the like were far more than effluxes of prevailing economic infrastructure but rather possessed their own logic.

Laclau and Mouffe begin where others leave off. Their book describes some of these critiques, with the notable exception of those of Hook, since the American discussion about Marxism is almost entirely absent in the European "crisis in Marxism" debate. They draw approvingly on the implications of Bernstein's idea that the working class is no longer dispossessed in the modern capitalist state but has instead become a citizen, a consumer, etc., owing chiefly to the mediating influence of social organization over class domination. This mediating influence is a factor that includes not only the power of the trade unions and the socialist parties, but also the state itself, which had become a space of contestation between and among classes rather than an instrument of the dominant class.

But it is Sorel who provides the crucial idea that Laclau and Mouffe will extend into a full-blown alternative to Marxism—the notion of the indeterminacy of the "identity of social agents." This concept is the logical outcome of Sorel's refusal to see economically based class relations as determinate of the political. Thus, if the political level is autonomous, just as the economic and the ideological, then the centrality of class and class struggle in the Marxist paradigm must necessarily be denied.

Still, Sorel accepts the Marxist designation of the proletariat as historical agent, even as he denies the penchant of the Marxist parties toward parliamentarianism. Sorel seeks the transformation of the

social order through the creation of a society of producers which is based upon the principle of self-management through industrial action, namely the mass strike. While it is true that major theorists of the Second International such as Rosa Luxemburg and the council communists (Anton Pannekoek, Herman Gorter) held similar views, only in the French and Spanish labor movements did these ideas still have deep roots in Western capitalist societies. The mass strike is not merely an act of withholding labor—it is a means of redemption, of social and cultural transformation, provided it is not detonated by demands so concrete that to grant them would defuse the movement. Further, when Sorel speaks of the need for a myth to animate the movements he is recovering what Bataille later is to call "expenditure" or excess as the spiritual basis of the movement, rather than "interests." Yet, even though his anti-economist critique of Marxism stands in the center of their own attempt to reformulate the radical democratic project, Laclau and Mouffe have not gone as far as Sorel in recognizing the cultural foundations for social movements.

For Laclau and Mouffe, Second International Marxism created an essentialist doctrine in which the working class was, *a priori*, the social agent. Nor was Gramsci exempt from such error. Although he saw the relatively powerful role ideology and the state performed in modern capitalist societies, hegemonic functions were still tied to classes. "The economic base (for Gramsci) may not assure the ultimate victory of the working class, since this depends on its capacity for hegemonic leadership. However, a failure in the hegemony of the working class can only be followed by a reconstitution of bourgeois hegemony so that, in the end, political struggle is a zero sum game among classes." Laclau and Mouffe seek to overcome this "inner essentialist core" of Gramsci by removing the idea of correspondence, or more exactly, of representation, from the concept of hegemony. Hegemony, to use Freud's idea about sexuality, "attaches itself" to movements, fractions of classes, or whatever, but its effects as well as its appearance are not reducible to class relations.

Hegemony is constituted, but not by primordial class relations. Following Sorel, Laclau and Mouffe argue that there is no necessary or logical relation between social agents and productive relations. Instead, they launch a frontal assault on the independent materiality of the economic, arguing instead for the primacy of *discursive formations* within which the social itself is constituted as a precarious field within which these formations contest for hegemony. In turn, all the categories of the social become merely positions in the discursive fields which, for Laclau and Mouffe, are now considered material

forces that do not attach to metaphysical "classes" but to concrete movements that are themselves articulated in terms of discursive practices.

One of the more refreshing aspects of this book is the reflexivity of its authors. Unlike many cultural and social theorists who have adopted what is sometimes called "discourse theory" on the purely method-ological plane as a tool for analysis, Laclau and Mouffe attack the issue philosophically. Thus, they acknowledge their distance, not only from the Hegelian dialectic and notions of totality that emanate from "Western" Marxism, but also from epistemological materialism ac-cording to which the objective world independent of will constitutes the object of social knowledge. Rather, they argue that all objects are constituted discursively, and they "affirm the material character of every discursive structure." Discourse, then, is by no means a category of thought, but is constituted as a "language game," following the suggestion of Wittgenstein, which itself embodies language and ac-tion. "The objective world is structured in relational sequences which do not necessarily have a finalistic sense and which, in most cases, do not actually require any meaning at all; it is sufficient that certain regularities establish differential positions for us to be able to speak of a discursive formation."

The consequence of all this for the critique of Marxism is profound. The distinction between base and superstructure which implies hier-archy of both determination and historical priority is jettisoned. In-stead, we have language and action constituting a host of discursive formations, each of which consists of "regularities of differential posi-tions." Thus, the impossibility of the social, considered by both Marx-ism and sociology as a "fact," since society is itself constituted by discourse rather than enjoying the ontological status of a totality requiring no further reduction. "There is no sutured space peculiar to 'society' since the social itself has no essence." Much of this work has already been done by Foucault, who tried to clear historical writing of its essentialist, *a priori* concepts such as identity, mediation, deter-mination, etc. The insistence on the ineluctability of difference is one issue. The second is whether *anything* is outside the discursive field. Drawing on a crucial passage of Foucault's *Archaeology of Knowledge*, Laclau and Mouffe insist that objects are constituted discursively, that the distinction between language and "the field" of action is spurious; language and "the field of action" are merely differentiated positions in a discursive formation. If this is so, the whole Marxist theory of ideology, even the profound renovations of Gramsci and Althusser who liberated it from "false consciousness" and placed it within institutions, are refuted. For, despite their efforts to make

ideology a material force, Gramsci and Althusser retained the distinction between social relations as an object *sui generis* and discourses which, in the last instance, were part of the superstructure. Marxism cannot escape the problem of representation inherent in the base-superstructure model which relegates the signified or represented to derivative status but, even more important, argues for correspondence and identity as axioms of Marxist epistemology.

Althusser's brave attempt to resolve this problem by means of Lacanian psychology provides the major critical intervention in *Hegemony and Socialist Strategy*. By showing that "everything existing in the social is overdetermined," Althusser rendered problematic his contrary declaration that the social was determined in the last instance by the economy. Yet, just as no Christian theologian can deny God no matter how revolutionary his/her account of the fate of humans, Marxism is tied to a discursive structure in which ideas such as the mode of production, mediation, crisis, and historical agency possess transhistorical priority.

Having radically decentered the discourse of Marxist social theory, the final chapter begins a new discourse of political theory which comprises the book's originality. Before discussing the political implications of Laclau and Mouffe's social linguistics, a few comments on the framework.

III.

1. Derrida admits that it is impossible to avoid logocentrism, since these structures are embedded in language and, of course, language is inseparable from thought (cf. Derrida in Macksey and Donato, eds., *The Structuralist Controversy*). Therefore, Derrida's philosophy is a provocation, not a system that can hope to replace Hegel or, indeed, any philosophy of totality that promises to transcend immediate conditions. Whether the expressive totality of the Hegelians, in which subject-object identity is the result of a long, contradictory historical process, or the structured totalities which acknowledge difference and, especially, discursive formations but insist on the idea of a *structure of dominance* that holds everything (provisionally) together (one such structure is the economy, another the unconscious), *making sense of the world entails determination.* Even Foucault, whose arguments parallel those of Laclau and Mouffe, faces the paradox of determinacy/indeterminacy when he *does* history instead of talking about it. Although renouncing the historical *a priori* of the political economy, Natural History, or clinical medicine as a "condition for the reality of statements," did not Foucault enter the history of moral/ethical

discourse as a condition and carry this *a priori* between and within centuries? It is not a question of posing political economy as a condition *against* the so-called marginal "superstructural" discourses that Foucault explores. I merely want to assert the ubiquity of essentialism. Indeed, Foucault almost becomes a functionalist when articulating a periodic *episteme* in terms of its discursive practices, while brilliantly succeeding in obliterating the distinction between language and object. His history is infused with interest which is by no means innocent.

Foucault may be regarded as an historian of the moral economy of Western Europe. He examines "rules that define a discursive practice," which are "caught up in the very things they connect." But the normative intention is not in the least disguised. For rules of human action are always normative, their "meaning" derived from the power relations of which they are a part. So Foucault, who demands that we recognize the historicity of every social relation and the embeddedness of power in speech and vice versa, must still assert a tacit logic in his history—discourse as determination. Moreover, Foucault's historiography is not constituted by pure dispersion in that it contains its own unity of method. Foucault's "rules" are positivities for examining the social. The object of historical inquiry is knowledge that constitutes itself as a science, but can be shown to be just another discursive practice implying power/domination. "Instead of exploring the consciousness/knowledge/science axis (which cannot escape subjectivity), archaeology explores the discursive practice/knowledge/science axis" (cf. Foucault, *Power/Knowledge*). Thus, the subject is not implied by the term "savoir," as opposed to "*connaissance*" because knowledge here does not entail a notion of ideas corresponding either to a "reality" independent of knowledge or possessing truth separate from the conditions of its production. Logically, these rules enunciated as such pose themselves, perhaps unwittingly, as alternatives to political economy which starts from an examination of the mode of production of material life, the relations that arise from the division of the social product, and the processes and conflicts over accumulation. These are different procedures in form, but the algorithmic substance is similar.

Laclau and Mouffe's reflexivity does not extend to the paradox of doing social "archaeology" as opposed to social theory. Even the most critical archaeology constitutes its object of knowledge as a critique of other possible objects; its discourses imply hierarchies of determination. We may choose certain discursive practices as crucial for specific historical "*epistemes*" in which case we have not abandoned the notion of determination, only *a priori* transhistorical judgment. That is, we might argue (as I would) that the efficacy of political

economy on the methodological plane may correspond to specific social formations situated in determinate positions, and would surely be included in any menu of discourses for an inquiry seeking explanation. The task would be to articulate the characteristic category of political economy (class, commodity, surplus value, profit, etc.) with those that may be specified concerning the political, cultural, or any other discursive formation. The problem with the Foucauldian algorithm is its exclusions. Class, commodity, and so forth simply disappear as proper objects of interrogation. In their passion to separate their own discourse from that of Marxism, Laclau and Mouffe have cogently argued against traditional Marxist hegemonies but have left room for the categories of political economy.

2. "Whereof one cannot speak, thereof one must be silent," says Wittgenstein in his *Tractatus*. This, together with its corollary, "The limits of my language means the limits of my world" signify the death of the extra-linguistic. Language loses its character as representation/expression and becomes the sole constitutive of what we mark as the social or, indeed, the natural. Foucault and Derrida have adapted these *dicta* absent the concern, still present in Wittgenstein, with meaning. Foucault says in an interview published in *Power/Knowledge* that nature cannot be comprehended apart from the signifying practices that recuperate "it" within discourse. In other words, nature may be understood only in its constructed context, only as it is articulated within culture. This has been a fecund advance from traditional materialist epistemology that insists on a realist theory of science and a reflection theory of knowledge. For what we have gained by discourse theory is that science/knowledge is liberated from the ideological connotation of its neutrality. We understand all knowledge in the context of power, not just social knowledge or politics which Althusser calls ideology. Thus, discourse is never far from the play of domination and resistance. Yet, just as Foucault's rules for historical investigation contain the tacit disappearance of political economy and especially the production of material life (now relegated to the realm of technical rationality which loses its contestatory power), so the reduction of social relations to discursive formations eliminates natural history, condemning it as "essentialist."

Since Engels and Marx placed human communities in the context of natural history and, in Engels's case, subjected them to the rules of natural scientific investigation, many tendencies within the Marxist movement have labored to free social relations from the burden of scientific Marxism, a feature of which was to insist that human societies were "organisms" that obeyed laws analogous to physics or, to be more exact, 18th-century physics. Lukács's celebrated attack on

Engels borrowed heavily from neo-Kantian *Geisteswissenschaft*, which asserted that social relations could only be understood through the interaction of the observer and the observed, a process that strictly precluded the "objectivity" of the social. For Lukács, it was a matter of remaining faithful to Marx's criticism of traditional materialism. *History and Class Consciousness* tries to comprehend society "subjectively, as sensuous human activity," that is, as a series of practices rather than "an object of contemplation." (The reference is, of course, to Marx's *Theses on Feuerbach*, especially the 2nd thesis.) His epistemological critique of the later Engels entailed a rupture with the scientism of the Second International, in which social transformation had the force of natural law that occurred independently of human intervention.

Laclau and Mouffe join contemporary poststructuralism in announcing the death of the *a priori* subject and implicitly associate themselves with Lacan's reading of Freud—the most important 20th-century theorist of the relatively unsocialized body. Lacan's emblematic pronouncement that the unconscious is structured "like a language" at once made Freudian theory compatible with French linguistic philosophy and removed the most daunting obstacle to the hegemony of the various analytic perspectives that have dominated 20th-century philosophy and social theory. For sexuality in Freud's hands could be harnessed only partially by means of its articulation as both utterance and discourse. The remainder, the excess, the surplus which escaped language's imperious tentacles disrupted social ordering. Yet, for him there was no question of the complete constitution of the human subject through discourse, since the limits of language did not limit the world (cf. Freud, *Civilization and its Discontents;* Lacan, *Ecrits*).

In another register, Ernst Bloch posits the "not yet conscious" mysteries that reveal themselves in dreams or remain at the gestural level, never articulated but incorporated into action. Bloch retains the impulse of the non-articulated intuition, will, desire, that for him explains much of the processes of social change. At times, like the Frankfurt School, he situates desire in art or, speaking politically, in youth for whom desire is the motor of development. Clearly, for Bloch the "new" cannot be merely a concatenation of discourses but attests to the presence of subjects constituted by the not yet conscious against which the prevailing order rails. Bloch's intervention, like Freud's, raises the question of the efficacy of rationalism as a method that explains historical events/transformations. Adopting the neo-romantic concept that time is a social rather than a natural category, and rejecting the rationalization of the unconscious, Bloch tries to posit

the subject as an indeterminate from the perspective of the social order, precisely because it is constituted by a different "now" than prevailing technologically mediated civilization. Further, he argues that the not yet conscious is situated as a pre-linguistic field in which desire struggles for articulation in *opposition* to the boundaries of prevailing discourses.

What, from Laclau and Mouffe's perspective, are we to make of the Chernobyl catastrophe and other nuclear disasters? Plainly, the mentality that permits the development of nuclear energy and weapons is formed by discourses in which "nature" becomes constituted entirely through technology. But the events themselves attest to a revolt of dominated nature. Whether the external world obeys laws independent of human intervention may be debated. But incontestable is its moment of autonomy, that it is a "subject" the ignorance of whose regularities portend dire consequences for humanity. This is precisely the contention of the ecology movement. Their critique of the arrogance embodied in technological societies, with their post-enlightenment discourses, has barely been heard by socialists—libertarian, authoritarian, or democratic. Laclau and Mouffe have still to absorb the experiences of the confrontation with the outcomes of these technologies, genetic engineering, and even some ordinary industrial practices such as chemistry which have, in the past decade, become occasions for a new look at the notion of the primacy of practice over its object. It may be that the floating signifier, discourse without object, and related doctrines of cultural primacy are by no means simple literary flourishes. Semiotic *philosophy*, as opposed to its descriptive procedures, is merely the cultural expression of the doctrine of the domination of nature which has become a destructive material force in contemporary history.

IV.

The importance of *Hegemony* consists in its pathbreaking attempt to make the literary, philosophical critique of poststructuralism political. Theirs remains an engaged discourse, although not to any existing party or political ideology. It is a "political imaginary" that is "radically libertarian and infinitely more politically ambitious than the classic left." They seek to extend the democratic revolution "to the whole of civil society and the state," as an alternative to the varieties of state socialism, legatees, in their view, of the Jacobin (read elitist) traditions of the French Revolution that aim "merely" to transform the ownership and control of the means of production, leaving civil society and the repressive state apparatus more or less intact. For

Laclau and Mouffe, the democratic revolution is prior to socialism which, in any case, no longer presents itself as the determinate negation of capitalism. Further, the workers' movements, contrary to the expectation by Marxists that they would seek to transform relations of production, have defined their political imaginary within these relations, a sign that the classical left "subject" of historical change has refused its assigned role.

Renouncing a general theory of politics, Laclau and Mouffe place their own democratic hopes in the new social movements that have emerged in the past two decades or which might appear in the future. But for them the feminist, ecology, or any other of the new social movements do not become "transcendent guarantors" of liberation. With Claude Lefort, they suggest that the "site of power is an empty space" filled in an indeterminate manner by those radical democratic discourses that succeed in entering the field of hegemonic practices. None of them enjoys a place of privilege owing to some condition that in advance assures them of premier place in the pantheon of political antagonisms.

Thus, the liberal notion of democratic pluralism is transformed as a political category to mean the autonomization of disparate discourses and struggles and their equivalence—equality in the social sphere. Laclau and Mouffe are so concerned to show the incipient authoritarianism in Marxism that such notions of moral, discursive, or any other kind of authority have no place. For they share the confusion of authority with authoritarianism that sometimes afflicts many forms of libertarian thought. This confusion prevents them from engaging the issue of what happens when a social movement gains power, not only within a civil society or the state, but also how its moral authority may enable it to set the agenda for left politics.

One would have to undertake a concrete investigation of the recent experiences of countries such as South Africa, Brazil, and Poland, each of which has forged an alliance between an insurgent workers' movement and the Church, to grasp the idea of authority without entailed domination. For the workers' movements of these countries function within a set of social antagonisms where their particular demands as workers conjoined with the more generalized demand for freedom from dictatorship. In these cases, a militant working class, acting as *a* but perhaps not *the* subject, has succeeded in exercising moral authority with other social movements, including the democratic movement of intellectuals. Since the workers' movements in these industrializing countries entered a less than empty space of power because a repressive state held nearly all of the reins, democratic demands dominate the political imaginary of these workers'

movements as well as other social movements. In Brazil, mass strikes in 1978–79 resulted in the formation of a broadly based Workers' Party that has challenged the traditional opposition to the military regime because it has abandoned the democratic front strategy of the old Brazilian left in favor of a radical democratic politics. In Poland, state socialism confronts the democratic workers' movement. And, in both countries, the Catholic Church has intervened on the side of the workers. The Brazilian church calls for the return of civil society to "base communities," while trying to force the state to relinquish authority over such institutions as education, health care, and the workplace. The social movements in Brazil are allied with the Workers' Party or the democratic front. Even the labor movement is divided in its affiliations. However, there is no question that the struggle for hegemony within society entails the appearance of new subjects, preeminently workers.

The common characteristics of these situations are fairly plain: in each country the authoritarian state combined with multinational corporations to invent a model of development based, in part, on the proletarianization of the countryside without the benefit of the bourgeois democratic revolution. In effect, a working class is constituted without rights. So far, the pattern of development is similar to the period of industrial revolution in Britain and other European countries. However, instead of a situation where the struggle for workers' and other democratic rights conflicts with a prevalent democratic ideology embodied in a parliamentary state, the authority offers only mass consumerism, a Fordist solution with which it expects to forestall workers' demands for trade union autonomy and political participation.

The working class is not only constituted as a separate economic category by heavy investments, policies of agricultural migration, etc., but it is also constituted discursively as a class by the globalization effect of economic development. The bourgeoisie of Brazil, the Communist Party of Poland, and the Afrikaner white minority of South Africa want to create a nationalist movement without a popular base in the developing proletariat. Consequently, the democratic workers' demands correspond to those of intellectuals in all these cases (church-based in part, university-based in part). The coalition becomes simultaneously anti-capitalist and democratic in Brazil and South Africa while anti-new class in Poland. The structure of democratic opposition, while differing in forms, is remarkably similar in many other ways among the three movements.

This account differs from a traditional Marxist understanding of class and class struggle. The Brazilian democratic movement arose

under specific conditions that differed from the Polish case. In each of them, the configuration of political struggle was determined by the conjuncture of the different forms of repressive states' rapid industrialization, the history of revolutionary and socialist discourses, as well as the concrete circumstances which produced an insurgent working-class movement, not the least of which was the presence of charismatic leaders within the metallurgical industries and within the black South African miners, typically the flagship sectors of advanced industrial economies. There is no question that subjects were formed in these conjunctures, overdetermined, accidental to a large degree, and fraught with consequences that were largely unintentional. Having said all this, it is clear that hegemony, constituted as moral and intellectual leadership, has become a social category in these situations. In these instances, the role of intellectuals is at once crucial and ambiguous. For the Brazilian labor movement works with intellectuals, but is by no means subordinate to them. The intellectuals of the church and the secular Marxist academics constitute quite separate discursive formations in the complex alliance that is the Workers' Party, but on every level of ideological struggle the metal workers have articulated their own position, including the vision of the new society they seek—in Laclau and Mouffe's terms, their political imaginary. Needless to say, their political imaginary differs from those articulated by intellectuals not linked directly to the labor movement.

In sum, a rigorous application of the principle of *historical specificity* in the articulation of radical democratic politics of the type Laclau and Mouffe affirm helps to confront discourse theory with its own *a priori*. One wishes the textual emphasis of their work could have been supplemented with case studies. Such studies would have encountered moments of hegemony without domination which would have corrected Laclau and Mouffe's confusion between authoritarianism and authority, the Subject with a complex of subjects, and restored political economy, natural history, and other despised discourses of the last century to a place in the multiple positions that constitute the social. Nevertheless, *Hegemony and Socialist Strategy* deserves careful reading. It raises most of the questions that have languished on the margins of traditional left discourse, particularly Leninist circles and even among democratic socialists. It is precisely in the wake of the current crisis that their book offers an opportunity to lay aside the legacy of an all but discredited past and start over.

5

Working-Class Culture
in the Electronic Age

Individual and collective identities are constructed on three articulated sites: the biological, the social, and the cultural. The biologically given characteristics which we bring to every social interaction are often covered over by social relations (such as the family and the school) and the technological sensorium that we call mass or popular culture. In Western culture these biological givens assume meaning over which individuals have some control, but are often beyond our powers to reverse. Our race and sex confer boundaries as well as possibilities in various relations, particularly the kind of friends we can make, work we can do, mates that are available to us. Of course, the meanings of race and sex, like those of class, are socially constituted—there is no "inherent" significance to these identities as social signs. However, we are born into these identities, given the social arrangements.

The second crucial site is our interaction with family, school, the workplace, and other conventional institutions such as the Church. These relationships are often conceived as self-determining, that is, free of their biological givens. Obviously, parents and teachers treat boys and girls differently: we might say they enjoy/suffer a different moral development regardless of class membership or race. As many writers have argued, the family remains, perhaps, the crucial site for reproducing sexual differences.

While schools are crucial secondary institutions in reproducing sexual difference, they play a major part in the reproduction of racial difference, the specific forms of which remain to be fully explored. It is enough here to point out that the school is the first place the child experiences as racially segregated, since modernism ended gender segregation. It is in school that the child experiences itself as white

or black: needless to say, textbooks make clear to blacks their subordinate status, apart from any overt content. Black images, even when they appear, are tokens of the power of the civil rights movement over the past thirty years, but black history and black culture remain absent, a silence which signifies relations of domination. Of course, there are less subtle signs of difference: the failure of racial integration since the Supreme Court decision outlawing segregation thirty-five years ago is an overwhelming feature of public schooling. White kids learn that they are of a specific race simply by virtue of the absence of blacks in their classrooms. Blacks understand this by parental instruction, but realize that race means subordination by virtue of second-class education, the inferior resources made available to them, and finally come to realize that their individual and collective life chances have been decided long before they enter the workworld (a realization white working-class kids only have by secondary school).

Class representations are largely constructed by mass-mediated culture, especially since the working-class community, like the urban-based mass-production industries that created it, passed into history. I do not want to devalue the importance of school for determining "how working-class kids get working class jobs" (in Paul Willis's account, mostly by rebelling against the middle-class curriculum[1]). This process still occurs in schools, but the working-class kids' culture—at least among whites—is acutely marginalized in an era when, in the older cities of industrial capitalism, the traditional working class is being wiped out.

In this paper I want to concentrate on the third crucial site where identity is constructed, that of mass-mediated culture. I especially want to trace the *displacement* of representations of the working class in this realm. I will show that there are no longer direct representations of the interactions among workers in American television, but that these have been refracted through the police shows that still (in 1988) dominate prime time. These same shows have become important in British and French television also. In this connection it may be argued that television shows that are "made in the USA" have become important exports. As American-made durable goods no longer dominate world markets for these products, the ingression of American culture in world communications markets has grown. This inverse ratio can be seen in new films in Paris. For example, in any given week, of the dozen new films opening in that city, between four and six are American imports. *Miami Vice, Hill Street Blues*, and *L.A. Law* are among the top twenty shows in English and French television. Only advertising appears to remain truly national, but signs of Americanization are appearing in French commercial videos, including ads.

Mass-media representations can no longer be grouped under institutional socializations which include the family, peer interactions, and schools. The media are *unique* sites precisely because of the specific place of technology in the production of culture. To be more precise, mass-mediated visual culture occupies the "objective" space of the dreamwork, and constitutes its double. Louis Althusser's claim that the school is the chief ideological state apparatus may hold for the production of the *symbolic* system, that constellation of signs and codes through which is construed the field of what counts as reliable knowledge.[2] But the mass media construct the *social imaginary*, the place where kids situate themselves in their emotional life, where the future appears as a narration of possibilities as well as limits.

I also want to argue that what we call "popular culture" has become technologically mediated, even as the acoustic guitar is now an instrument for the production of high or esoteric music. The popular is still produced by the "people," but is no longer appropriated directly (just as the biological givens return in a subsumed form through social construction). That is to say, we can no longer (if we ever could) distinguish what really counts as a popular form from the electronically produced culture that is consumed as records, television programs, or movies.[3] Television is not just a manipulator of popular culture, it constitutes a crucial element in the construction of imaginary life and is appropriated, just like rock music for young people, as popular culture (in the same manner as songs and dances for rural populations in the pre-industrial era).

The electronic media can determine, to some degree, *how* social life is represented (that is, their autonomous field of action consists in modes of representation), but not whether a social category *will* be represented. Therefore, it is literally not possible to totally exclude working-class representations, but is it equally improbable that these representations would remain direct under conditions where the cultural traditions of workers are disappearing or occupying smaller social spaces. Moreover, modes of representation are themselves refracted narratives of working-class history. So, if we find representations of working-class life assuming the configuration of police shows or, in the case of Bruce Springsteen, a nostalgia for the absent subject, we can take these forms as social knowledge open to critical deciphering like all fictions.

II.

When I worked in the steel mills, the barroom was far more than a place to have a casual beer or to get drunk. It was scene of union

politics, the site of convivial relationships that were hard to sustain on the shop floor because of the noise, frequent speedups, and the ever watchful eye of the foreman. Of course we had the john, but only for twenty minutes at a time; as the metal was heating up in furnaces, we often took a break. Sometimes the john substituted for the broom. Animated arguments took place about baseball, women, or an accident that had just occurred, usually one in which one of our fellow workers was hurt (I remember Felix who caught a hot wire in his leg). But inevitably, the warning buzzer would interrupt our discussions—metal was nearly ready to come out and be drawn into wire.

So, the "gin mill" was the place where our collective identity as a community was forged and reproduced. Even when we had harsh disagreements about things that really mattered (whether we should stop work over a safety grievance or whether Jackie Robinson was a better second baseman than Billy Martin, a tinderbox of an issue in 1960), we knew that the next day we would have to pull together in the hot mill, that our disputes were in the family. We also knew that we had to fight the boss together, not only for the ordinary reasons of better pay and benefits, but for our survival. The mill was a dangerous place and, for most of us, losing a limb meant losing the best paying job we were ever likely to own, for in the union shops of the 1950s and early 1960s, the job was a property right. As we used to say, the only reason you could get fired was if you punched the foreman while sober.

Steelwork was definitely male culture. As in Freud's essay on femininity, women were the mysterious "other." We did not know much about them and, apart from the incessant desire that occupied our prurient conversations, they did not enter into our working lives. Women were an obscure object of our desire, but desire also reached out for a secure collective identity. For even as early as fifteen years after the war, the neighborhoods of Newark, Elizabeth, and Jersey City (within which working people saw in the faces of others a part of their own selves, a self that was recognized in the local grocery store, at bingo games held in the basements of Catholic Churches which became the place where the women's community was formed) were in the process of dissolving. I remember meeting shopmates at the movies, in the neighborhood Chinese restaurant where we took the kids for dinner some Sunday evenings, in the bar on South Orange Avenue where a diemaker named John hung out (we became friends because we were both interested in music; he played accordian, professionally, at Polish weddings on weekends).

I went to christenings and confirmations in the area around the place which was located in an industrial suburb. Most of the families

were of Eastern and Southern European backgrounds, not only Italians and Poles (although they were in the majority), but also Czechs, Russians, and Greeks. People lived around the northern New Jersey plants in wood frame one-family houses or in "uppers" (the second and third floors of multiple dwellings). Those of us who were not veterans of the Second World War or the Korean War did not qualify for special mortgage deals, so we rented apartments that ate about 25% of our monthly pay. However, a growing minority of my friends were moving to the middle-class suburbs where single-family housing developments were mushrooming, or more graphically, springing up like weeds. These were more modern homes, often built without firm foundations even though they were constructed on landfill. They surely did not fulfill the letter of James Truslow Adam's "American Dream," but they were an acceptable facsimile until something better came along.

Suburban flight was made feasible by low-interest mortgages, but also by the federal highway program initiated by President Harry Truman and fulfilled by the Eisenhower administration. In earlier years, living fifteen or twenty miles from the plant was simply not an option because the roads were invariably local. Such a round trip could take more than two hours. Now, barring traffic jams, evening- and night-shift workers could make it to work in twenty minutes, and those working days simply left home before rush hour and came back late. For many, being away from the wife and kids presented few, if any, problems; male culture excluded women and the notion that men should share child care was simply unthinkable in most families in those days. Certainly, many workers were left behind—blacks and Hispanics, young workers not yet able to raise a down payment or still unmarried, and older workers who had literally failed to recover from the Depression wipe-out.

White working-class flight was engendered, in part, by the influx of Southern and Caribbean blacks into large Northern cities, and also by the failure of federal and state lawmakers to expand the federal housing program beyond the poor. In fact, the choice of the home mortgage program was the alternative to new multi-dwelling housing for workers; housing for large families was simply unavailable in the cities at rents that even relatively high-paid steel workers could afford. Racism was not the "cause" of white flight in the sense that individuals who harbored these attitudes decided to move to get away from blacks. Racism is the result of a combination of developments. In addition to the urban housing shortage (where virtually no new one-family moderate income homes were constructed after the War), the era was marked by a precipitous decline in services—schools, hospi-

tals, and amenities such as recreation and child care were in either serious disrepair or overcrowded.

In historical retrospect, the deterioration of the urban regions after the War was federal and corporate policy. By the mid-1960s center-city industrial plants were closing down. In Harrison, the industrial suburb of Newark, General Motors removed its roller bearing plant to the Union county suburb, Kenilworth. General Electric closed its lamp factory in the black section of Newark, and by the end of the decade, no major industrial plant remained in that city. Jersey City and Hoboken suffered similar fates; industrial expansion was still a powerful spur to economic growth, but not in the big cities. Capital and white working-class flight go together with the federal housing and highway programs, and the enthusiasm of local communities to give away the keys to the town to any corporation willing to build a plant, office building, or research facility.

The dispersion of white workers into the suburbs did not immediately destroy working-class communities, although they were considerably weakened by the late 1950s. The gin mill next to the production mill retained its pride of place. Sometimes this function was performed by a bar located in a local union hall or in a fraternal association of, say, Poles or Ukrainians. Typically, a worker would "stop" at the bar after going off shift for an hour or two before going to a home that could be as far as even forty miles away. There, he would play darts, shuffle board, or pool, or sit at the bar and just drink and talk.

Those who worked days arrived home at 7 p.m. (the shift ends at 3 p.m.). After supper, if there were no chores, the family might sit in front of the television set. The television explosion of the 1950s is generally acknowledged to have changed the leisure-time activities of Americans. The simulations that film brought to theater audiences now became daily fare.

III.

Until the early 1960s, a small number of films and TV shows offered direct representations of white workers (usually in a comic or pathetic mode) but the mode of this presentation changed in the next decades. Workers became the object of liberal scorn, portrayed as racist and sexist, and equally important, as politically and socially conservative. Archie Bunker (*All in the Family* [1971–83]) was not only a comic character: he was a moral agent suffused with evil, a direct violation of the code according to which the working class (however scarce its media image) was invariably a hero. In contrast to Marlon Brando's 1954 portrayal (*On the Waterfront*) of a benighted but brave longshore-

man who, in the last analysis, comes down for truth and justice, Bunker is a troglodyte, a "hard hat" whose wrath is aimed at the young, the poor, and the blacks.

It was hard for working-class kids to identify with Archie, but he was, as late as the mid-1970s, a palpable working-class figure, recognizable by his syntax, his body language, his gruff, semi-articulate speech that parodied the results of working-class culture. As I shall demonstrate, Archie proved to be a rearguard character. After his demise (or, rather, his good fortune in having moved up the social ladder), specifically working-class representations disappear with him. Today, working-class kids may still look forward to getting working-class jobs, but forging a class identity is more difficult than ever. They confront a media complex that consistently denies their existence. However, in what amounts to a grudging acknowledgment that it is really impossible to achieve this result, working-class male identity is *displaced* to other, upwardly mobile occupations (e.g., police, football players, and other sites where conventional masculine roles are ubiquitous).

The message is clear: working-class identity, always problematic in American mass culture, is no longer an option. In media representations, we live in a post-industrial service society in which only the traditional *markers* of working-class culture survive. This is especially true for the barroom, where waves of male industrial workers have congregated to share their grievances against the boss, their private troubles, their dreams of collective power and individual escape, their visions of women, their power displacements to the sports arena. But working-class men do not inhabit these television or movie precincts. Instead, they are the watering holes of off-duty cops, of derelicts, of miscellaneous white-collar administrators. The working-class is absent among these signifiers, even as the sites and the forms of conviviality correspond to typical working-class cultural scenes.

Electronically mediated cultural forms play an enlarged role in the formation of cultural identities. Of course, the claim that media are so hegemonic that they exclude the influence of family, peers, and schools appears excessive. But it would be a serious error to conclude that it is an even match. I claim that electronically mediated cultural forms have the upper hand because they carry the authority of the society that, over the last half century, has displaced patriarchal authority. For the discourse of social authority promises what family and friends cannot deliver: a qualitatively better life, consumption on an expanded scale, a chance to move beyond the limits of traditional working-class life.

No institution represents the promise of this type of transcendence

more than the school, for its curriculum is widely understood as a ticket to class mobility. However, the *content* of that alternative is offered working-class kids by the situation comedies of television, the celluloid dreams of the movies, and especially the advertisements which evoke lifestyles considered worthy of emulation. I argue that the relationship between schooling and media representations of vocational and cultural aspirations has become symbiotic: to the extent that the curriculum is almost entirely geared to the presumed occupational requirements of modern corporations and the state, the dependence of what counts as education on the collective cultural ideal is almost total. For these occupational requirements, especially in large parts of the service sector, are not so much technical as they are ideological. That is, just as many advertisements sell not products but capitalism, so school learning is organized around behaviors required by types of bureaucratic work, as well as the rewards offered by consumer society for performance according to established corporate norms. The student is no longer (if *he* ever was) enthusiastic about discovering new things to know, much less Truth. Rather, he wants to find out how the real world works, especially what it takes to achieve a certain level of consumption. In this, the high school is the major site where the "real" world of work is discovered. The student remembers little or nothing of the content of knowledge (facts of history, how to perform algebraic equations, the story line of *Silas Marner*) but remembers how to succeed in receiving good grades, gaining admission to a decent college, or university, and how to curry favor with authorities—teachers, counselors, employers.

Working-class kids often fail to get the message right. As Paul Willis tells us, their rebellion against school authority, manifested as the refusal to internalize the two parts of the curriculum (its manifest "knowledge-based" content and its latent demand for discipline and respect for authority) ensures that they will get working-class jobs rather than make it up the ladder. But, while assembly-line, construction, and other heavy industrial labor was available for school leavers until the 1970s in the U.S. and U.K., these options are today foreclosed by the restructured world economy. Parents, especially fathers, can no longer serve as substitute representations of viable occupational alternatives to those imposed by school and the media. Peers may dissuade an individual from integrating into the prescribed curricula, but the cultural ideal is now increasingly provided by the media. As this ideal erases working-class representations so the class sensorium disappears.

We see this problematic replayed in the film *Dirty Dancing* (1987). A wealthy family in the early 1960s goes to a Borscht Belt Catskill

mountain resort for a short vacation. Two daughters are immediately plunged into the social life, mostly with waiters and entertainers. The waiter chosen by one of the daughters is a Yale Law School student and turns out to be a philanderer. The other daughter commits the transgression that provides the dramatic grist for the narrative: she falls in love with the resort's star attraction, a working-class youth who has succeeded in learning Latin, ballet, and other "exotic" dances. He gives lessons, performs, and fools around with the women who work as entertainers or in the kitchen, similarly of lower-class background. Unlike other films of this developing genre of class indiscretion (working-class men/upper-class women), this film has a happy ending because the young woman chooses to become a dancer—she exercises her option to downward mobility, to be declassed. The working-class man has become a professional; he may be working in the Catskills but he certainly is talented. And these qualities have already separated him from his roots, so the relationship is acceptable.

I shall amplify on the theme of displacement later in this paper. For now, it is enough to ask how to engage in a pedagogy among working-class students concerning their social identity. Indeed, if identification is a basis for the forging of a personal identity, school and media consort to persuade, cajole, and, by the absence of representations, force working-class kids to accept middle-class identities as the only legitimate option available to them. However, it is obvious that many will choose neither to accept this course or, having bought into the aspirations, will "fail" to make the grade. The result for both groups is cultural homelessness. Clearly, the task of a pedagogy that addresses this dilemma is to address it by a critical examination of its contours, its motivations, and its consequences.

From this discussion, several issues come to the front as being important: the ineluctability of the merger of masculinity with working-class identity; the question of displacement and its effects on self-images; and the class/gender reversals in contemporary representations in film and television (that is, the degree to which male "conquest" becomes the power equivalent of class difference). The next section will address these issues.

IV.

The stimulation of the unconscious by "imaging" (the term Teresa de Lauretis's[4]) consists in simulating the dreamwork so that identities are formed through identification with the gendered characters that appear on the screen. Aural media are also powerful desiring machines, but sound is burdened with an enormous load because images

must be produced by the listener. Identification can be fomented, but with difficulty. The film form invokes the stark real-life character. De Lauretis argues that women do not insert themselves into film culture, that they are absent in imaging. They cannot identify with the actual representations of women on the screen, for these women are the objects of male desire; they do not occupy subject-positions from which emanate a distinctive female voice. Thus, there is no chance for identification unless women accept the object space to which they have been assigned.

Males identify with characters (protagonists, heroes) who are the subjects of narratives; women are objects of desire/exchange/conflict among males and only assume distinctive character when they occupy male subject-positions from which, in both comedies and drama, they must inevitably fall (e.g., the Spencer Tracy/Katherine Hepburn comedies such as *Woman of the Year* [1942] and *Desk Set* [1957], and the Joan Crawford soap operas such as *Mildred Pierce* [1945], in which women who speak as male characters find that adopting these personae invites self-destruction). Male workers do find representations in film and television in the 1950s. The characters of Ralph Cramden and Ed Norton in *The Honeymooners* (1951–56; revived 1966–70 as part of *The Jackie Gleason Show*) and Chester Riley in *The Life of Riley* (1949–58) are comically absurd, the situations often artificial and juvenile, but family relationships articulate with the prevalent war between the sexes, the distinctiveness of male culture, the absence of a corresponding women's community.

Ralph Cramden is a bus driver who, like many working-class men, dreams of escaping his routine, relatively low-paid job by entering a constant succession of bound-to-fail business schemes. His driving ambition for wealth and social position is lodged entirely in his (male) imaginary. Ralph's wife Alice can barely disguise contempt for his fantasies and foolish projects—most of which serve not to enhance the opportunity for real social mobility, but Ralph's pathetic efforts to establish his dominance in the home. On the other side is Norton, a sewer worker who harbors neither illusion nor the desire to flee his job. The sewer affords him a considerable measure of autonomy, at least in comparison to factory work or even driving a bus. He enjoys the lack of responsibility his job entails but fervently asserts its dignified character against the constant chidings of his quixotic friend.

As with most television situation comedies, the characters have a cartoon quality: there is no room for complexity in the representations. Additionally, the stripped-down sets evoke 1930s Depression decorum rather than the postwar era. The honeymooners have been left behind the white urban exodus; they are transhistorical working-

class types. Norton is invariably dressed in a T-shirt and wears his hat indoors. Cramden dons the uniform of a bus driver, signifying the ambiguity of his situation. Clearly he is a wage laborer, but his will is that of a petty official since genuine wealth has been foreclosed to him. Cramden displaces his frustration onto intrafamilial quarrels. His wife's housework never counts as real work—his characteristic posture is that of an inquisitor (what have you been doing all day?). Since she rarely awards him the deference he urgently needs, given his relatively degraded social position, his usual gesture is the verbal threat of violence (against women): "one of these days . . . pow, right in the kisser." Alice seems bored by his remonstrations, and we, the audience, know that Ralph is simply too henpecked (or, in the male vernacular, pussy whipped) to follow through.

The Honeymooners retains its large audience after thirty years because it displays the range of class and gender relations. Its class ideology is represented by the absence of the labor process except discursively. The family relations displace the class relations, as Ralph seeks to dominate Alice, who as the real proletarian, remains recalcitrant. Here we see the inner core of male fantasies: lacking the power individually to achieve the freedom wealth presumably affords, domination becomes the object of male desire. As with Hegel's master, Ralph desperately covets Alice's recognition, but is denied such pleasure, except in the last instance when, at his wit's end, Ralph demands the approbation which she must grant.

The Honeymooners succeeds as a tableau of the sadomasochistic family romance. Ralph's infantile behavior generates Alice's maternal role even as there are no children in the household. Ralph plays master, insofar as he trumpets his breadwinner status, but also is the emotionally dependent male for whom sexuality is identical with submission. Alice is not a moral agent, only a mirror to the absurdity of male will.

Caricature notwithstanding, working-class life demanded representations in the 1950s and early 1960s. By the latter half of the decade, the dispersion of working-class culture made direct representation improbable. The film *Joe* (1970) lacked the framework to comprehend the dimensions of the youth revolt. In this film, Ralph has succeeded in owning a one-family house, complete with a finished basement and late model car. Ralph rejected Alice's hints that maybe they could leave the inner city for greener fields, but Joe has achieved the castle without the power of the lord, except in the family. Yet, the satisfaction of mastery is denied him by his child's refusal to follow the path laid out by society. The child returns to the jungle of the cities and prefers sex, drugs, and (presumably) rock and roll to the sterility

of suburban life. Youth culture respects not at all the middle-class aspirations of its elders. Where the previous generation knew economic class as a regulative principle, including the real subordination of women by men, the generation of the 1960s was, by comparison, free-floating. The universalization of post-secondary schooling (misnamed higher education, then as now) brought many working-class kids in contact with ruling- and upper-class peers. The results from the point of view of the established social structure was potentially devastating. Surely class resentments and distinctions do not disappear in youth culture, but are explicitly challenged by the effort to invent new normative principles of social relations. These relations, which hold equality as its highest cultural ideal, challenge generations of difference, not only of economic power but of sexually construed cultures. In the end Joe must commit murder to expiate the transgressions of the children.

But the worker as tragic hero is a transitional figure, for the tragedy is born of the disintegration already prefigured by consumer society, especially suburbanization. Working-class culture is preeminently urban; it belongs to the industrializing era which, by the late 1960s, has passed. Post-industrial culture is already postmodern: it is marked by boundary-crossing. As David Halle found, while working-class culture still finds renewal on the shop floor, its residential base is dispersed.[5] In the suburbs of major metropolitan centers, industrial workers mow their lawns alongside professionals, managers, and small business neighbors.

In the 1977–78 season, Archie Bunker, the Queens, New York political and social neanderthal, opened a gin mill. Having pushed himself up into the business-owning small middle class, Archie left his working-class roots behind, not only in his newly found proprietorship, but also in his contacts. In this assimilation, he continued the tendencies of the earlier incarnation of the show; recall, the Bunker family lived in that part of New York that most resembled the suburbs. The only black family he knew owned and operated a dry cleaning business (the Jeffersons, their *own* TV series beginning in 1975). In other words, he rubbed shoulders with those who had more completely achieved one of the crucial elements of the American dream, a business of one's own. So it is entirely reasonable that Archie should aspire to gaining a toehold in the social ladder. With that, the Archie of *Archie Bunker's Place* (the series' new name, as of 1979) disappears into the middle class.

From the mid-1970s, there simply are no direct representations of working-class males (much less women) in television. Representations are dispersed to beer advertisements (thirty-second images of football

players hoisting their favorite brands, jostling each other in timid evocations of the ribbing characteristic of working-class bar culture) and cop shows in which characteristic working-class culture is displaced and recontextualized in the stationhouse, on the streets, and the bars in which cops congregate. These are displacements, so we see only the reminders—conviviality and friendship that is overdetermined by the police buddy system, the obligatory partnership. It is in these interactions, when the partners of say, *Hill Street Blues* (first aired, 1981), discuss their personal problems or their troubles with the Department, that the old class solidarity bonds are permitted to come to the surface, often against the Captain or even the lieutenants who are a step above the line and possess some authority. We know that the patrolmen (and some patrolwomen) may rise to Sergeant, but are not likely to make Lieutenant, much less Captain. These are not educated men and women. Their bravery entitles them to recognition, not rank. They have their own hangouts, their personal troubles (especially with their love lives). In contrast, officials, whatever their origins, do not congregate in barrooms; they have no sharer of their troubles because they must observe the tacit code of hierarchy.

In recent films, displacement of class to the police continues, but is joined by displacement of sex/gender relations to class as well. Hollywood movies (such as *Someone to Watch Over Me* [1987] and *Barfly* [1987]) are marked by a conventional theme in contemporary narrative: the working-class man is powerfully attracted to an upper-class woman, disrupting not only the prohibition of interclass romance, but also the family romance. In these instances, to be working class is identified with masculinity, upper class with femininity. Barbet Schroeder's *Barfly* is the non-story of a derelict writer who meets two women: a derelict, apparently a renegade from upper-class life, who names her profession as "drinking," and a woman publisher of a literary magazine who "discovers" the writer. The triangle is resolved by his choice of the woman barfly who, like him, lives to drink and engages in barroom brawls. Her masculinity allows him to hook up with her, to combine sex and male bonding. In contrast, his benefactor is a beautiful woman who cannot hold her liquor and, because she lives outside male lower-class culture, cannot hold him.

The woman barfly engages the world like a man in other ways also. She goes off with the writer's arch enemy, a bartender in his favorite hangout, because he comes to work one day with a full bottle of bourbon. Like many males, her loyalty to people is always subordinate to loyalty to pleasure. In the end, the writer admires such priorities, for his own life has been conducted according to the precept that conventional morality is for the nerds.

Someone to Watch Over Me finds a cop of plainly working-class parentage married to a tough, fiesty working-class woman, who live together with their kids in a modest single-family house in Queens—in effect, Archie Bunker's kid has become a cop. The cop is assigned to protect an upper-class woman, ensconced in a Manhattan townhouse. He is assigned the midnight shift and quickly has an affair with her, an event that disrupts his tension-filled but stable home life. As with the young publisher of *Barfly*, the woman is attracted by the merger of class identity and masculinity, and he by the reverse class/sex combination. The film reenacts a crucial male working-class fantasy: to dominate a beautiful rich woman, to make the "impossible dream" real.

These films address the insufficiency of middle-class comfort for the generation of upwardly mobile working-class kids born after the Second World War. The protagonist of *Barfly* chooses the underlife, a degraded bohemia punctuated by the struggle for male honor even in the lower depths. The cop is socialized into a conventional honorific position—the centurian—but finds it suffused with mediocrity and, most important of all, marked by repetition and continuity with the anterior generation. What is new is adventure, which can only be fulfilled by sexual indiscretion, "penetration" into the forbidden territory of the upper class. But besides the exotic, for the cop, buried in the routine tasks dictated by a bureaucracy that seems entirely beyond his power to control, sex becomes the power that can propel him out of his own real-life subordination.

It may be that today sex discourse refers to class issues; but it is also true that class discourse refers to gender domination. The import of the image of the working class cum cop engaging in sexual relations with a woman in an entirely improbable class position is not that American society is somehow democratic—these relationships end in disaster. They are themselves sundered, but more importantly, they wreck families, personal lives, and so forth. The significance is otherwise. Class is no barrier when upper-class women are involved. In current representations, the reverse is rarely portrayed. Femininity is not a universal signifier. That privilege is reserved for male culture.

There are, of course, no public representations of working-class culture other than the images associated with male bonding. In fact, one may read *Barfly* as a signal that one key site of class solidarity, the bar, has been declassed. Or, more precisely, the lumpies are the legatees of what was once a marginalized but distinct aspect of American subcultures. And, just as women are absent from media representations of social agents, they do not constitute themselves as a part of working-class culture. Working-class culture is almost always white

and male, even in its displaced forms. The community of women is generally denied but, as I have argued, women appear as the new proletarians insofar as maleness exercises itself as dominating power.

At first glace, *Flashdance* (1983) is an exception to the rule. A woman welder in a steel fabricating plant falls in love with the boss, himself cast in the tradition of the self-made man rather than the MBA or accountant mode. Here class difference is mediated by other bonds of solidarity, particularly sexuality (itself a difference) and membership in the same occupational community. The film presents the "new" woman as both male and female. Yet the relationship presupposes both her male and female personae. Like *Barfly*, interclass sexual relations are possible only when the woman displays masculinity, which remains the privileged class position.

In short, in contrast to the 1950s when a viable working-class culture, connected to powerful large-scale industry, was accorded considerable status in media representations, class has been displaced in two ways: first, to other signifiers of masculinity, and second, to the code violations entailed in sexual relations between working-class or declassed men and upper-class women. In this case, sex/class relations are reversed. Men, despite lower-class roots, achieve class parity with women due to the status conferred upon masculine sexuality and its powers by society.

In *Someone to Watch Over Me* and other examples of this relationship, the absent male is a businessman. His shadowy existence is owed to the obvious fact entailed by the conditions of his own success: his real marriage is to the business, not to his wife. Sexuality of the traditional sort is confined to those without sublimations, which accounts for its relatively ambiguous role in the barfly's life. Writing and booze are serious competitors, but for the working-class man, neither art nor business provide channels for the discharge of erotic energies. At the same time, sex is not really an acceptable form of power, for unlike art or business (real work) its results are horrendous from a moral point of view. The message of this film is that transgression, although possible, is not desirable. Similar to 19th-century and early 20th-century novels (Thomas Hardy, D.H. Lawrence), love is forbidden by class difference, and when the barrier is transgressed, dire consequences ensue.

Yet, moral proscription aside, the sex/class/power axis in television and movies constitutes a critique of the cultural ideal of consumer society that passes for the 1980s equivalent of the mobility myth. For the entrepreneurial ambition which motored two generations of immigrants in the 20th century has disappeared from view; the remainder is the civil service which has become the far horizon of

well-being for a new working class that can no longer count on high-paying factory jobs. The army and the police have replaced industrial labor for working-class men, for whom professional options simply never existed.

Male bonding persists in these contexts, but not the solidarity that is born of mutual recognition among production workers who share a common fate as well as a common existence. For the civil servant, existence is never identical to essence. There is always one place more in the bureaucratic hierarchy for which to strive. On this material foundation, a family could, as late as 1980, enjoy the prospect of owning a single-family home in the cop or non-commissioned enclaves bordering on the suburbs. Such options are increasingly out of the question. So is social solidarity (at least for the younger officers), because the concept of collective fate is constantly disturbed by the latest promotional examination.

The only vital life consists in dreams of power, the most vivid form of which is male sexuality. Contrasted to earlier direct representations in which sex is virtually absent from discourse, but where class persists, today's movies and television programs code sex, class, and power interchangeably. As with the earlier genre, women do not occupy subject-positions: they remain the palpable objects of male desire, and by this precise relation experience class reversal.

In sum, the persistence of even these displaced representations of workers and their culture attests to the media's yearning for a source of vitality and renewal which clearly cannot be derived within ruling-class relationships, a genre that survives not in the drawing room comedy but in the old tradition of portrayals of scandal and corruption (such as Oliver Stone's Wall Street [1987]). This lack of credible ruling-class subjects occurs at a time when public confidence in business appears to be considerably higher than at anytime since the Gilded Age. Yet, what excited the old public's imagination rather than admiration was the degree, earlier in the century, to which the capitalist merged with the frontiersman. Despite his ruthlessness, he was a romantic figure, a conquerer, a risk-taker, and above all, sexy. This figure was displaced to the underworld boss in the 1930s and 1940s, when the entrepreneurship had already passed to the hijacker, the bank robber, and the gambler—types revived briefly in the 1960s.

The working class is no longer possible as mythic figure, but neither is Ivan Boesky, and while politicians and investment bankers have lost any semblance of sexuality, male or otherwise, class culture survives as masculinity. What working-class culture may signify is the last hope for class equality, provided that the object is a woman.

Notes

1. Paul Willis, *Learning to Labor* (New York: Columbia University Press, 1977).

2. Louis Althusser, "Ideology and Ideological State Apparatuses," in *Lenin and Philosophy* (London: New Left Books, 1971).

3. I exclude "film" from this list because of the market distinction made between the art film and movies in the last two decades, eg. the cinema of Eric Rohmer, Louis Malle, Yvonne Rainer, Agnes Varda, and the late John Huston, compared with Stephen Spielberg, Sidney Lumet (whose position is a bit ambiguous), and Oliver Stone (whose location is not).

4. Teresa Di Lauretis, *Alice Doesn't: Feminism, Semiotics, Cinema* (Bloomington: Indiana University press, 1984) pp. 37–69.

5. David Halle, *America's Working Men: Work, Home and Politics Among the Blue-collar Property Owners* (Chicago: University of Chicago Press, 1984).

6

The White Working Class
and the Transformation of
American Politics

I.

In the summer of 1988, the Democrats left their convention convinced that the long drought was over. For the first time since 1976, they could taste national political power. Their presidential candidate, Governor Michael Dukakis of Massachusetts, held a commanding lead in the early polls over Vice-President George Bush, the Republican contender. Dukakis brought to the campaign some formidable assets. As a Greek-American, his nomination signified the determination of his party to recognize the importance of the white ethnic groups (which, in America, is nearly always a code term for the working class), especially those from Eastern and Southern Europe. These groups, although comprising a considerable proportion of the population, had been unrepresented at the commanding heights of political and economic power. Moreover, he had marshaled an enviable record as governor, taking credit for his state's booming economy throughout the 1980s.

The only other example of ethnic representation at the top of a major party ticket was the Republicans' selection of Spiro Agnew as Richard Nixon's vice-presidential running mate in 1968. Subsequently, Agnew was forced to resign in disgrace during the Watergate scandals. In the light of the events surrounding this affair, Dukakis's nomination was a bold move: it was calculated to put the Republicans on the defensive for the first time in more than a decade, especially on the "middle America" issue—the debate about who "really" represented working people. The Democrats' chances were also improved by the Republicans' selection of George Bush, who seemed to revert to the traditional image of the party as representative of the very rich and the large corporations.

After all, Bush had been, against his earlier judgments, a loyal

lieutenant of Ronald Reagan whose magical powers among the electorate seemed to have deserted him after the Iran-contra scandals erupted shortly after his reelection. By nominating Dukakis, the Democrats were determined to reclaim many of their errant white working-class constituents, captured by conservatives since 1966. For unlike Bush, who was a scion of a patrician family and went on to become a Texas oil millionaire, Dukakis was a son of the middle class, the embodiment of the American Dream that almost anyone of talent who worked hard and lived a clean life could rise in the political and corporate system.

Moreover, Dukakis brought to the campaign a fat "war chest," and, even more important, the support of the Kennedy faction of the party, which was widely perceived to be a crucial condition for nomination. He had also weathered a grueling primary election struggle—against prominent congressional leaders and, especially, the powerful insurgency of Jesse Jackson—without succumbing to the kind of rancorous rhetoric that might have antagonized the party professionals or Jackson's African-American and left-liberal constituencies. In short, he was poised for victory. Yet, when the votes were counted in November, Bush soundly defeated Dukakis. What happened?

The most obvious reason for the Republican victory was the inept campaign waged by the Democrats. The campaign season began with Bush television ads depicting Dukakis as a governor "soft" on crime. The ads showed a black man, Willie Horton, who raped a white woman when on furlough from prison under a special Massachusetts program that permitted convicted felons to be released for brief periods of time. This damage was compounded by another highly publicized television image of the debris in Boston harbor, understood as a sign of Dukakis's incompetent administration, which was Bush's counterattack against Dukakis's effort to portray himself as an "environmentalist" candidate.

The conventional political wisdom attributed Dukakis's defeat to his inability to counter Bush's "negative" attacks effectively. In truth, Dukakis was incredibly slow and indecisive in response, which led to the widespread expert perception that his reputation as a strong public official was, to say the least, ill-deserved. But, despite Dukakis's shortcomings, the decline of the Democrats as a national political party in the past quarter century goes deeper than this conjuncture; Dukakis's defeat was a symptom of the sea change in American political culture, one that has witnessed the permanent end to the New Deal and the political coalition of labor, blacks, and progressive sections of the middle class that sustained it for thirty years.

The most important of these are the sweeping inroads the right had

made among the white, male working class. Since Richard Nixon's victory over the Democratic nominee, Hubert Humphrey, in the 1968 election, white workers, even those who are union members, have decisively supported the right-wing candidate. Moreover, in 1968, many workers supported the third party campaign of right-wing populist, George Wallace, who ran against the claimed alliance of the civil rights movement, the large corporations, and the liberals. In contrast to 1980, when a majority of union members voted for Reagan, the AFL–CIO claimed that the Democratic candidate, Walter Mondale, had regained a majority of these voters in his losing 1984 race. But by that time African-Americans and women had been recruited in large numbers into public employee unions and, at the same time, unionized construction and industrial plants (where white males predominate) were experiencing substantial declines. While information concerning the precise voting behavior of white male union members is hard to get, when correlated with voter preferences among all white working-class males (most of whom are non-union) and the closeness of union members' preferences between the two parties, it is reasonable to infer considerable labor support for the right. Moreover, America's largest and most powerful union, the Teamsters (truck drivers and allied trades), endorsed Reagan in both the 1980 and 1984 elections.

At the heart of this profound transformation is the significance of gender, sexuality, and race in American political life since the mid–1960s. I want to discuss these issues a little later. But to provide a context for this discussion, we must recall that from 1936 to 1966 American political culture was dominated by the discourse of social justice within the global context of U.S. world economic and political hegemony. Most Americans supported the anti-communist foreign policy of the United States, but also expected that the tremendous economic supremacy enjoyed by U.S. corporations in world markets was a necessary condition for their own prosperity. Even during the 1950s, when a Republican president, Dwight Eisenhower, set a generally conservative tone to national politics, the U.S. Supreme Court handed down several contrary decisions that had the force of law, notably the 1954 *Brown v. Board of Education* which declared school segregation a constitutional violation and ordered local school districts to draw up plans that would provide equality of educational opportunity to black and white students through racial integration. During the following year, the Montgomery Bus boycott, led by Rev. Martin Luther King, Jr. dramatized the fact that blacks were prepared to go beyond legal means to abolish segregation, and would engage in direct, non-violent action even if it meant breaking "immoral" laws

that prohibited blacks from using public accommodations alongside whites.

The fifties and sixties were years of trial for Americans who proclaimed, as part of the dominant nationalist faith, that theirs was a free society. Almost none of the key institutions, North or South, were immune from charges of overt or implicit racism. The schools, government and private employment, the armed forces, and even organizations such as churches and trade unions were subject to scrutiny and often suffered internal turmoil as blacks and other people of color began to make demands that the color bar come down. The period ending with Lyndon Johnson's presidency was a kind of national self-appraisal. Those who resisted modernity appeared to have suffered ignominious defeat in the courts, especially when local authorities, employers, and unions flaunted the law and refused to let blacks in the door.

On the surface, working- and middle-class Americans seemed, at least in the late 1950s and early 1960s, to acknowledge the rights of blacks. In view of the unparalleled postwar prosperity, racial integration did not appear to threaten white jobs or living standards. Black gains were not likely to mean losses for working-class whites. Yet, as the sixties wore on, there were some well-publicized confrontations at construction sites between civil rights demonstrators and workers. And, the black middle class fought against "red-lining," the widespread practice of banks that refused to grant to black buyers housing mortgages and small business loans in black communities. White neighborhoods resisted court-ordered "bussing" plans that forced school desegregation. By 1968, the earlier appearance of a national consensus on racial equality was in shambles, and the conservatives, having been soundly defeated four years earlier, rushed in to reap the angry harvest.

The 1968 elections were a referendum on Johnson's Vietnam War policy, but also on a decade marked by struggles for racial justice and the rise of student radicalism. Nixon adroitly capitalized on both. He vaguely promised to end the six-year "Democrat-inspired" war, a gesture that appealed to the growing anti-war sentiment, attacked the New Left and the counterculture as a logical outcome of liberal permissiveness, and employed anti-welfare state rhetoric as a thinly veiled mask for racist appeals. His famous invocation of "the silent majority" of "middle Americans" as conservative dissenters was put at the center of his campaign discourse. This was coded as an appeal to working-class whites and members of the middle strata. By the end of the campaign, the Republican party, abetted by a few key intellectuals, had transformed public perception from its traditional

image as a faithful representative of wealth and power to the party of the white underdog. Nixon was the first in what proved to be the long list of right-wing candidates who would run against the liberal "establishment" that remains today the bedrock of Republican electoral strategy, even though the party has held power in all but four of the last twenty-two years. (Reagan, a California governor, was bold enough to run against the federal government as such. In retrospect he now appears as the American precursor of Russian President Boris Yeltsin.)

Meanwhile, in 1967 and 1968, clusters of women were gathering in small New York, Boston, and Bay area (San Francisco and Berkeley) rooms and forming "consciousness raising" groups, speaking the bitterness of their oppression. Many were rebelling against the shabby treatment they suffered at the hands of New Left men. Others, recently separated from their husbands and suburban homes, were seeking a new way of life. All of them yearned to discover their own voice, to be free of the tutelage of and constraints imposed by men. From tiny groups, a mass women's movement emerged by the early 1970s. Among its public demands, none was more visible and, in the context of Christian America, more controversial than abortion rights. True to recent patterns, the struggle for abortion rights was finally won in the courts rather than the legislatures which, despite Democratic majorities in most states and Congress, had, with a few exceptions, notably New York and California, steadfastly refused to bow to feminist demands.

In 1973, in the *Roe v. Wade* case, the Supreme Court struck down the Texas law that prohibited women from obtaining an abortion. Confirming that abortion restrictions represent a violation of a woman's right to "privacy," the Court not only struck a blow for women's freedom but it laid the condition for the most virulent political struggle of the 1980s. *Roe v. Wade* became one of the cornerstones of Ronald Reagan's successful meteoric rise to the presidency after having been counted out by the experts as late as the primary season which began in 1979. Its repeal has matched Reagan's evocation of free enterprise and attacks against big government as crucial elements of right-wing ideology.

Abortion rights has been more than a political issue. It has touched misogynist undercurrents in U.S. society, mobilized supporters of the patriarchal family for whom modernity is anathema, and become a crucial element of right-wing ideology. In contrast to some other feminist issues, such as equal pay for equal work and other measures opposing discrimination in employment—issues which enjoy broad support, even among religionists—abortion flies in the face of one of

the sacred principles of the modern Catholic Church with its 50 million American adherents, and many sects of Protestantism, especially Baptists and other branches of "fundamentalist" Christianity. For the religious right consistently argues that life begins with the fetus and that God is the only entity entitled to end it. In the United States, the most religious one of all "advanced" industrial societies, the struggle around abortion has concentrated the cultural contradictions of modernity. Amid rampant technophilia and a deep faith in the capacity of science to solve many social problems, Americans, despite their reluctance to attend church services, harbor a gnawing guilt about secularity. This guilt is expiated, even when unresolved, by a political displacement to conservative politics. Together with the seventies civil rights developments, it had been the basis for massive right-wing inroads into the working class and provided the key to conservative political ascendancy.

It is not so much that anything approaching a majority now opposes abortion rights. On the contrary. With some vacillation, polls show that almost 70% of Americans favor a woman's right to abortion under most circumstances. This is the rational side, but not the only one. The issue has mobilized large sections of the South, the region most imbued with religious fervor, and become one of the bases of the rightist grass roots movement that marches under the banner "right to life." Like the earlier fundamentalist Christian movement that opposed (and still opposes) teaching biological evolution in the schools and insists on the equal right of biblical interpretations of creation to be considered a science, the right to life movement has focused attention on the fragile hold secular ideology has on vast portions of the U.S. population. In this sense, abortion rights challenges not only male privilege, by making reproduction decisions the ultimate prerogative of women, but the foundational ideology of American nationalism, Christianity. In this respect, abortion issues have become the catalyst for linking Christianity with patriotism against the evils of secular humanism, the primary perpetrators of which are left-wing intellectuals and women (not to mention Jews).

Needless to say, these sentiments are underlined by the cultural perception shared by large numbers of Americans that moral values, social cohesion and, above all, parental authority to enforce civilized behavior, have fallen apart. As the country falls deeper into economic recession, the social fabric is visibly frayed: in the cities we are obsessed with "crime in the streets," the incidence of which has risen in proportion to rising poverty and unemployment; suburban youth show signs of personal despair, an observation buttressed by the alarming suicide rate among teenagers; and government at all levels

displays its incapacity or unwillingness to address the multiple, and seemingly intractable, social and economic problems facing the country. Like most Western capitalist countries, the U.S. is imbued with the politics of consensus, the putative opposition stymied by its adoption of the ideology of the real.

As a result, in 1991, faced with huge budget deficits, the Democratic leaders in Congress sit with a right-wing president and agree to cut health benefits for the aged and to increase the so-called "sin" taxes— alcohol, gasoline, cigarettes. They present the bipartisan "plan" to their congressional colleagues who promptly vote against it on class grounds. For a single historic moment, the Democratic majority shouts the slogans of the workers and the poor. "Tax the rich, not the poor" they say, and the leaders are forced to return to the conference table. The result: they still stick it to the poor but are forced, against their will, to appear to impose an additional burden upon those with high incomes. Amid these machinations the electorate becomes even more cynical and, consequently, less likely to vote in the next elections.

II.

One of the paradoxes of the generally conservative seventies decade was the persistence of the doctrine and the policy of what became known as "affirmative action." The term connotes a different approach to ending the color bar than the one embodied in the Civil Rights Acts of 1964 and 1967. The idea was fairly straightforward: in consideration of centuries of systematic institutional discrimination against blacks and women, and the entrenched interests of white men who controlled access to many occupations, industries, and universities, courts mandated that schools and employers develop detailed *quota* systems to insure that the victims were accorded access as students or workers to these institutions. Working around the paralyzed legislative process, the courts also assumed responsibility for supervising these plans. In the 1970s, large numbers of employers had initiated preferential hiring programs of blacks and women, especially for management positions. Medical schools and law schools were enrolling unprecedented numbers of minorities and women, and a new African-American political class came into being.

As the demographic shift within large cities to black and Hispanic majorities was matched by the emergence of a mature black political class by the early 1980s, African-Americans controlled the mayoralties of most large cities—the major exceptions being New York, San

Francisco and Boston—and had increased their representation in Congress and state legislatures. In 1984, it was possible for Jesse Jackson to enter the Democratic presidential primary as a credible candidate.

To many white workers and members of the middle strata, these gains threatened their already precarious sense of privilege, especially as the United States economy entered its long slide after the energy crisis of 1973–76. Then came the *Bakke* case. Alan Bakke had applied for admission to law school at the Berkeley campus of the University of California but was turned down in favor of an African-American applicant whose test scores and grade point averages, although good enough to pass, were lower than the white applicant. Bakke's suit to gain admission was successful, but the Supreme Court refused to rescind Affirmative Action programs. The wide publicity given the case underscored, for many, the injustice of the racial quota system. A familiar charge of "reverse discrimination" became a rallying cry of conservatives and contributed to Reagan's stunning 1980 victory.

The combination of visible gains by African-Americans in the middle rungs of the occupational structure, along with the parallel development of a female managerial class and the decline of living standards in the first years of the Reagan presidency, set the stage for the rightward shift of the working class as well as the male middle strata electorate. By the mid-1980s, the New Deal coalition that had controlled national politics for thirty years was definitively in shambles. The Democrats still had the support of organized labor, an asset which was particularly important for fund-raising and campaign militants, but the labor movement itself could no longer "deliver" a majority of its still predominant white male membership.

The grand coalition was superficially intact, but the relationship of forces within it had changed. Now a strong and well-organized women's movement, African-Americans, Latinos, the growing movement of the handicapped, and the mass organizations of retired workers and professionals combined to exercise perhaps decisive influence on party policy on social issues, even as its economic policy was, except on some social security issues, indistinguishable from that of the Republicans, especially in the 1980s. The unions were important, but had lost much of their power due to de-industrialization, internationalization of production, and their continuing weakness among the growing private service sector. Even more important, the coalition was only statistically and *ideologically* majoritarian; in practice, it lacked the means, financial and political, to mobilize most of its

potential constituents. For the first time, we learned the power, but also the limits, of effective discourse. The social movements could set a climate of counter-opinion, able to redefine social justice to mean cultural change, but could not deliver the "divisions" to a Democratic candidate.

The Republicans claimed significant majorities in the old middle class of small shopkeepers and captured the imagination of frustrated professionals who were convinced that their tax money was paying for welfare "cheats," most of whom they mistakenly believed were people of color. And, imbued with the middle-class cultural ideal that was embodied in small home ownership and other consumer goods, male white workers deserted the post-New Deal Democrats who, they believed, had been captured by "special interests," a euphemism for the social movements.

In 1978, as Bakke's suit was making its way through the courts, two right-wing populists, Howard Jarvis and Paul Gann, led a movement to place on the California ballot a proposition that put a limit on the right of the legislature to tax its citizens. Proposition 13 was the first shot sounded in what became a national taxpayers' revolt that culminated less than a decade later in the so-called Gramm-Rudman-Hollings law that required the federal budget to balance expenditures and income on penalty of massive across-the-board spending cuts. This measure followed congressional approval of Ronald Reagan's tax plan, a plan that represented one of the biggest income transfers, through the tax system, from the poor to the rich. The silent majority of white middle- and working-class voters raised their voices in behalf of the large corporations and the rich because they identified with the powerful. Moreover, it expressed deep resentments against the perceived beneficiaries of non-military public spending—people of color and women (even though the overwhelming majority of social security and welfare recipients were white).

Yet, the tax revolt cannot be reduced to racial and gender splits; even as domestic spending cuts were implemented the already large military budget was nearly doubled by the Reagan administration. But, adroitly, Reagan revived a familiar rationale for the huge "peace-time" military budget: the evil Soviet empire.

The backdrop for American foreign policy of the 1980s was the "new" Cold War. After the Vietnam War debacle, Reagan bid his middle American followers to "stand tall" against what he claimed was a threat to U.S. security emanating from the Russians and the Democrats' betrayal of U.S. sovereignty by refusing to put enough force in the battlefield to vanquish the Communists in Vietnam. In

consideration of this mythic opponent, the era has been marked by the return of the repressed: U.S. political and military interventions into Central America, Latin America, and the Caribbean, always covert (as in 1973 when the Nixon administration financed the anti-Socialist Chilean military coup), now became a proud, almost flagrant aspect of U.S. foreign policy. This aggressivity was underscored by the flimsily rationalized military invasion of Grenada in 1984 and the open administration financial and military backing of the Nicaraguan contras against the Sandinista regime.

Stung by their historic image as the war party, the Democrats offered sporadic, vacillating, and weak resistance to the relentless Reagan administration policy of systemic third world interventions. Seen in this perspective, the U.S. intervention into the Persian Gulf in the summer of 1990 appears less dramatic. Of course, the difference between the earlier military excursions and the most recent conflict with Iraq has been the Bush administration's good fortune to have undertaken its adventure at a time of general Soviet cooperation and the reluctant approbation of a resurgent Europe and Japan.

It would be inaccurate to claim that the Reagan-Bush foreign policies have encountered only token internal opposition, in contrast to the massive anti-war movement of the 1960s and early 1970s which toppled a sitting president. The "silent majority" responded to the war atmosphere with enthusiasm, but its children studiously refrained from joining the military which, as a consequence, became increasingly African-American. And, a fairly strong movement against the Central American intervention emerged by the mid-1980s and was able to catch the Reaganites in a series of outrageous violations of congressional mandates limiting U.S. aid to the contras. These culminated in the Iran-contra scandals which, however, failed to topple Reagan because, characteristically, the Democrats suffered from a failure of nerve.

Until recently the Bush and Reagan administrations benefitted from two intervening developments: Richard Nixon's astute move to end the military draft in favor of a volunteer army, an event that took the wind out of the anti-militarism opposition; and the brilliant ability of the Reagan administration to *displace* a long list of domestic woes to patriotic fervor. For at the very moment when international economic competition and the world economic crisis were driving U.S. living standards down (even as a relatively short-lived expansion of the service sector was underway), the U.S. was beginning to flex its military muscle throughout the world. The new Cold War was more than a diversion; it reached down to the wounded (male) collective ego,

providing it with renewed virility after the years of humiliation in Southeast Asia and equally taking its mind off the fact that middle- and working-class men were unable to support their families on a single income. This fact, underscored by the inflationary pressures of the late 1970s and early 1980s, drove millions of women into the labor force which, together with rising feminist consciousness, produced a new family crisis.

One of the crucial measures of the crisis was the huge divorce rate that affected nearly half of all marriages by the mid–1980s. Faced with their loss of power in the home, many working-class and middle-class men, when not invited to leave, simply departed. In the Reagan decade, the phenomenon of single parent families, dominated by working women, many of them at the low rungs of the economic ladder, was no longer unusual. What became known as the "feminization of poverty" was overdetermined by the absence of men contributing additional income in working-class homes and by the outrageously low wages offered to most categories of "women's" work. In this context, the one bright spot in an otherwise dismal picture for women was the rapid expansion of public employees unions in the 1970s. The largest of these—the State, County, and Municipal Workers, with more than 1 million members—and the several large hospital workers unions paid special attention to their (mostly) women members. Needless to say, despite impressive gains in these sectors, most women who ran single parent households suffered from the critical shortage of day care facilities, adequate nutrition, and decent housing. While the proportion of the poor did not dramatically rise in the 1980s, their composition was shifted to women and children.

Taken together, the new Cold War and the racist and misogynist backlash were the means by which substantial segments of white male workers and members of the middle strata were able to acquire a public identity and a political voice. For the past quarter century there simply has been no discourse of social justice or solidarity capable of countering the hegemony of right-wing populism, except on specific issues. Where in previous historical periods, it was possible to concentrate economic reversals or worker demands in the vocabularies of progressivism, these have been decisively eclipsed within the white working class. As a consequence, the popular left of trade unions, progressive organizations among European immigrant populations—the traditional repositories of the rhetoric of social justice—, as well as political mobilization in behalf of its program, no longer command the social and political weight to effectively overcome the right.

Three crucial events of the late 1980s illustrate the degree to which

racism had captured the high ground of community life. The first occurred on the subway when Bernhard Goetz, a white engineer, shot an African-American youth because he felt physically threatened by the young man and his friends. The second and third incidents, at Howard Beach and involved young whites who caused the death of African-American youths whose only infraction was to have walked into virtually all-white working-class neighborhoods. These developments dominated the New York news media for several years. They revealed the degree to which racism had taken a leading role in determining both political and social discourse.

In the 1989 New York mayoralty elections, the Democratic candidate David Dinkins, a black politician, barely won after a media barrage by his Republican opponent, Rudolph Guiliani, an Italian-American prosecutor, alleging that the city was in the midst of a crime wave induced by widespread drug use, especially "crack," in the black and Latino communities of the city. Dinkins's narrow margin of victory stunned the city, despite the fact that it had elected only two Republican mayors in this century. And these were candidates who challenged the Democratic machine *from the left*. Guiliani's campaign was plainly oriented to the conservative shift among white working-class voters, many of whom were Italian but also Dinkins' alleged weak character trait: he was charged with being too weak to handle "high pressure" politics.

Of course, the early months of the new Dinkins administration were marked by a media "blitz" on crime issues, a campaign that has forced the Mayor to announce new measures to increase the police force and build new jails. As the city plunged further into a full-blown economic recession, it became evident that the price of the new crime-fighting policy would be substantial reductions in services, layoffs of city workers to pay for the hiring of new police, and a serious confrontation with municipal unions.

III.

The bare obstacle to the revival of the "left" (the amalgam of popular forces, not the "ideological" left) is that at least half of its potential constituency declines to vote in local, state, and national elections. Moreover, this abstention does not present itself as a protest against the state, the corruption of the parties or against their policies and platforms. As Baudrillard has argued following the suggestion of Italian social theorist Antonio Negri, abstention is beyond protest; it represents the refusal of politics as such. An overwhelming majority of young voters (18–25) stay away from the polls (even when they have

a "man on horseback" to vote for), a majority of African-Americans and Latinos (in the latter case they are as often as not aliens, both legal and illegal), and most low-wage workers are similarly estranged from electoral politics.

The refusal to participate means that elections are, largely, the business of the ruling groups and their managers; the professional middle strata; small business people, including farmers; and the most stable sections of the working class in which white males outnumber women. Although women comprise slightly more than half of the labor force, they are typically found in non-union sectors, such as the services, and, therefore, low-wage, less secure occupations. In contrast to many other countries, bank employees are poorly paid and labor turnover is high, especially in so-called "back office" word processing jobs. Thus, most financial service jobs, the growth industry of the 1980s are at the low end of the occupational structure. In a system where voting is voluntary (and also inconvenient for working people who, typically are not granted a holiday to vote) working women and those on public assistance, many of whom are heads of household, turn out to the polls in fairly small numbers. Similarly, black unemployment, which is officially more than 10% but much larger in the cities (and affects 75% of young black teenagers), and the preponderance of African-American workers at the low end of the wage structure conspire, lacking organized expression, to distance them from politics. Needless to say, when blacks vote, they usually support the Democrats, as do working women.

As for the large middle-class youth electorate, a majority has consistently supported the right since the end of the Vietnam era. The most recent example is the Louisiana senatorial election in October 1990 where a massive white youth vote turned out to support the challenge of David Duke, a former Ku Klux Klan leader. Duke appealed without apology to the deep racial insecurities of increasingly threatened whites, especially youth whose economic and social prospects are increasingly grim. (I would explain this strong turn to the right by the appearance created by conservative intellectuals especially during Reagan's presidency that the Republicans had all the ideas while the Democrats were relegated to the role of critics who, in the last instance, caved in to conservative policies when they perceived their electoral position threatened.)

For decades, political scientists have noted what became known as the "deadlock" in American politics. The major contention of the theory is that several factors have prevented the U.S. political system from working as it should. Consequently, America is in the throes of a *legitimation crisis* that threatens the social fabric of society. In this

conception, a key role of the democratic process is to provide a channel through which discontent is expressed. However, when institutions of government, political parties, and voluntary associations such as unions and civil organizations are rent with competing interests that cancel each other out; or, when one interest so dominates that subordinate groups, frustrated by their exclusion from policy, opt for extra-parliamentary means of protest or opt out of the political system entirely; or, when civil society has been suppressed by bureaucratic domination so that discontent expresses itself as abstention—from work as much as public life—a society ceases to remain viable and begins to unravel.

This composite description of some variants on the legitimation crisis is a summary judgment whose validity is increasingly taken for granted. The Jackson campaign may be seen, in this context, as an attempt to expand the political public rather than realign it. The great achievement of the 1988 campaign was to have attracted some new African–American categories to the political process. However, Jackson was not sufficiently radical to achieve a major breakthrough. For one thing, he confined his activities to the Democratic party and refused to run as a third party candidate in the general election because he was attempting to move the Democratic party to the left from within. Second, he presented himself as a militant champion of the general program of the old New Deal coalition and, despite some gestures to the new social movements, remained ensconced within that framework. His only innovations were in the area of foreign policy, a departure quickly neutralized by his subsequent open-throated support for the U.S. military intervention in the Persian Gulf. If both the coalition and its ideological and programmatic traditions are surpassed by historical developments—except among the elites of the popular left—then he is not likely to attract new constituents who are disaffected from politics, especially of the old kind.

Compare Jackson's effort to that of Duke. True, Duke captured the Louisiana Republican primary and, thereby, his candidacy benefitted from the legitimacy of a recognized national political party. However, his program was a sharp departure from many elements of the national political consensus, especially on race. Unlike most right-wing politicians who still pay lip-service to the old social justice agenda, especially on civil rights, Duke presented himself as a genuine representative of an outlaw doctrine—white supremacy—and captured 44% of the popular vote.

Many political observers have argued recently that profound discontent with the political system reaches deep into American culture. Many are outraged by the corporate power grab of the last decade;

others see the mounting deficit, bank failures, and financial scandals as signs that both parties are complicitous in fleecing the public. As we have learned, from both the European and the U.S. experience, populism cuts both ways. Currently, the likely winners among the disaffected will be the right, since the left appears to be hopelessly wedded to an old politics that has outlived its time.

7

Why Work?

I.

The "labor metaphysic," as C. Wright Mills once called it, still dominates labor and leftist ideology. This notion entails not only the primacy of the working class as the chief agent of historical transformation, but also the vision of labor as a moral presupposition of left-wing politics. Trade unions and socialists are prepared, on grounds of solidarity, to propose shorter hours to spread work and thus support the less fortunate among the working class, but to suggest a campaign to reduce work on *social and ideological* grounds remains highly suspect. It is precisely this latter thing I wish to do here.

II.

The question of work is at the heart of the socialist, labor, and Marxist traditions. Historically, the labor movement focused on the struggle over the working day. The eight-hour-a-day movement initiated in the 1880s in the United States was premised on the idea that workers needed eight hours "to do what they will" and that the work day should be shortened to provide this freedom. Labor itself was regarded as intrinsically oppressive since the concept presupposed capitalist relations in which the worker had lost control over the work process. Thus, the labor movement conceived its task *within capitalism* to reduce the amount of labor time required for the reproduction of the worker. The "distribution of time, both between capital and labor, and within the laborer's own working day, became the essential question."

The socialist movement at the turn of the century mediated this demand in two ways. First, in its parliamentary expression, the working-class parties insisted that the state provide a "social wage," that

is, a portion of social capital to be withdrawn from investment and transferred directly to the working class in the form of health insurance, unemployment benefits, and the like. Second, as the socialists began to come to power *within* the capitalist framework, inevitably they not only concerned themselves with specific working-class demands but also with the "national interest." This shift in focus generated policies geared towards accumulation rather than redistribution, except insofar as the enlarged social wage was not understood as the chief representation of workers' demands on the state. The workers' parties became indifferent to the shorter work day and increasingly centered on measures to insure high productivity, such as technological development, and thereby provide room for a growing welfare state.

To be sure, technological development has always constituted the material basis for an agreement with the employers on reducing the work day. This is especially true where strong unions have thwarted efforts to increase labor intensity by means of speedup and stretchout. Yet the socialists encouraged technological change under the rationale of reducing the import burden, improving the balance of payments and trade, and reducing unemployment. The last-named objective was, of course, contradictory to the aim of technological transformation, which is usually labor-saving. Seen in the context of the international market system, however, this "national" strategy takes on a different character: "modernization," as the socialist governments of France, Sweden, and almost all Eastern European countries have argued, becomes a means to generate long-range economic growth and jobs.

After World War II, then, Europe turns more and more "Americanized," falling into Fordism. Accordingly, workers surrender their power over the labor process in return for higher wages, and an easy-credit system which will enable them to buy single-family homes, cars, and other durable goods. As, moreover, the reconstruction of Europe requires more, not less, labor, the socialist and labor movements abandon the shorter work day and emphasize higher wages instead. At least for two generations, the interests of labor consequently seemed to converge with those of capital: economic growth became the new universal, overshadowing class struggle; the zero-sum game as no longer in effect; struggles were confined to combatting individual employers who insisted on reaping all the benefits of technological change and economic comparative advantages; and the central issue over time was shelved.

It must be stressed that this new orientation was not dictated by "reformism" alone. For it coincides with the advent of the Cold War,

which serves politically and ideologically to diminish the space for radical reform. Partly as a result, the Social Democrats in Sweden, for instance, are thus burnt badly on the nationalization issue in the 1948 elections (though they manage to stay in power). In the United States, the liberal Democratic party, supported by a relatively power-ful trade union movement, loses control over Congress in 1946 as a prelude to its complete capitulation to the right-wing attack, a capitulation forcefully expressed in the enactment of the Taft-Hartley Act in 1947 and in the expulsions of a dozen leftist unions from the CIO in 1949. The ideological split within the labor movement re-emerges: in Great Britain, Ernest Bevin, an erstwhile trade unionist and now Foreign Secretary, plays an instrumental role in creating NATO and promoting the Cold War everywhere; the World Federation of Trade Unions is cut in two when a new international federation explicitly based on Cold War precepts is formed. "Free" labor move-ments subsequently come to align themselves willingly with the West-ern ideological, political, and military objectives, which henceforth serve as the overall framework for political and economic action, including the demands for wage increases and welfare measures.

By the 1960s, with the glow of consumer society wearing thin, workers turned their attention to the labor process, which by then had become almost entirely rationalized and devoid of craft. After a long hiatus, there was now a resurgence of the idea of *self-management*, most dramatically during May '68 in France and the "hot autumn" in Italy the following year. For the first time since Spain in the thirties, workers' control was raised as the central demand of revolutionary socialism and militant unionism. This tradition, which actually goes back to Proudhon, assumes that workers' control should be sought not through the state but at the point of production, but also that the dominant form of wage labor corresponds to the crafts and that labor itself is a kind of redemption by which spiritual and social needs are fulfilled and without which humanity in its most fundamental sense is impossible. Both the social democratic and communist parties, on the other hand, had long ignored the workplace in favor of legislation and wage-centered collective bargaining, and thus found themselves at variance with this new surge.

The ground had been prepared in the mid-sixties by writers like André Gorz and Serge Mallet in their works, respectively *Strategy to Labor* and *The New Working Class*. The latter's argument for self-management was linked to the technological transformation of the labor process. He pointed to the contradiction between higher quali-fications in a growing sector of the labor force and the persistence of Taylorist divisions to which these people were still subjected. For

Gorz and Mallet, self-management corresponded to the maturation of what Marx had noted a century earlier: that knowledge would finally become the main productive force, though still subsumed under capital. Intellectual labor, according to these theorists, would not permit rationalization without resistance, and this resistance would consequently be the foundation struggle to democratize the workplace, as well as constitute the heart of the socialist project for society at large.

Self-management had also been the center of the anti-Stalinist program of Yugoslav socialism, though, of course, the workers' councils there remained subjected to the power of the Communist League and the state. Yugoslavia, nevertheless, was the only country in Europe to initiate self-management as a matter of political and economic policy, but was also considered a special case which could not to be emulated elsewhere.

Since the late sixties, however, self-management has become widely adopted, in truncated and distorted forms, by corporations, "progressive" unions, and left-wing social democrats. The key point in this process is the utilization of participation, control, and even self-management as slogans to achieve national advantages in economic growth and productivity. The subversive significance has been lost to the extent that workers' control more often than not takes the form of buy-outs of sick corporations, quality of worklife programs initiated by management, and participation schemes designed to increase output.

III.

Marxist theory has viewed the problematic of work with as much ambivalence as the labor and socialist movements. Marx himself expresses the view that labor in capitalism is "forced" upon the worker, and thus cannot be the means by which freedom and happiness is achieved. His conclusion (especially in *Grundrisse*) is that only qualified labor—scientific and technical labor formed during "free time"—can view itself as something other than compulsion. There is no question of labor (as opposed to work) being free activity when it is subsumed under capital. Marx ascribes the tendency of capital to "degrade" labor through managerial and machine technology to the limits imposed by the growing strength of organized labor and its capacity to limit accumulation. Productivity can only be increased through the lengthening of the work day. As labor successfully fights this, accumulation comes to depend increasingly on rationalization of the labor process, which in turn means the transference of knowledge to management. The part played by direct labor in production

is reduced and indirect labor—design, administration, and maintenance of equipment—takes on a broader role. Direct labor, consequently, is relentlessly dequalified and its power reduced to "watchman and regulator," its "mastery" over nature severely attenuated.

Here we have a new phase of proletarianization. Unlike the industrial era, where the machine operator constituted a real link with inorganic nature and, rationalization notwithstanding, remained the chief actor of production, the new worker is moved to the margin of the labor process. The loss of autonomy on the part of qualified labor extends, furthermore, to the professionals themselves, a process of proletarianization which is today taking place on a grand scale. As professionals have joined unions in greater numbers, capital has subordinated their labor to the point where "intellectual labor" itself is under attack. With the computerization of the workplace, routine tasks are transferred to the machine but the sphere of autonomy is simultaneously restricted except for the narrow layer of computer scientists and engineers responsible for devising the systems. Decision-making is increasingly confined to the choice of "commands" offered by machines, a series of multiple choice questions instead of the essay. Indeed, the very concept of a "program" presupposes a high degree of standardization of intellectual labor.

IV.

How, in a situation such as this, can the demand the workers' control remain subversive? In fact, it can only be seen as defensive actions. Labor of all kinds still needs to prevent their work from endangering life and limb, and from this viewpoint, democratizing or controlling the workplace can serve to impose certain limits. That, however, does not eliminate the central issue: is workplace democracy really a possibility or is the most appropriate way to solve the twin problems of advancing technology and increasing unemployment not a return to the early demand of the labor movement, that of a shorter work day?

V.

I shall return to this question later. For now, let us instead look at two concrete examples of how trade unions have dealt with technological change. Two major kinds of deals illustrate the range of decisions unions and their members made regarding the qualitatively new technology that employers proposed to introduce in the workplace. Both presuppose a politics of *effects*. The first, and perhaps oldest, was the

UAW's response to Ford's engine block innovation at the Cleveland plant, the transfer machine. Instead of machining and assembling engine blocks by hand, workers became watchers, regulators, and service mechanics of a machine that was more or less self-regulating and performed the assembly operations automatically. To be sure, this was a far cry from the dream of the fully automatic factory; the machine often broke down and required human intervention to maintain production. But the myriad manual tasks associated with machine operation were transferred to the machine. After considerable discussion and debate the union greeted this change favorably and only demanded employers provide "supplementary unemployment benefits" to those displaced by increased productivity.

Similarly, the United Steelworkers negotiated supplementary unemployment benefits plans when major corporations in the industry proposed that they replace the mechanical method of rolling steel with a console that controlled such operations as speed and feed of metal, adjustment of widths, and coil winding by electronic means. In time, the highly skilled, hand-sensitive job of roller was eliminated and the operator manipulated buttons on a console from inside the booth. Wages were not reduced and for several years after the introduction of the new method, the high volume of Vietnam War-induced demand for basic steel and its products prevented significant layoffs. But when the war ended and steel companies demanded more latitude to automate other steelmaking processes, the higher level of productivity combined with a relative decline in steel production to permanently reduce work forces by more than half. By the mid-1970s the union had surrendered its longstanding requirement that no new machine technology or new work methods be introduced during the life of the contract and declared itself willing to grant the employers as much flexibility as they needed to fight growing international competition and challenges from domestic producers of substitute materials such as plastics. In return, workers received longer vacations and, like the autoworkers, succeeded in obtaining a contract provision that enabled long-time employees to retire after 30 years. Thus, in addition to income guarantees for a limited period of unemployment (usually one year), the auto and steel unions opted for a modified work-sharing contract that restricted the extent of permanent layoffs resulting from economic and technological changes.

Still, these "solutions" have resulted in considerable hardships for many workers in these industries. By the early 1980s, economic conditions had deteriorated sufficiently to produce permanent redundancy: older plants were closed forever, and modernized factories employed fewer workers because, by this time, automation had spread to auto

assembly plants and steel fabricating. The dominant technology was computer-based. Numerical controls quickly spread to machine shops in all metal fabricating sectors, including aircraft, machine tool production, and metal-forming plants for auto and other industries; robotics were slowly implanted on the assembly line; and computer-regulated materials handling equipment brought parts from one work station to another, replacing the fork lift driver.

In lieu of substantial wage increase, the 1984 agreements with major companies retard layoffs except for economic reasons. That is, workers displaced by machines or work reorganization may be assigned to a job pool, thereby retaining their income for a considerably longer period than was provided by SUB. Faced with the rapidly accelerating pace of technological transformation, the union membership voted by a narrow margin to continue the income guarantee approach and permitting employers free reign in opening and closing plants, to engage in "outsourcing" (contracting parts production overseas and to non-union plants), and to put technologies in plants with few, if any, restraints.

The second approach is best exemplified by the longshore and printing industries' programs. Perhaps the landmark agreement in this mode was the Mechanization and Modernization agreement concluded between the Pacific Maritime Association (PMA) and the West Coast-based International Longshoremens and Warehousemens Union (ILWU) in 1962. Noted throughout the labor movement as a tough, honest, and militant union, ILWU was marked by an active rank-and-file membership that had fought bitterly in the 1930s to establish union control over hiring, the work process and procedures, as well as to achieve extensive benefits. This union, although not composed primarily of "craft" workers, had succeeded in achieving the basic premise of craft unionism, control over the supply and methods of labor. It exercised iron control over such issues as: who could enter the industry and how many; which workers were sent to jobs by the hiring hall; and how much cargo was loaded and unloaded in a single day. Workers were rarely if ever employed permanently by a single employer; instead the employer was obliged to request labor from the hiring hall on a job-by-job basis. The contract stipulated the size of crews. When the job was ended (cargo had been loaded on or unloaded from a ship, for example), the workers returned to the hiring hall to be dispatched to the next job. On the job, the steward was the most powerful figure and determined all of its technical as well as political aspects. The nature of longshoring was essentially cooperative and little, if any, competition cropped up on the job. Those features of the job not stipulated by the contract were tacitly regulated

by the rules established by collective labor. The San Francisco docks were the pace setter for the entire coastal stevedoring system. The work culture was inscribed into the system of labor relations, both among the workers and between labor and employers. Like the Steel-workers Union, the ILWU had won strict limits on the ability of employers to introduce technological innovations. When PMA made a request for containerizations of cargo the first response of the membership was to reject the suggestion. For some time prior to 1960, some European ports had been using containers. These large box-like structures were able to hold tons of cargo, could be stored away from the dock, and were transportable onto the ship mechanically. The long tradition of hand loading, aided by the famous dockers' "hook" (a small metal object used to snare the cargo), was rendered all but obsolete for much of longshoring.

Containerization increased worker productivity manifold and threatened the jobs of thousands of longshoremen. Equally important, the containers could be operated by a single crane driver working with a small crew of workers who had been required to move cargo from the dock to the ship's cargo hole. Henceforth hand work was pretty much confined to bulk cargo in the "hole," unloading the cargo and arranging it safely and securely aboard ship. Not only were the crews reduced eightfold, but the tradition that had sustained labor's control over the production process was on the way to destruction. These were the major initial considerations that engendered rank-and-file opposition when the union leadership finally agreed to bring to them the proposal to permit containers on the West Coast docks.

Unlike the auto and steel solutions, the M and M agreement provided work or income guarantees regardless of the extent of technological change. In return for permitting containerization and the consequent partial reorganization of the management or work, long-shoremen were assured an annual wage whether they worked or not. For many older workers these annual guarantees might endure until retirement, but for others the guarantees would be subject to a review, and depended ultimately on the economic position of employers and extent of redundancy. The union retained its hiring hall and would control the work assignments, but there was no question, at least in the long run, of preserving the work culture that had effectively sustained worker power. Not only would crews be reduced but the containers would gradually remove a considerable power lever from the workers' hands, their skills that were rooted in an oral tradition passed from generation to generation and sedimented in a complex tacit set of rules and procedures.

Leaders and members finally agreed to the proposal with many

misgivings. As in other cases, they became persuaded that without containers their docks would not remain competitive with other ports. Further, since containers are transported by trucks, the entire shipping industry was jeopardized, except for international trade. Competition within the transportation industry, which included air cargo, trucking, and the high costs of large pools of hand labor, became the overwhelming argument that forced the union to permit containerization.

Like steel, the docks witnessed little change in the level of employment the first years after the agreement. Even though containers displaced labor the volume of traffic due to the Vietnam War and the generally high level of economic activity sustained longshore jobs, not only for those assigned to directly share the benefits of productivity gains (called "A" men), but also others assigned more casual opportunities for employment (called "B" men). Again, as the 1970s produced significantly reduced shipping business, both because of the precarious economy and competition from other transportation sectors, redundancy became more common. Five-day weeks were reduced to two or three for the most privileged group and others were unemployed for long periods. Further, the port of San Francisco lost considerable business to other West Coast ports such as Oakland, Puget Sound, and Los Angeles.

Technological change is by no means the only cause of substantial reductions in traditional blue collar jobs in production and transportation. On the contrary, it is a *response* both to sharpening competition in international and domestic markets and the economic strength of organized workers. Union power to raise wages and impose a relatively substantial "social" wage on employers (particularly privately financed pension and health plans) is certainly an incentive for employers to institute technical innovation in order to reduce the size of the work force. But equally important in such trades as longshoring and printing was the power of the traditional work culture to restrict managerial prerogatives, especially the ability of the boss to assign and direct the labor force, to impose output norms, and to hire and fire workers at will.

The great San Francisco strike of 1934 established, among other things, union control over hiring, a magnificently democratic way of assigning the work force by the union, and became the spearhead for the CIO organizing drive on the West Coast that brought hundreds of thousands of workers into the industrial union movement. Competition in these industries intensified in the 1960s and 1970s, as employers sought a way to regain the advantages they had lost during the previous two decades when labor's political and economic weight,

based on its ability to control the supply of labor and the mode of working, had combined to raise labor costs and restrict profits.

The various efforts of labor to cope with technological change (which has become for capital a central strategy of economic survival in a harsher world economic order) has raised a large number of new questions, not only for workers but for society as a whole. Perhaps the most obvious is whether advanced industrial societies of the West can provide sufficient employment and/or income to maintain the historical level of material culture that was created during the first two decades after the War. Since the worldwide economic crisis beginning in the early 1970s, European countries have met the challenge of a changing economic climate by enlarging transfer payments to those displaced by reduced markets and technological change. Among these, the key measures are a relatively high level of long-term income maintenance, government-financed retraining programs, and the nationalization of sick industries that amount to government subsidies for retaining plants that have proven economically redundant in the national and international markets. All of these measures, with the exception of nationalization, presuppose an economic slide of short duration.

We are now faced with the unexpected but startling prospect for long-term 10–15% unemployment in all advanced capitalist countries because growth rates have not matched forecasts and employers are scrambling to use labor-saving technologies to bolster profit rates, especially in Europe where labor's power prevents the alternative strategy of wage cutting. The situation in the U.S. was similar during the 1970s, but the last five years has witnessed massive concessions by unions which simply lack the political or social weight to resist employer assaults on their hard-won gains.

However, 10–15% permanent unemployment raises larger issues for the entire society as a whole. Since the workers and their unions moved, implicitly, on the assumption that work itself was no longer the defining activity of their lives, the question was what to do with *time*, the most knotty and complex question of technological change. For this was no longer the same as labor's historic struggle for the shorter work day/week which was based upon the excruciating consequences of the 12- or 14-hour day for safety and workers' humanity. Now free time has displaced labor time as a burden. It is no longer a question of developing a creative approach to what has been called "leisure," since this category presupposes that work is still the principal feature of social time and "free" time is its surplus.

William DiFazio's study of Brooklyn longshoremen *Longshoremen* deals with this question. It is a case study of a group of workers for

whom "work" has been relegated to the margins of social existence and freedom has become the unknown care of their lives. He has discovered that many longshoremen in Brooklyn have found an alternative to work as organizing principle. It may be argued that this community still revolves around the putative workplace. After all, the hiring hall, which is grounded in the industry, is the center of longshoremen's social life. And, their identity remains tied to their occupation. But this only explains how it was possible to form a community in the first place. It does not explain how the men were able to sustain their friendships, networks of social contacts and strong ties over more than a decade.

DiFazio finds that, after some years of unwork, these men have lost the lingering desire to perform labor. They regard the prospect of putting in a day's work with some dread and would much rather hang around with each other, or spend time at home or in the neighborhood. These workers do not spend all their free time watching TV or drinking in bars; instead, they begin to share with their wives the housework and childrearing, even if this shift produces some anxiety about sex roles. This propensity to treasure their unwork without severe emotional and mental strain might confound social workers, researchers, and civic leaders. It is important because it confirms that in post-labor periods working-class culture doesn't disintegrate. It may be argued that the guaranteed income plan, which offers a decent working-class wage and, unlike the unemployment benefit or public assistance, does not plunge the individual into virtual penury, is responsible for this fact. Further, these men remain respected members of the industrial community because their agreement recognizes them as valuable members willing and able to work if the need arises.

The significance of DiFazio's narrative goes far beyond the specific case. These men have resources with which to resist many of the disintegrative tendencies of what Henri Lefebvre has termed the "bureaucratic society of controlled consumption."

The longshore experience illustrates one of the counteracting tendencies in the evolving post-industrial culture of late capitalist society, namely, that the shift from production to consumption as the locus of everyday life is by no means automatic when "free" time dominates "necessary" labor time. When the workplace and the neighborhood are spatially contiguous and workers have succeeded in preserving an institutional equivalent of the shop floor to provide the basis for their social interaction, consumerism is relegated to a subordinate place in their everyday experience, although some workers still perform two jobs, enter the part-time work force, or otherwise try to earn extra income.

In contrast, in the postwar period, even where the industrial or clerical workplace is relatively stable, living spaces have become widely dispersed so that a collective face-to-face culture becomes improbable. The disjunction of work and living space obliges many to travel for as much as two hours to the job, leaving little time or energy for ordinary social intercourse in bars, bowling alleys, or union halls. The classic model of contemporary mass society is provided by the suburban or exurban location of industrial and commercial working spaces. The horizontal patterns of home construction produce low density living arrangements. Hence, the nuclear family, the shopping center, the mass media constitute the nexus of social relationships that often effectively countervail the collective tasks performed at the workplace.

In the past decade, employers have taken care to diffuse even this collective work site by radically decentralizing production and administrative labor, a development facilitated by transportation and communication technologies that vitiate the requirement of face-to-face interaction to move paper or things. The old plant or office of the mechanical era employing thousands of workers in a single city, most of whom reside there as well, is rapidly disappearing. In this regard, chemical and oil refining has long provided a model for industrial investment and IBM a parallel case for office as well as production labor. In both cases, advanced technologies permit both fairly small facilities and wide dispersal of their location.

We may doubt that the relatively upbeat tale of the Brooklyn Longshoremen can be duplicated without a strong union. In most cases, workers who are rendered redundant by economic or technological changes are forced to reenter the labor market as "naked" individuals; in most cases the specific industrial skills they acquired disappear with their jobs. The much reduced work force that replaces them is required to learn new skills that are incommensurable with the older tasks. Moreover, workers have left their union in the plant, office warehouse, or truck barn from which they had been displaced. In only a few cases does the union remain at their side to assist them to find a new job. Even unions like the longshoremen's that maintain hiring halls offer few opportunities for their own members, much less new entrants, into the market. This unfortunate situation is a product not merely of the rapidly changing labor market and the economic circumstances that have restricted union power, but of the loss of the ethic of class solidarity among unions themselves. In most cases, unions have defined their responsibility more and more narrowly in terms of the remaining labor force. "We see our job as servicing union members," said one union official. And, as the former secretary-trea-

surer of the ILWU told this writer shortly after the signing of the M and M agreement, "This union can't be responsible for future generations or for the rest of the labor movement. We must be mainly concerned with our own."

As computerization and other labor-saving technologies spread, the jobs described by DiFazio are part of the past. For the generations of semi-skilled workers that entered the labor force in the 1970s and early 80s, low-paid service jobs have replaced blue collar jobs in production and transportation. These jobs are relatively labor intensive are located in competitive or highly decentralized industries which are, for a variety of reasons not organized by unions. For a growing fraction of the working population technological change means permanent unemployment without the benefits enjoyed by such groups as the longshoremen. These are people for whom paid labor remains a distant and sought after shore.

We are on the threshold of an epoch envisioned more than twenty years ago by the *Triple Revolution* group which asserted that all of our conventional ideas about the relationship between time and work were made obsolete by automation. Since, in the 1960s, empirical reality seemed to disconfirm their hopeful but apocalyptic ideas, leisure became the new organizing principle of post-industrial society. However, these notions arc once more on the social agenda and it's remarkable how unprepared we are to think about them. It's not a question of speaking of the old battle cry of a full employment economy, of Keynesian economic programs to "put America back to work." These concepts belong squarely to the pre-computer era. For information technology, as is well known, has penetrated every crevice of our industrial culture, computers are a cultural as well as purely instrumental intervention into production. To fail to grasp the degree to which this culture now dominates both thought and economic and social institutions is to misread our times.

Until now, I have been using the phrase "post-industrial" without defining it. What I mean is not the same as the fairly obvious statement that most people who work are engaged in service occupations rather than the production of things. This development, it seems to me, would not prevent calling our society "industrial" if the quantity of necessary labor still defined our material culture. For "Taylorism" is not merely a technology of material production, it is a category of the technical division of labor, particularly the separation of intellectual and manual labor. This separation still dominates nearly all wage labor, whether of the production of things or of services. The point of management science is to organize the labor process hierarchically on the assumption that this is a more efficient way of achieving a

given level of output. Its tacit purpose is to deprive the majority of the workers of their collective autonomy through transferring skills either to machines or to the executive and administrative functions.

The shift from Taylorism to Fordism signals a radical shift in the locus of economic activity. Fordism is the managerial strategy of simultaneously chaining labor to a series of externally determined repetitive tasks and providing workers with the means to sustain the circulation of the products they make. Introduced in the years immediately prior to the Second World War, *Fordism* rapidly established itself by the 1950s as the mode of capitalist reproduction. Mass consumption was not conditioned on high wages alone. Two other crucial components were 1) the time credit system that permitted the consumption of consumer durables such as houses and cars by workers and a large fraction of the middle strata, and 2) the rise of advertising which eventually came to provide the fundamental reason for being of radio, TV, and mass-circulation magazines. This regime of production-distribution, circulation, and consumption is a specific feature of the second decade of this century and became ubiquitous only in the third decade.

As cybernetic and computer-mediated technologies have spread to all major economic sectors, the question "why work?" is now an issue in all advanced capitalist societies. Computer-mediated clerical labor signals the crisis of work as the defining activity of our society. Its traditional meanings are surely called into question by the discovery, now fairly commonplace, that such computer work as data processing by the use of video display terminals, is fraught with danger and frustration. According to a *Wall Street Journal* article, "the terminal users had to follow rigid work procedures and didn't have control over their work." The article goes on to note that computer data processing emulated Taylorism with one important addition, "the computer system has been programmed to monitor workers' performance." And, workers are paid according to their production, like piece workers of yesteryear. Further, data processing has become as monovalenced as any assembly line labor.

Far from suggesting a new era in which worker autonomy corresponds to multivalenced labor (workers performing a variety of different tasks under their own control), computer-mediated clerical labor chains the workers to a machine and the most crude industrial conceptions of productivity. The repressive managerial programs associated with such arrangements produce a Fordist worker mentality. However, these women are not paid well enough to afford the durable consumption of traditional assembly line workers. On the other hand, the work itself is not satisfying enough to make clerical labor meaning-

ful. For one thing, the "data" input is not linked in the operator's mind to any specific product. That is, the work is highly abstract without becoming conceptual and is, therefore, more stressful than the automobile assembly line where workers can dream as their hands perform individually meaningless tasks but the product is concrete and widely understood. Data processors must concentrate and their work is "measured." For another, in the typical office this labor is performed in isolation: the data processor interacts with a machine that doesn't engage in conversation or other types of linguistic intercourse. In many offices, workers are confined to carrels which reinforce their mutual segregation except during breaks. The absence of intrinsic significance to the performed work produces mental exhaustion which is only exacerbated by the monitoring which data processors must endure. It is no wonder, then, that operators are reported to stay on the job two years or less. The problem is that most other work available to women is of the same kind. Confined to a rigid occupational structure in which the limits of their responsibility and skill are enforced by coercive measures, many clerical workers live for leisure, the time away from wage labor, only to find that this is also bounded time, bounded by housework and cultural consumption.

Perhaps an even more dramatic indication of the crisis is revealed in the enormous proliferation of part-time employment in retail and wholesale trades, the fastest growing employment sector in American life. These trades are still largely labor intensive (despite some automatic procedures at check-out counters, where employees no longer need to know simple arithmetic because the electronic cash register makes the correct change when the numbers are pushed, weigh produce and calculate its price when the price per pound is given). The persistence of most labor intensive jobs are directly related to two economic phenomena: small competitive industries and conditions in which the minimum wage is still the fulcrum around which labor is paid. Many retail food, clothing, and department stores are part of national or regional chains that have simply calculated the comparative advantages of employing a higher proportion of direct labor to investing in large-scale machine technology. The persistence of hand labor in these sectors is a form of disguised unemployment, or underemployment. For if these workers earned higher wages, employers would be obliged to introduce labor-saving machines more widely. Further, by employing increasingly greater quantities of part-time labor, employers are able to pay less and keep union organization down. Part-time workers are less likely to demand higher wages or seek union organization. Moreover, this kind of semi-skilled labor is viewed by workers as instrumental to obtaining income as a means

to an end. The work itself, even more than industrial labor, is viewed as extrinsic to personal identity, because it is usually more temporary and sometimes casual. Women engage in part-time clerical and retail jobs to help support their families and are attracted to those places that permit flexible worktime. Today millions of people take whatever part-time work is available regardless of its content and do not expect to be fulfilled by it, except in relation to income it yields. Thus, part-time labor has hastened the shift of individual identity to the private sphere, abetting the "forgetting" associated with the trivial nature of repetitive tasks.

The incredible expansion of what Baran and Sweezy in their book *Monopoly Capital* (1964) call the "sales effort" is, in many ways, a form of disguised unemployment. It is a symptom of society's reluctance to accept the reality that underlies all kinds of labor in late capitalist society: the national economy simply no longer requires the vast army of labor that seeks wages and salaries. Indeed, millions still seek jobs, *but only to earn a living.* Few jobs still carry with them the idea of *vocation* such as is usually associated with professions or genuine crafts (neither of which correspond to their contemporary practices). Even much industrial labor of the past—mining for example—was closely linked with work cultures that far overshadowed the semi-skilled character of the work itself. The sense of vocation experienced by workers in the retail trades or civil services (two of the most important service sectors) was long eclipsed by the advent of the corporate selling (McDonald's is perhaps the leading example in food, Federated Department Stores in general retailing).

None of this is meant to assert that there is no work to perform in our society. On the contrary, the vast project of civil reconstruction of our physical infrastructures, such as water systems, mass transit, and roads, would require considerable investment in labor and machinery. Further, our society suffers from systematic deprivation of those services crucial for contemporary human life, such as health, child care, and education. These public functions are performed on the basis of the system of wage payments when a guaranteed income program could suffice. A publicly organized guaranteed income plan would not abolish work, nor need it reduce income differentials entirely. But it would remove the coercive aspect of labor, except insofar as every citizen would still be required to perform public work, just as most European countries require a period of military service for all adult males. Under these circumstances, the private sector would be obliged to offer material and social incentives in order to attract labor. It is precisely for this reason that corporations and even small mercantile interests have opposed, in principle, the expansion of the

public sector on the basis of a competitive salary scale. The key element in the ability of employers to keep industrial and clerical wages low has been the relative deprivation of public employees. If this hypothesis is true, the rise of public employees' unionism in the 1960s and 70s was a threatening event to capital because workers achieved a considerable measure of wage equalization, forcing wages up in the private sector.

Of course, unwork continues to be inscribed within the workplace. In his *Accumulation Crises* James O'Connor has made a convincing argument that the struggle over time goes on in the factory and office. From the point of view of capital, frequent breaks, whether sanctioned or not, machine breakdowns, informal sabotage, slowdowns in production, lateness and absenteeism and longer vacations, are forms of unproductive labor. These disruptions inside the workday are manifestations of the tendency to progressive diminution of work in late capitalist societies. This is not only a "cultural" question, but a serious terrain of struggle over the production of economic surplus. In times of severe competition on a world scale, capital has bent every effort to tie workers more closely to the machine, monitoring their output and trying to impose productivity norms on sectors historically immune from such measures. It seems that only in the defense establishment are such norms routinely ignored because the prices charged the federal government reflect the extent of unproductive time.

VI.

This is the material context for the advent of post-industrial society with its displacements: spatial atomization that forms the material basis for individualism; the changed focus from work culture to consumerism; e.g., the transformation of work relations from Taylorism to Fordism, signifying the change from the ideology of redemption through labor to the redemptive character of the individual possession of non-productive things. This last is embodied in the rise of the GNP as the center of the economic debate. Gross National Product does not differentiate among different kinds of production: the proliferation of fast food outlets, the construction of more shopping centers, and other such activities are just as desirable as a ton of steel or a barrel of oil. As we have blurred such distinctions, the *productivist* ethic is considerably weakened.

Post-industrial society signifies a new mode of life. We no longer search for an underlying ethical rationale for social production. Production is now seen as an aspect of the "internal cohesion" of the system which becomes, for its own sake, a source of legitimation.

Under this regime, if building shopping centers contributes to economic growth, it is slightly absurd to ask whether they fulfill a social need or whether such investment meets the criterion of being the most morally sound way of allocating resources. Even though scarcity still functions as a crucial ideology of social domination, its social logic does not regulate investment decisions. The traditional contradiction between production for accumulation and production as a parsimonious allocation of scarce resources seems to have fallen victim to the GNP imperative. From the standpoint of system maintenance we dare not ask why we are producing certain goods. Indeed, Jimmy Carter and his putative successor Walter Mondale fell victim to exactly such considerations in the 1980s, when Ronald Reagan and the conservative Republican majority, reversing roles, excoriated the Democrats for pessimism and all but openly advocated a morally neutral approach to economic growth that permitted a wanton arms buildup as the centerpiece of their strategy of growth for its own sake.

Surely, growth for its own sake has been a leading aspect of late capitalist culture. It formed the foundation of Keynesianism from the 1930s, when the economist succeeded in making macroeconomic discourse hegemonic within economic reasoning. Henceforth, digging holes, providing transfer payments to individuals, and permanent arms production would be evaluated, with some restrictions, exclusively in terms of their growth-producing potential rather than according to use as a criterion. Even the world economic crisis of the 1970s and 80s has failed to cause a profound shift in this discourse. On the contrary, in the U.S. the crisis has engendered a Keynesian revival even after much handwringing about the world debt and the deficit in advanced capitalist countries, and after the no-growth debates. Today, mere suggestions that growth should be tempered either in the interest of environmentalism or fiscal prudence are viewed as heresy, except for the third world and the poor of the advanced countries. System cohesion now requires a differential, situational ethic: austerity for the poor, profligacy for the rest.

At the same time, the proliferation within our own country of consumerism has resulted in a vast expansion of retail service industries, such as restaurants, and even the old time familial ethic of homemaking has partially broken down. We are now urged to constitute our daily lives as *buying and eating*. In the suburbs, the bureaucratic society of controlled consumption becomes a new universal; in the cities it is a marker of class and status, actually no longer a general signifier.

Of course, the second activity is watching. As Jean Baudrillard has argued, contrary to the common sociological wisdom that holds that

the media envelopes the masses, and its messages are directed towards a passive receptor, the microgroups that constitute at least a portion of the "masses" do not passively receive television, but recode its emanations in terms of the rituals and cultural practices of the group. Surely, the Brooklyn longshoremen are one of these microgroups for which the messages of radio and television still run up against social life which possesses its own traditions and codes of meaning. And, as DiFazio shows, even Baudrillard's pessimistic idea that the postmodern era is marked not by depoliticization but by mass aggressive rejection of the political sphere, must be severely modified by the existence of the longshore *culture.*

But what of those who have withdrawn to the domestic sphere (literally or figuratively), or otherwise find themselves isolated not in microspheres, such as communities, but in the nuclear family? The family cannot be said to form an alternate cultural sphere capable of resistance. It is here that Jean Baudrillard's derivations of Henri Lefebvre's ideas are of interest. Privatization is not only a rebellion against being represented by the political. According to Baudrillard in his *In the Shadow of Silent Majorities* it signifies *the end of the social.* The masses, he asserts, are no longer historical subjects, but nor are they objects. They are "hyperreal"; they have been quantified as eternal sets of statistical tests aggregating their desires, changing views, propensities, and prejudices. They are incapable of being represented politically or socially (hence the end of the social sciences in the strictest sense) because their "reality" is now purely a series of signifiers, their representations entirely simulated. Hence, politics and social science, two discourses that purport to treat of economic, political, and social relations as a legitimate object of investigation must lose their legitimacy.

Following from this semiotic recuperation of the categories of the political and the social, Baudrillard concludes that power itself is in crisis because its referent, the masses, has disappeared or, to be more exact, it resists participation by virtue of its refusal of public life. Baudrillard has taken over claims that *sign/value* has overcome use value, that is spectacular consumption. Official social science frantically tries to preserve the use value of commodities in the interest of economic rationality, but the masses "block the economy," resist the "objective imperative of needs and the rational balancing of behavior and ends." He notes that spectacular consumption signifies "the end of the economic" by the subversion of its rational definitions.

Baudrillard's position is that our societies are experiencing an implosion of non-participation in the economic, political, and social behaviors/categories that constitute meaning, including those critical/

revolutionary discourses inherited from the French Revolution. And he names terrorism as the final "politics" of this blind implosive condition, because it aims at the silence and non-participation of the masses without "revolutionary consequences," only blind refusal. Another sign of implosion, according to Baudrillard, is revealed by Mr. McLuhan's notion of the media as the message. He recodes this as mass (age). In effect, Baudrillard reads *Understanding Media* as an argument for mass media as a black box, in which both the sales effort and the propaganda role of TV are futile efforts to impose meaning on the masses when meaning is itself in question. According to Baudrillard the masses are not alienated, for this condition implies a specificity of both subject and object: Marx argued that alienated labor would explode the relations of production that have enslaved it, but the new situation is not one of revolutionary action or quiet desperation but of terrorism.

The armed youth gangs exhibit this language of terrorism. Their refusal of school and other kinds of adult authority expresses itself out of the barrel of their submachine gun. The recent youth gang is not a phenomenon of "mass society," for this term can only connote the absence of a microsphere or subculture. Rather, mass society is the signifier of the idea that masses are subject to a manipulated and simulated culture imposed from without. In many representations of mass society theory, from Mills to Lefebvre, we encounter only images of passivity. The terror struck by youth for whom the worlds of meaning characteristic of the old culture have imploded is not "senseless" or blind as Baudrillard characterizes contemporary violence of this sort. Rather, it is a symptom of a specific, not anomic refusal to be integrated into the administered society. Earlier studies of "alienated" youth, such as those performed in the fifties by Olin and Cloward, in the sixties by Kenniston and Flacks, and in the seventies by Willis and Corrigan in England and Larkin in the United States indicate that working-class and middle-class youth constitute subcultures of resistance on the way to integration into the hierarchical relations of industrial and administrative labor or, in the sixties, into the politics of protest. The politics of protest of the middle-class youth led to the formation of the New Left, an alternative to the prevailing systems of meaning or, to be more precise, a redefinition of traditional democratic symbols. The rebellion of school dropouts turned out to be a reaffirmation of working-class values which, while refusing the mobility paths offered by their completion of the curriculum, unwittingly reproduced labor power in production sectors.

The new youth gangs not only have sophisticated weapons, they use them against authority representatives they dislike. This is a

departure from the pattern of the last great gang era of the fifties, when most of the violence was perpetrated by gangs against each other and was the consequence of bungled petty thievery. Now we witness attacks against institutional authority which, however misplaced, reveal the destructiveness of a terror that has been removed from its political context of both left and right. To be sure, it is still specific, but no longer invokes ideological flags to justify itself. In the vernacular of skinhead culture and punk rock and roll, the new language of terrorism articulates not as affirmation of the virtues of a class subculture, for this still entails participation. In contrast, the Stones and Bruce Springsteen are nothing if not tribunes of working-class youth condemned to the Taylorist assembly-line. Where their anger is laced with both irony and sentimentality which are the markers of a radical/conservative proletarian youth subculture, punk signals the rootlessness of declassed youth for whom labor is itself a disease to be avoided at all costs. Punk songs are framed in the discourse of refusal not only of the blandishments of middle-class values but of the older working-class ethic as well. "I want the reign of anarchy in the U.K." sing the Sex Pistols and "I don't want a Holiday in the Sun," a less than oblique reference to the definition of workers' free time as "leisure" to be enjoyed as a temporary escape from the routines of ordinary industrial labor.

It does not matter that the British economy makes no room for its youth, that joblessness is involuntary. Fifteen years after the last generation of youth to enter the traditional industrial working class, young American blacks and their counterparts in the U.K. are caught not so much in the net of consumerism and TV as by the hopelessness of their situation. Having been explicitly excluded from labor force participation and distanced from their elders' aspirations, they embraced the alternative of unwork rather than view it as disgrace. The terrorism of contemporary rock and roll for the larger society is that it betrays little or no respect for the paths onto which they have been trained to travel. Youth communities are constructed out of their exclusion, their culture is rife with the rituals neither of protest nor passivity but of hostile and aggressive despair.

The high rate of youth unemployment is among the most ubiquitous signifiers of post-industrial society. Many have been screened from labor force participation regardless of the expansion of labor intensive retail services.

American core cities and rural slums are marked by crowded male street life in daytime. The difference between the situation faced by ghetto and slum youth and the longshoremen in DiFazio's study is that the latter remain part of the labor market despite the separation

of work and income which has allowed them to escape the labor process. Both face a restricted job market that has been shaped by the new world economy and the technological imperatives that accompany it. Neither group would benefit collectively from retraining programs, prudent consumption, or any of the other palliatives offered by liberal institutions. Even if schools were more efficient, that is, were able to provide job specific skills to the millions of younger and older people excluded from labor force participation except on a casual basis, the overproduction of labor power characteristic of the current situation would remain. Individuals would still fall through the cracks, especially those coming from homes with strong middle-class and professional ideologies. But the struggle for jobs would remain subordinate to the struggle for time, and the main question would still be who will pay for the necessary shift away from work to unwork.

I am not claiming that terrorism in everyday life is attributable exclusively to the institutional backwardness in the wake of permanent technological displacement. But the degree of privatization in these societies is in no small measure a consequence of the emptying of meaning from traditional industrial norms such as work, representative political institutions, and the notion of the public as the final arbiter of social policy and ethical consensus. I am claiming that just as labor has been severed from income, so community and culture have been separated from the labor process and no longer depend for their vitality on the socializing function of the workplace.

Instead, consumerism, atomization, depoliticization, etc., are one response to the new situation. Youth, minority, and women's communities form around schools, neighborhoods, churches, and other sites that are now radically disjointed from industrial culture. In this respect, Ida Susser's excellent study of a Brooklyn sub-working class neighborhood *Norman Street*, which has lost most of its industrial base in the past two decades confirms DiFazio's contention that both earlier mass society theory and its newer version by Baudrillard lack universal applicability. Susser shows how a neighborhood successfully fought a battle over social consumption, in this case the city's plan to close a firehouse. Further she demonstrates the remarkable persistence of neighborhood organization and struggle despite repeated defeats on a host of issues.

What emerges from this discussion is that the new situation produces decentered consequences which from the point of view of the general economic and social presuppositions are quite varied. De-industrialization, technological transformation, the emergence of a large and growing service sector, consumerism, the "society of the

spectacle"—none of these fully accounts for what is possible. Most post-liberal liberal theorists are locked into the discourse of critique that, despite many valuable insights, is so totalizing as to exclude the possibility of resistances that are not necessarily short-lived. Further, they have all argued, to one degree to another, that postmodern culture is devoid of normative structures that preserve meaning but instead have succumbed to various sorts of instrumental rationalities and purely administrative forms. While I would argue that ours is surely a post-enlightenment culture, that is, a culture which no longer defends the regulatory force of ethical principles, it does not follow that this marks the eclipse of reason as theorists from Horkheimer to Baudrillard contend. Ours is decidedly not the age of the triumph of the irrational. At the same time, it is premature to contend that an alternative normative order has been successfully developed and, with it, a theory of postmodernity to help it along. What is certain, however, is that the old categories no longer suffice either to explain or reproduce social life and that the old notion of the social which, after all, depended on an intimate tie between work and morality, can be saved.

At the dawn of the new cybernetic age, social theory and social policy were more prepared than now to confront the consequences of its fantastic productivity gains. President Nixon went so far as to appoint Daniel Patrick Moynihan to prepare a new guaranteed income plan to replace the outmoded welfare system which, after the Depression, had been geared to the existence of a permanent underclass of about ⅕ of the population, including the halt, sick, and lame. The Nixon administration began to recognize that unemployment was no longer cyclical but had become a structural feature of the economy which could not be eradicated even by high growth rates. While the Moynihan plan was weakened by the ordinary political and economic constraints, mainly the stubborn employer resistance to an income program that could potentially cut into the low-wage labor force, the administration had recognized that something new and different had already occurred that the old institutional arrangements could not absorb.

However, the proposition that work could be severed from income was not to become national policy. Its implications for the economic and moral order were simply too threatening for a society that held itself together only by surplus repression. The concept of "surplus" repression advanced by Herbert Marcuse thirty years ago referred to Freud's idea that civilization survives by rigidly imposing labor discipline upon its members who would otherwise seek pleasure if left to their own devices. According to Marcuse, labor is the foundation of the bourgeois moral order and had to be preserved lest that order

disintegrate. In a society marked by post-scarcity conditions owing to technologically wrought plenty, the idea of separating work from income becomes the most subversive political and cultural force. (see *One Dimensional MAN*)

We are not obliged to accept Marcuse's Freudian framework to appreciate the power of surplus repression as a regulative category. It signifies the contradiction between our collective productive powers and those institutional and moral precepts that maintain a hierarchical occupational and social order. Among these, the idea of the *wage* remains preeminent. That is, we are still subject to the spurious notion that income results from a "fair day's" labor. Millions of new service jobs created in the past two decades in proportion as jobs in the goods-producing sector have disappeared are centered principally in activities whose social use is open to serious question and, as I have previously argued, is largely a form of disguised unemployment

The political climate is unfavorable even for a substantial reduction of working hours, a measure which would certainly share the available work among a larger group of people and would threaten the underlying moral structure that income should be a consequence of hard work. Like the struggles of the early part of this century, the shorter work week is opposed by guardians of our capitalist economic assumptions and their moral acolytes who claim that such an arrangement would lead to sloth. The problem is not the opposition alone. The sad fact is that workers and their unions in nearly all Western capitalist and state socialist societies have surrendered the shorter work week demand not only because in most cases the labor movement has been so severely weakened that it could not win, but also because it has lost the will to oppose the institutions of surplus repression. Today, most workers have introjected the conditions of their own domination by enthusiastically accepting, on the explicitly ideological plane, the idea that the wage is a fair exchange for a given quantity of labor. Unconsciously, of course, workers take every opportunity to steal time on the job for themselves, many are "experts" in appearing to be busy when they are doing "nothing" from the point of view of the employer.

Underneath we may be terrified of free time. To have time on our hands produces not only personal anxiety but challenges the cultural assumptions of the prevailing order. Yet, time is the contested terrain of our age. To abolish the old distinction between necessary and free time would surely require introducing the fundamental distinction between work and labor. Although the original connotation in ancient Greece was to mark the head off from the body, to separate craft from the labor of the slave, we may now recast it. Work is that human

activity which expresses creative achievement and corresponds, therefore, to part of *desire*, our will to objectivate ourselves individually and collectively by creating objects or social relations. Except in rare cases, work does not compensate itself by means of the wage or other forms of money exchange, although artists and craftpersons often live the conflict between their work as a commodity and its self-objectivation aspect. Concomitantly, as Hannah Arendt observes, labor held in contempt as a lower form of activity in ancient times became the defining activity of life in the modern era. Arendt traces this ascendancy to Locke's discovery "that labor is the source of all property." Following from this, Adam Smith and Marx discovered it to be the source of all wealth and "value," respectively (in *The Human Condition*).

Marx made the crucial distinction between use value and exchange value to show how the relations among products of different uses were regulated. According to Marx, capitalism tended to reduce all work to labor and labor to quantitatively measurable units of time. In our period, the relation of labor to time has become more problematic, but work has been almost completely subsumed under labor. Thus, the crisis of leisure—the effort of people to regain their sense of craft, and liberate themselves from their complete dependence on the wage relation for personal and social meaning.

If work was liberated from its instrumental character, we might discover how to resolve the leisure problem. When time becomes unbounded, moral decay does not necessarily follow. But, having been formed in a society in which work as a defining activity is completely recorded as labor, most people are left defenseless by free time, thrown to the twins of buying and eating. The Brooklyn Longshoremen had an ability to form relations, and to make these a new kind of work. This is surely not commensurate with the old idea of craft, in which objects express the unity of mental and manual labor, but friendship and community-making have become as rare talents as good cabinet-making.

In some respects the idea of community-building resembles Habermas's privileging of communicative action, in his most recent *Theory of Communication Action*. Face-to-face interaction, which has become more problematic in our postmodern culture, defies the electronic mode by which communication is mediated. It is the precondition for group formation, political intervention, and individual development. Further, it subverts the molar nuclearization of everyday life, that is, the contemporary process which Deleuze and Guattari have described as aggregation. Workplace, geographically and institutionally based communities, are able, to some extent, to define their own

relations. They view themselves as subjects and find, often in a limited sphere, a language of social action that vitiated the symbolic violence of mass media versions of reality.

But here the resemblance with Habermas ends. The public sphere and its modes of discourse are not spatially separate from the workplace and other sites of instrumental action. His radical distinctions must be taken as purely analytic. For labor is never purely instrumental, nor is intersubjective communication entirely non-instrumental. The manifold relations that people enter into in everyday life are layered with the vernacular of labor, of "free leisure time," of the search for some kind of intersubjectively arrived consensus about reality. But ordinary life is not infused with the "rational" scientific spirit. Its discourse is permeated with emotional, intuitive, as well as intellectual aspects, the separation of which is impossible.

Some wish to abandon the concept of "work" in connection with an emancipatory vision of the good life. Certainly, this is Habermas's intention. However, Arendt's distinction preserves what seems fundamental in the nature of interaction, whether in the process of object production or the development of relations such as commodities. We must "work" to create, quite intentionally, new forms of social life in order to reinvent a politics in which individuals are truly empowered. This power flows both from its link with knowledge, as Foucault has argued, and from the spiritual and political weight of organized action. This is the originality of work in postmodern industrial society.

VII.

The notion of workplace democracy where all categories of labor participate in councils which set production norms, determine what is to be produced, how much and by whom, designate technologies appropriate to ecological, physical, and economic conditions—this notion presupposes what Gramsci called a historic bloc capable of exercising political and ideological hegemony within society, or at least some sort of effective counterhegemony. These conditions exist nowhere, not even in the Scandinavian countries or Italy. The present situation demands, therefore, a *radical strategic shift* towards the reduction of labor time.

This struggle would in fact be necessary whatever the hegemonic situation. For the claim that labor as a form of life should be central to human existence no longer corresponds to the actual development of the productive forces; capital showed itself capable of transforming the terms of production while strengthening its control. The assumed contradiction between new productive forces and outmoded relations

of production has resolved: labor was weakened and displaced from the labor process, and the scene of class struggle shifted from the shop floor to other terrains. Struggles continue on the shop floor, of course, and affect accumulation, but they have assumed an underground, perhaps even antipolitical existence. Workers still try to protect their knowledge and to negotiate information work rules with line supervision, but new managerial techniques constantly undermine these efforts. Resistance persists, and unions try to seal new terms of collaboration with capital; yet workers' power is reduced.

The struggle for the shorter work day, rather than the work week, would be a new offensive strategy because it would embrace the growing millions of part-time workers, mostly women, for whom such labor is an absolute necessity though the wages keep them in a state of penury. Overtime would have to be banned. For at the moment, the 8-hour day means for many workers nothing but an obligation to work overtime at premium pay. The focus on shorter hours would inevitably shift the focus from the workplace, and the almost exclusive emphasis on higher income, to a wider field of social, political, and cultural activity. Unions would have to become communities once more instead of insurance companies. They would revert, in this sense, to the models of the Knights of Labor and the Industrial Workers of the World: in both, any worker joined the union but did not especially seek a contract with the employers. Even though the IWW fought industrial struggles, it organized explicitly around the idea that immediate needs should be linked to revolutionary transformation. The union was thus much more than a trade union: it was a radical departure from the European socialist conception of three separate domains, the political, economic, and social, with corresponding forms of organization, the party, the union, and the fraternal and social groups.

In the absence of a labor party, and with the rightward drift of the Democratic Party, American workers have little choice but to center their struggles within the trade union movement. These unions, however, have sunk to their lowest ebb since the late 1920s, a malaise which can be attributed not only to the world economic crisis of the past 15 years, but also to their structural incapacity to change in the wake of the massive alterations in America's global economic position. Like the left, unions are stuck in the swamp of welfarism, consumerism, and corporativism: they seem ready, in desperation, to seek a new strategy as millions of workers abandon either reliance on, or ideological affiliation with, these policies.

These defections are not merely the result of the conservative onslaught but also of the failure of the left and the unions to come up

with an offensive strategy to deal both with the crisis and the attacks against the postwar compromises between labor and capital. The first error was the simple defense of the old social contract against its rightwing detractors; the second one that unions have been all too willing, with some exceptions like the American and British miners, to cooperate. And the third and final error is that unions have focused on saving *jobs* rather than fighting for the principle of guaranteed income which insures a decent living standard. The left everywhere remains on the defensive after 15 years of retreat, and imagination has migrated elsewhere. The left and labor are so tied to politics as the art of the possible, so tied to economic expansion as a condition for social justice, so tied to the religious idea of labor as redemptive activity, that they have no alternatives in the face of the stagnation in capital accumulation.

When labor marched for the 8-hour day a hundred years ago, most American workers were suffering the 12-hour day and many of them worked even longer than that, six or seven days a week. The 8-hour day took fifty years to realize, but in the fifty years following that not a single hour has been shaved off. Even in crisis-ridden France and Germany, labor and socialist forces have succeeded in making small gains, but the United States and Britain exemplify the rule: labor fights to save the jobs, loses, and watches its armies reduced to batallions.

As German Greens and American women, minorities, and ecological movements have found, the labor movement, however reluctant, still constitutes the most powerful organizational force for social transformation. It is not that labor can hope to become a vanguard, at least in the near future, but its vitality is a measure of the health of the general movement. It is a crucial terrain, because, beyond work, questions of peace and war, social justice, and third world liberation, are related to the capacity of labor to break the bonds of contract unionism. Yet, the task remains for labor to abolish itself.

8

Postmodernism and Politics

Modernism and modernity refer to similar but non-identical aspects of 20th-century life. The first concerns movements which seek to strip representations of their life-world referents, the immediate narratives forming the core of our everyday, taken-for-granted worlds of life experience. Political and economic modernity, on the other hand, has to do with growth-oriented planning and production, with a pluralist political system in which class politics is replaced by interest group struggles, and with a strong bureaucracy which can regulate relations among, and between, money and human capital. Most postmodernist discourse is directed towards the deconstruction of the myths of *modernism* while leaving *modernity* as the best context within which its eclectic and diverse activities may flourish.

I.

By now, nearly everyone agrees that the shift in sensibility Nietzsche announced about a century ago has finally arrived. Postmodernism, the name given to this shift, is marked by the renunciation of foundational thought; of rules governing art; and of the ideological "master discourses" liberalism and Marxism. A major change in the political and cultural problematic, it is in turn related to other changes that have taken place since World War II. These can be summarized as follows:

1. Production in our now global economy is dispersed and de-territorialized. This is true for traditional commodity production such as steel, cars, and clothing, as well as for the communications and information industry, which have partially replaced the old use values as crucial sources of investment, profit, and hegemony. Relatedly, the economic dominance of Western Europe and the United States has been challenged by countries like Japan, Korea, and Malaysia, repre-

sentative of new regional power. Of course, this does not spell the end of American production. In fact, certain industries have "revived" but on different foundations. "Mini" mills have replaced centralized steel production; some Japanese auto corporations have built plants in the U.S., at times on a non-union, paternalistic basis; low-wage apparel manufacturing survives on immigrant labor, both inside and outside the official economy. But the once commanding American lead in electronics has passed to the Pacific region and the dominance over the crucial automobile industry has been lost.

2. The nation-state is alive but by no means well. Having swept the third world in the immediate postwar period, nationalism appears to be in retreat. It lives as a vital force in the advanced capitalist countries only as a reactionary response to transnationalism which, however, abjures Western hegemony ideologically even as it submits to it. Problems arise, meanwhile, out of the need to accommodate transnational corporations devoid of the older loyalty to nations of origin. For globalized production signifies transnational if not truly international ownership. The corporate "metastates" play on the differences between the old and new powers, moving opportunistically from one to the other. Thus, in economic terms at least, the transnationals enter into the balance of world power. "Productivism" in this setting becomes a program of a mostly defeated national or state capitalism that seeks vainly to revive the old liberalism as a means of economic revival and political hegemony.[1]

3. National politics sinks into deeper crisis. Duly chosen by the electorate, the state regime is delegated the task of solving problems such as deficient investment, prodigious unemployment of "human" capital, international trade disruptions, and problems in world power arrangements, that is, products of market inequities. These tasks, in most late capitalist societies, are removed from political contention: parties and movements may oppose prevailing policies but not the state functions themselves, or the underlying discourse of economic growth that propels them.[2] Yet as the state assumes larger responsibilities for the social order, the economy, and the functions necessary for transnational commerce and politics, it is also impoverished, principally in terms of revenues.[3] Austerity becomes the chief instrument of policy for social democrats and conservatives alike. Economic stability is purchased at the price of lower wages and cuts in the social wage. The parliamentary left pledges to administer this austerity with a human face, while the right pushes authoritarian measures which create wider income inequality. None of the major political forces promises any social change or economic affluence for the immense majority.

4. The moral foundation of these regimes is thus in question. Politicians are distinguished by powerlessness, especially in controlling the national economy. We expect nothing from them and their parties today except the maintenance of the status quo. The right wins because it promises to return the country to the days when things were better, claiming that the "free" market is the mechanism whereby prosperity can be achieved. Few accept this, but because the left promises nothing, there is a general willingness to gamble. De-territorialization of production itself entails radically new patterns of everyday life.

It means, for one thing, that we have lost a sense of place. The foundation of this culture may be expressed emblematically by the evocations of work, family, and community. These are conceived as a totality, the parts of which are inseparable. Within the moral regime, work occupies a place of determination over the other elements. Community is built not so much around common geographic space as on common work, which, in turn, structures the family and the community. A concomitant of moral life is the division of labor, especially between the men, who perform "productive" work, i.e., labor, the products of which are exchanged for money or other commodities, and women, who perform household work that is, by the aforementioned definition, "unproductive." In turn, the community is conceived as an extension of the two workplaces: the factory and the household. The moral basis of modern culture in Western Europe and the U.S. is also undermined by the very fact that they are now consumer societies through and through.

5. Political life, then, is no longer rooted in a conception of a qualitatively better world. Even social movements, which in the 1970s accused the political parties, left and right, of operating without vision, have ceased articulating their utopias and sunk into *Realpolitik*. Since the 1960s, they have been postmodern because they rejected the assumptions of modernity: reliance on formal democratic processes, growth politics based on an unalloyed support for industrialism, and, of course, sexual and power hierarchies. However, when they assume electoral power, on instrumental grounds they are obliged to soften their intransigent anti-modernism. The ecological slogan, "save the earth," is inherited from 19th-century *Naturphilosophie* but, expressed as a political program, becomes postmodern in its demand for direct democracy, that is, popular control unmediated by the state over natural and social resources. Where radical modernism seeks to "seize" state power in order to advance the development of the productive forces, postmodern political movements ask that these productive forces be partially dismantled. Postmodern politics demands de-terri-

torialization and regionalization (not the same thing) of political and economic institutions.[4] Since the modern state is marked by its extreme centralizing tendencies (especially in Europe) and this is perceived as a logical development of modernity, postmodern movements oppose statism, including its socialist form, and demand the minimalist, central state.

6. The ecology movement, one kind of postmodern politics, is divided on de-territorialization or regionalism. Some argue that the community is the best site of economic, political, and cultural life, and that communitarian social relations would then be horizontal as opposed to the vertical (hierarchical) configuration of power that is inherent in static versions of social rule. Regionalism, another position, argues for local governance defined geographically by way of a reading of the ecological environment. Both programs retain the primacy of the political insofar as they seek forms of power based on a conception of *scarcity*, a scarcity no longer of economic resources but of the ecosystem itself.

7. Terrorism is another major kind of postmodern politics. Like ecopolitics, it repudiates the retreat of other radicals into defending parliamentary democracy as the last hope of humankind in the wake of authoritarian state forms, East and West. Terrorism must be understood here in its two moments. First, acts of violence against those who "represent" legitimate power—the historical act preferred by some anarchists and nationalists—originated in the premodern revolt against modernity; but contemporary terrorism of this type results from the disillusionment of the generation of the sixties with conventional radical politics. Socialism, it is felt, either surrendered the will to create a kind of politics totally different from bourgeois democratic parliamentarism, or concluded that Soviet state socialism represented a new historical advance for humankind. Dissatisfied with these alternatives, terrorists revolted (rather like their anarchist forebears) against the smooth, repressive, democratic state of late capitalism and the state socialisms of the Communists.

Baudrillard calls attention to a second form of political terrorism: consumer society, privatization, and withdrawal of the masses from participation in the sham of parliamentary democracy. This is surely more damaging than any deed against the symbols of hierarchical power, for its deprives global capitalism of the legitimacy which can be procured only through mass participation in the national state.[5] Not only have more people chosen to withhold their ballot, but public life withers in all late capitalist and state socialist societies. Social and political theory, however, remains split on exactly what this refusal means. Should we be relieved that politics and culture are

finally liberated from their modernist foundations, or should we, like Habermas for example, doggedly retain the hope that propositions of universal validity can guide social life?

The third type of terrorism is performed by the state—both the so-called democratic regimes and those labeled authoritarian. In both cases, terrorism is an extension of policy and morally justified as a necessary evil in an evil world. For "democratic" societies, state terrorism often consists in attacks on subject populations who, it is claimed, have mistakenly allied themselves with evil forces in the pursuit of economic and political liberation. Or, terror is perpetrated upon internal dissenters whose motives are suspect and whose actions abet the objectives of external enemies. The latter justification applies to undemocratic societies as well. In these instances, terrorism is seen as an aspect of a holy war promulgated in the name of antiimperialism, and the moral principles of revolutionary society. The contrast between the two is important. Democratic societies characteristically deny their own propensity to wipe out dissent by force, claiming instead their fealty to methods of persuasion to win or settle disputes. Therefore, evidence of state-initiated terror has an aspect of scandal. In the other cases, where terrorism is morally rather than instrumentally justified, the scandal appears only when the legitimacy of the regime is challenged on other grounds.

II.

Recall Habermas's distinction between communicative action and discourse: communicative action refers to truth arrived at through the perfection of speech acts whose grammatical and semantic aspects have been fully explored to eliminate distortion (actually a variant on C.S. Peirce's theory of the relation of truth to the scientific community). In this view, postmodernity is thus cowardice, or to put it in a less militant way, postmodernity reveals a kind of exhaustion of a Marxist paradigm which can no longer credibly maintain its own truth claims.[6] But while Marxism, which presents itself as post-liberal, may have reached the end of the line, modernity according to Habermas has not. He admonishes us to recognize its unfinished tasks: the rule of reason.[7] Rather than rules of governance based on power or discursive hegemonies, we are exhorted to create a new imaginary, one that would recognize that a politics based on power endangers human survival. Habermas privileges those societies able to resolve social conflicts, at least provisionally, so as to permit a kind of collective reflexivity. Characteristically, Habermas finds that the barriers to learning are found not in the exigencies of class interest, but in

distorted communication.[8] The mediation of communication by inter-
est constitutes here an obstacle to reflexive knowledge. "Progressive"
societies are those capable of *learning*—that is, acquiring knowledge
that overcomes the limits of strategic or instrumental action.

I have invoked Habermas's objection to postmodernism in order to
highlight one of the latter's ineluctable features, *the rejection of univer-
sal reason as a foundation for human affairs*. Reason in this sense is a
series of rules of thought that any ideal rational person might adopt
if his/her purpose was to achieve propositions of universal validity.
Postmodern thought, on the contrary, is bound to discourse, literally
narratives about the world that are admittedly *partial*. Indeed, one of
the crucial features of discourse is the intimate tie between knowledge
and interest, the latter being understood as a "standpoint" from which
to grasp "reality." Putting these terms in inverted commas signifies the
will to abandon scientificity, science as a set of propositions claiming
validity by any given competent investigatory. What postmodernists
deny is precisely this category of impartial competence. For compe-
tence is constituted as a series of exclusions—of women, of people of
color, of nature as a historical agent, of the truth value of art.

Fredric Jameson differs, of course, from Habermas in his criticism
of postmodernism when he identifies it as the cultural logic of late
capitalism.[9] Yet his critique is actually another version of universal
reason. Jameson does not establish the validity of Marxism by de-
fending it against postmodernity, but by invoking its categories to
explain the phenomenon. Thus he preserves the most stunning ele-
ment of Marxist theory, its explanatory power. He places postmodern-
ism in the context of the transformations of capitalism, hence avoiding
the more or less tepid waters which prevent art criticism from ex-
plaining the phenomena it describes.

Chantal Mouffe and Ernesto Laclau, though professed post-Marx-
ists, have curiously remained tied to the scientific paradigm insofar as
they do not refuse ascriptive explanation.[10] Working within Gramsci's
concept of hegemony, they want to develop the Foucauldian relation
of knowledge to power. While distancing themselves from the eco-
nomic categories of Marxism, they greet postmodernism as one path
towards the definition of new historical agents. To be sure, agency in
their discourse is no longer rooted in anything that might be described
as "social relations," much less "relations of production," but is rather
to be found in the permutations and combinations of language. They
are caught, therefore, in the logical contradiction of supporting social
movements while arguing that agency can be found only in discursive
formations.

For Mouffe and Laclau, as for Jean-François Lyotard in his *The*

Postmodern Condition, postmodernist politics consists in the effort to combine the shift in the object of knowledge from society to language with the identification of new political agents which might replace class. However, even if these agents are situated in discursive rather than social fields, the form of Marxism is retained while its categories are not. Against Habermas's attempt to move the ground of politics from class struggle to disinterested communication among competent speakers, and against Jameson's insistence that postmodernism can be understood only if placed in the context of a developmental theory of capitalist periodicity, Mouffe and Laclau argue for postmodernism as a way to generate a new politics of interest, which they call radical democracy.

In fact, however, this concept cannot be conceived in an anti-foundational framework. For radical democracy as a political stance must surely be *an ethical a priori*, if it is not to be seen as a manifestation of the unfolding of the history of class struggles or, in Adam Przeworski's terms, the struggles over class formation.[11] If one abandons here the idea that social forces are situated in a determinate relation to the means of material production, one is left with the assertion of radical democracy as the outcome of the practices of social movements. Now, we may legitimate this viewpoint by arguing that "subject-positions" parallel class positions, in which case my contention that Mouffe and Laclau have not strayed very far from Marxism is justified. Or radical democracy must be a demand adduced from empirical, historical examination of the actual practices of social movements for which democratic struggles have apparently been the vehicle of intervention. In that case, the phrase radical democracy argues not for a new imaginary, but for the existing imaginary as the future imaginary: social movements constituted in subordinate subject-positions always fight for self-determination as the ground of their practices, and thus there is no necessity of justifying by means of transcendent categories.

There is finally a third possibility. We may borrow from moral philosophy the ethical standard of freedom, liberty, and democracy, which, in this instance, then becomes a restatement of the rule of reason over human affairs. Democracy as the rule of reason asserts that bondage can be justified only by a frankly elitist statement about the rational character of subordination on the basis of racial or eugenic superiority, degrees of civilization, etc. But in that case radical democracy as a political stance would not avoid the essentialism it attributes to Marxism; it merely substitutes ethics for history. There are several ways to ground a democratic vision: we may argue that democracy corresponds to a certain level of civilization, whether engendered by the progressive elimination of scarcity through the devel-

opment of productive forces or by a cultural stage; or democracy is conceived as the immanence of reason in its humanist configuration; or by asserting the disappearance of the *a priori* subject of history which occupies a privileged position. Since subject-*positions* replace historical subjects, agency is constituted by conjuncture and not by "unfolding." Yet, even the most poststructuralist arguments do not avoid the problem of the choice of democracy as a characterization of their specifically political position. It is clear that the choice of democracy, especially its radical variant (direct governance, extension of democratic process to the economic sphere, collective self-management, and so forth), is not entirely determinate, either by historical or logical argument. It requires a discursive choice.

Lyotard and Baudrillard try to avoid explanation in their respective accounts of the postmodern condition. By describing rather than explaining, they obviously depart from their respective Marxist roots. But their descriptions of contemporary culture and politics (or, in Baudrillard's terms, the "end of politics") actually bear the ineradicable stamp of Critical Theory. In Baudrillard, for example, the villain remains consumer society, technology, the absence of a public in which critical debate about important issues can take place, and so forth. To the extent that he retains at all the idea of historical agency, this is not far from Marcuse's "Great Refusal." However, the refusniks here are not the intellectuals who insist on the relevance of history, philosophy, and art to a contemporary world which disdains high culture. On the contrary, it is those who withdraw their participation from society, who engage in a politics of anti-politics and ask only to be freed from its obligations, obligations that are, in any case, simulacra of citizenship. The refusal of the privatized masses is, for Baudrillard, not evidence of apathy but of a politics that views the democratic state as a ruse.

Now his discursive terrorism should not be mistaken for an attack on the ethical foundations of politics. On the contrary, he is reaffirming such ethics. Terrorism is directed against the cynicism of the democratic state which, however much it promises the freedom to participate in governance, merely delivers an *ersatz* public sphere, an imitation of public life. Of course, this leads to the conclusion that the end of politics is derived from the end of the social. For Baudrillard, all that exists is power, which "casts a shadow" on the masses, creates an imitation of real public life—which at any rate does not exist, and may never have existed.

What makes his position a politics is the claim that the masses are withdrawing "without knowing it" from the social and political areas in which power legitimates itself. Refusals are no longer directed

against capitalism, imperialism, and other targets of traditional Marxism, but are instead, along the lines of Foucault, aimed at power as such. The intellectual cannot pretend to offer programs, strategies, and tactics for a putative political or social movement, since the referents are empty shells. Hence the conclusion that power as such is the enemy, and that any talk of reform, even revolution, is a diversion from the real task—to annihilate the legitimacy of the state and the parties of order (including communists and social democrats). The task, in other words, is to shift the discourse to exposure of the whole game. Baudrillard thus takes on the appearance of a postmodern prophet but is really a funeral director of modernism, a parent he despises but is nevertheless symbiotically tied to.

Obviously, none of the political forms and ideologies are perfect representations of a postmodern politics, but it includes generally an effort of theory to find a pathway back to reason, even as it takes on the coloring of the refusal of reason as presently constituted by the state and the political parties of order. There the similarities among post-Marxist and postmodernist political theorists end. Baudrillard identifies no new historical actors to replace those that have been found to be either exhausted or engaged in sham, whereas Mouffe and Laclau posit the alternative of radical democracy as the cutting edge of agency. What makes the latter discourse postmodern is its explicit refusal to ground itself in History or in the universalization of particular actors. Consequently, once the Marxist problematic is gone, radical democracy appears as a cultural posit whose only other alternative is nihilism.

But if, as I have suggested, radical democracy is ethically grounded, its postmodernist claim is shaky. The Mouffe and Laclau argument rests on the basis that politics (the state) can be constituted only by the interplay of discursive formations if it is to avoid the authoritarianism inherent in Marxist or liberal essentialism. Radical democracy, then, presents itself as a consequence of the shift from social relations ensconced in a definite conception of human nature to discursive relations which presuppose that political action is rooted only in the struggle for hegemony, in other words, that power makes its own demands. Yet radical democracy does not *necessarily* entail de-territorialization, only the construction of decisions from below. "Below" could encompass geographically situated communities such as factories, offices, neighborhoods, or communities not rooted in a sense of place.

Conceivably, the space of this politics could be situated in the intentional communities attempted by various countercultures. These are postmodern because they deny evolutionist ideology. They assume

that the existing state of affairs may last indefinitely and, even if overturned, may not make room for freedom as long as the new society remains statist and ideologically committed to social hierarchy (as opposed to economic equality). Mass politics signifies for them the end of public discourse, where there is face-to-face communication and decisions are arrived at through consciously applying the rules of evidence and argument. There is no question of seeking or securing a "mass base," for the masses are among the variables of the scientific paradigm that is the modern state: past historical actors such as the working class have lost their autonomous voice. Postmodern politics, then, takes as its object the pragmatic willingness of ruling groups to accommodate the demands of organized movements which, in turn, frame their own politics organized entirely in terms set externally by the ruling class. This assessment provides the basis for the terrorist alternatives, but also for the countercultures.

Even if utopian thought seeks to transform the present by articulating an alternative future, its power lies in its lack of respect for politics as the art of the possible, in its insistence that realism consists in the demand for the impossible. Utopianism is discursive terrorism to the degree that it challenges the prevailing historical and instrumental rationality of bourgeois culture.

III.

The referent of postmodern thought is *practice*, whether in science or human conduct. Its task is not to provide an axiomatic structure to guide thinking but to perform "reading" upon scientific, cultural, and social texts. The function of reading becomes either to reveal the immanence of the text, explicating its antinomies and contradictions (put more historically, its *tendency*), or similarly to unpack its latency—the degree to which it conforms, despite protestations to the contrary, to a first principle, or to an *a priori* logic.

The application of epistemological relativism to political theory results in a pluralist paradigm that explicitly "refutes" theories of power built on structural foundations. Instead of, for example, the primacy of the accumulation process with its concomitant class differentiation and struggle, we are offered an image analogous to a parallelogram of forces contending as a democratic polis in a "marketplace," where power distribution occurs but does not obey any definite laws. We deconstruct "giveness" to show the cracks the sutures have patched, to demonstrate that what is taken as privileged discourse is merely a construction that conceals power and self-interest. "Who governs" is thus in the final account a purely empirical question,

although power tends to accrue to those possessing superior economic resources. Rather than searching for "laws," the postmodern theorist is committed to framing propositions that together constitute a working model tailored to an empirically verifiable situation, the ideal case being the small- or medium-size city, the government agency, the specific labor union or corporation. The "case study" approach is construed, now continuously, now not, on the basis of foundational agnosticism or anti-foundationalism. And, notwithstanding its greater Foucauldian analysis of "history"-framed-as-discourse, it resembles its American case-study cousin.

I, too, take knowledge as a practice, but this does not exhaust the set of practices that constitutes discourse. There are practices that participate directly in, or confront, hegemonic power. Discourse/action constitutes the object of political inquiry, and politics is a menu of interventions within the problematic of power, whose effectivity is differentiated by both discursive positions and control of the means of production and coercion. This field, therefore, is not limited to the specificity of knowledge as discourse. Economy, state, and parties are non-subsumable fields which have been conditioned by postmodernity.

But postmodern politics is not exhausted by practices on the left. Right-wing postmodernism has never been so public: witness the flagrant disregard for legislative mandates and sanctions by the Reagan, Nixon, and other administrations of late capitalist societies. In effect, the popular mandate, a cardinal principle of modernist political ideology, becomes subversive to the postmodern state when it is not rendered superfluous.

Such considerations have been theorized by Samuel Huntington and others.[12] Huntington's attack, launched under the aegis of protecting democratic civilization, is a symptom of the fact that politics is today in a period of radical transition. The degeneration of official democracy has never before been more evident, and it is this rapid decline that gives rise to the left defense of political modernity, especially by post-Marxists. It is too early to judge the debate about whether the radical revision of modernity or its transcendence seems appropriate to the political conjuncture. Rather, my brief map may help to clarify what is at stake in the argument.

This much is clear: the idea of the end of politics is unacceptable, even if descriptions of the *fact* of the degeneration of the public sphere are absolutely accurate. For agency is constituted in the gap between the promises of modern democratic society and its subversion by the various right-wing states. Politics renews itself primarily in extra-parliamentary forms which, given the still potent effectivity of the

modern state form, if not its particular manifestations of governance, draws social movements into its orbit. Some call this cooptation, but it is more accurate to understand it as a process related to the economic and cultural hegemony of late capitalism, which draws the excluded not only by its dreamwork, but by the political imaginary that still occupies its own subjects.

Democracy remains prior to socialism, because of its having been denied to third world societies and because it remains unfulfilled in the first and second worlds. Marxism acknowledges the temporal but not the ethical priority of democracy or, to be more exact, argues that socialism represents the extension of democracy to the economic sphere. The theorists of the first and second internationals regarded the achievements of the bourgeois democratic revolutions in Europe as achievements that constituted a legacy of the proletarian revolution, but did not extend its critique beyond the point reached by Graccus Babeuf at the end of the revolutionary period in France. Babeuf, it will be recalled, criticized the regime for limiting democracy to the political sphere while leaving inequality intact in economic relations.

It was the anarchists and Proudonists who extended the argument: their vision, similar to that of Marx himself, was of the self-management of society by the producers. However, like the early Bolsheviks, their conception of the role of *politics* extended to the social sphere as well as the economic sphere, to which Marxist orthodoxy responded that there could be no socialism in the bedroom. Thus the notion that democracy is prior to socialism signifies that emancipation extends beyond the labor process to the sphere of cultural life. As Henri Lefevbre and the situationists in France, following the surrealists, have argued, the field of contestation is everyday life which includes, but is not limited to, the workplace and the state.

For example, the struggle for trade union rights in Korea, Brazil, South Africa, and, in recent years, in the United States and the United Kingdom is eloquent testimony to the claim that modernity has not yet exhausted itself, that these apparently "elementary achievements" of industrial capitalist societies cannot be taken for granted. So too, traditional individual and collective liberties have not yet become commonplace in revolutionary societies such as China, the Soviet Union, and Eastern European countries, while they remain a problem in recently "democratized" countries like the Philippines and Argentina. What has become crystal clear in the past decade is that the easy assumptions of modernist political ideology—that a free market and a democratic state go hand in hand—are simply not true. For we have learned from both Eastern European and certain Latin American

cases that in this postmodern era, economic, political, and cultural relations are not synchronous, and that each sphere is relatively autonomous.

Nor can it be safely assumed, as both liberal and Marxist theorists are wont to do, that it is the economic, in the last instance at least, which comes to prevail. To be sure, as the Brazilian, Polish, and South African examples amply demonstrate, the struggle for democracy often presupposes the formation of a powerful working-class movement that sees itself not merely as a force for self-betterment through specifically trade union action, but also as a *national* movement. And, only in this sense—only by the merger of the class movement and the national movement—does nationalism retain a progressive content. Otherwise, as I have noted, nationalism as a democratizing ideology is not necessarily democratic. On the contrary, as in the case of Israel and its neighbors, it may become an instrument of domination, both of capital and of one nation over another.

It is important to note that these national movements do not present themselves in the classic European form. In Poland and Brazil they are tied to the project of revitalizing the Church's role in political and social life. Unlike the bourgeois and socialist revolutions, which involved the marginalization of the Church from centers of power, base Christian communities—especially in Latin America—have placed the Catholic church in the midst of the struggle for democratic power. In South Africa the Protestant churches have been severely tested by the racial terrain upon which class questions are fought. Race plays a crucial role as *detonator* of class and cultural contradictions; it is a provisional master discourse that mobilizes all others, including the role of religion in politics.

These liberation movements are not directed chiefly toward modernity but toward radical critiques of modernity as it appears in developing societies. For the assumption of postwar modernizing movements, emanating from both capital and radical party intellectuals in these countries, is that democracy is too high a price to pay, and that a command economy abetted by strong military leadership is a necessary expedient of development. Thus these working-class-based popular movements have, themselves, raised the very democratic demands that refute those theorists of modernity who would claim that democracy is necessarily a specifically middle-class ideology and that it is necessarily a concomitant to market-driven development.

As the Soviet case shows, the success of a development strategy may or may not entail the formation of a "free" market. Nor does the development of a large working class entail the organization of a *movement* that links class justice to democratic political forms. While

such movements have animated recent struggles for democracy in Korea, South Africa, and Brazil, we await similar developments in Malaysia, Taiwan, and Venezuela. In these instances, capital formation has proceeded without the decisive intervention of workers' movements, which, of course, has led to severe exploitation of labor. Where workers have organized to challenge the absolute power of capital, as in Venezuela, they are quickly incorporated on the basis of privileged arrangements, such as in the oil industry.

The concomitant emergence of new democratic and class movements still seems to depend in many cases on the link between intellectuals and workers' organizations. As Touraine argues in his study of the Polish Solidarity movement, such connections are not made on the basis of the classic Leninist model of party formations, in which workers are hegemonized by intellectuals armed with Marxist science. On the contrary, we now see significant elements of the working class who are "educated," not only in the sense of basic literacy, but also in political and organizational alternatives. The political intellectuals who are found in the universities, the Church, and among independent professions such as the law, medicine, and literature, contend, as Gramsci theorized, for moral and intellectual leadership—not necessarily of the nation as a whole, but of the vast technical and intellectual strata that populate all state-driven industrializing societies. Least of all groups do these intellectuals lead the workers. Rather, we ought to speak of an *alliance* of necessary democratic ingredients.

The bourgeois-democratic stage is not set for a socialist revolution. Instead socialism is to be understood as an extension of the democratic revolution. In nearly all cases, "democracy" is apprehended in three inseparable aspects: first, its parliamentary forms which, however, are not viewed as an end for which the movement strives, but as one (vital) component; second, the intellectuals understand political freedom, especially in securing individual rights of expression; and finally, workers naturally demand the unconditional rights to join unions of their own choosing, and above all, the right to assemble freely and strike. These various demands are not incommensurable, but they cannot be conflated, even under the rubric of "human rights." This is why we ought to speak of an alliance rather than in strictly Gramscian terms. For embedded in Gramsci's idea of hegemony is the assumption that intellectuals as a social category do not bring to social movements any interests of their own. This explicit denial of intellectuals as a "class" is rooted in the notion of an intellectual as a person of "ideas," who represents national culture but is not directly linked to its economic and political life. For Gramsci, as for Lenin, intellectuals affiliate with various classes, playing the role of cultural

mediator on behalf of these classes. While Gramsci recognizes that intellectuals are vital actors in the historical process, their importance stems from their function rather than from their position within the social structure.

In the recent explosion of democratic movements, especially in the countries of the semi-periphery, intellectuals relate to workers and peasant movements in two ways: as technical intellectuals of these movements, producing literature, performing bureaucratic tasks, advising leaders of policy, etc.; and as participants in alliance organizations directed towards the middle classes, of which they are a part. Where modernist social movements relied on intellectuals to interpret their goals and programs as much to themselves as to the social formation, in postmodern politics the social movements constitute themselves. If this model is not (yet) completely fulfilled everywhere (as in the Brazilian peasant movement, which relied heavily upon urban intellectual support), the tendency is definitely away from the traditional liberal or Leninist hegemonies. In this sense, the new social movements are *self-produced*, not only with regard to their appearance on the historical stage (the Luxemburgist "spontaneous mass movement"), but also with respect to their ideology, which is not merely "trade unionist" in content, but clearly radically democratic. Here, the term "radical" entails a conception of democracy that goes beyond the parliamentary forms, even as it embraces the notion of representative government. More to the point, the social movements (unevenly) are internationalist and communitarian. They speak *for* their own local aspirations *against* the power of the multinationals which control their labor power *as well as* against the national state which increasingly speaks for itself as well as a segment of local capital. At the same time, these movements are increasingly aware that their own claims are bound up with those of others, whether within national borders or beyond. "Socialism," then, is not being brought to the workers of the semi-periphery from the outside, by intellectuals. In many cases, it is the name given to economic democracy, not to the centralization of ownership and control by the state. Even in revolutionary societies such as Nicaragua, such policies are no longer proposed, much less implemented. Nicaragua has adopted, instead, a model of the garrison state under the weight of U.S. intervention, while its economy remains largely in private hands.

As a modernizing strategy, socialism fails in an international economy dominated by capitalist commodity relations. As *war communism*, it can be employed as a temporary expedient during civil war, but in the long term the new movements demand that it be articulated with their own democratic goals. This is by no means identical with

the European doctrine of social democracy formulated as the alternative to both liberal and state capitalism at the turn of the century. Social democracy became, against the will of its left-wing, a second modernizing strategy. In effect, it argued that state planning, the welfare state, and parliamentary democracy, plus the limited nationalization of essential industries, constituted a viable program for modernization. As we know retrospectively, its successes presupposed the subordination of the colonial world and the abatement of imperialist rivalries. Luxemburgism, which never won the support of a significant section of the workers' movement after 1912, assumed modernity and proposed what might be called *generalized* democracy in an unarticulated form. Postmodern politics resumes this theme with the crucial amendment that the state, held by Marxist theory to be the bearer of the new social order, even if it is destined to wither away, retains a limited function as the guarantor of democratic rights. For radical democrats, social ownership, the state, and the legislative system are no longer understood as transitional forms to a higher order specified by History, but as important, albeit subordinate, elements of a plural social formation in which social movements play a crucial and independent part.

Only the most myopic observer can regard Solidarity or the South African Union of Mineworkers as traditional trade unions. Like the São Paolo metalworkers, they are characterized by a whole network of cultural affinities. The union is not primarily an instrumental organization; it is the name given to their communities. In some cases, these movements affiliate themselves with political parties that represent their (parliamentary) political demands, just as the trade union negotiates with employers. The point, however, is to grasp what lies beyond, and prior to, these functional elements, and to see the difference between their democracy and that of the social democracy or communist movements rooted in the older legacy. In the new movements, the union is the repository of the broad social vision; it is linked to the neighborhoods as well as to the workplace. In short, it is a cultural as well as an economic form.

I want to insist, finally, that the development of these new social movements, in both late capitalist societies and the industrializing societies of the communist and third worlds, *transforms* the meaning of the terms "democracy" and "agency" so that the claim, advanced by theorist such as Habermas, that modernity has not been exhausted is surely not identical with the ideology of the new movements. What is postmodern about these movements consists in this: they borrow freely the terms and programs of modernity but place them in new discursive contexts. We must be careful, therefore, in comparing the

actions and voices of the new movements with what we already have at hand in the history of the Western left. The new social movements speak in postmodern voices; they enter the national and international political arena speaking a language of localism and regionalism, a discourse which, although internationalist, does not appeal to traditional class solidarity as its primary line of attack, but addresses *power itself* as an antagonist. In this consists the originality of the post-liberal and post-Marxist movements.

Traditional liberal and Marxist conceptions of historical transformation have each relied on a conception of agency that is located in the privileged position of particular agents. Liberalism is virtually identical with the claim of the middle class to the program of modernity: individual freedom and the free capitalist market, representative democracy and the pluralist state. Its discourse discounts other ideologies and movements for their deviations from this norm and locates historical agency in the class that bears these values. Accepting the productivist orientation of modernity, Marxism argues that possessive individualism leads, even if unintentionally, to the perpetuation of inequality. While liberalism argues that the bourgeois conception of freedom, having been achieved by its state, marks the end of history, and certainly of class struggle, Marxism shows that the working class constitutes the exclusion in this image.

Through its critique of liberalism as the ideology of stasis, except for capital accumulation, Marxism asserts that democratic values can be achieved only by a radical reconstruction of the relations of production, and the proletariat becomes the bearer of these relations. But Marxism, in fact, is an inversion of the master discourse of liberalism. Its understanding of social movements is similar to its conception of the peasantry and the urban petty bourgeoisie. Oppressed by capital, these classes ally themselves with the working class which, for strategic reasons, incorporates some of their demands. But they are classes of the past and, hence, "intermediate" to the great classes of industrial capitalism: the proletariat and big capital. Homologously, the new social movements of ecology, feminism, racial freedom, and gay and lesbian freedom are valid efforts to combat aspects of capitalist rule which oppress these sections of the new petty bourgeoisie of professionals, artists, and other intermediate layers of society who comprise the cadre for the movements. In the last instance, the labor movement, of which the revolutionary socialist party is the vanguard, is primary. Needless to say, this formulation differs from Jacobinism only in its referents; the signifiers remain the same.

New social movements have opposed these formulations by insisting that they are moral and political agents in their own right,

that the discourses of the movements are alternatives to those of Marxism and liberalism, and that the fulfillment of their conception of everyday relations is not identical to, and may even contradict, those of liberal and traditional left political and ideological discourses. Implicit in this reply is a new conception of historical agent(s) that reduces agency neither to its class nor to other fixed determinations. In this conception, "agent" becomes plural so that "class" arguments are displaced. The working classes are surely agents where they constitute themselves as social movements, that is, where they propose by thought and action to disrupt the reproduction of economic, social, and political life; where they make demands that challenge existing arrangements; and where they offer a vision of a different life. However, workers, and the political parties of which they are constituents, do not always fulfill these "requirements"; in Western Europe and the United States, in particular, they characteristically are not social movements. The question of the existence of their agency is not in doubt. What is in question is their *position* with respect to social transformation. When they do not act as part of the opposition, not only to the party in power, but to the prevailing contract, their status becomes ambiguous.

All of which raises the question of what is "left" in the current conjuncture; the question is not one of the empirically popular but of which movements are genuinely subversive to the order of social things. Only in this context can the issue of historical agency be addressed, if by "historical" we mean those discourses and movements, regardless of class "location," that constitute the real alternatives.

Notes

1. Witness the emergence of the new entrepreneurial spirit in the U.S. and the U.K. and the concomitant hysteria concerning high labor costs which, it is held, have priced goods made within these countries out of the international markets. The cry to compete accompanies the genuine internationalization of production in nearly all the major capital and consumer goods industries.

2. The work of Walter Dean Burnham is particularly apposite here. Almost alone among mainstream students of politics, he has called attention to the crisis of American political parties. See Walter Dean Burnham, *The Crisis of American Politics*.

3. Of course, one would not want to ignore the huge military budget in the U.S. But in the postwar era high spending has not always been a zero-sum game with respect to transfer payments. The key intervening variable is the refusal of financial institutions to bear the growth of the debt in the wake of the decline of traditional social movements.

4. The distinction between the two is important. De-territorialization simply entails

the disaggregation of production from large centers such as Detroit, Pittsburgh, and New York, although it often accompanies greater centralization of ownership. Conservative ecologists praise aspects of this development on environmental grounds (reduction of pollution and congestion) and conflate it with regionalization, which always implies the creation of a greater measure of local self-sufficiency; in other words, the internationalization and nationalization of the division of labor. Regionalist arguments, at best, combine this perspective with the effort to combat the alienation which is often attributed to the domination of nature.

5. Two pamphlets by Baudrillard express succinctly his anti-political arguments. Jean Baudrillard, *In the Shadow of the Silent Majorities* and *Simulations*, both published by *Semiotext(e)* (1985).

6. Jürgen Habermas, *Communication and the Evolution of Society* (Boston: Beacon Press, 1979).

7. Jürgen Habermas, "Modernity—An Incomplete Project," in Hal Foster, ed., *The Anti-Aesthetic: Essays on Postmodern Culture* (Port Townsend: Bay Press, 1983), pp. 3–16.

8. Jürgen Habermas, *Theory of Communicative Action*, vol. 1, trans. Thomas McCarthy (Boston: Beacon Press, 1984).

9. Fredric Jameson, "Postmodernism, or the Cultural Logic of Late Capitalism," *New Left Review*, #146, 1984.

10. Ernesto Laclau and Chantal Mouffe, *Hegemony and Socialist Strategy* (London: Verso, 1985).

11. Adam Przeworski, "Proletariat into Class," *Politics and Society*, 6,2.

12. Samuel Huntington.

Index

Abercrombie, Nicholas, 25
Abortion rights, 60, 214–15
Accumulation Crisis (O'Connor), 241
Adams, James Truslow, 197
Adler, Max, 147
Administration, total, 174n.45
Adorno, Theodore, 80, 174n.45
Advertising, 238
Affirmative action, 216
AFL-CIO, 32–33
African-American, 30–31. *See also* Blacks; Race; Racism
African National Congress (ANC), 49
Agassi, Joseph, 145
Agency
 history and concept of, 11
 intellectuals and class formation, 126
 Marxist theory of class, 127
 post-Marxism, 128–29
 postmodern concept of historical, 270
Age of Reason (Paine), 135
Agnew, Spiro, 58, 210
Airlines, 1, 2–3
Air traffic controllers, 1, 2
Allied Printing Trades, 1–2
All in the Family (Television program), 198, 199, 204

Althusser, Louis
 Marxist theories of the state, 81, 181, 182
 Marxist theory of ideology, 184–85
 school as chief ideological state apparatus, 195
 science and ideology, 85, 94–95, 131
 scientificity of Marxism, 177–78
 theory of ideology, 118–20
American Home Products Corporation, 50
American Revolution, 133–36
Amin, Samir, 10
Ancient Order of Hibernians (Molly Maguires), 115
Anti-war movement, 64–65
Appearances, theory of, 123n.28
Arab nationalism, 13
Archaeology of Knowledge (Foucault), 184
Arendt, Hannah, 249, 250
Argentina, 264
Armenia, 143
Articles of Confederation, 136
Artisanship and artisans, 76, 84, 87, 90, 112, 122n.13, 134
Artists, 154–55
Asian-Americans, 53

Assembly line, 84, 114–15
Attali, Jacques, 166
Authoritarianism, 64, 190–92
Authority, 190–92
Automobile industry, 3–4, 71, 73n.29, 124n.50
Autoworkers Union, 4
Avant-garde, 169–70, 173n.38

Babeuf, Graccus, 264
Bachelard, Gaston, 178
Bacon, Francis, 95–96
Bakke, Alan, 217, 218
Baran, Paul, 108, 119, 240
Barfly (film), 205, 206
Bataille, George, 179, 183
Baudrillard, Jean, 78, 221, 242–44, 256, 260–61
Bauer, Otto, 147
Bergson, Henri-Louis, 24
Bernstein, Eduard, 180, 181
Bevin, Ernest, 227
Bill of Rights, 136
Bioengineering, 144, 157–58
Blacks. See also Race; Racism
 communist movement, 42
 decline of U.S. working-class living standards, 75n.60
 difference between race and ethnic identities, 53
 occupational discrimination, 222
 social movements and American ideology, 30–31
 stereotypes, 56–57
 as unionists, 68
Bloch, Ernst, 179, 188–89
Bolsheviks and Bolshevism, 46, 172n.17
Bommarito, Peter, 55
Borkenau, Franz, 96
Bourdieu, Pierre, 78, 160
Braverman, Harry
 assembly line as model of all capitalist production, 117
 capital-logic analysis, 84, 85, 86, 90, 93, 94, 97, 102, 107, 108, 110, 119

relation of scientific development to development of technique, 123n.29
Brazil, 21, 49, 190–92, 264, 265, 266
British Labor Party, 128
Brown v. Board of Education (1954), 212
Bureaucracy, 81
Burnham, Walter Dean, 270n.2
Bush, George, 58, 210–11, 219–20

Calhoun, Craig, 43
California, 53, 218
Capital. See also Capital-logic theory
 dispersion and globalization, 5–6
 flight, 3, 50
 historical argument on uneven development, 116–17
 socialism and inevitability of revolution, 77
Capital (Marx), 86, 102, 107
Capitalism
 crisis in Marxism, 179–80
 end of organized, 7, 8
 global economic crisis, 125
 Marxist logic of capital, 79–80
 Marx's two-class model and structure of mature, 21–22
Capital-logic theory
 ideological implications of, 92–99
 modern Marxism and rise of, 110–20
 subsumption and subordination of labor under capital, 79–92
 theory of Leninist party and radical intellectuals, 103
Caribbean, 49, 53
Carter, Jimmy, 242
Castoriadis, Cornelius, 176
Catholic Church, 60, 190–91, 215, 265
Censorship, 155
Central Intelligence Agency, 15
Chemical technology, 97
Chernobyl catastrophe, 189
Chevenment, Jean-Pierre, 164, 167

Child-rearing, 29
China, 139–40, 141, 154, 162, 264
Chirac, Jacques, 165
Christianity, 215
Cities, 73n.30, 197–98. *See also* Urbanization
Citizenship, 64–65
Class. *See also* Middle class; Working class
 absence of clearly articulated discourse in U.S., 66–72
 construction by mass-mediated culture, 194
 ethnicity, race, and gender in discourse, 52–66
 intellectuals and formation, 129–37
 Marxism and historical materialism, 15–24
 Marxism and theory of formation, 126–29
 politics and ideology in discourse, 33–52
 reemergence in American political and cultural discourse, 9
 social movements and ideology in discourse, 24–33
 struggle at point of production and logic of capital, 109
Clothing and Textile Workers Union, 4
Cobb, Jonathan, 67
Cold War, 218–20, 226–27
Common denominator, 17
Common sense, 138
Communication, 22–23
Communism, 103
Communist Manifesto (Marx), 107, 126
Communist party (U.S.), 41–42, 74n.49
Communitarianism, 256
Community, 156–57, 249–50
Compassion, 168
Computers, 237, 238–39
Connolly, James, 42, 44
Conservatism, political, 47, 59–60.
 See also Reagan, Ronald; Republican party
Constitution, 136, 151
Construction industry, 6
Consumerism, 27, 28–29, 242
Consumption, 22, 25, 238
Containerization, freight, 232–33
Contribution to the Critique of Political Economy (Marx), 85
Copernican Revolution, 94
Corporate campaign, 2
Correspondence theory, 24
Crafts, 91. *See also* Artisanship and artisans
Craxi, Bennito, 128
Credit, consumer, 25–26
Criticism, 178
Croix, G. E. M., 19–20
Culture
 feminism and critique of contemporary, 29
 struggle at point of production and logic of capital, 109
 working class and electronic age, 193–208
Culture of Critical Discourse (CCD), 146, 162–63
Cuomo, Mario, 59–60
Czechoslovakia, 140, 154

Data processing, 238–39
Davis, Angela, 74n.49
Debs, Eugene V., 35
Declaration of Independence, 136
Deep ecology, 28
De Gaulle, Charles, 167
De-industrialization, 3, 31, 50, 58
De Lauretis, Teresa, 201–202
Democratic Party
 Cold War and capitulation to right wing, 227
 collapse of New Deal coalition, 217–18
 Roosevelt and New Deal, 35
 social movements and American ideology, 31, 32–33

Wilson and labor movement, 34–35

Democracy
 Laclau and Mouffe's political theory, 176
 postmodernism and politics, 259–60, 264
 Soviet intellectuals and reforms, 142–43
 white working class and transformation of politics, 210–16
 workplace, 111–12, 250
Derrida, Jacques, 177, 185, 187
Desegregation, 213
Desk Set (film), 202
De-territorialization, 5, 256, 270–71n.4
Development, dialectical theory of, 112
Dialectic of Sex (Firestone), 10
DiFazio, William, 234–35, 237, 243
Dijksterhuis, E. J., 94, 95, 96
Dinkins, David, 59, 221
Dirty Dancing (film), 200–201
Discourse theory, 184
Discursive formations, 183–84
Displacement, 8
Divorce, 220
Dixon, Melvin, 62
Domination, 21
DuBois, W. E. B., 74n.49
DuChessi, William, 55
Dukakis, Michael, 58, 210–11
Duke, David, 222, 223

Earth First, 28
Eastern Airlines, 1, 2–3
Eastern Europe. See also individual countries
 artists and cultural intellectuals, 155
 collapse of collectivist regimes and social contract with workers, 47–49
 modernization and economic growth, 226
 nationalism and politics of identity, 12–13

postmodernism and politics, 264–65
 scientific and political intellectuals, 139–40, 153
 traditional intellectuals and the proletariat, 103
Eastern Europeans (U.S. immigrants)
 ethnic and race identities, 57–58
 ethnic organizations in American industrial cities, 37
 unions and skilled trades, 55
Ecole Normale Supérieure, 164
Ecology movement
 hegemony of traditional working class, 176–77
 intellectuals and political identity, 143–44
 postmodern politics and de-territorialization, 256
 scientific community and debate, 157
 social movements and American ideology, 27–29
Economic and Philosophical Manuscripts (Marx), 124n.42
Economics. See also Growth, economic
 automobile industry and safety legislation, 73n.29
 capitalist system and periodic breakdown, 104
 de-industrialization and capital flight, 3
 feminism and social justice, 61, 62
 fiscal conservatism of minority politicians, 59–60
 "new world order," 47
 underground economy, 70
 working-class family, 67–68
Education
 class and relation of children to, 67
 class, status, and post-secondary, 26
 media and working-class culture, 200

reproduction of racial and sexual difference, 193–94

Effects, politics of, 229

Ehrenreich, Barbara and John, 126

The 18th Brumaire of Louis Bonaparte (Marx), 127

Eight-hour day movement, 88, 225, 251, 252

Eisenhower, Dwight, 212

Electrical technology, 97

Electronic age, 193–208

Elias, Norbert, 150–51, 152, 161

Engels, Friedrich, 122n.13, 187–88

English Peasant Revolt (1381), 18

Entertainment industry, 57

Entrepreneurism, 270n.1

Environmentalism. See Ecology movement; Green parties

Enzensberger, Hans Magnus, 80

Estonia, 143, 173n.21

Ethnicity
 blacks as class, 30–31
 compared to race identity, 53
 discursive power of American ideology, 53–60
 socialist and communist movements in U.S., 40, 41
 subcultures and group affiliation, 37
 white working class and transformation of American politics, 210

Europe. *See also* Eastern Europe; Western Europe; individual countries
 capital flight and labor movement, 5–6
 social movements and class ideology, 31–32
 crisis of capital and logic of subsumption of labor under capital, 110
 unemployment in 1970s and 1980s, 51
 United States and differences between, 11–12
 workers' movement and organizations, 37

Expansionism, 14–15

Exploitation, 21

Exxon Oil Corporation, 144

Facism, 64, 179

Family, 61, 62, 67–68, 243

Faraday, Michael, 144–45

Federalist Papers, 135

Feminism. *See also* Radical feminism; Women's movement
 fractured identities and disruption, 60–63
 hegemony of traditional working class, 176–77
 new political culture, 171
 social movements and American ideology, 29–30

Field, Sally, 61

Films
 feminism and family, 61
 market distinction between art film and movie, 209n.3
 stereotypical portrayals of Italian-Americans, 55–56
 working class culture in electronic age, 198–99, 200–202, 203–204, 205–208

Finnish-Americans, 39–40

Firestone, Shulamith, 10

Flashdance (film), 207

Fleck, Ludvik, 163

Florio, Jim, 59

Food and Commercial Workers, 38–39

Fordism, 84, 226, 238

Ford Motor Company, 230

Foreign policy, 15, 218–20

Foreign trade, 105

Foucault, Jean
 discourse theory and critique of Marxism, 184
 fundamental concepts of discourse theory, 177
 history and political economy, 185–86, 187
 knowledge/power system, 129
 politics and individual empowerment, 250

France
 American television, 194
 modernization and economic
 growth, 226
 socialist party under Mitterand,
 164–67
 subsumption of scientific and
 technological labor under capi-
 tal, 109, 110
 technocratic character of commu-
 nist parties, 103
 unions and capital logic, 108
 unions and socialist party, 128
Frankfurt school, 80, 169, 174n.45
French Revolution, 133, 165, 189
Freud, Sigmund, 188
Fukuyama, Francis, 10, 11
Fur and Leather Workers, 41
The Future of Intellectuals and the
 Rise of the New Class
 (Gouldner), 126, 162

Gann, Paul, 218
Garment industry, 41, 116
Geisteswissenschaft, 188
Gender. See also Feminism; Mascu-
 linity; Sexuality
 biological identities, 193
 class discourse and domination,
 206
 education and reproduction of
 difference, 193
 feminization of poverty, 62, 220
 historical materialism and iden-
 tity, 17–18
 occupational discrimination, 222
 unions and class, 68
Georgia (republic), 143
German-Americans, 39
German Ideology (Marx), 124n.42,
 146
Germany, 48–49, 128, 143–44, 166
Giannini group, 57
Globalization, 5–6
Goetz, Bernhard, 221
Goodfellas (film), 56

Gorbachev, Mikhail, 142, 172–
 73n.21
Gorz, André, 84, 103, 109, 137, 143,
 227–28
Gouldner, Alvin, 34, 78, 126, 146,
 160–63, 170
Gramsci, Antonio
 concept of bourgeois hegemony,
 119
 intellectuals and class formation,
 130–32, 136, 139, 149
 intellectuals and workers, 266
 Marxist theories of revolution, 83
 Marxist theory of ideology, 184–
 85
 theory of hegemony, 150, 160,
 182, 183, 250
Great Britain. See United Kingdom
Greece, 248
Greek-Americans, 58
Green parties, 32, 143–44, 167–68,
 171
Grenada, 219
Gross National Product, 241–42
Growth, economic, 27, 242
Grundrisse (Marx), 92, 98, 102, 144
Guild system, 89
Guiliani, Rudolph, 221

Habermas, Jürgen, 78, 152–53, 249–
 50, 257–58, 268
Halle, David, 204
Haraszti, Miklos, 154–55
Haraway, Donna, 29
Harding, Sandra, 29
Hartsock, Nancy, 10
Health care, 7, 32–33
Hegel, Georg, 16, 185
Hegemony, theory of, 119–20, 183–
 84
Hegemony and Socialist Strategy
 (Laclau & Mouffe), 176–77, 185,
 189–92
High school, 200
Hill Street Blues (television pro-
 gram), 205
Hispanic-Americans, 53

Historical materialism
 concept of class, 15–24
 Hook's critique of, 181
 poststructuralist critique, 177
 science and capital logic theory,
 96–97
 theory of intellectuals, 153
Historical specificity, 192
Historiography, 186
History, 83, 129, 152. *See also* Historical materialism
History and Class Consciousness
 (Lukacs), 102, 188
Hoerder, Dirk, 135
Homestead strike of 1892, 114
Homosexuality, 62–63
The Honeymooners (television program), 202–203
Hook, Sidney, 181
Horton, Willie, 58, 211
Housing, 197–98
Hungary, 154
Huntington, Samuel, 263

Iaccoca, Lee, 57
Idealism, 180
Ideology
 Althusser and theory of, 118–20
 capital logic theory, 92–99
 middle class and power, 71
 politics and class discourse, 33–52
 race, ethnicity, and discursive
 power of American, 53–60
 science and political theory of intellectuals, 131
 social movements and class, 31–32
Imaging, 201–202
Immigration. *See also* individual
 ethnicities
 plight of workers, 70–71
 socialist movement in U.S., 39–40
 U.S. culture and postcolonial societies, 52–53
Imperialism, 13–15, 105
Industrialization, 50, 76–77

Industrial Workers of the World
 (IWW), 35, 251
Industry. *See* Small business; specific industries
Information technology, 97
Intellectuals
 class formation, 128–37, 143–71
 postmodernism and politics, 266–67
 revival of interest in economic
 and political positions of, 125–26
 role of in twentieth century, 137–43
 theory of capital logic, 119–20
 theory of Leninist party and capital-logic argument, 103
International Ladies Garment
 Workers, 4, 70
International Longshoremens and
 Warehousemens Union (ILWU),
 231–33
International Longshoremen's Association (ILA), 55
International Workers Order, 41
In the Shadow of Silent Majorities
 (Baudrillard), 243
Iran, 13
Iran-contra scandal, 219
Irish-Americans, 42–43, 43–44, 55
Israel, 265
Italian-Americans, 53–60
Italy, 103, 108, 128, 147

Jackson, Jesse, 170–71, 211, 217,
 223
Jacoby, Russell, 159
Jameson, Fredric, 258, 259
Japan, 253–54
Jarvis, Howard, 218
Jay, John, 135
Jewish immigrants, 39, 40, 41, 44,
 142
Joe (film), 203–204
Johnson, Lyndon, 213

Kautsky, Karl, 77, 120n.1, 148
Keller, Evelyn Fox, 29

Keynesianism, 242
King, Martin Luther, Jr., 212
Kiss of Death (film), 56
Knowledge
 Elias's and Gouldner's theories of, 161, 162
 power system, 129
 as practice and postmodern theory, 263
 theory of power and history of, 150–52
Konrad, Georg, 126, 141
Korea, 264, 266
Kramer vs. Kramer (film), 61
Kuhn, Thomas, 156, 163, 178

Labor. *See also* Capital logic
 collective power of, 112–14
 Marxist theory and discussions of capital, 16
 Marx on as class in historical sense, 21
 reduction of work on social and ideological grounds, 225–52
Labor and Monopoly Capital (Braverman), 102
Labor movement. *See also* Unions
 changing composition of U.S., 68–69
 decline of and Democratic Party, 32–33
 unions and class identity, 1–9
Lacan, Jacques, 188
Laclau, Ernesto, 169, 176–77, 182–92, 258–59, 261
Landes, David, 123n.29
Larkin, James, 43
Lasch, Christopher, 60
Last Exit to Brooklyn (film), 62
Latour, Bruno, 145, 163
Latvia, 143, 173n.21
Learning, 258
Lefebvre, Henri, 81, 112, 235, 243, 264
Lefort, Claude, 176, 190
Legitimation crisis, 222–23
Leisure, 234–35, 249

Lenin, V. I. *See also* Marxism-Leninism
 capital logic theory, 107–108
 foreign trade and imperialism, 105, 123n.39
 intellectuals and socialist revolution, 148–49
 socialist revolution from inside capitalist social relations, 83
 theoretical statement on intellectuals as historical agents, 138–39
 ultra-centralism and revolutionary theory, 77, 147–48
Leninism, 102, 103. *See also* Marxism-Leninism
Liberalism, 269
The Life of Riley (television program), 202
Literature, 159
Lithuania, 143, 173n.21
Little Caesar (film), 55
Longshore industry, 231–33, 234–35
Longshoremen (DiFazio), 234–35
Lukacs, Gyorgy, 102, 122n.27, 123n.28, 187–88
Luxemburg, Rosa, 147–48, 148–49, 183, 268
Lyotard, Jean-François, 258–59, 260

Machine tool industry, 116–17
Machinists Union, 4
McLuhan, Marshall, 244
Madison, James, 135
Malaysia, 266
Mallet, Serge, 227–28
Management, 6–7, 92
Mandel, Ernest, 86
Mannheim, Karl, 152, 153
Marcuse, Herbert, 80, 110, 124n.41, 174n.45, 247–48, 260
Marglin, Steven, 84, 90
Marx, Karl. *See also* Marxism; individual titles
 Adorno and critique of political economy, 174n.45

artisanal mode of production and socialist movement, 121–22n.13

development of subsumption thesis, 120–21n.4

insistence on historical framework for all knowledge, 123n.28

natural history and human communities, 187–88

power of knowledge, 146–47, 149, 228

Proudhon's doctrines, 122n.23

relation of labor to time, 249

Marxism. *See also* Marx, Karl; Neo-Marxism; Post-Marxism

capital logic theory, 84–99, 110–20

class theory, 126–29

debate on crisis in, 175–92

democracy and socialism, 264

historical materialism and concept of class, 15–24

industrialization and social world, 76–77

intellectuals and working class, 150

praxis and theory of culture, 118

problematic of work, 228–29

problems raised in recent theory, 78–86

theory of revolution, 77–78

Marxism-Leninism, 10–11

Masculinity, 201–208. *See also* Gender; Sexuality

Massachusetts, 133, 134, 135

Massachusetts Institute of Technology, 144

Mass strike, 183

Maxwell, Robert, 2

Maxwell, William, 145

Mazzocchi, Tony, 55

Mead, George Herbert, 23

Mean Streets (film), 56

Mechanization, 91, 95, 231–33

Media. *See also* Films; Television

Baudrillard on mass, 244

French socialist party, 167

scientific and artistic culture, 155

Merton, Robert, 161, 162

Michels, Robert, 127

Michnik, Adam, 154

Middle class, 71, 75n.60

Middle East, 13

Mildred Pierce (film), 202

Miliband, Ralph, 121n.6

Militarism and military, 13–15, 64, 218–19, 270n.3

Mills, C. Wright, 225

Minimum wage, 239

Mitterand, Francois, 164–67, 168

Modernism, 253, 261

Modernity

abortion rights, 215

postmodernist discourse, 253, 257, 265

values of and new politics of identity, 12

Modernization

French Socialist Party, 165

long-term economic growth and jobs, 226

steel industry, 113, 117

Molecular biology, 158

Mondale, Walter, 212, 242

Monopoly Capital (Baran & Sweezy), 240

Montagna, Joe, 57

Moonstruck (film), 55

Mouffe, Chantal, 169, 176–77, 182–92, 258–59, 261

Movies. *See* Films

Moynihan, Daniel Patrick, 247

Music, popular, 245

National Education Association, 4

Nationalism. *See also* Patriotism

Eastern European political choices and economics, 48

Irish socialism, 42–43

modernity and new politics of identity, 12–15

postmodernism and politics, 254, 265

protectionism, 50

working-class as outgrowth of
powerlessness, 64
Nationalization, 234
Nation-state, 254
Nativism, 52–53
Natural history, 187–88
Nature, 16–17, 28, 85
Negri, Antonio, 221
Neocapitalism, 108
Neo-Marxism, 20, 81, 147
New Deal, 35, 36, 41
New England, 133–35
New Jersey, 196–98
New Left, 20, 65–66, 244
The New Working Class (Mallet),
227–28
New York City, 221
New York Daily News, 1–2
Nicaragua, 219, 267
Nietzsche, Friedrich, 253
9 to 5 (film), 61
Nixon, Richard, 212, 213–14, 219,
247, 263
Norman Street (Susser), 246
Norma Rae (film), 61
Nuclear energy, 189
Nuclear weapons, 157

O'Connor, James, 241
Offe, Claus, 8
Oil industry, 3, 144
One Dimensional Man (Marcuse),
110, 174n.45
On the Waterfront (film), 198–99
Organization, workplace, 115
Organizational affiliations, 37–38,
40–41
Overpopulation, 106. *See also* Un-
employment

Pacific Maritime Association (PMA),
231, 232
Pacino, Al, 55
Packard, Steve, 113–14, 115
Paine, Thomas, 135–36
Pan-Africanism, 49
Pan-Arab movement, 13

Paradigms, scientific, 156
Partisan Review, 173n.38
Parti Socialiste (PS), 164–67
Part-time employment, 69–70, 239–
40, 251
Pasteur, Louis, 145
Patriotism, 63–64. *See also* Nation-
alism
Peasants, 54, 127
Peirce, C. S., 257
Pensions, 7
Perestroika, 143
Persian Gulf War, 14, 64, 65, 219
Petrochemical industry, 145
Philippines, 264
Philosophy, semiotic, 189
Pilots, 2
Poland
authority and domination, 190–
92
collapse of collectivist regimes
and social contracts with work-
ers, 47–48
intellectuals and reform, 154, 162
postmodernism and politics, 265
Solidarity Labor Union, 47, 268
Political clubs, 40–41
Politics
and ideology in class discourse,
15–72
exclusion of Southern and East-
ern Europeans, 58–60
labor movement, unions, and
class identity, 5–9
postmodernism, 253–70
white working class and transfor-
mation of, 210–24
Pollution, 157. *See also* Ecological
movement
Pope family, 57
Popper, Karl, 177, 178
Popular culture, 52, 195
Pornography, 29
Postcolonialism, 52
Postindustrialism, 51–52, 237, 241–
50
Post-Marxism, 128–29

The Postmodern Condition (Lyotard), 259
Postmodernism, 253–70
Poststructuralism, 176, 189–92
Poulantzas, Nicos, 121n.6, 181
Poverty, 31, 62, 69, 220
Power, 129, 150–51. *See also* Knowledge
Practice, 262
Printing industry, 1–2, 116, 231
Privatization, 243
Production, 18–19, 253–54
Productivism, 254
Productivity, worker, 141
Progressivism, 25, 32
Proposition 13, 218
Protectionism, 50
Protestantism, 215
Proudhon, Pierre Joseph, 94, 122n.13, 122n.23
Przeworski, Adam, 259
Public interest groups, 28
Public opinion, 1
Public sector, 4, 240–41
Puerto Rico, 50
Punk music, 245

Quill, Michael, 43

Race
 biological identities, 193
 blacks as class, 30
 compared to ethnic identity, 53, 58
 discursive power of American ideology, 53–60
 education and reproduction of difference, 193–94
 significance in politics since mid-1960s, 212–13, 216–18
 unions and class, 68
Racial quotas, 216
Racism
 cities and housing, 197–98
 class affiliation and, 67
 protectionism and nationalism, 50–51

 resurgence in 1980s, 220–21
Radical democracy, 259, 261
Radical feminism, 171
Raging Bull (film), 56
Reagan, Ronald
 abortion rights, 214
 black working class and poverty, 31
 economic policy and politics, 242
 military spending, 157, 218–20
 postmodernism and politics, 263
 Republican electoral strategy, 211, 214
 white working class and union endorsements, 212
Reason, 258
Red-lining, 213
Reform and reformism, 12, 226–27
Regionalism, 256, 271n.4
Reich, Wilhelm, 64, 179
Reification, 122n.27
Relativism, 262–63
Religion, 17, 215. *See also* Catholic Church
Representation, theory of, 127–28, 185
Repression, surplus, 247–48
Republican party, 210–11, 213–14
Results of the Immediate Process of Production (Marx), 86–92, 102
Revisionism, 19
Revolution. *See also* American Revolution; French Revolution; Russian Revolution
 left-wing intellectuals, 137–39
 Lenin's ultra-centralism, 147–48
 Marxist theories of, 77–78, 82, 83
 scientific-technological and Marxist theory of subsumption, 99–110
 theory of social, 120n.1
Riots, 134
Robeson, Paul, 74n.49
Robinson, Edward G., 55
Rocard, Michel, 165, 166
Rock and roll, 245
Roe v. Wade (1973), 214

Rolling Stones, 245
Roosevelt, Franklin D., 33, 35, 36
Rubber industry, 4
Russell, Bertrand, 178
Russian Revolution, 44, 45–46, 138–39, 147

Sabotage, industrial, 111
Sadlowski campaign, 112
Safety, worker, 111
Sahlins, Marshall, 78
Sakharov, Andrei, 141, 142
Salaried employees, 26
San Francisco, 232, 233
Scarcity, 256
Schorske, Carl, 37
Science and scientists
 autonomy in Western societies, 155
 capital logic theory, 79, 80, 85–86, 92, 94–97, 144–46
 communities and politics, 156–58, 162–63
 feminist critique of, 29
 internal history, 152
 Marxism's claims to scientificity, 177–80
 Marxist concept of class, 17
 political theory of intellectuals, 131
 pressure to conform, 155–56
 role of intellectuals in 20th century, 137
 theory of social relations of, 161–62
Scientific determinism, 180
Scorsese, Martin, 56
Scotto, Anthony, 55
Second International Marxism, 180–81, 182–85
Selections from the Prison Notebooks (Gramsci), 130
Self-criticism, 178
Self-management, 227–28
Self-organization, 20, 21
Semiotic philosophy, 189
Sennett, Richard, 67
Sexism, 67. See also Gender

Sex Pistols, 245
Sexuality, 60, 207
Simmel, George, 96, 122–23n.27
Singer, Daniel, 164
Skill, degradation of labor, 111–18. See also Artisanship and artisans
Small business, 23–24
Social archaeology, 186–87
Social democracy, 31–32
Social ecology, 27, 171
Social imaginary, 195
Socialism
 capitalist development and revolution, 77–78
 French under Mitterand, 164–67
 German model in U.S., 39
 global challenge to fundamental change, 175–76
 "grassroots" agarian and class, 43–44
 Irish nationalism, 42–43
 political clubs, 40–41
Socialist party (SP), 35–36, 39
Social justice, 27
Social linguistics, 185–89
Social location, 22–23
Social movements, 11, 24–33, 34
Social space, 4–5
Social transformation, theory of, 111
Social wage, 225–26
Sociology, 25, 115
Solidarity, class, 23
Solidarity Labor Union, 47, 268
Sombart, Werner, 67
Someone to Watch Over Me (film), 205, 206, 207
Sorel, Georges, 180–81, 182–83
South Africa. See also South African Union of Mineworkers
 authority and domination, 190–92
 postmodernism and politics, 264, 265, 266
 worker organization and political influence, 49
 worker self-organization and racial domination, 21

South African Union of Mineworkers, 268
Soviet Union
 artists and cultural intellectuals, 155
 collapse of collectivist regimes and social contract with workers, 47–49
 humanistic intellectuals and democratic movement, 162
 scientific and political intellectuals, 140–43, 153, 154
 socialism and working-class identity, 44–46
 traditional individual and collective liberties, 264
Spain, 167
Sports, 57
Springsteen, Bruce, 195, 245
Stalin, Josef, 77, 120n.1, 172n.17
State
 compassionate as image, 168
 intellectuals and, 154–57
 Marxist theories of, 81, 82
 Miliband-Poulantzas debate on theory of, 121n.6
 terrorism, 257
Status, 25
Steel industry
 merger of science and industry, 145–46
 modernization, 113, 117
 reductions in employment, 3, 4
 skills and labor, 116
 strikes, 114, 147
 unions and technological change, 230
 worker cooperation, 113–14
 working class culture, 195–97
Steel Workers Union, 4, 117
Stereotypes, racial and ethnic, 54, 55–57
Stone, Kathy, 84, 90
Strategic defense initiative, 157
Strategy to Labor (Gorz), 227–28
Strikes. See also Mass strikes
 class combat in U.S., 66

French, Italian, and U.S. wildcat of early 1970s, 20
 lessons of recent, 1–3
 militant union struggles against concessions during 1980s, 38–39
 Miners strike of 1984–85 and British politics, 38
 public opinion and class affiliations, 69
 political aspirations of working class, 147
 steel industry, 114
Subjectivity, 101–102
Subsumption, theory of, 80, 82, 83, 84–92, 104, 106. See also Capital
Suburbanization, 23, 73n.30, 197, 198, 204
Sufferage, 132–33
Supreme Court, 151, 212, 217
Surplus repression, 247–48
Surplus value, 87, 90, 92
Susser, Ida, 246
Sweden, 128, 166, 226, 227
Sweezy, Paul, 108, 119, 240
Szelenyi, Ivan, 126, 141

Taft-Hartley Act (1947), 227
Taiwan, 266
Taxpayer's revolt, 218
Taylorism, 84, 117, 237, 238
Teamsters union, 212
Technology
 logic of capital and autonomy, 94
 Marcuse on as social force, 124n.41
 subsumption of labor under capital, 85, 86
 transfer and convergence of capitalism and socialism, 121n.11
 unions and change, 229–41
Television, 194, 195, 198, 202–203, 204–205. See also Media
Terrorism, 244–46, 256–57, 260, 262
Textbooks, 194

Theory of Communication Action (Habermas), 249

Third World. *See also* individual countries
anti-third worldism among liberal proponents of modernity, 126
capital logic and revolution, 108
intellectuals and urban working class, 130
Marx's theory of subsumption, 80
Reagan foreign policy and military aggression, 219

Tool-making trade, 91

Town meetings, 133–34, 135

Tractatus (Wittgenstein), 187

Transportation, 197

Transport Workers Union, 43

Triple Revolution group, 237

Trotsky, Leon, 77

Truth, 178

Underground economy, 70

Understanding Media (McLuhan), 244

Unemployment
high rate of youth, 245
part-time employment and underemployment, 239, 240
permanent in advanced capitalist countries, 234
Western Europe and U.S. in 1970s and 1980s, 51

Unified Socialist Party (PSU), 164

Unions, trade
capital and labor process, 99–100, 104
class, gender, and race in recent years, 68–69, 70
decline of and Democratic Party, 33, 251–52
ethnicity and skilled trades, 55
expansion of public employees', 220, 241
labor movement and class identity, 1–9
narrowing of definition of responsibilities, 236–37
postmodernism and politics, 263, 268
power of political machines, 33–34
recent gains among women, 61–62
science and intellectuals, 137
social welfare system, 40
technological change, 229–41
white working class and political conservatism, 212

United Auto Workers (UAW), 230

United Kingdom
American television, 194
class and pubs as institutions, 37–38
Cold War and ideological split in labor movement, 227
modernity and struggle for trade union rights, 264
political controversy and 1984–85 Miners strike, 38
unemployment in 1970s and 1980s, 51
unions and capital logic, 108
youth and involuntary joblessness, 245

United States
economic dominance and postmodernism, 253–54
Europe and comparative perspective on labor movement, 11–12
modernity and struggle for trade union rights, 264
moral basis of modern culture, 255
nationalism and politics of identity, 13–15
nationalism and protectionism, 50–51
as postindustrial society, 51–52
social movements and ideology in class discourse, 24–33

United Steelworkers union, 114, 230

Universities, 159–60

Urbanization, 22–23. *See also* Cities
Urry, John, 25
Utopianism, 262

Vanishing Rooms (film), 62–63
Venezuela, 266
Violence, 55–56. *See also* Terrorism
Viscusi, Robert, 55
Vocation, 240
Voting, 133–34, 211–24

Wage labor, 87
Walesa, Lech, 154
Walker, Charles, 113–14, 115
Wallace, George, 212
Wall Street Journal, 238
War communism, 267
Weber, Max, 151, 169
Welfare system, 247
Western Europe. *See also* Europe;
 individual countries
 capitalism and social benefits, 7
 economic dominance and post-
 modernism, 253
 moral basis of modern culture,
 255
What is to be Done? (Lenin), 138–39
Willis, Paul, 194, 200
Wilson, Woodrow, 34–35
Wittgenstein, Ludwig, 177, 178,
 184, 187
Woman of the Year (film), 202
Women's movement, 214–15. *See
 also* Feminism; Gender

Workers Party (PT), 49
Work groups, 115
Working class. *See also* Class
 crisis in Marxism, 179–80
 culture and electronic age, 193–
 208
 decline and rise of class identity,
 10–72
 labor movement, unions, and
 class identity, 7–9
 postmodern concept of historical
 agents, 270
 renunciation of idea of hegemony,
 177
 white and transformation of
 American politics, 210–24
Working day
 reduction of on social and ideo-
 logical grounds, 225–52
 subsumption of labor by capital,
 87, 88, 89, 104–105
World Federation of Trade Unions,
 227
World wars, 179

Yeltsin, Boris, 142
Youth
 unemployment, 245
 gangs and terrorism, 244–45
 voting and political participation,
 221, 222
Yugoslavia, 228